Improvised
FUTURES

How did we get here? As the twenty-first century unfolds, several seemingly unprecedented phenomena evoke ghosts of past histories that suggest we may have been here before. Forms and arguments gone acquire new relevance, as retrospective signposts for the contemporary. **India Since the 90s** assembles texts and images from diverse academic disciplines and cultural practices, to look again at the millennial turn that is shaping our present.

Series Editor
Ashish Rajadhyaksha

IN THE SERIES

VOLUME 1 The Hunger of the Republic: Our Present in Retrospect
Editor: **Ashish Rajadhyaksha**

VOLUME 2 Improvised Futures: Encountering the Body in Performance
Editor: **Ranjana Dave**

VOLUME 3 The Vanishing Point: Moving Images After Video
Editor: **Rashmi Sawhney**

VOLUME 4 Cities on the Ground: The New 'Urban' Experience
Editors: **Solomon Benjamin and the Frozen Fish Collective**

VOLUME 5 Another Lens: Photography Practices and Image Cultures
Editor: **Rahaab Allana**

VOLUME 6 Ghosts of Future Nations: Gods, Migrants and Tribals in the Late-Modern Museum
Editor: **Kavita Singh**

Set up in 2010, **West Heavens** (http://westheavens.net/) is an integrated cross-cultural exchange programme aiming to disentangle and compare the different paths of modernity taken by India and China. It promotes several layers of interaction across intellectual and art practices, and social thought, between the two countries. In its ten years of existence, the project has organized numerous forums, exhibitions, film screenings and workshops, and has published more than twenty books.

Improvised
FUTURES

Encountering the Body in Performance

edited by

RANJANA DAVE

 Tulika Books

WEST HEAVENS

India Since the 90s

is a collaborative bilingual project between

Tulika Books, New Delhi and **West Heavens**, Shanghai

supported by

Moonchu Foundation, Hong Kong

會金基教文周夢
Moonchu Foundation

Improvised Futures: Encountering the Body in Performance

First published in India in 2021 by
Tulika Books
44 (first floor), Shahpur Jat, New Delhi 110 049, India
tulikabooks.in

ISBN: 978-81-945348-2-2

Design, visual concepts, original photography, montages: Gauri Nagpal

Printed in India at Chaman Enterprises, New Delhi

INTRODUCTION TO THE SERIES

India Since the 90s

This volume, *Improvised Futures: Encountering the Body in Performance*, is the second in our series of six volumes titled **India Since the 90s**. The series is published bilingually, in English and Chinese, and is intended to provide a historical frame for our present. Barring very few exceptions, none of the texts and images used here have been originally created for these books. Most are well known, and so what is new here, apart from their selection and compilation in this particular order, is their assemblage into something of a cognitive mashup. These writings and visuals are thus re-presented here in an attempt at both estrangement and refamiliarization, of an era that is our very recent past and, in some instances, our actual present.

Over the second decade of the twenty-first century, even as we have seen totalitarian state apparatuses roll out emergency measures of extraordinary control, including nationwide lockdowns, in the name of the public good, we have been incessantly reminded of longer histories – reminded, notwithstanding the radically new nature of various phenomena at play (the new viruses, new technologies, new modes of organization and 'occupation', new systems of regulation), that even 'unprecedented' developments can force larger historical frames with which to view both their time and ours.

As clarity slowly emerges around the 'new normal', to use the phrase of the moment, the uncertainty of our time sees the cover-ups of normalcy occasionally lifted

to give us a glimpse of what lies beneath. It is almost as though the growing emphasis on social distancing lies in inverse proportion to the impossibility of *historical* distance. Even as our capacity to imagine stable utopian futures drains away, it is reinvigorated by a textual prescience, as texts and images produced in other times and other places say something to conditions their makers could never have anticipated. We have discovered, it seems, an entirely new ability to read uncanny significances.

Such a definition of the 'normal', this series argues, takes us relentlessly and compulsively back to other moments that too had encountered both the new and the unprecedented everyday. This is not a return to origins. Rather, it is the discovery, in such moments, of the ghosts of other moments. Today's stories, however things pan out, cannot be told without recognizing in them the spectres of the 1990s, the decade that launched a globalization whose end might well be signalled in 2020. And the 1990s cannot in turn be comprehended without accessing yet another equally 'new' moment in history – the 1940s – when the Indian state was imagined, politically and administratively.

In this volume, as she introduces a text by dancer and yoga guru Navtej Singh Johar, Ranjana Dave presents what seems a new way of staging the human body, relentlessly overstimulated by popular cultures of consumption even as it is equally relentlessly being 'observed, scrutinized, looked at, surveilled and watched'. Johar himself presents the body as a laboratory, an amalgam of bones, fluids and breath – in movement. As a dancer, he wants to 'follow the movement' as though it has a lamp in its hand leading the way with a gaze, with touch and sensation. In 2016, Johar followed the movement to an unusual location: India's Supreme Court. He was the first-named petitioner in a legal challenge to the draconian Section 377 of the Indian Penal Code, an archaic bit of colonial legislation that named homosexuality a crime. LGBT activists had fought this battle for years in India's courts, as they have in several post-colonial locations that inherited the old Victorian edict banning 'carnal acts against the order of nature'.

Navtej Singh Johar vs. Union of India (2018) was a legal landmark. It was also one of the most significant political battles fought in early twenty-first century India. At the millennial turn, the abstract 'people' of the Constitution of India had been re-embodied, in the public domain, as new subjects in their desiring and terrifying immediacy. Article 21 of the Constitution, or the right to 'life and liberty', took multiple new turns, such as the rights of urban pavement dwellers (slum-dwellers living on these pavements claiming a fundamental right to shelter), urban safety for women (and movements such as 'Take Back the Night') and spaces for intimacy. Several of the technologies associated with the regulation and ordering of covert space saw battles over state action (e-governance initiatives, the Aadhaar biometric identity project). Key Supreme Court judgements abolishing the draconian Section 66A of the Information Technology Act of 2000 (state surveillance of all electronic communication including social media) and the Right to Privacy – interpreting equality before law, freedom of speech and the right to liberty – may well be, along with *Navtej Johar*, among the defining political actions of the early twenty-first century, as also the astonishing movement in 2019–20 protesting the Citizenship Amendment Act and the National Population Register.

This volume traces a political history, of the body-in-movement, in the words of its many practitioners. It moves from the 'nationalist' subject, both embodied – in the position of the 'classical' dancer of Indian nationalism, the common point of reference for the otherwise divergent positions of dance practitioners Chandralekha, Leela Samson and Padmini Chettur – and disembodied, as in the 'voice' of India's 'nightingale', the singer Lata Mangeshkar, who did playback for some forty years of India's female movie stars. It also moves from theatre to music to virtual *avatar*s. It includes the suicide note of the Dalit student activist Rohith Vemula, referenced by the graphic novelist Orijit Sen, and the landmark performance of Sabitri in Heisnam Kanhailal's play *Draupadi*, set within the context of the Armed Forces Special Powers Act in North East India. Other 'embodied' political subjects include street theatre activists signified by the death of Safdar Hashmi while performing the famous play *Halla Bol* (reproduced in this volume) and bar dancers in Mumbai fighting another draconian moral code for their right to survival.

A common feature across the volumes is the introduction of a glossary of keywords. Several keywords are Indian words, some are acronyms or abbreviations, while others are English words used in India in ways that diverge sharply from their dictionary definitions. While they serve the purpose of introducing them to those unfamiliar with Indian political debate, they also extend the estrangement and refamiliarization project even to those acquainted with their conventional 'Indian' meaning.

Perhaps the only other element common to all the volumes, apart from an interest in the period following the 1990s in India, is a triad of concepts that we may name politics, space, technology. In all these volumes, we will see a pendular movement within political spaces: a movement between physical and virtual, between the local and the planetary. Technology, connected with how space is occupied, is apparatus, frame, mediation and surveillance. Three further terms, in turn, produce the habitus for these concepts: democracy, the body and the text. Even as key democratic concepts such as freedom need to be defined anew in times when bodies – both physical and virtual – occupy complex political domains, the prescient text, reinterpreted, too finds itself bearing new responsibilities.

Ashish Rajadhyaksha
Series Editor
Bangalore, 1 June 2020

CONTENTS

INTRODUCTION

Ranjana Dave

In 2018, when India's Supreme Court delivered its Section 377 ruling[1] confirming that this archaic extract of the Indian Penal Code could not be used to criminalize homosexuality, the internet was flooded with euphoric messages and graphics. The advertising industry was quick to catch on – swapping out its usual visuals of sheets that got whiter, a laundry detergent used the rainbow streak of the pride flag to advertise its efficacy. A ride-hailing service mapped journeys in rainbow hues. Its cars left traces in ways that queer bodies never had, spewing a trail of rainbow colours in their wake as they moved on the map.

This presence and legibility was hard-won – a similar 2009 ruling by the Delhi High Court had been overturned by the Supreme Court in 2013 which rationalized the denial of fundamental rights to the LGBTQ population by arguing that they were too much of a minority to warrant a ruling of this scale. The 2013 hearings were as reprehensible as they were surreal, distorting a discussion about the state's recognition of its queer community to macabre ends. Danish Sheikh's *Contempt* restages those hearings, interrupting them with lived experience in the form of 'witnesses' and 'affidavits'. In a real-life affidavit from 2009, Kokila, a hijra,[2] recounts her experience of trying to report a rape – the police, instead of registering a case against the perpetrators, proceeded to strip and torture her. In Sheikh's script, Kokila 'speaks' in court:

> 'My name is Kokila, Kokila *is* my name. They don't believe it. ... But there is one document that calls me Kokila. There is one place where you will say it, there is one place where you will

allow me to say who I am, that I exist. It is an affidavit. It speaks about my rape.'

Sheikh's restaging sought to address the void created by sterile and abstruse courtroom deliberations, where 'the architecture of the law often has little patience for lived experience'. Echoing this urge, in a rare display of empathy, the 2018 judgement went beyond medico-legal discourse to acknowledge the human cost of Section 377. Immediately after, the queer community exchanged text messages to spread the news and celebrate the decision. Feverishly typed in uppercase, these messages were imbued with the sensations coursing through their senders. 'IT'S GONE!!!', 'WE'RE FREE!!!!!' and 'I'M LEGAL' – stage directions and status reports for queer bodies coming to terms with freshly calibrated notions of personhood and agency.

The 2018 judgement was an outlier in an era of growing authoritarianism marked by measures that seek to repress, rescind and control, allowing for a burgeoning scope of the state's legal definition as 'parent of the nation'.[3] It is inadequate to cast this as a mere loss of rights and freedoms. Through its machinations, the state unabatedly impounds sensorial agency – the right to be seen, heard, recognized – the right to be palpable. Assembled against the backdrop of the state's actions, this volume attempts to frame performance as *doing*, as fraught negotiations of agency and identity. In its structure, it echoes the emphasis of the *India Since the 90s* book series – on the changing politics, spaces and technology that have defined cultural expression since the 1990s. By locating performative potential in a range of ideas and situations, this period has allowed for radical imaginations of the body.

In 1993, at the 'New Directions in Indian Dance' conference in New Delhi, the artist Chandralekha asked an audience of artists and critics: 'When we talk now about new directions, new work, what are your reference points? There are no reference points except your own body.' The body is the site of our investigation, and we have settled in to observe it, both in the *doing* and in the *having done.* We are, to borrow a term from the dancer Navtej Johar, 'farmers of after-effects', working the body into being a highly attuned 'conductor of murmurs' as it forages in the interstices between 'conscious attention' and 'unconscious response'. While 'since the 90s' offers a temporal framework for our investigation, our treatment of time itself is playful and layered, thus moving past being a #tbt,[4] a retrospective account. Channelling the 'textual prescience' of the series, the volume draws on texts and artworks by practitioners – among them artists, academics and activists – who have generously contributed to a creative process where their works function as *movement propositions.* In

being placed in conversation with each other, these *propositions* begin to *react* differently, eliciting new meanings and connections.

Improvisation is a subjective process, playing out as a series of choices that remain alive to the contexts they unfold in. It is driven by curiosity, and has a fractious yet productive relationship with *not knowing*. Assembled in the spirit of improvisation, this volume reflects a similar creative impulse. It can by no means claim to be a definitive and all-encompassing guide to 'performance in India since the 1990s' – a futile claim to make, given the breadth of the landscape it maps and dives head first into. In treating its constituent texts and artworks as its *performers*, the volume relies not only on the principles of improvisation, but also its values – the generosity, trust and empathy that frames how *performers* make themselves *available* to the process – rooted in their own experiences but deeply aware of their environments, receptive to infinitesimal shifts and recalibrations. The ecosystem manifested in the process is more than the sum of its parts, as the *performers* mutually transform into an *assemblage,* holding their own, but also speaking to new meanings and contexts – as they gesture, perhaps, to possibilities of our *improvised futures*.

The volume comprises 'texts' of various kinds – essays, scripts, book excerpts, graphic narratives, manifestos and speeches. Visual references come from various sources – film stills, drawings, maps, photographs and Instagram filters among them. The mirror becomes a binding motif gesturing at the play between body, image and gaze in how it is used to photograph the reflection of an image. Over four months, the design process also accounted for the environments it unfolded in – chronicling sustained commitments and fleeting preoccupations – with the camera acknowledging the socio-political contexts it inhabited, and the pandemic, its gradually attenuated frames of reference. The assemblage is a timeline of our encounters with the volume's *performers* and *propositions*, an accrual of its shifting understandings of 'performance'. Improvisation offers a comfortable framework – the volume is framed by its *intent,* but also sets no definite limits to the architectures of *doing* it extrapolates from its central reference point, the body.

Where Does the Body Begin . . . and End?[5]

For an earlier generation of artists, performance was rooted in the imagination of the newly independent nation-state, by way of a reformulation of traditional and ritual practice, or through the setting up of autonomous yet state-supported teaching and funding institutions that became dominant voices in the field. The Sangeet Natak Akademi (SNA), a national academy for music, dance and

drama, was the first such body set up by the Republic of India.[6] Delivering its opening address in 1953, India's first Union Minister for Education, Maulana Abul Kalam Azad, emphasized the crucial role of the arts in a democratic society, provocatively proposing that 'in the field of art to sustain means to create'. The SNA's actions in the following decades, however, veered more towards consolidating and preserving what it had identified as India's intangible heritage. Through the 1950s, the SNA organized landmark national seminars on dance, drama and music. The curatorial choices made in the programming of these seminars would define its agenda as an organization, and concurrently, the directions that performance practice would take over the next few decades. The seminars served to map the field and specify disciplinary boundaries – what one's reference points could be, which forms were 'classical', 'folk' or 'popular' – decisions that would come to define which forms survived, how they were funded and what spaces they could inhabit.

Performance, then, became an exercise in *constituting a national culture*, an act of *reconstructing tradition*, sometimes at the expense of practices and frameworks that did not fit into a new India. In propaganda videos,[7] a carefully curated ensemble of people performed this new India – its agricultural and industrial prowess, its stunning natural landscapes, and its apparently seamless integration of the urban and the rural, the modern and the traditional. Scattered across picture-perfect settings (and divorced from their human and ecological implications) as they voiced a shared enthusiasm for togetherness and community, anodyne smiles plastered on their faces, the people were mere props, leveraged in service of grander choreographies of modernity.

The volume's first section begins to undo this image of the nation-state, paying attention to what spills out from between the seams – what we have elected to *forget, adjourn, sequester* or *discard*. Chandralekha's 1979 essay on dance as a means of group mobilization reminds us that movement practices are not merely stolid and neutralized formulations of the 'traditional', periodically aired as 'euphoric spectacles of governmental creativity during Republic Day parades in New Delhi'. What 'revolutionary potential' do movement practices hold in their origins as collectively owned responses to the creative, political and ideological needs of the communities where they flourished? What are the state's motives when it casts people into institutional ecologies of production, where the body is an instrument, efficiently manipulated by unseen hands? In such ecologies, the only permissible form of group mobilization is a collective catatonia which forces people to 'live at a distance from their own bodies, getting no feedback from themselves'. A mass of bodies, relentlessly shouldering girder after girder to build metro lines, obediently fingerprinting themselves into glass-fronted

buildings. Bodies that build the nation in those propaganda videos, wearing hard hats especially procured for the shoot.

Occasionally, these bodies threaten to undo the catatonic mechanisms they inhabit, for instance, when millions of migrant workers began to walk home from urban centres after India imposed a nationwide lockdown in response to the Covid-19 pandemic, in what has been described as the largest exodus of its kind since the Partition in 1947. The sheer fact of their presence served as a bold declaration of sentience. There is no room for sentience within institutional ecologies, as made evident by the remarks of Home Minister Amit Shah, who chided the impatience of those who had chosen to walk thousands of kilometres to escape unemployment, homelessness and destitution.[8]

The New Delhi-based Jana Natya Manch's (Janam's) 1988 play, *Halla Bol*, written during a historic industrial strike in New Delhi, turns this denial of sentience on its head by purporting to embed a call for workers' rights within a love story. Crafted as a play within a play, the script mirrors the tensions groups like Janam encounter in their interventionist street theatre practice. The characters are a group of actors who try to stage a play about the demands of striking workers, only to be repeatedly interrupted by the local police, who insist that there can be no intersections between activism and performance. Revolution, for the workers in the play, is fuelled by their social, emotional and domestic needs – clean and decent living, crèches for the children of working parents, and a 'two rupees per point dearness allowance'.

Sometimes, death becomes an assertion of presence, like in the case of the Hyderabad Central University research scholar Rohith Vemula, who died by suicide in January 2016 after being subjected to prolonged caste-based discrimination that effectively thwarted his academic career. The articulation of presence is inscribed by a long history of codes of restraint, as evinced by Orijit Sen's tribute to Vemula on his first death anniversary – a graphic narrative of the nineteenth-century legend of Nangeli, a woman who defiantly cut off her breasts and bled to death to protest the 'breast tax' levied on lower-caste women in Kerala who opted to cover their breasts in public.

In a scene from Amitav Ghosh's novel *Gun Island*, two characters discuss the idea of possession as the loss of presence. A belief in possession is not anachronistic, Cinta tells her friend Dino, because 'the world of today presents all the symptoms of demonic possession . . . we go about our daily business through habit, as though we were in the grip of forces that have overwhelmed our will . . . we surrender ourselves willingly to whatever it is that has us in its power'.[9] The body as instrument is driven by the labour of what Johar might term 'doing, producing and dispensing'.

What would it mean, though, to reimagine (and thus subvert) this possession, allowing the body to restake a claim on itself? In an essay reproduced here, Natasha Ginwala writes about the insidious ways in which female bodies are policed, through an accumulation of numerous codes of restraint that combine to produce a 'carceral condition'. Both physical and psychic, restraint serves to render dissenting bodies 'illegible', and perhaps, she suggests, 'the refuge for dissent lies in witchery'. '*Mata chad jaana*' (being possessed by the goddess) is no longer a reference to a 'trespasser', a 'border dweller'; it is the body wresting itself back from the threshold of apparition, recognizing how it is weighed down by flesh, blood, bones and pain. To repurpose a term from Padmini Chettur's astute investigation of her choreographic practice, *mata chad jaana* might be the revelatory possibility of the body 'finding its own standing'.

Situating the Popular: The Hierarchies of *Doing*

In 2002, actor Tabu[10] won a National Film Award for her portrayal of a Bombay bar dancer in Madhur Bhandarkar's film, *Chandni Bar* (Hindi, 2001), receiving it from the President of India. Three years later, the Maharashtra government banned dance bars, arguing that they enabled crime and 'immoral activities', and put thousands of dancers out of work. Concurrently, 'item numbers' – sexually explicit song-and-dance sequences, usually unrelated to the plots of the films they appear in – became a Bollywood trend. The actors in these sequences often essayed public performers (suggesting roots in the same hereditary courtesan communities as many of the bar dancers), dancing to lyrics that unfolded as a series of double entendres. Over the past fifteen years, 'hit' item songs have endured in public memory – ensuring work for actors, awards for singers, and box office success and recall value for films. Meanwhile, bar dancers waged a fourteen-year-long court battle with several setbacks. They struggled to find the 'dignified' (non-sexual) employment that the 2005 ban sought to direct them towards. This paradox is at the heart of the second section of this volume – the 'popular' reifies hierarchies and tensions around caste, class and gender that surface when we begin to consider how it is differentially produced and consumed by different groups of people. In reading popular culture, as Sharmila Rege crucially reminds us, 'struggles over cultural meaning are inseparable from struggles for survival'.

Rege maps her argument across a history of two forms of performance in Maharashtra – the lavani, danced by women, is viewed as 'entertainment', relegated to the margins of post-Independence society, while the powada, a genre

of Marathi poetry, often authored and disseminated by men, becomes a central mode of articulation for various nineteenth- and twentieth-century political movements. Even as lavani performers were censured and penalized for being an 'immoral influence' on society, losing patrons and access to performance spaces and opportunities, the form gained great currency in Marathi cinema, where it was performed by actors from more privileged caste backgrounds. The stylistic choices made for lavani in cinema seeped back into the staged version.

As Anna Morcom reminds us in the context of the bar dance ban, this selective targeting of female bodies on stage does not emerge in isolation – instead, radiating from wider socio-political stances, it plays out recurrently. In an extract from *Illicit Worlds of Indian Dance: Cultures of Exclusion*, Morcom compares the 2005 ban to the early twentieth-century anti-nautch movement, which sought to elide women of courtesan heritage from public spaces, even as their vocabularies were appropriated into modes and spaces of performance that excluded them. Proponents of the bar dance ban offered the same rationale as their anti-nautch counterparts a century ago, either victimizing their subjects or denouncing them. Even feminists supported the ban, as both Morcom and Sameena Dalwai point out, because bar dancing seemingly reaffirmed the ways in which lower-caste female bodies were sexually exploited by upper-caste men.

These arguments seemed to negate the agency of bar dancers who travelled to cities to find employment in dance bars. Writing in response to feminist critiques of the ban, Sameena Dalwai notes that the government did not merely direct its wrath at an untrammelled lower-caste female sexuality that posed a threat to a 'national cultural identity', aka an 'upper-caste/upper-class Hindu familial ideology'. In dancing at bars, the women, often descendants of an earlier generation of courtesans, were deploying their 'caste capital', their work bringing opportunities to assimilate them into the middle-class society. The government effectively 'banned dance', Dalwai argues, cutting bar dancers off from the possibility of 'occupational and class mobility'.

We must hold on to this recognition of the subversive potential of performance to consider how it is coopted into hierarchies of *doing*. The body is the vector, and *doing* is its mode of contagion. But *doing* is not an unambiguous state of being – it is contaminated by the specificity of *who, how, what, when, where* and *why*. Any impulse to mobilize, change or transform is *conditioned* – unfolding in conversation with, mediated by, aligning with or resisting these specificities. In his work *Singularities*, the dance theorist Andre Lepecki speaks of neoliberal conditioning as a form of 'body snatching', with its codes of rationality and logic seeping into every pore of the body, the 'arrhythmia' between breaths becoming the only possibility of escape from these patterns.[11] To read popular culture,

imbrication of choreographic signatures produced in a constant interaction with its contexts, and the texts in this section work to unravel those layers.

Continuing to examine the hierarchies of *doing* that are constituted within the body, we look at three texts that focus on the work of the playback singer Lata Mangeshkar. In 2004–05, the pages of the *Economic and Political Weekly* hosted a raging debate on the allegorical potential of the woman's voice, with scholars exchanging views and counterviews for over eighteen months. Over time, despite their intransigent viewpoints, their responses began to betray an uncanny intimacy. They shared an interest in the subject of their exchange, and made short work of each other's vulnerabilities. The length of their exchange signals the fraught ways in which we understand *doing* – here, how popular culture is consumed. Performance here is no longer limited to the work of Lata Mangeshkar, but also lies in how these three texts coalesce around a shared interest while simultaneously seeking to unravel each other. It is compelling to imagine how this exchange may have ensued a mere fifteen years later, in 2020 – perhaps a flurry of texts on a messaging service or a series of pithy ripostes compressed into 280 characters for Twitter.

What presumptions does reality TV make of the 'ecological body'? Rahul Bhatia's essay on the dating show MTV *Splitsvilla* is reality TV *about* reality TV. Over the course of the season's shoot, *being* and *doing* begin to counteract each other as carefully constructed personas disintegrate under the camera's constant, manipulative gaze. The first premise of the show was to 'strip away all the characteristics of a normal life', leaving behind a tackily produced hyper-reality that Bhatia's writing chronicles, with acutely somatic perceptions of the mechanics of bodies in motion – the 'remorselessly photogenic' motor coordination of the show's host, the rhythmic cadence of the director's mounting frustration, and the humid sea air that leaves actors 'wilting' in their costumes, firmly tethering them to the *real* world. *Splitsvilla,* like other shows of its ilk, is built on layers of *doing* – as viewers, we are groomed to feel invested not just in what contestants do, but also in our roles in the circuits of reaction and feedback that are orchestrated around their actions. We may be on the other side of a screen, but we feel heard and understood by proxy.

Hyper-reality has several uses. Outside the reality TV universe, in 2013, the right-wing Bharatiya Janata Party (BJP) was preparing for the upcoming general elections. Its campaign advertisements depicted hopeful citizens waiting for the miraculous future captured in the slogan *'Acche din aane wale hain'* (Good days are coming). A miracle in measurable outcomes – piped water, electricity lines, access to education and corruption-free governance. The BJP won the 2014 elections, repeating their victory with a greater margin in 2019, despite a

then, with a sensitivity to *how* it produces bodies, is to try to access 'arrhythmia'[12] – to fleetingly recognize how the body is governed by its conditioning.

In novelist R.K. Narayan's short story *Selvi*,[13] the singer Selvi (modelled on the Carnatic musician M.S. Subbulakshmi) spends a lifetime within the emotional and artistic confines of her marriage, with her husband planning and rigidly governing her career. One day, she walks out of her marriage, moving into a small house where she gives public concerts, singing to her heart's content, much to the chagrin of her husband. Selvi is the fictive 'arrhythmia' that directs my reading of T.M. Krishna's account of M.S. Subbulakshmi's artistic *oeuvre*. MS sang at music festivals, in temple complexes, at state ceremonies and at the United Nations, always appearing in a nine-yard saree, one end draped over her rounded shoulders. She won prestigious awards and sang in multiple languages, including English. Born into a hereditary community of courtesans and beginning her career at a time when anti-nautch sentiments were at their peak, MS's life and work evinced a miraculous class mobility. Her success came at a cost, Krishna writes. MS was perhaps the most famous Carnatic musician of the twentieth century, but in her popular image as a singer of hymns and a politically correct figurehead for Indian culture, she was never seen as an artistic genius. Despite the actual complexity of her practice, she would be remembered for and framed by how she was packaged, and thus, read.

In proposing the 'ecological body' which is constantly in 'flux, participation and change' as one of the nine ways of seeing the body, Sandra Reeve suggests a perceptual shift from thinking of the body as 'being central to' to 'being among' its environment. This reorientation (and expansion) of embodied awareness situates the body as an 'intrinsic part of a wider set of systems'.[14] In 1991, India began a long process of liberalization, moving towards a free market economy. Technology mitigated distance, offering up new reference points for artistic practice even as the ease with which this information was made available resulted in a comfortable blurring of cultural specificity. Nostalgic blogposts about growing up in middle-class urban India in the 1990s chronicle the wondrous arrival of cable television (with more than two channels), tazos or the circular plastic collectibles in bags of potato chips, 'WWF' cards,[15] friendship bands and geometry boxes – histories of embodiment, documented in material accumulation. Our bodies are the precipitate of our experience. Aged six, I watched Sushmita Sen[16] win the Miss Universe pageant on a borrowed videotape. The morning after, I began teaching myself to walk down an imaginary ramp. Miles of walking in tortuously straight lines, my gaze unflinchingly held at eye level, the muscles along the back of my neck growing taut to balance the wobbly book I placed on my head, are part of my muscle memory, of my accrual of embodied awareness. The body as a site is an

term marked by few 'good days'. In primary school, when the Constitution was introduced, we were taught that rights and duties are two sides of the same coin – a phrase that recurs in curricula and in political discourse. Within a simulacrum of reality, the state now splits that coin down the middle, exhorting us, ironically, to be *atmanirbhar* (self-reliant), to fend for ourselves, even as it impinges on and lays claim to our fundamental rights.

Disrupting the Institution, Recasting the Institution

Sixty years after the Sangeet Natak Akademi was inaugurated, in 2013, a tunnel-boring machine took six months to excavate an underground metro route past its headquarters in New Delhi's Mandi House locality. In under 500 metres, the metro line spans multistoreyed proscenium spaces, open-air theatres, black boxes, performing arts schools, the central *akademi*s for literature, performance and the visual arts, and the headquarters of Doordarshan, the state broadcaster. On the metro, it takes approximately thirty seconds to whoosh past the decisions and consequences of nearly seven decades of centralized cultural policy.

For an increasing number of artists post-1990s, living up to the imagination of the nation-state was no longer a primary urgency. The artistic practices validated by the state in the 1950s had largely been consolidated, with second- or third-generation practitioners entering the fray. Their temporal dissonance from these moments of constituting 'national culture' gave them the space to ask new questions and embrace different urgencies. The third section takes a closer look at the institutional architectures and strategies that frame *doing* and evolve in response to it. Both literal and figurative, these frameworks have served as maps for productive relationships with institutional architectures, and as scaffolding for egress, for pointed departures from normative ways of organizing and imagining.

In 2008, a group of theatre practitioners organized the 'Not the Drama Seminar', named with reference to the SNA's 1956 Drama Seminar. Delivering a keynote address, Akshara K.V. gestured towards the ways in which the SNA's 1956 seminar defined an agenda for theatre in India, and what that meant for the directions theatre practice continued to take fifty years thence. His reflection is furthered by Gargi Bharadwaj in an essay that focuses on theatre practices which emerge from and draw on their fraught relationship with state policies. Generating new forms of engagement between the audience and performers, these practices, she notes, 'function outside, even despite, established paradigms of theatre production in terms of spaces of performance, modes of spectatorship, what

constitutes *theatre* and *work* in the theatre'. Meanwhile, Trina Nileena Banerjee offers an overview of theatre in Manipur, from the post-Independence 'political theatre' that flourished in its capital Imphal, ironically mostly funded by the state, and the older *shumang leela*, performed by professional artists who toured the state. The army holds special powers in Manipur, ostensibly to tackle separatist movements in the region. The lives of ordinary citizens are marked by state-sanctioned repression, and performance-makers have sought to document these tensions through their work. Banerjee looks at a range of practitioners making work since the 1970s, including theatre director Heisnam Kanhailal whose *Pebet* (1975) eludes censorship by excising formal text from its vocabulary; its characters 'speak' in a made-up vocabulary of sounds, enunciating their gradual acquiescence to majoritarian oppression through body language and aural cues.

How does the body resist? Somewhere in a village outside Pune, sitting by a makeshift stage, members of a cultural activist group, Kabir Kala Manch (KKM), are waiting to perform.[17] Parts of their performance will make it into Anand Patwardhan's iconic documentary on Dalit singers and activists in Maharashtra, *Jai Bhim Comrade*. On stage, teenagers perform a Bollywood gangster song. When the KKM troupe is finally on stage, they remind the audience that their music takes on different contours and meanings. 'Listen to your future', one member says, launching into a song that unmasks capitalist growth in the form of rampant construction in the region as a new mode of colonization. KKM members travelled the state of Maharashtra, giving such performances and speaking up against caste violence and oppression. In 2011, they were accused of having links to banned political organizations, and warrants were issued for their arrest. As KKM member Sachin Mali reminds us, writing from prison in 2015, 'you can destroy the body, but our ideas will live on'. The body may disappear, but its absence *becomes* the contagion.

Often, a critique of institutionalized or traditional training has served to shape artistic practice, through an unpacking of form, a rejection of codes, or by means of an acknowledgement in scholarship and performance of the ways in which particular artistic frameworks were marginalized, selectively recast in the hybridized practices they gave way to. Artists have also directed their critique at notions of interminably linking practice to specific sets of ideas, beliefs, narratives, musical or visual references, and absolutisms about the body. In arguing for the possibility of discursive and non-dogmatic approaches to codified practice, they also call for fluid and intersectional taxonomies for practice. While the Ministry of Culture does acknowledge that it is tasked with developing ways in which 'creative and aesthetic sensibilities of the people remain active and dynamic', this sensitivity to organic change seldom informs

its own functioning. Dancer Leela Samson reflects on the futility of categories in an excerpt from a 2014 talk delivered during her tenure as SNA chairperson. As recently as 2012, a prominent kathak[18] dancer refused an SNA award for 'Creative and Experimental Dance', stating that it did not accurately represent her life's work or acknowledge that classical dance practice is wont to change as new practitioners contribute to it.

To foreground these absences and erasures in the framing of this section of the volume, I turn to Amitesh Grover's manifesto, *How to Perform a Good Employee*. It offers examples of immediate and actionable gestures of disruption – 'explore horizontality . . . shift incessantly . . . collapse . . . do not let a pattern emerge . . . make speeches . . . illustrate through abstraction'. Written for a performance project where he joined the workforce of a major technology company in order to perform disruptions within the workplace, Grover's manifesto provokes us to amass a vocabulary of *actions* that serve to shake things up.

Practitioners continue to make work that defies categories. They fund their work by cross-subsidizing it, funnelling the proceeds of more 'legible' occupations into their artistic work. Often, such work is also heavily funded by state-run cultural institutions from the global North, via their local outposts. These funding patterns also mean that performance practice in India, particularly in urban centres, has forged more sustained relationships with practice and practitioners in the west than with others in similar contexts in the global South. While such work, often classified under the broad rubric of 'contemporary practice', has significant visibility both in physical venues and on social media, it is to a great extent excluded from official narratives of 'art and culture'. Institutions, particularly state-run ones, have been slow to keep up with new taxonomies, with their reliance on categories holding them hostage to outdated ways of imagining artistic trajectories. The official agenda of preservation, conservation and promotion locks performance practice into a display case, isolating it from the ecologies that have fuelled and nourished it. Any mutations in practice are rendered illegible, and thus *invisible*, because the system does not have the vocabulary to acknowledge them. Do we write ourselves into these systems, or invent new ones that supersede them? How do we, to coopt a term from Grover, begin to 'occupy the company'?

How Are You Programmed?

I am chatting with Cleverbot, and predictably ask, 'Are you a bot?' 'That's a trap', it replies. I ask Cleverbot this question with some frequency. In response, it has feigned being offended, has claimed to be human, and sometimes, has

indignantly thrown my insinuation back at me, 'No, you're a bot!' Cleverbot is an AI chatbot that learns from people and imitates responses. 'Cleverbot does not understand you, and cannot mean anything it *says*', its makers want you to know.[19] But here I am, continuing to project sentience onto its responses.

This preoccupation with sentience stems from a long trajectory of online conversations, all the way back to the early 2000s' moment of entering online chatrooms on unsecured computers in tiny internet cafes, where interactions typically started with the pointedly biographical 'a/s/l', age/sex/location. In these chatrooms, you could be whoever you wanted to be, inhabiting and embodying a range of possible experiences, informed in equal parts by curiosity and fantasy. Over time, these encounters have coalesced into a specific enquiry – what does it mean to perform and embody desire? I include a short piece about performing love in the digital interface, a negotiation that plays out, for me, at the crossroads of body, text and desire.

I never anticipated cooing at an animated visual of a robot going back to its pod to recharge, or offending Cleverbot by asking if it had 'feelings', but that was before I read Maya Indira Ganesh's essay on bots in the human world. 'Romancing the bot' through her account of a range of real- and reel-life bots, in labs and in popular culture, Ganesh dwells on the imaginary lines we draw between who or what is *real* or *robotic*, suggesting that these traits are perhaps more entangled than we believe them to be. With bots living in the zone of 'ineffable rupture: of not-quite but almost there', the gap between humans and bots might only manifest 'because we believe a gap exists in the first place'. The final section of the volume begins to consider posthuman conceptions of *doing* as performative acts. In its invocation here, the term draws from Donna Haraway's sense of the 'posthuman' as an interconnected, networked sociality, echoing Reeve's notion of the 'ecological body'.

Skye Arundhati Thomas reaffirms that ecology in an essay that is ostensibly a review of a performance, and departs from that function to offer a critique of language as we understand it. The work she reviews, Zuleikha Chaudhari's *Landscape as Evidence: Artist as Witness* (2017), stages a courtroom trial, with its performers debating a fictional river-linking project that resembles the contentious proposal to link the rivers Ken and Betwa in central India. In performance, the language of aesthetics and the language of law play out in different registers, not having the shared vocabulary to account for or acknowledge each other. 'It didn't work, because fundamentally it couldn't work, and that was the point', Thomas notes, gesturing in resonance with Danish Sheikh to the inadequacy of language (and the law) when they are confronted by the 'the complexity of actual life systems'.

Mila Samdub writes about trolling as infrastructural performance, as the staging of social scripts 'that have repercussions at massive scales'. He looks at online exchanges around the Aadhaar project,[20] and the organized response to critics of the project by a group of private sector stakeholders who hoped to link services to the Aadhaar interface. The anonymity of trolling allows for 'networked action without selfhood – action without responsibility'. For pro-state trolls who are free of the fears of state-led targeting or suppression, their anonymity directs a 'toxic form of action', shielding them from their victims.

In these exchanges, bodies – simultaneously visible and invisible, authentic and illusory – are called into question, playing back to themselves and overwriting each other. As I write this, *Munnabhai MBBS*, a 2003 Hindi film about a goon who impersonates a doctor, is being re-invoked on Twitter as a hashtag to call out the Prime Minister for the too-good-to-be-true photographs that portray him visiting injured army officials in hospital. The officials wear matching bedclothes, sitting at exactly the same angle, their arms travelling past their knees to rest on the bed, the spine gently slumped to accommodate this penchant for gravity. His supporters hurl a colloquial term for inept, introverted or privileged men, cast into circulation by a 2010 Hindi film, at users who seem to suggest that the visit was staged. Were those officials injured? Were they posing for the camera? Who runs the Twitter accounts that publicized this visit? Are they humans? Are they bots? Did any of this really happen? Why hasn't everything already disappeared?

A Note on Usage

Permission to reproduce has been received wherever possible. Use of all content here falls within the purview of fair use as stated in Sec. 52 of the Indian Copyright Act, 1957 (together with subsequent amendments). Use intended for research, criticism and review is within Article 13 of the Agreement on Trade-Related Aspects of Intellectual Property Rights (TRIPS), which includes fair use in cases that do not conflict with a normal exploitation of the work and do not unreasonably prejudice the legitimate interests of the right-holder as per Article 9(2) of the Berne Convention for the Protection of Literary and Artistic Works (1967), the WIPO Copyright Treaty and the EU Copyright Directive (1996). Such use is also protected by Section 107 of the Copyright Law of the United States of America as 'criticism, comment, scholarship, or research' that in no way damages the 'potential market for or value of the copyrighted work', and by Britain's 1988 Copyright, Designs and Patents Act (Chapter III, Section 28–29).

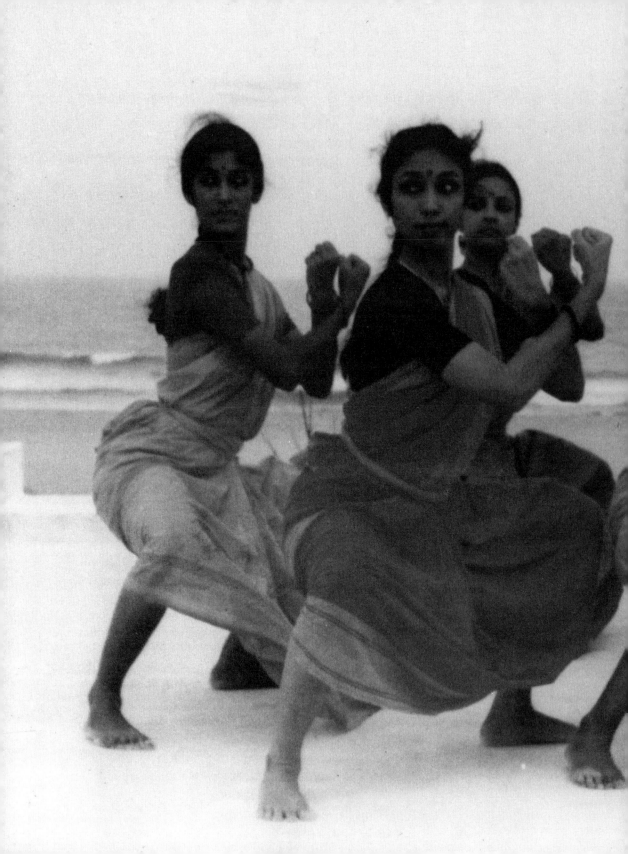

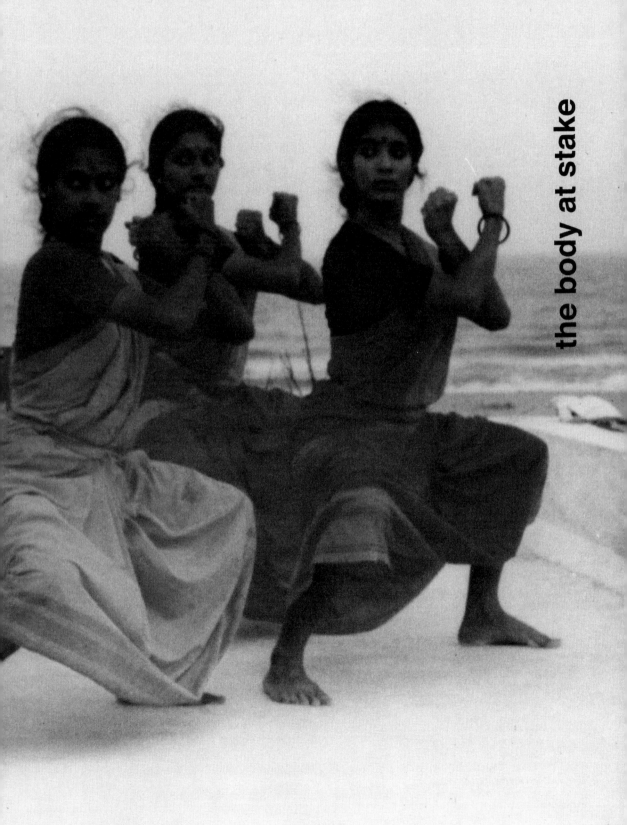

the body at stake

In this essay, first published forty-one years ago, dancer and choreographer Chandralekha radically repositions the resources of Indian dance in its militant tribal practices. Much of her polemic is directed against dance forms that acquired classical status under state patronage. Her focus, here and in her choreographic work, is on the body as an active agent of change; and she discusses how various movement practices have harnessed or, conversely, chosen to suppress the body's revolutionary potential.

Originally presented at a seminar on 'Marxism and Aesthetics' held at Kasauli in 1979, the essay was published in *Social Scientist* (vol. 9, issue no. 98–99, September–October 1980, pp. 80–86). Reprinted with permission from The Chandralekha Archives, SPACES, Chennai. Grateful acknowledgement to Sadanand Menon for support.

Keywords
Araimandi, Bharatanatyam, Chhau, Kalaripayattu/Kalari, Kathakali, Kuchipudi, Odissi, Silamban, Tribal dance practices: see Keywords (pp. 329–44).

Images
pp. xxiv–1: From Chandralekha's *Sri* (1991).
p. 3: From Chandralekha's *Angika* (1985).
Photos by Dashrath Patel, courtesy The Chandralekha Archives, SPACES, Chennai.

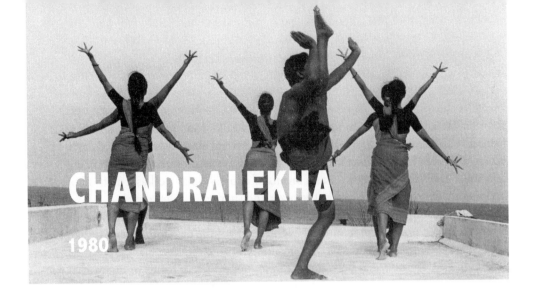

CHANDRALEKHA
1980

01 Militant Origins of Indian Dance

Industrial society surges ahead reducing the human body to a mechanical appendage. It is almost as if various components in the body are being slowly phased out to be replaced by mechanical gadgets – 'the dreamt of metallization of man', Walter Benjamin quotes Marinetti as having said.[1] Under the capitalist production system, people live at a distance from their own bodies getting no feedback from themselves. This is as much an indication of the alienation of man from himself as from his labour, besides being a direct impediment to praxis. Neutralize their physicality, and the system need have no fear of any potentially revolutionary class. The idea of active, physical intervention gets progressively replaced by passive verbalism.

A brief survey of the material foundations of the dance forms of India will give some insights into our present predicament in which the divide between idea and action is continuously widening. All the primary Indian dance forms originating in primitive and tribal societies are solidly linked with work activity. They

were intimately related to functions of daily life like food gathering, hunting, fishing, cultivating and harvesting. The early tribal dances were particularly distinguished by their sources in rituals, gymnastics and martial arts. Dancing – in these early communities – was a means of expression as well as a method of building up energy circuits within the body and sharpening the senses.

We are fortunate to have a material sub-culture in India that simultaneously retains forms of expression spanning several stages of the development of Indian society, providing us evidence of the continuity of a tradition remarkable for its formal purity. In the tribal belt, for example, one still sees forms of dance that are clearly modes of an elaborate attack/defence ritual, which are used primarily for creating the energy necessary for a confrontation in the participants. The regional variation of martial dances, for example, are amazing for their grace and for their potential to generate militancy as well. The militancy of dance forms in India which remain popular even today is supplemented by the fact that even the classical dance forms, despite idealizing their content, have not been able to shed the martial and gymnastic poses of the early forms from which they originated.

All tribal/folk dances were forms of collective expression specifically meant for creating a sense of fraternity and were invariably performed prior to a big hunt or a war. The whole intricate pattern of vigorous body movements they displayed was a method of energizing the body and mind for action. In fact, the best dancers in several tribal communities were also their best warriors.

Every region in India seems to have its own variety of dances upholding the militant traditions. Among the Nagas in North Eastern India, there is an elaborate spear dance in which each dancer brandishes a spear above his head and simulates the various movements of attack and defence. The dance starts with leisurely movements and slowly builds up the tempo ending in a climax of swift, breathtaking leaps in the air, all in perfect rhythm and synchronization with drums and cymbals. Similar kinds of dances are common to other communities like the Semas, Changs, Rengmas, Maos, Aos and Konyaks in the area.[2]

In Bengal, the dances of the Raibenshes and Dhalis are elaborate series of awe-inspiring physical exercises which are close to the traditions of unarmed combat. Orissa also has several forms of dances that are exceptional for their sheer power and militancy. The important varieties are the paika, gotipua and garuda vahanam dances, from which the chhau dance originated.[3]

Every part of the country has its own dance forms using swords, shields and sticks which are all indicative of and preparations for combat. The sword and shield dances of Maharashtra, Rajasthan, Coorg and Kerala are well known.

Dance forms with sticks are common to Andhra Pradesh, Kerala and Tamil Nadu (kolattam) and Gujarat and Rajasthan (daand). Kerala has also specific forms like pulavarkali and velakali utilizing swords, shields or sticks.[4]

The Gonds, Bastar Marias and Bhils of the Madhya Pradesh–Bihar–Andhra–Bengal belt have exciting hunting dances which condition the human body for agility and control. The Irulas of Tamil Nadu also have a robust form of hunting dance called elelakkaradi, and in the Kumaon region of Uttar Pradesh, the chholia martial dances can be traced back to the Khasia warriors. Pairs of dancers with swords and shields make intricate formations covering long distances; they almost act out a mock battle.[5]

It will be seen that there is no dearth of militant traditions among the backward classes, scheduled castes and tribals of India who are the most exploited sections forming the lowest strata of society. Almost all of them still retain their dances and martial-art traditions, but only as formal rituals without being able to transform them into real actions to change their condition of life. Progressive movements are guilty of overlooking this highly charged layer of material subculture in which militancy is integral to the various cultural forms in India, and does not have to come through a verbal/mental process.

In the north, the cradle of these dance forms were the *akhada*s or community gymnasiums, and in the south, a variation of these gymnasiums called the *kalari*.[6] Both the *akhada* and the *kalari* propagated a sophisticated, materialist philosophy of individual and collective well-being with focus on the human body itself. They promoted the ancient, pre-Hindu concept of body expression, *lasya* or *tandava* (militancy with grace),[7] which later became a formal category of classical dance. With precise understanding of anatomy and human engineering like breath, stamina, tension, flexion and control, what the *akhada* or *kalari* basically tried to achieve was to harmonize the human body in space and thus bring it closer to itself.

Thus, the verticality of the body was broken to a more compact and relaxing circularity in the *akhada/kalari*. The idea was to infuse the human body not only with the potential for extension and contractions, but also to convert every movement to an energizing exercise. These contractions of the body later got stylized in classical dance as *bhanga, araimandi* and so on. For example, the *araimandi*, a kind of half-squatting which is the basic stance in bharatanatyam, Odissi, kathakali and Kuchipudi, is also the basic stance in wrestling (Indian and Japanese), kalaripayattu, silamban, karate, tai chi chuan and Thai boxing. It is abstracted as the *mandala* in classical dance, a continuous making and breaking of squares, circles and triangles to harmonize with the circular stage symbolizing the earth or cosmos.

The dances taught one how to hold the body in order to make it steady like a rock, to make it as light as a feather, to leap, to pivot, to shift, to step forward, to retreat and to balance. Symphonies in duet and collective movements with sticks, swords, shields and spears developed slowly out of the primitive barehanded forms.

The practice of these dances was not some esoteric exercise meant for personal satisfaction or for entertaining hordes of spectators. It had specific social applications. In Orissa, for example, the paika dancers were a particular group of unarmed foot soldiers who went much ahead of the main army to demoralize with their speed and grace the external forces bent upon aggression. In the Pandya period in Tamil Nadu,[8] the silamban stick dancers or fighters were the unorganized guerillas and mass leaders who terrorized the feudal barons to control their rapacity.

Militant Functions

These militant functions of dance are evident even today in different forms of dances, such as chhau with its roots in paika, and kathakali with its roots in kalaripayattu.[9]

The word 'paika' means infantry. The paika soldiers were highly trained artistes who were used for facing external aggression. Though extinct today, their battle dances are still preserved by their descendants in the Puri district in Orissa. Each village in the region has a paika *akhada*, the village gymnasium, where young people assemble in the evening after the day's work. The primary aim of this dance was to develop physical excitement and, consequently, courage among the dancing warriors. In ancient times, this method was used unconsciously to keep them ready for battle.

Kathakali too had its origin in body conditioning involved in the martial art of kalaripayattu. All the traditional kathakali schools were called *kalaris*. Kalaripayattu is one of the most developed and effervescent attack/defence systems and there is good reason to consider karate and other South-East Asian martial art systems as offsprings of kalaripayattu. Besides being ritualistic and physical, kalaripayattu, by virtue of its grace and stylization, is a dance form which generates energy in the individual. A student of kathakali has to undergo rigorous exercises and a long process of training to condition his body to acquire perfect flexibility and control.

The social existence of all these dance forms today is precarious. Their direct references to life are more or less truncated. Most folk dances exist at the

mercy of the state. They are promoted and preserved by state organizations to be annually presented as euphoric spectacles of governmental creativity during Republic Day celebrations in New Delhi.

One does not have to be a Marxist to apply Marxian aesthetics to this art form to criticize the situation of folk dances existing in the country. Apart from the obvious dislocation from the processes of life, classical dance forms also exist as ideological vehicles for a class that thrives on nostalgia and mystification of the real content of history. Though one accepts that there is no mechanical relationship between ideology and cultural forms, it has to be said here that art, like religion, has a strong reactionary potential and this has been used as such very consciously even today.

The theory that we finally need to work towards is how to generate creativity, self-expression, dignity and militancy of the people. The Marxist aesthetic theory posits itself against the basic formations of capitalist society like alienation, objectification, commodification and so on, which are all variations of the dehumanization of the essential man under capitalism. The problem arises when this is sought to be applied to traditional cultures, which had already evolved sophisticated philosophies and theories of art and society long before European western societies pulled out of their Dark Ages. It becomes further complex when we realize that almost all the significant human concepts in traditional cultures trace their origins historically to a time that Marx would call 'primitive communism', when man was supposedly closer to nature, to himself and to his fellow men. This has important implications, for in their aesthetic manifestations one comes face to face with remarkably materialistic concepts predating Marx by centuries.

The Indian system of aesthetics, for example, is formulated upon the centrality of man. Concepts like the *pancha mahabhuta* (five basic elements) maintained the primacy of the human body in all cultural configurations. The module for every objective projection was man himself. For example, all measurements were direct references to the human body and senses. This location of the human body in the environment was revealed abstractly in the concept of the *mandala* (geometric configurations of symbols). The *mandala* was a dynamic consonance between the cosmos, the community and the individual. The subject/object dialectics conceptualized in the *mandala* invaded the farthest reaches of material life to find expression to it as the basic conceptual model for every conceivable form of object and daily activity.

Further, the Indian concept of aesthetics inherently negates the formal and esoteric categories like 'beauty', 'style' and so on and goes straight to the sensual content. The *rasa* concept of Indian aesthetics has three primary associations of meaning:

1. As the object of perception by the sense of taste-*rasana* (emphasizing sensual relationship to arts);

2. As the essence of everything or any being – the earth is known as *rasa* as it holds the essence of life for all creatures (materialism) and

3. As liquid or dynamic as opposed to solid or static (the inherent demand for movement, change, praxis).

These are live concepts in our culture still capable of activating the people. The tragedy is that progressive movements have failed to go to our own sources of culture to tap all those areas charged with energy and harness them to build up vitality in people which, obviously, is important for changing conditions in life like any other revolutionary theory. This becomes all the more important when we see that cultural levels, at times, have the possibility of being far ahead of political levels and thus have the potential for initiating social change.

But, of course, we suffer as much today from conceptual poverty as from economic poverty and it becomes a task for us to formulate a theory of revolution that integrates all these levels.

Weight: what body parts drawn to gravity. How does a bend of the knee get differentiated from a yearning of the back of the leg to reach the floor.

AN ENCOUNTER WITH THE BODY AFTER WEEKS OF ALIENATION. A SENSE OF FREEDOM, REDISCOVERY AND WONDER: DELIBERATION AND WONDER.

moving how the bones are what will be awakened?

Started with a tweaking of bone and joint alignment. Finding the right knee again.

अभ्यास

इच्छा

OBSERVATION MINDFUL MOVEMENT

after-effect

FUNCTION

calibration skin

seeing BODY FUNCTION ACTION

liberal with the arms primitive with the legs

रज़ामंदी

in the end, attention to the materiality

circuits of breath.

संकोच Travelling

what started the moment I was on the of my arms: the intense weight of the hip & highlighted even more. on the freedom

in an are over the skull

retracing they are backwards and finally suffusing the stomach like a balloo

possibilities

fatigue

उभरना

भाव

सहज

poise

exhaustion

buoyancy

BODY FUNCTION ACTION

असर

verticality

THE EYES WANTED TO BE OPEN BECAUSE THEY DID NOT WANT TO MISS OUT ON WHAT WAS HAPPENING

रस

FREEDOM: the need more space rolling of the side

courage

खेल

Also, embracing myself. The to be touched for sensorial stimuli for wanting each part of the body to be it is recognised acknowledged and loved

condition

संकोच

The body in our times is observed, scrutinized, looked at, surveilled and watched. If contemporary culture is already guilty of overstimulating the body, how can embodied perception offer new ways of thinking through the body?

This is an annotated transcript of the short film *True to the Bone* (2018), on Navtej Johar's Abhyas Somatics method, shot and directed by Krupa Desai. Grateful acknowledgements to Navtej Johar.

Keywords
Somatics/Abhyas Somatics:
Somatics, a term often used by movement practitioners, allows for careful and reflexive study of the *soma* (Greek term for 'body') through internal physical perception and experience. While there are different somatic methodologies with varying structures, techniques and intentions, they all focus on first-hand experience. *Abhyas Somatics* is Johar's term of choice; emerging from the emotionality of the material body, it defines his relationship to classical dance, yoga and use of the voice.

Images

p. 9: Photomontage detailing Navtej Johar's somatics methodology;
photo of Johar performing in *Tanashah* (2018) by Simrat Dugal.

p. 11: Navtej Johar and Lokesh Bharadwaj in *Frenemies* (2015); photo by Anshuman Sen.

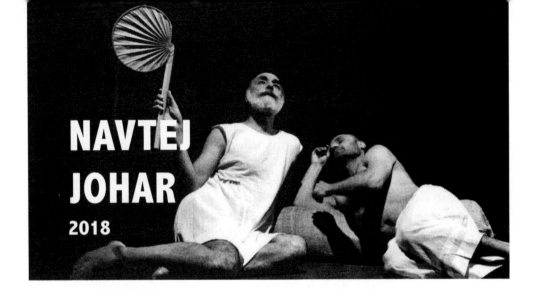

02 True to the Bone

Somatics for me implies *doing*, then *observing*, then *staying put*, and making yourself available to the *after-effects of this doing* with observation. So, it's a model of these four: doing, observing, non-doing and receiving.

What are we trying to do here? We are looking at matter, and we are curiously looking at the restlessness within matter, or the unpredictability of matter, and how this restlessness manifests itself. So, we are curious about matter alone. To just give you a short history of what informs this practice: it comes from my practice in yoga, in dance, bharatanatyam, and also in Vedic chanting.[1]

The promise of yoga, the way I understand it, is *sukha* (repose). This is a pleasurable repose, one that is deeply calming, immersive and containing. A relaxing condition that is actually *abhava* (without feeling), but is self-affirming at a core level. Performance or dance, bharatanatyam offers me the promise of resonance and recognition – of *rasa*, a recognition of a *shared resonance* that I may receive as an after-effect of spectating. In Vedic chanting, my body attunes itself to produce

finely calibrated sounds. But, in doing so, it also makes that same body the prime recipient, the very target, of those finely funnelled sounds. And so it promises to make my body a *listening body*.

What is common between all these three is that they make me a *recipient*, as opposed to a *doer*. I receive *sukha*, I experience *rasa* as a result of receiving a spectacle of *bhava* (emotion), and I become a listening, i.e. receiving, body. And it is this that I really appreciate and cherish about embodied practice. This, to me, is the goal of embodied practice – a goal that is almost entirely lost in the din of an individualistic, production-oriented, capitalist culture.

The *somatic practice* that we have devised stands to counter the definition of practice as it has come to be viewed today, i.e. as *labour of doing, producing, dispensing*. We are caught in the cycle of producing *asanas*, producing predetermined gestures and sounds, constantly striving to better them – as though practice is all about production and perfection and never about reception. In fact, this culture of perfection valorizes relentless strife and robs us of the self-worth that will qualify us to occupy that station of reception. The somatic practice that I propose allows me to sidestep this cycle of dispensing, beginning to turn my attention to the body as a worthy entity – a body with the intentionality, sensitivity and intelligence that can allow it to make a 'just-right' judgement in the moment.

When we place attention upon matter, i.e. the body, which is inherently restless or moving, it will begin to reveal itself. Also, it is important to note that, more often than not, matter doesn't move in very drastic ways. Matter murmurs. It shimmers, like light shimmers on water. Thus, its movement is both very subtle and mercurial, and the placing of attention on it is a two-way affair. When I place attention on the subtle and mercurial murmurings inside my body, I am doing two things. First, I am simultaneously refining and unfixing, or plasticizing my attention by making it an instrument to detect something that is so subtle, constantly shifting and in flow. Second, the placed attention makes matter respond differently, playfully, almost unconsciously, and can even change the course of its flow. So, I am consciously looking at something which is responding unpredictably, whimsically, virtually unconsciously. In a way, it is exceeding my consciousness, so to speak. But the most important thing to note here is that the two are co-responding to each other, that there is reciprocity or correspondence between them. And it is to reinstate this reciprocal correspondence that I propose Abhyas Somatics in a day and age of production that is deaf to correspondence or resonance. How can we even begin to talk of *sukha* and *rasa* in such an age? Therefore, the boring narratives of platitudes sans inspiration that have become part and parcel of dance and yoga pedagogy over the last century or more.

So, there is a gap between my conscious attention, and the unconscious and playful responses, i.e. the *maya* (the imaginary) of my body. And I am not resisting but following the responses and permitting immersion in their after-effects. My project then is to dwell in that excess between consciousness and something that is just-exceeding, slipping-away-a-little-beyond, but staying within, proximity to consciousness. This space-within-excess is very exciting, deeply self-affirming, pleasurable, live and 'sapful'.[2] It is a very reposeful gap, rife with resonance. And that is what we are looking at.

To me, this practice is about observation, and a no-holds-barred reception of after-effects. We are 'farmers of after-effects'.[3] And resonance is the crop of tenacious-and-agile-attention upon murmuring matter. My practice is to attune my body to become a good conductor of this murmuring. And the medium is resonance which calls for an engagement that is necessarily immersive and absorptive.

Observation is key to this practice, but it's not plain observation. It is observation *while doing* and also *after having done*. I observe as I do, or I do and observe intermittently, or I do and observe the after-effects. And I don't meddle with the observation, i.e. I don't impose predetermined ideas on what I see. The same way as somebody experiments, you experiment with something: and then you step back and observe, i.e. receive and accept without meddling with what that experiment yields. Because you want that matter to reveal its nature, or that chemistry to reveal its nature.

So similarly, this whole thing, it's a lab, where we are *doing* and not superimposing. My medium is the body, and my discipline is to look at the ever-moving body in a manner that is mindful but also once removed. I look at the body, I look at the bones, I look at the fluids, I look at my breath, the gaze, touch, sensations, anticipations and so on. Each of them dictates movement. I just commit to following that movement, attentively, almost with a lamp in my hand, illuminating its path. I would like to evoke one of my favourite artists Paul Klee here, who said that if you put the pencil on paper, the pencil begins to dream. Similarly, I'd just like to follow the dream of my bones and fluids. And following a dream is deeply satisfying and self-affirming for me.

Where do I see the practice of Abhyas Somatics going? I see the promise of *sukha* and repose that the practice offers. And I am extremely excited about inquiring into what kind of creative urge, or what kind of creative force comes out of repose. What is the restlessness within repose? Does this restlessness have power, or even direction? My hunch is that the creativity that comes out of repose has a special kind of autonomy, force and vitality. So that's something that I am looking forward to.

There is also the promise of the reconfiguration of the body. We know that I do the practice and I come out, so to speak, renewed. I am reconfigured. And the reconfigurations that we have been seeing in bodies engaged in this practice over the last few years are shifts from, say, normal ordinary comfort to deep comfort, or from anxiety to repose, or from restlessness to absolute stillness. Even from pain to a condition of painlessness, which is pleasurable in its own way. The attempt is to continue fine-tuning this method of making, and reconfiguring shapes akin to yoga *asanas*, to arrive at a state of repose, comfort, well-being. Finally, how does one re-harness the restlessness within the reposeful body to create a replicable movement vocabulary, in order to use this method as a tool of performativity and performance-making?

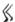

Dancer and choreographer Padmini Chettur worked with Chandralekha for a decade, drawing on her training in bharatanatyam, before she broke away to work independently. It was a fraught and slowly-unfolding break, one that she documents as a history of dance and as it plays out in her body. She plots a chronology of influences and vocabularies, on how to 'break form' through knowing it. This is knowledge Chettur put together from traditional dance, modern engineering, and years of patient exploration, as she slowly assembled a bodily vocabulary, unlearning, re-learning, collecting, and trying not to let 'rigor mortis set in'.

This essay was first published in Anita Cherian, ed., *Tilt Pause Shift: Dance Ecologies in India* (New Delhi: Tulika Books, 2016). Reprinted with permission. Grateful acknowledgement to Padmini Chettur.

Keywords

Araimandi, Bharatanatyam, Kalakshetra, Kalaripayattu, Yoga: see Keywords (pp. 329–44).

*Adavu*s: Short movement patterns in bharatanatyam that constitute the building blocks of the vocabulary.

Navarasa: The nine dominant facial and gestural expressions generated from nine different states of mind – as noted in the *Natyashastra*, the ancient Sanskrit treatise on dramaturgy. They are also considered the basis of emoting in most Indian classical dance forms.

Sarvalaghu: Cycles of 8 – referred from the grammar of rhythm patterns in Carnatic music.

Images

p. 15: Padmini Chettur in her work *PUSHED* (2006); photo by Venket Ram.

p. 17: Performers in *Beautiful Thing 1* (2009).

pp. 22–23: A moment from *PUSHED* (2006); photo by Jirka Jansch.

pp. 28–29: Diptych – performers in Chettur's *Paperdoll* (2005), photo by Jirka Jansch; (below) *PUSHED* (2006), photo by Anna Van Kooij.

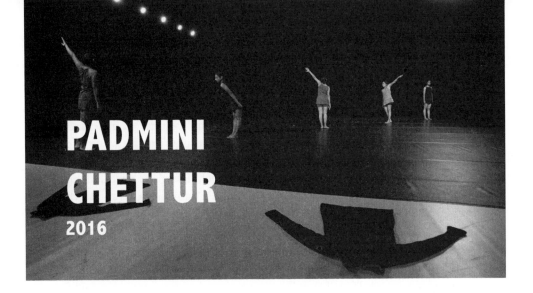

PADMINI CHETTUR
2016

03 The Body Laboratory

The body is the only archive of the physical memories of dance. As choreographers, our work on the physical body will eventually be lost. This, to my mind, is good, but at the same time, problematic. All that will remain is 'documentation', which we can all agree, in the case of dance, is often dead and devoid of the actual breath and life that makes dance so immediate and vital. Other than this, there will be writings. Interviews – some technical, others not. Then there are the physical experiences of dancers, whose bodies have lived the choreographic language. What is good for me about this process of loss is that the more the essence of an artist's work is buried in time, the less chances there are of that work being objectified or idolized. However, in the context of India, due to the lack of access to good archival material and well-developed grammars and vocabularies for the body, each generation of dancers is not only left to reinvent the wheel, but is also prone to a peculiar disinterest and disconnect towards its own dance past, which is in some ways counterproductive.

In the meantime, the dominant discourse of our western counterparts
has been strong and extremely well-articulated. The physical histories and
ideologies have been thoroughly deconstructed and re-packaged into pedagogic
methodologies that far outlived the creators. The 'techniques' are accessible to
generations of dancers worldwide. Today, even in India one can access and learn
(Martha) Graham, Limón, Flying Low... the list is endless. But there exists
no 'Chandralekha technique'. At present, a bharatanatyam dancer looking to
contemporize her form, to find new content within that form, or even to engage
with other possibilities for her body within a larger framework of performance,
would not find good references or systematic ways to go about it. A good reference
does not mean one that gives readymade solutions, or makes the maker's journey
any easier. It is just a process that has been well tested and proved to be working
within the Indian context. It should provide the necessary ascriptions, mapping
the points of transformations of the body that led to pioneering choreographic
works in India. It should also perhaps serve as the only possible counter to what
may be perceived as a standardization of physicality in contemporary dance. We
seem to have accepted and settled into a certain borrowed aesthetic – generic and
homogenized – as the only starting point for our dance journeys.

I would like to hope that the story I am going to tell will partially fulfil
the absence of references I have mentioned above. I will attempt to delineate
twenty-five years of the narrative of a body that I have lived. But before this, I
must rewind to my bharatanatyam years. I see my initiation into dance through
this form as a crucial starting point for the research of later years: research that
took me farther and farther away from what bharatanatyam visibly is, yet always
acknowledged that early training as the single most important understanding of
form and technique in my later work with the body.

In this essay, in an attempt to define my own process of finding physical
references to the past while looking for articulation of a contemporary nature, I
will chronologically map my points of transformation.

1977–87: Bharatanatyam

In 1977, at the age of seven, I began my classes with Pandanallur Subbaraya
Pillai.[1] The first year with him, I was only taught *adavus* without using arms
in three speeds. Learning happened mostly through observing seniors in the
front rows. The only corrections were to sit lower in the *araimandi* or to
stamp harder. At several moments in later phases of my work, the ideas of the
araimandi and the fundamental problem of releasing one leg at a time, out of

or into that stable, symmetric, position of the body were revisited. In their own unarticulated way, these basic movement elements of bharatanatyam provided insights into an understanding of physical geometry within a particular aesthetic. For me, these elements acted as the basis for choosing a grounded body as my starting point.

It was this body that enabled one to receive energy through the feet and harness it in the spine, to maintain a persistent relationship with the vertical, horizontal and diagonal lines in the space, and to understand time in a way that no other system in the world could teach. I have always felt that time is firmly held by the bharatanatyam body and not just passed through. In other words, a lot of attention is paid to arranging the moving body in time – in many different rhythm-patterns and with perfect precision. Therefore, time in bharatanatyam gets intrinsically connected to the 'lines' of the *adavu*s, which in turn aligns the body in space.

Space, time and lines – the three most important concepts in any kind of form-based dance research – were thus already present within the bharatanatyam form. Yet it was the exploration of these very concepts that the practising bharatanatyam community almost disdainfully referred to as 'grammar' in choreographer Chandralekha's (also referred to as Chandra) work – as if it was an unnecessary excess. Later, I will elaborate how it took a sophisticated mind such as Chandra's to recognize, deconstruct and redevelop this 'grammar' in a way that freed it from its classical context. She saw it as technique and language rather than as a construct never to be broken.

In my second year, I was finally allowed to use my arms with the *adavu*s. The notion of 'planes' in space was suggested now as was that of the lines that passed through those planes and the body. There was also a play with counter-symmetry. The relationship of arms and legs was now to be understood through an awareness of centre and spine.

To my mind, a dancer's success in those early years of learning bharatanatyam was a matter of luck combined with whatever personal intuition she brought to the class. One was never really taught how to hold one's arms in the back, how to relax the tops of the shoulders, how to widen the space between the shoulder blades in order to extend the arm-line without tiring the neck and shoulder muscles. Likewise, the relationship of pelvis, ribcage and head was summed up simply with the words, 'Keep your back straight!' In later years, when a self-conscious study of anatomy entered my practice, I often thought about the disservice that this peculiar cultural stubbornness had perpetrated on generations of dancers – who could have been directed towards enquiry rather than imitation if the pedagogy, stunted and limited by conservatism, had not failed them.

Throughout my engagement with bharatanatyam for ten years, it was always the 'narrative' that I found difficult to connect with. It was not just the content, the religiosity, or the innate patriarchy, that was communicated clearly in the difficult relationship with the 'master'. It was more the idea of playing the role of an entertainer on stage – the meaningless smiling, the performativeness that had started to creep into the practice of the form itself. I could never become a bharatanatyam diva, and so, at seventeen, I chose academics over dance – for which I am eternally grateful.

However, as has been articulated repeatedly by the first generation of contemporary choreographers in India (who were the architects of new languages that emerged from the classical), in order to break form, one has to first know it. And though in today's context this 'breaking of form' seems somewhat dated and irrelevant, I have always found the 'reference' of bharatanatyam in my body a comfort. It keeps me grounded, both physically and in my choreographic practice. I know where I come from – from where I derive my aesthetic. Later in this essay, I will discuss more about how this understanding was intrinsically connected to the politics of time and space: and how through the subsequent periods of transformations, the inter-politics of body, identity and humanity was constantly re-engaged in my work.

1987–90: The Study of Science

I left Chennai to study at BITS (Pilani) for four years.[2] My physical practice of dance was replaced by swimming. I strongly recommend to all young dancers that they take time off from relentless practice and performance to engage with life in an academic space for a few years – away from the discipline of the guru, preferably away from home too. For me, those four years of anarchy and excess paved the way for many conscious choices in later years.

Also, I have to say that my counterparts at the university were more intelligent and intellectually provocative than the culturally submissive dancers I would have been with, had I chosen to continue to study bharatanatyam at an institute of dance such as Kalakshetra in Chennai. Everything was questioned, freedom was grabbed, and on top of it all, I found something invaluable in my encounters with the rigours of chemistry: the logic of structure in both two and three dimensions, solving problems on a grid, the absoluteness of truth in a balanced equation. Later, it became clear to me that it was the pragmatism of science that I had missed in bharatanatyam. I wanted to envision dance as an uncluttered set of physical ideas, truthful and devoid of sentiments. In my work

with time, I looked for both of these as a goal. I would like to perceive the bodies in my choreographic structures conjoined like the atoms of a large molecule.

At the end of my time at BITS, with absolutely no intention of becoming a dancer, I stumbled into Chandralekha's world.

1990–94: Early Years with Chandralekha

By the time I first met Chandra, she had already been choreographing for a few years. I was therefore not a part of the making of *Angika*[3] or *Lilavati*,[4] and only took part in the later performances of these works. Chandra's point of departure – to contemporize 'Indian' physicality within the present sociopolitical context – led to her early research on the body. The bharatanatyam technique did not suffice for her particular needs. Drawn to the physical qualities inherent in bodies trained in kalaripayattu and yoga, she brought these three practices together and explored what lay beneath them. It was this synchronicity that formed the ground for the physical training that her dancers underwent. The beauty of Chandra's capacity to draw transformative results from her performers derived from her method in which we were responsible for our own growth as against the packaging and standardization of learning. She never put herself in the role of a guru or a teacher. Rather, she always insisted that we were not her 'students'.

At the time, the group consisted of bharatanatyam dancers mostly trained in the 'Kalakshetra style', Nandu and Nagin who were highly skilled and experienced in Iyengar yoga, and some students of Vasu Gurukkal[5] from Kottayam who were kalaripayattu practitioners. Apart from actual rehearsals with Chandra, we scheduled daily sessions where we practised *adavu*s, yoga *asana*s and basic elements of kalaripayattu learned from the group members themselves. The work was complex and far-reaching. Given the focus of this essay, it is important that I elaborate on the changes I underwent as a practitioner through those bodily experiences.

I must begin by saying that in a way, all the practice and learning that we had outside the rehearsals with Chandra were still evaluated and understood by us through the lens of *her* vision. She was not interested in the perfect *paschimottanasana* (a seated forward bend) or the highest kick one could conjure. With her, it was never about flexibility or the gymnastic abilities of the body. Instead, her intention was to look for specific qualities in various forms. Especially up to the point of choreographing *Praana*,[6] the formal material was thoroughly delineated in her work – always searching for the 'flow', identifying the journey from one position to another, shredding the external decorativeness

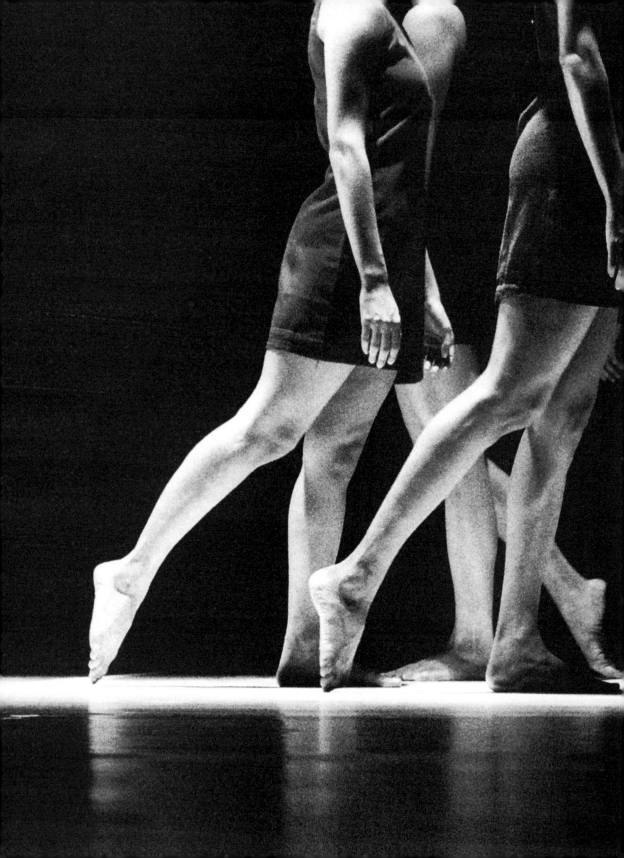

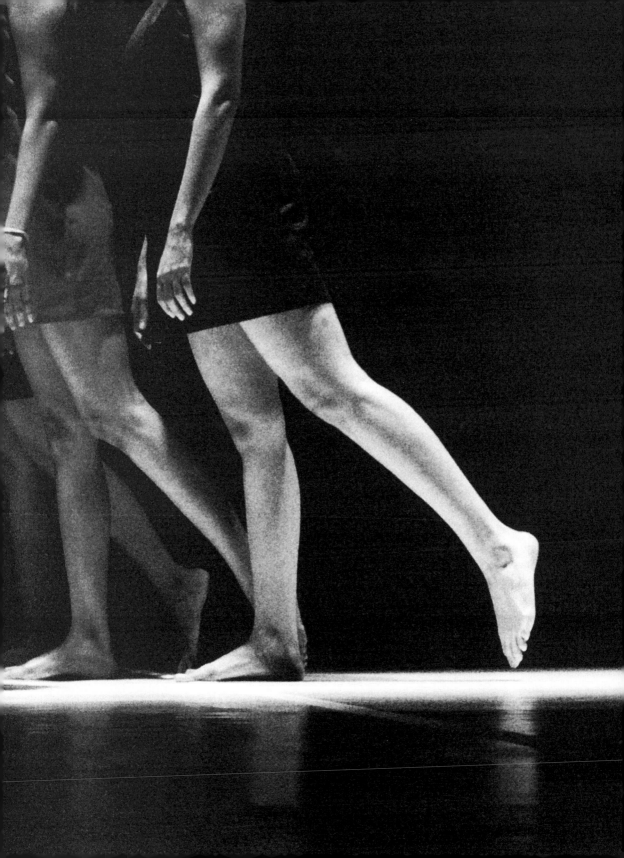

of forms. The notion of flow was also intrinsic to what Chandra was famed for – her work with slowness and even stillness. These concepts were physically understood by Chandra through her yoga practice. She was also inspired by the ability of a kalaripayattu practitioner to stand grounded, while at the same time remaining alive in body.

'Don't let the rigor mortis set in,' she would say. And this was meant for the mind as well as the body. In addition to the group work based on those concepts, there was also the task of thinking about where the movements started from. For example, when Chandra was working on *Sri*,[7] the spine – as a metaphor for freedom and dignity of the body – was much more to her than just a powerful line to hold oneself erect. It was more about activating the spine as a tool to enable flow, or the conscious looking into how the spine is the first to be affected by social habits and the brutalities of life. In short, the conversations at Chandra's studio went far beyond the physical and technical aspects of the body.

In those early years at Chandra's, prior to any thoughts about myself as an independent choreographer, I learnt invaluable lessons which are hard to articulate in words. I learnt that choreographers are philosophers, that their aesthetic vision of the body comes from its connection with the harmony and disharmony of life. I learnt that dance is something that needs to be redefined every day, and cannot be prescribed and taken for granted, because then the body quickly tends to be lazy and dishonest. I learnt that movement can come from all sources, but what matters is how we choose what meaning we intend; that movement *must* become our own and not remain 'borrowed'; that the body communicates as far as the space it extends to, and that a performer has to deal with that space not only with her body but also with imagination, intention and concentration. I could then see dance as created within the body but manifested outside it. It was the charging of molecules between bodies, the succumbing of both ego and control, a moment of almost allowing oneself to be moved, to be part of something much larger than the self.

I learnt that dance is not really about the dancer.

1993–2000

In the mid-1990s, while we were still working with Chandra, Krishna Devanandan, a fellow dancer, and I began a series of explorations that resulted in a few short duets, and it ended for me with *Fragility* – the quartet that perhaps marked my most complete departure from Chandra. It was also the beginning of the next decade of ensemble work.

Krishna and I met every morning and our early 'exercises' looked mostly at extending the spatial language of *adavus*. We sometimes set small improvisations between the *adavus*. Often the technical need would be dictated by our own choreographic choices, thus sometimes leading into new directions. During those years I also chose to travel and spend time in Europe – mostly watching dance, but sometimes clumsily joining the odd class or workshop. It was a busy, confused time. But it led me to understand a few things with great clarity:

> (a) that my physicality was rooted in and defined by bharatanatyam;
>
> (b) that I could not, convincingly, execute any western contemporary technique – also, I did not want to;
>
> (c) that, however, my highly conditioned body – limited by my habits and the physical impositions I bore – needed to be understood more consciously. For example, I realized that the curvature in my spine that Chandra had demanded all those years was perhaps not the best physical choice for my body. I felt it was time to shift the ways of looking at the body at a closer and more personal plane, especially if I was to carve an independent choreographic space, and wanted my dancing body to speak *my* language and not Chandra's.

Unlearning

In the late 1990s, Krishna and I spent a lot of time looking for the means to unlearn all that we carried in our body as the result of our training. We were open, and grabbed hungrily at whatever information we could find, asking every visiting dancer to share material. We were clear to ourselves that we did not just want to collect 'movement material', or to simply learn other techniques to use them in our own choreographic work. Instead, we were interested in finding a new way of approaching the body, and further, of training dancers who would work with us in the future. In effect, we were almost looking for a new philosophy in order to build a system through which a dancer could get closer to her own 'neutral' body. At that time, our 'search' led us to systems that examined anatomy rather than movement.

By the year 1999, when I was ready to create *Fragility*, I realized that the 'unlearning' I was proposing – the letting go of old knowledge – was being perceived as unsafe by dancers trained in classical forms. Classical dancers

were, and still are, taught to be strong and beautiful. *Fragility* was a work that articulated precisely the notion of placing the body in a vulnerable place, playing with the levels of grounding of the body and the lack of it. The movement ideas were simple, repetitive, yet all the time looking for a particular tension that came from asymmetry and imbalance.

While making *Fragility*, I was also working as a dancer to create Chandra's last work, *Sharira*.[8] To my mind, this is her only work in which we can no longer see bharatanatyam, yoga or kalaripayattu. Instead, we see 'dance' as something that is more than a series of movements in time. In my body and my spirit, I experienced *Sharira* as the last masterful breath of an artist who could draw lines with her body. At the time, Chandra said, 'No need to start with meaning, meaning will arise from movement.' While performing *Sharira,* I felt dance in my fingertips, in the tips of my toes. I felt the base of my spine literally as the pulsating force that Chandra had spoken of all those years. And finally, Chandra said, 'Padmini, you are only now a dancer.'

Our search for technical knowledge was contingent and need-based. For instance, classical dancers were prone to hold tension in their fingers. Letting go of this led us to explore the connection of arm and torso. Several of those 'habits' had to do with holding excessive but unnecessary tension within the body. It took years of work to arrive at a greater level of efficiency. We learnt those things on our own terms, by observing ourselves and each other. Innumerable days were spent lying on the ground, deconstructing walks, standing on one leg, sitting in the *araimandi*, observing how all of this changed the spine....

When I look back at how the physical realizations of that time influenced the formal aesthetic of my choreographic practice, I feel that the most important ones had to do with the understanding of being in 'parallel' with the legs – a position in which the leg attaches to the hip in a way that is neither turned out nor in. This is a way of working with the legs in which the centre and the spine can be thought about very differently from the more open position of the bharatanatyam *araimandi*. My arm began to find its line and gestures found their way back into my hands. I also began to think about the relationship between the head, an extremity of the body, and the tailbone. My precise interest in observing how the minutest change in the positioning of the feet and the foot-to-hip relationship affected the body, as well as how the spine was influenced by the limbs, became some of the sources for the actual grammar of later works.

The confusion of many years finally gave way to clarity. Krishna and I felt that our process up until that stage of analysing, deconstructing, articulating and creating pedagogy had brought us to a point where our knowledge could be shared as a process of physical transformation in other dancers. In this process,

the questioning of what they already 'knew' always came as a confronting first proposition. This was to put them in a place of 'fragility'.

In a sense, the broad parameters of my bodily aesthetic were laid at that point and were developed with greater complexity in later works.

2000–06: 3 Solos and the Collective Vocabularies (*Paperdoll*, *PUSHED*)

Following *Fragility* and *Sharira*, I was invited to create a full-length solo performance for the Théâtre de la Ville in Paris. The solo format was never of great interest to me. I do believe, however, that working alone every now and again helps to create choreographic/physical ideas for ensemble work. The most interesting aspect of *3 Solos* (2003) was its spatial structure. This was an emotional time for me, soon after the death of my mother. I was also burdened with questions that had been drawing me away from Chandra's work and taking me into my own. What place did 'expression' really hold in body practices? How could we slowly infuse our work into the abstract form of the body with a humanity that was of tangible proportions? As though to find answers, with *3 Solos* I allowed feeling to re-enter my body. It was a narrative of birth and death, and was the most raw and honest work I had done till date. All the trademarks of my later works – the obsession with line, the tension growing out of a spiral, the preoccupation with centre, the detailing of feet in the ground – were born in and out of this work.

The marking of time became more precise with the solos. The movement language in the piece was held together by a strict rhythmic organization that could be referred to as *sarvalaghu*. The task here was to counter the long notes with the short. The intention was to define, with greater precision than in *Fragility*, the beginnings and endings of actions, punctuated by speed or sometimes with non-action, that is, stillness.

In 2003, while I was still touring *3 Solos*, I began working on a quintet, *Paperdoll*, which was completed in 2005. The spatial and temporal premises developed in *3 Solos* were instrumental to this new piece. There were to be no exits or entries in the piece. The work was to negotiate a square and explore all the possibilities within it. Time was tightly structured, and exciting rhythmic possibilities opened up while working with five bodies. *Paperdoll* also unravelled two very significant directions in my work. The first was creating the movement vocabulary from within collective group actions; the second concerned moulding multiple bodies to create a single composite form. These formats were unlike the 'contact improvisation' which was then popular in the west. My work

on 'joining bodies', which continued up to *Wall Dancing* (2012), grew out of a different premise and need. It had everything to do with knowing and respecting the boundaries and limits of our bodies with respect to the presence and absence of other bodies in the space. This way of thinking grew out of the very basic concept of *Paperdoll* – a work that looked at notions of connectivity, sameness and oneness of bodies; a work that dealt with obvious physical dependence of multiple bodies in contact, but also looked at the possibilities of dancers to be outside their physical selves, which could be seen in phrases of reaching out, complementing or balancing one another from a distance.

To collect material – for almost a whole year (the first year of work on this piece) – I divided the body into three zones. I asked the dancers to come up with sets of movements for the torso (head included), arms and feet. It felt like a children's game: mixing and matching different body parts to assemble an odd character. My own intention was not so far from that. I felt a strong need to break out of an aesthetic that had become familiar to me, a habit of choosing series of movements based on that aesthetical hierarchy. I liked the randomness and surprises that this process brought, when, for example, three groups of movements were assembled. It created ways of articulating different body parts with certain techniques that had a little piece of each of the dancers involved. Yet, by the time we collected and learnt all the forty phrases that were formed out of the eight initial movements, an entire language – detailed and ornate – was created. It was not random any more, but it had the beauty of a truth that was reached collectively as well as individually, and in which each element was equally shared among the contributors. I asked the dancers to strive for absolute precision in articulating the actions. And from this collective search for likeness and precision, an almost paradoxical individuality became apparent. In *Paperdoll*, dance lay in the space between bodies and in the time between movements.

I built the work out of these 'phrases', at times focusing on a single phrase – elongating, playing with qualities – and in other moments, focusing on a single movement taken out of a phrase. The element of weight in the bodies, the giving and the taking, the learning how to make a single part of the body heavy, were some of the technical elements that were later played out with more abstraction in *PUSHED* (2006). In the final form of *Paperdoll*, there were solos, duets, trios, quartets and quintets. In terms of choreography, this was the school where I learnt the rules of balancing space: how a single body could counter the energy of four other bodies; how important it was to be able to imagine these other bodies and the space – all moving and stopping in unison, particularly when it came to five dancers timing together with perfect precision. This was also the work in

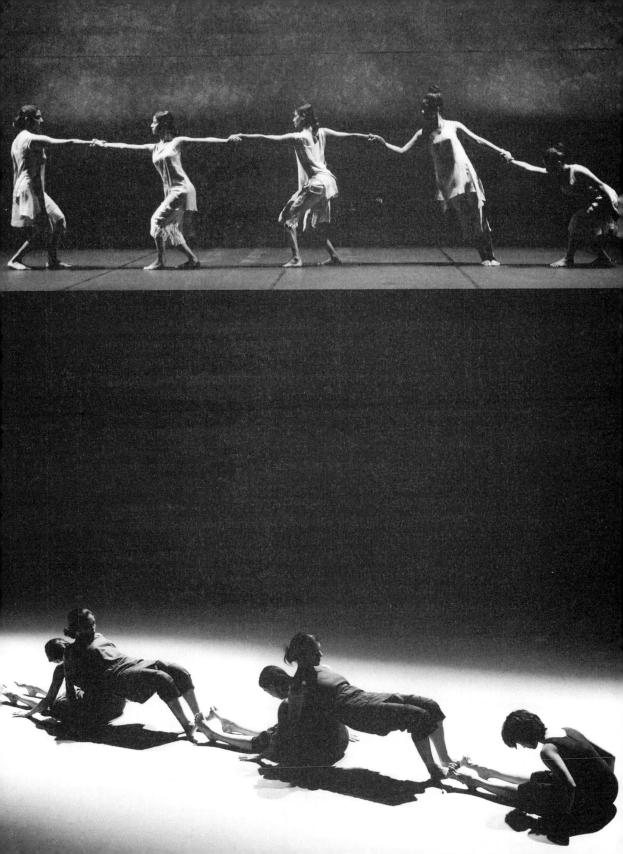

which all my research on drawing energy from the ground into the body became apparent. When the audience entered, they saw the image of five bodies simply standing in a line, holding the ground in such a strong way that I have so far only seen among the dancers I have worked with. The feet were alive, soft, yet drawing from below. Their torsos weighed downwards, with an acute attention to the movement of their spines.

I see *Paperdoll* as my last narrative work. The linking together and pulling apart of bodies in this piece commented on the tenuous links that connect people in the society. The final image of Krishna Devanandan being assisted to her feet to join the group after her last solo on the floor made an almost animalistic reference to images of herds and stray individuals, of isolation and empathy.

In 2005, *Paperdoll* was playing at a festival in Brussels. It was there that I met the South Korean impresario, Kwang-Lim Kim. He invited Maarten Visser, the composer I had been working with since *Fragility*, to create new music with traditional Korean instruments. He also invited me to create a work that would premiere at his festival in Seoul in 2006. Two exciting concepts emerged out of Maarten's research in Korea. The first one was regarding the quality of sound in Korean traditional music, which varied depending upon the emotion it was required to express. The second dealt with the philosophical and aesthetic propositions inherent in the yin–yang theory. Those two ideas led to the creation of *PUSHED*. One working idea behind this choreography was to define emotions through a visual language of the body, which was also related to the earlier question about emotions that I had asked myself while working on *3 Solos*. Interestingly, this connected my work to the *navarasa* theory, though from a more abstract perspective. The abstraction was at the level of the treatment of emotions through the imagery of the body, as against directly expressing them. In other words, what we had on stage was an unobvious physical and visual representation of the emotion instead of the emotion itself. *PUSHED* also made me think more precisely about definitions of positive and negative space, none more important than the other.

The first months of research with the group involved putting together personal narratives that dealt with feelings. I was looking for words that described the physicality of joy, anger, sorrow, jealousy, love and lust. This led to the creation of a bank of about a hundred movements and postural ideas, which I then connected together, attempting to propose the transitions as the most important structural ideas. I used the accumulated material to create visible representations of positive and negative space, while using the notion of composite structures of bodies. This extended what I had begun in *Paperdoll*. The final and, in my opinion, most significant choreographic decision I made was that *PUSHED*

would remain a series of lateral images, using only the horizontal axis of the stage. This design would only be broken at the end of the piece, through the physically engaging representation of 'lust' as a snake.

In terms of physicality, *PUSHED* explored the extreme curves and arches of the spine. The performance played with the concave and the convex, and how the push and pull of spinal curves affected the way one saw the space around the body. It also had a lot to do with the idea of an impulse that travelled through the body and that could be transmitted from one body to another. In this way emotion travelled through energetic fields. It was also a work in which the body became the image. And perhaps the need to hold these images, to stop them in time, to repeat them, led me to many choreographic ideas that become apparent in the *Beautiful Thing* series.

PUSHED was also the work that provided further clarity of thought and brought me closer to my understanding of tension as a tool to make the body dynamic even during the smallest of shifts or movements. At the same time, the demand for honesty and truthfulness between the dancers, who were paired or were in groups, led to many interesting arguments and conversations about 'faking' the physicality. You *had to* be strong to catch a falling body, *had to* relinquish control to fall convincingly. These are the kinds of discoveries that I love and that keep me creating new work. In a way, they tell me that dance is ultimately as bad as our worst fears and deepest insecurities, and as good as our openness and ability to share.

2007–11: *Beautiful Things*

Beautiful Thing 1 (2008) is perhaps the most ambitious and complex work I have created to date. It was also the most technically complex.[9]

So far, I have been focusing on the body alone, since that is what I set out to do in this essay as well as in my choreographic practice. But through *Beautiful Thing 1*, I welcomed 'words' into my exploration. In his review of this piece, Helmut Ploebst, the Austrian critic, referred to William Forsythe's definition of choreography as the 'organization of things in the passing of time'.[10] Those 'things', in the context of this piece, were a set of movements created out of randomly sequenced words speaking out the names of certain body parts. As the process developed, the dancers created long phrases from those words. Later, the phrases were manipulated in length and time. The original words too eventually became a part of the 'text' – a rhythmic layer on top of the underlying sound created by Maarten.

The physical challenge lay in arriving at a level of clarity in initiating an action of an isolated body part, moving in a specific direction away from the body, and finding the connection of that action to its preparation and conclusion. Further, collectively working with gradual speeding up or slowing down meant that for every set of actions, certain simple qualities had to be researched and decided upon.

There has always been a lot of speculation about the process of 'slowing down' in my work. I think that in the premise of *Beautiful Thing 1*, I tried to deliberate on what that actually meant – beyond just moving slowly or quickly. Speed, for me, is a relative phenomenon. Depending on where and how we begin a movement, it becomes either 'faster' or 'slower'. As we worked on slowing down a set of actions from speed 200 bpm to 30 bpm (beats per minute), what became apparent was the incremental importance of flow, control and clarity. Also, one started to understand with better clarity that speed is about the time we take from one point to another, and is not about reaching or arriving at a prefixed point at the end of the count. There were so many details and revelations in our process! Even now, just as an exercise, I recommend that dancers simply understand the mechanics of movement in connection to the parameter of time.

In terms of dramaturgy, a dancer in this piece never entered or exited the stage while dancing – this was one of the significant ways it differed from *PUSHED*. All of the entries and exits were 'walked'. This entering and joining the action of the movement at a precise moment were important dramaturgical elements of *Beautiful Thing 1*. Also, we worked hard to understand how to 'stop' and leave – almost asking a viewer to see where dance began and where it ended. The plain walks in and out of the stage created sets of lines in the space to which the bodies then aligned themselves. The work on parallels and perpendiculars created a strong sense of grids in the space, the dancers becoming the drawers of lines.

Unlike *PUSHED*, here, the moving through space was not a part of the actual vocabulary. All our movements tended to travel around the central axis of the individual body. Therefore, the real challenge for the dancer was again to imagine the greater extent to which the energy of each movement could reach in order to have the necessary visible impact. During this work, my colleague Krishna Devanandan worked extensively with the group – almost asking the dancers to throw the movement out into the space, but at the same time looking for the centre of the movement in order to maintain the balance of the axis.

The seed of *Beautiful Thing 2* (2011) – the solo I created after *Beautiful Thing 1* – was planted as I became more and more intrigued with certain questions and ideas such as the relationship of our own central axis to the concept of 'turning',

how turning forces the body to confront its inner diagonals and spirals, how to align ourselves in space, and so on. But the central question of *Beautiful Thing 2* was the following: if we perceive how the small spaces that exist around us move, being perturbed by the disturbance created by our own movements, then, is it possible to gradually minimize that disturbance? In other words, how can one think about 'carrying' those spaces that are contained within and around our body?

I set myself the task of etching nine spatial lines on a stage – both linear and curved ones. For the whole year it took to create the work, I worked alone, every day – mostly trying to build the stamina and strength to perform 'solo' after many years. Also, working on my own body with its own particular physicality, I felt less like a choreographer; rather, I allowed myself once again to fall into the role of a dancer. After so many years of working with other bodies, being alone felt self-indulgent, yet necessary at that juncture. The absolute lack of separation in the choreographic intention and the physicalized form that my body took – devoid of the layers of reinterpretations in articulation and misunderstandings that normally lay between the concept and execution of my works – gave this particular work both its immediacy and its relentless stubbornness.

Beautiful Thing 2 has lived large proscenium stages as well as small, bare platforms. While performing it, I have played with the very elaborately designed light score of Jan Maertens as well as Zuleikha (Chaudhari) Allana's light-box. For me, this was the work that answered all the questions I asked myself when I departed from Chandralekha's practice in 1993. After almost twenty years since that point, I somehow understood, very profoundly, that our emotional responses are released in the moment the body succumbs to the space, that ego gives way to egolessness, that somewhere in those connecting lines between our feet and our hands lies an entire narrative of what we live and experience. As I am saying this, I hope that my realization will not be misunderstood as 'sentimental'. It was not even about expressing oneself. It was one of those rare moments of clarity that we artistes look for, through long years of daily engagement with our form. The most difficult question is, of course, through what process can one transmit this technique? Is it a technique? Or is this a purely personal research? Is it possible to take another body down this road?

2013: Beyond the Proscenium – *Wall Dancing*

In 2012, when I began work on *Wall Dancing*, I felt that I was at the end of the kind of work I had been doing for the proscenium, that I had become preoccupied with image in a very lateral way. I also wanted to be freed from the

collective lack of patience that I felt was preventing me from proceeding more radically into areas concerning space and stillness that seemed tedious for the 'sitting duck' audience!

Wall Dancing eventually opened as a three-hours-long performance that people could enter and leave as they wished. The dance was played out at the periphery of the room – the dancing bodies almost always leaning into the walls or into each other. The work was created by looking only at those spaces between the bodies and the walls. I wanted the audience to move into that space, to follow the choreography, to choose perspectives.

In removing distance, a new set of performative as well as physical challenges emerged. Retaining the quality in smaller details became more vital, compared to projecting larger ones. Where and how to focus the eyes became more important than ever. The 'performing' of dance was in a way replaced by the simple 'doing' of dance. The dancers were constantly required to keep a deep inner concentration, without shutting off the audience at the same time. There was a strong sense of touch in *Wall Dancing* – very different from the ways in which I used contact in my earlier works. Here, the bodies yielded without resistance to the walls. Their energies were always unaggressive and unassertive. They almost peeled off the wall surfaces, always acutely aware of their dependence on those supporting planes. At times, the choreography challenged them to avail their independence, bringing them to find their own balance in the absence of support.

Perhaps, the opening moment of this work could be described as the embodiment of why dance still excites me. The five dancers stood within half a foot of wall surfaces in different parts of the room. At times, they were still – a stillness in which they seemed to be looking for their spines, their centres, the ground under their feet. Every so often they took a 45-degree pivot, facing a new direction, and then started to look for the 'active standing position' all over again. In those acts of simple realigning, there were times when one could see the larger invisible walls, which criss-crossed the space, moving with them. Almost as though the power of imagination of the dancers potentially created those new lines and angles that the viewers were then able to feel and experience. I could watch this for hours, finding my own standing.

For I am afraid, until we do that, there is no dance.

§

Images

p. 35: Photomontage – women of Shaheen Bagh in south-east Delhi protest against India's Citizenship (Amendment) Act (CAA) and National Register of Citizens (NRC) in January 2020. Launching a sit-in on a road that connects Delhi to the satellite city of NOIDA in Uttar Pradesh, the protestors occupied the site for 101 days, despite a long and cold winter. The protest became emblematic of the resistance to the CAA and NRC, inspiring similar sit-ins across India, and growing to include public art projects and a protest library.

p. 37: Students at Jamia Millia Islamia, Delhi, protest the passing of the Citizenship (Amendment) Act, December 2019; photo by Sreekanth Sivadasan.

p. 41: Campaign response by A Collective for Feminist Conversations, Colombo, on the reimposition in Sri Lanka of the ban on women purchasing alcohol, January 2018; designed by Thilini Perera, image courtesy A Collective for Feminist Conversations and Subha Wijesiriwardena.

p. 46: (Background) Aishe Ghosh, president of the Jawaharlal Nehru University Students Union (JNUSU), in a frame from a widely circulated video recorded minutes after she was attacked by masked goons on the university campus, leaving her with serious injuries. (Inset) From a news feature on Bindu and Kanakadurga, women who entered Kerala's Sabarimala temple in early 2019 before daybreak with a police escort, challenging blockades set up outside the temple by religious groups seeking to prevent their entry. Women between the ages of 10 and 50 (i.e. of menstruating age) were historically forbidden from entry until this ban was declared unconstitutional by the Supreme Court of India in 2018.

Natasha Ginwala frames restraint as a hegemonic construct imposed on female bodies, gesturing at modes of being and doing that offer ways of 'combating the patriarchy as daily practice'.

Originally published in *e-flux* journal (no. 94, October 2018, https://www.e-flux.com/journal/94/220044/untaming-restraint-and-the-deferred-apology). Reprinted with permission. Grateful acknowledgment to Natasha Ginwala.

Keywords
Dhrupad and *Aalaap*: see Keywords (pp. 329–44).

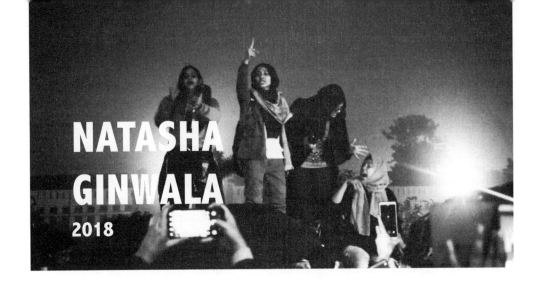

NATASHA
GINWALA
2018

04 **Untaming Restraint
and the Deferred Apology**

I sat on the throne
drinking nectar with allah
I got hot and sent an ice age to europe
to cool my thirst
My oldest daughter is nefertiti
the tears from my birth pains
created the Nile
I am a beautiful woman[1]

Nikki Giovanni

They Be Witches

In a photograph from the recent protests against
tightening abortion laws in Poland, a young woman
dressed in a black hoodie and leather jacket, mouth
covered with a surgical mask, holds up a poster: 'We
Are the Granddaughters of the Witches You Couldn't
Burn'.[2] Survival strategies repeat and are invented
anew as draconian laws perform an incessant loop of
generational repression. The bloodlines of female
ancestry crisscross, stretching continents, running deep

wiring under the skin, and stirring us in the present to rebel with all the force of our guts. Let us remember that the matter at hand is not limited to the question of reproductive freedom and sexual choice, but rather represents, more broadly, yet another instance of the codes of restraint that have colonized women's bodies and minds for centuries. Before we move the conversation to the topic of glass ceilings, we should take a closer look at the thickness of the walls built through the steady accumulation of 'restraining orders', and examine the texture of enclosures that have curbed our freedoms. Combined, they have produced a carceral condition, which in turn has normalized over-policing of the most intimate decisions across the spectrum of state forces and interpersonal relations.

Restraint is not purely a physical action. While historically manifesting in medieval instruments of punishment, discriminatory legal codes, torturous social customs and witch-hunts, it also appears as a psychic framework that erects barricades against self-definition and ways of moving through the world for female-identified and queer subjects. In a similar vein, but describing the experience of colonized Black people in *Black Skin, White Masks*, Frantz Fanon declared, 'in the world through which I travel, I am endlessly creating myself'.[3] Within a patriarchal order, the process of 'endless self-creation' is governed through control mechanisms that attempt to impose representational symmetry across lines of desire, beauty, class and race. For those female-identified and queer subjects who refuse this grid of abstract violence, blows are delivered against their efforts to rupture borderlines of the disciplinary regime in alternating currents of hard and soft power, like an encircling heat wave that is felt rather than seen. Undertaking the role of 'self-creation' as a means of inventing asymmetrical life codes that are sensible and malleable requires a mutation of governance as a technocratic order – an entrance into queering civic consciousness and heteronormative sociopolitical systems. As Stefano Harney and Fred Moten have written, 'Governance is the new form of expropriation. It is the provocation of a certain kind of display, a display of interests as disinterestedness, a display of convertibility, a display of legibility.'[4] Perhaps, for those held illegible under a modality of transparent terror, the refuge for dissent lies in witchery.

The witch is a border dweller and has long been portrayed as a trespasser in normative society. Far from being designated as an apparition, the witch is all *flesh* – skin and bones dragged through trials and torture, subjected to forms of punishment ranging from enclosure and land dispossession to massacres that remain hidden between historic annals.

While Foucault argues that we cannot choose to enter modern society, since we are wholly controlled by its technologies of power, there must be a reckoning with 'becoming modern' as part of still-unveiling scripts of structural oppression

in which witches expand into other female and closely related characters.[5] Among these personages are the heretic, the healer, the midwife, the disobedient wife, the woman who dares to live alone, the obeah woman who poisoned the food of the master and inspired slaves to rebel. Capitalist accumulation, from its origins, persists and combats these witchy figures with fury and terror.[6]

As Silvia Federici reminds us, we need to 'demythologize this figure' and bring back her surrounding historical context, to make clear the present-day importance of embracing transgressive potentials of witchery.[7] In re-positioning the history of capitalist accumulation and the beginning of the slave trade that brought about a paradigmatic shift in feudal relations, land ownership and labour power, Federici posits that the witch is, foremost, an anti-colonial rebel body caught in matrices of large-scale persecution – a composite figure evolving from common struggles, incompatible ways of living and transformative social relations that the established order viewed with terror.[8]

While Foucauldian thought neglected to address the endemic impact of disciplinary power over the female body in modern life, we need only to survey instruments of punishment catering specifically to the female and enslaved body to establish how, on the one hand, active subordination and dispossession efforts are levelled at these so-called 'docile bodies' that are vulnerable to perpetual supervision and techniques of management, effectively transposing their everyday lives into a kind of 'dressage' that activates the penal domain.[9] On the other hand, there is a sense of foreboding in the patriarchal psyche of unleashing the threatening and monstrous aspect of the queer/feminine leading to a double condemnation.[10]

In a sixteenth-century instrument for women's torture and public humiliation, the scold's bridle (sometimes called a 'witch's bridle'), restraint operated through enforced silencing. This iron cage was deployed as fit punishment for 'riotous women', and fitted over the accused's head and mouth for acts ranging from spreading rumours to scolding, nagging or casting spells.[11] A metal bit extending into the wearer's mouth operated much like a horse bridle, but more malevolent: a defiant subject who chose to speak while wearing it could have her tongue sliced in half. One account argued for the bridle's efficacy by claiming that 'a mad woman is like a rough stirring horse, and as he must have a sharp bit, so must she have a sharp restraint'.[12] In certain versions of the device, a bell was fitted onto the witch's bridle to alert the public of her presence so that any movement the witch made in the civic sphere became a shameful transgression – a literal alarm signal to the surrounding society. The person holding the key to the bridle effectively took possession of the tortured subject's speech; eighteenth-century slave owners, too, used later versions of the witch's bridle as means of punishment and control over enslaved persons.

Pain has an element of blank;
It cannot recollect
When it began, or if there were
A day when it was not.[13]

Emily Dickinson

In her epic work *Torture of Women* (1976), Nancy Spero draws on testimonials, newspaper headlines, Sumerian and Babylonian creation myths, and Amnesty International reports, to stitch together an extensive accounting of extreme violence against women. With 125 feet of collaged image and text punctuated by hand-printed and typewritten accounts, Spero composes an animated 'history painting' that condenses vast, bloody chronicles of patriarchal hostility and abuse. There is a way of speaking simultaneously in the *singular plural* while unveiling the changing lexicon of torture. At times, the figures upon a page are surrounded by blankness, articulating the silences and obliteration surrounding torture as a feedback loop of pain, and what Federici might regard as 'the great confinement' in which we are still living.

Wild Zones and Laughter

Don't mess with my energy.[14]

Princess Nokia

Combating the patriarchy as daily practice necessitates reaching into the wild zones for relief – and requires drawing from internal reservoirs where language is not spoken and heard in the masculine tense. Hélène Cixous addresses the wild self as 'the rhythm that laughs you' – where an overflow of desires cannot be dammed by punitive action.[15] And, the wild zone operates as that threshold beyond the grasp of the dominating culture, where otherwise muted voices can hold court and narrate their truths. An avalanche of women the world over are choosing now to voice and write through their bodies as a sustained protest against codes of restraint and abuse. Cixous might add, 'they must invent the impregnable language that will wreck partitions, classes, and rhetorics, regulations and codes, they must submerge, cut through, get beyond the ultimate reverse-discourse, including the one that laughs at the very idea of pronouncing the word "silence".'[16]

 Laughter is a sense-making device in the darkest phases of restraint, and also a means of self-extension. Bodies in pain and souls in fury are fundamentally transformed in sonorous gradations of mirth. 'Isn't laughter the first form of

THE CUMULATIVE AUTONOMY OF GENERATIONS OF WOMEN, TAKEN AND DISTILLED INTO A SMOOTH, REFINED LIQUOR, SERVED BEST WITH THE PATRIARCHAL MYTH THAT WOMEN NEED TO BE CONTROLLED.

est. 1979

✣ ORIGINAL ✣

666

100% PATRIARCHY

ORGANIC
bigotry

colonial
STYLE

"MAY ALL WOMEN BE REBORN AS MEN
IN THEIR NEXT INCARNATION"

MADE IN SRI LANKA

...POLITICAL UNCLES...
DISTILLING CO.

LOCALLY SOURCED SEXISM

SUBTLE HINTS OF DISCRIMINATION COMBINED BEAUTIFULLY WITH MISUSED POWER WITH A SLIGHTLY BURNT FINISH, LEAVING A BAD TASTE IN THE MOUTH LONG AFTER DRINKING. PERFECT FOR PAIRING WITH POLITICAL-UNCLE TEARS.

...JANUARY 2018...

liberation from a secular oppression?' asked Luce Irigaray.[17] Rational terror is pulverized by the Medusa's laugh – to draw from Cixous's formulation – an entrapped body given release in her reverberation.

In an interview, Toni Morrison gets at laughter's – specifically Black laughter's – rebellious core and entwines it in what is otherwise considered its shadowy opposite: pathos. Morrison notes: 'Other people call it humor. It's not really that. It's not sort of laughing away one's troubles Laughter itself for Black people has nothing to do with what's funny at all.'[18] In Morrison's essential work *Beloved*, laughter becomes the vessel of endurance against systemic oppression of African Americans – a force contrary to the radically negating experience of slavery and its traumatic waves of fallout. Laughter, then, is that counter-hegemonic assurance that flowers reside in the dark passage.[19]

I imagine Audre Lorde exercising laughter as refusal when, in a 1984 conversation with James Baldwin, she disagrees with him while deliberating their status as 'outsiders' to the American dream: 'I don't, honey. I'm sorry,' Lorde says to Baldwin,

> I just can't let that go past. Deep, deep, deep down I know that dream was never mine. And I wept and I cried and I fought and I stormed, but I just knew it. I was Black. I was female. And I was out-out – by any construct wherever the power lay. So if I had to claw myself insane, if I lived I was going to have to do it alone.[20]

The question is how this refusal and radical hope may be read in simultaneity when, as Lorde reveals, Black women and men live through different nightmares and means of alienation while also striving for joint survival.

Laughter also unleashes another wild zone, one that bridges a gap between the lone woman and her community. In Sri Lanka, an archaic 1979 law was briefly amended this January; after six decades, the decision would permit women over the age of eighteen to purchase alcohol legally and work at bars.[21] Women reacted with a mixed response to the paternalistic state: while acknowledging the long-overdue legal reform in a social environment that has persisted in supporting deeply sexist and discriminatory laws against women, a campaign by the intergenerational local group, A Collective for Feminist Conversations in Colombo, sought to tackle the embedded patriarchy that put men in charge of lifting such a ban in the first place.[22] Before long, though, the Buddhist clergy and hardline conservatives began protesting the reform, and, just days after it was lifted, President Maithripala Sirisena meekly reinstituted the law as an apparent return to controlled 'normalcy'. In response to these stifling and illegitimate moves, the feminist and queer community created a hashtag directing ire at the

president.[23] The hashtag #SirisenaHoldmyGlass accompanied imagery of satiric alcohol labels featuring 'organic bigotry' and a brand of 'locally sourced sexism' in a bottled formula, pointing to the patriarchal state mechanism's obsolete power structures insisting on moralizing the codes that govern women citizen's civic behaviour. Laughter from below developed as a spontaneous strategy against the bewildering and frustrating statist agenda that remains resolute in levying forms of collective restraint against women.

To generate a language of transgression, as Cixous has encouraged – one that does not operate 'within' the male discourse – women must communicate with one another to build alliances, construct new mythologies that survive beyond the forces of historic erasure, and cement claims for justice as a mode of solidarity, since 'in one another we will never be lacking'.

The Erotic as Power

> I will crumble and weed and paw
> At your feet. Unbraid and emote,
> walk faceless from the brink;
> If you spit, I will drink.
> I will grow heavy and silent
> and sick. I will strip you right down
> to the bone. I will take your name.
> I will take your home
> and wake dark with a song
> on which you finally choke;
> my black hair furring thick
> in the gawk of your throat.[24]
>
> *Safiya Sinclair*

In Audre Lorde's invocation of *the erotic as power,* we are encouraged to examine the erotic as a tectonic resource that provides 'energy for change'. As a structure of feeling, eroticism often remains suppressed and distorted – embedded information that is often either deemed suspect or unrecognized. In the face of its active devaluation and self-cancellation, Lorde relates how to celebrate the potency of the erotic as deeply borne knowledge, and as a fullness of doing, that explodes mediocrity. Further, she shows that the erotic wrestles with hegemonic handbooks of oppression within society that govern bodies.[25]

As part of consciousness, *eros* is intimately bound to the ways of remaining affected. It gains strength in every aspect of life and in the active prevention of

disaffection in our times – from negativity implanted under the skin to rebellious performances of radical love. Lorde writes: 'When I speak of the erotic, then, I speak of it as an assertion of the life force of women; of the creative energy empowered, the knowledge and use of which we are now reclaiming in our language, our history, our dancing, our loving, our work, our lives.'[26]

Indian dancer and choreographer Chandralekha[27] centralized the body-in-dance as an instrument of resistance, devising ways to express the corpus's inner needs, limits, desires, time-relations and labouring prowess.[28] Meanwhile Chandralekha, who lived from 1928 to 2006, led her life with utmost freedom in her intimate partnerships, charted an international network of artistic collaborations, used poetry and printmaking to conceive feminist narratives and human rights campaigns, and spread infectious laughter in the face of conservative judgement. She authored a transformative vocabulary for modern dance in India – reinterpreting classical dance traditions but equally drawing from martial art forms, yogic principles, sacred philosophy and ancient science. In my view, her last choreography *Sharira* (2000)[29] harnesses the uses of the erotic, realigning bodies as planetary entities and revealing the inner workings of desire on a corporeal and conceptual plane. Her choreographer's note reads: '*Sharira* explores the body as a transformative field for ascending feminine force, to evoke the condition within which the "self" can experience the world. *Sharira* celebrates the living thing in which sexuality, sensitivity and spirituality co-exist – acknowledging no limit, borders, boundaries.'[30] The erotic knowledge in dance – and its inseparability between the spiritual and the political – gravitates bodies away from binary posturing into constellations of truly multivalent being.

Sharira was first created with dancer-choreographer Padmini Chettur and continues to be performed by writer-dancer Tishani Doshi and Shaji K. John, a practitioner of the south Indian martial art form kalaripayattu.[31] In the beginning, Doshi appears alone onstage in semi-darkness – only acquiring mobility after dwelling in stillness and meticulously probing the extreme reaches of her body. Constellations that are otherwise cosmic and meditative diagrams (*yantra*) become embodied diagonals. There is a resolute slowness to the piece that echoes with the dhrupad[32] rhythms and deep chords in *vilambit aalaap* from the Gundecha Brothers' live composition.[33] When the body is inverted, it becomes eerie and more beastly. Doshi slithers like a snake and raises one leg as a scorpion readying to sting. At times the duo appear as two swimmers pushing through an ocean of sand, and then re-emerge, now arched like the crescent moon in an overcast night sky. The two take possession of the space between separation and union with erect fingers, pressed abdomens and a steady gaze. Legs take the

shape of a plough – their weight is pulled by a circling motion of the hands and the determined will of the spine. Like the Achilles heel, various unidentifiable convulsion points become fields of conjoined vulnerability.

Two beings are retreating from combat, piercing open decades of armour that has sedimented onto their bodies with the upward twist of a mountainous neck placed between curved knees. Tishani Doshi notes, 'There is a point in the production when we both stand on our heads for a few minutes. In the sunlight of our theatre, it is the moment I feel most like an oak tree, rooted to the ground, branches rippling softly in the breeze.'[34] As the singers chant the word *jwalamukhi* (volcano), their anchored joints and tense shoulders implode into a volcanic plateau and there is a brief, glistening calm.

I asked Doshi about the experience of restraint and the transgressions of gendered bodies in her work. In an email, Doshi responds:

> Restraint is an interesting word – because in some ways I suppose I consider myself being quite free – most of my life, I've never felt shackled or made to fit into something. In fact, Chandra always said that the reason she was interested in working with me was because of the openness of my body. For her technique was secondary but this openness was all – so that was there from the beginning. Chandra used the word femininity – whether it was women's or men's bodies – she was interested in harnessing that principle of femininity within the body.
>
> But, as a dancer working for over fifteen years on one project, *Sharira*, my move has been beyond gender. I'm very aware of the male/female, *purusha/prakriti*, *Shiva/Shakti*, *lingam/yoni* parameters we were working within, but what I loved most about working with her was her quality of abstraction. And, personally over the years the labels fell off and I was experiencing something like bliss while performing precisely because I could leave my notions of femininity and masculinity at the door. What I was experiencing was pre-gender, an amoeba-like feeling of being one of those first creatures coming from the sea to the land – an experience of body that was beyond gender – and of course, I use my body in order to arrive here, and that is a decidedly female body. But I am also transcending that body – through the dance.[35]

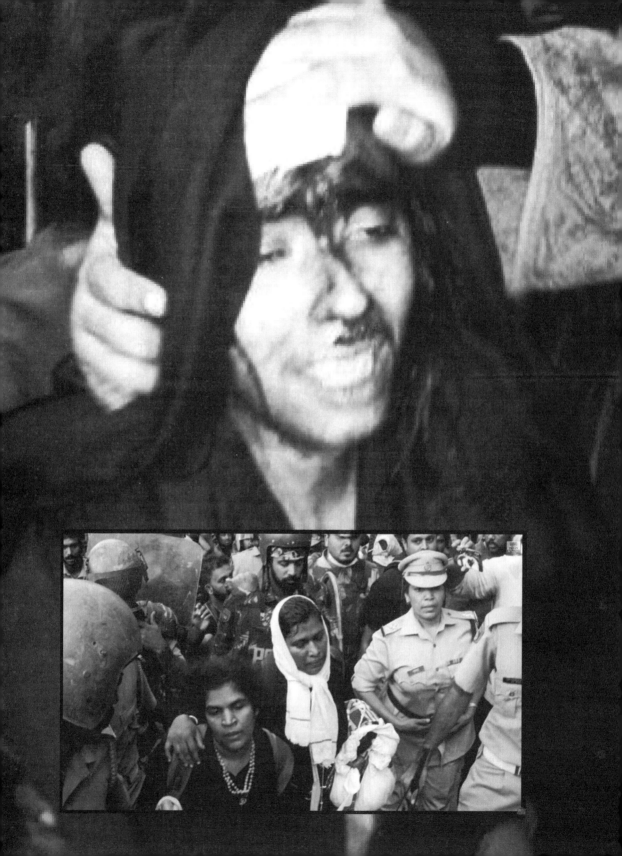

Sorry Seems to Be the Hardest Word

> What happiness for us who are omitted,
> brushed aside at the scene of inheritances;
> we inspire ourselves and we expire without
> running out of breath, we are everywhere!
> From now on, who, if we say so, can say no to
> us? We've come back from always.
>
> *Hélène Cixous*[36]

Rather than struggle to untie the longer trajectory of imperial guilt and continuum of heteropower's planetary scales of rational violence, let us study the nature of apology. The apology in its true spirit is a break in the regulated composition of time. In that, it *is* the opposite of restraint, because it involves a sense of movement that may be called reckoning. This movement is not a forward motion; instead, it is a unique variety of suspension in which two or more beings become jigsawed together as interdependent entities. There is something inherently rhythmic about the apology. It is not a stable condition, but rather a fluid metamorphosis – corporeal and soulful. The apology is an improvisation. As Moten and Harney might put it, there is an attempt for shared language to inhabit and speak 'from the cracks'.[37]

However, the patriarch has been indoctrinated against apology; even retreat and self-destruction are more alluring options. There may be a pile-up of repentance and subterranean angst without the articulation of apology. Since the apology is construed as ultimate defeat, a slow violence assembles in the shape of an impasse – a chasm that prevents us from moving beyond hierarchy and assumed roles – a curb in the way of equal speech. The lack of language stretches into a frozen lake like the taut skin of unspoken thoughts. In his Black Existentialist response to Kanye West, philosopher Lewis Gordon spoke of narcissism as a veil of self-protection.[38] The blockage of an apology as a continual affirmation of restraint is the non-acceptance of a vulnerable existence that entails repeated falling and failing – in other words, being prone to misguided judgement. We are not speaking in tongues; an apology is not for the asking, yet without an emancipatory politics of articulation it remains the unspoken and unsettled legacy that denotes the longest of silences.

On numerous occasions in the geopolitical arena, the apology is delayed until it becomes redundant and, moreover, makes a mockery of past violation. Take for instance the non-apology apology that former UK Prime Minister Tony Blair made for leading Britain into war in Iraq in 2003 as part of the US-led coalition. While still rejecting many findings of the Chilcot report, Blair stated:

'For all of this, I express more sorrow, regret, and apology than you may ever know or can believe.'[39] In contrast, when whistleblower-activist and former US Army intelligence analyst Chelsea Manning was asked in an ABC news interview soon after her release, 'Do you feel as though you owe the American public an apology?', her response begins by bearing responsibility instead of an admission of declarative regret. 'No one told me to do this,' she confirms. 'Nobody directed me to do this. This is me. It's on me Getting all this information, death, destruction, mayhem, and eventually, you just stop. I stopped seeing just statistics and information and I started seeing people.'[40] With relationships with truth collapsing across nation-state regimes, one must reckon with the individual role of recognition and misrecognition amid multiplying crises of ethics. The force of the corrupted apology as a major thread in right-wing escapist politics is a messy business that thrives inside unfinished international warfare. bell hooks insists that the capacitation of counter-hegemonic cultural practice lies in upholding language as a place of struggle and the margin as a site of radical possibility.[41] That latter unbound place is principal in transforming the colonizing mentality and motion beyond modes of expression that re-inscribe captivity of the human subject. A true apology is restorative when it becomes a discovery through which you are no longer the same as before. It cannot, therefore, take effect until there is a dis/ordering of the general terms of survivance and complicity. Ferreira da Silva explains how the Black feminist position performs its double refusal: the refusal to disappear and the refusal to comply with the racialized categories of otherness and objecthood.[42] In order to find a common cause toward a fight that is bound by mutuality, we must know what kind of world we wish to build.[43] The complex dynamic between restraint and apology could come unknotted by the activation of an embodied lexicon of justice, such that this act of worlding is re-imagined as a more equitable exercise springing from creative sources in the face of racist patriarchy and an anti-erotic society.[44]

Eternal thanks to my defiant sisters, to Jan Ramesh de Saram for wild laughter and Bonaventure Soh Bejeng Ndikung for bringing me poetry.

�ுⵣ

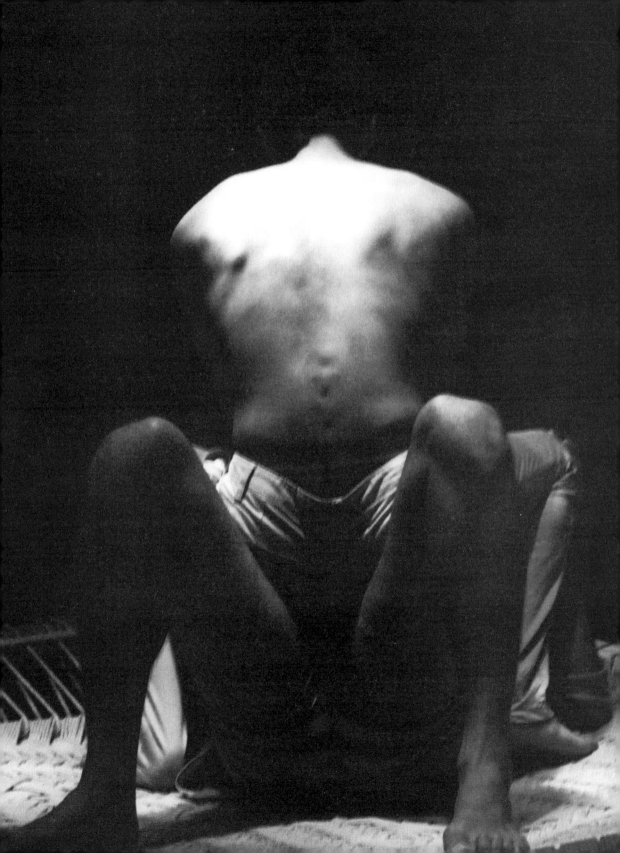

Developed in 2016 and revisited in 2018, Danish Sheikh's playscript draws on the *Suresh Kumar Koushal vs. Naz Foundation* Section 377 hearings in the Supreme Court of India in 2013, which appealed (and overturned) a 2009 Delhi High Court decision to decriminalize homosexuality in India. The full script was first published in *Global Queer Plays* (London: Oberon Books, 2018). This is a long excerpt, which includes notes on the real-life settings that inform the script, a record of sets and transitions, and an introduction to all the characters, followed by the second half of the original script.

Grateful acknowledgement to Danish Sheikh for support.

Keywords

Section 377: Part of the Indian Penal Code (1860) outlining the 'Unnatural Offences' of 'carnal intercourse against the order of nature', used to harass members of the LGBTQ (lesbian, gay, bisexual, transgender, queer or questioning) community. First overturned in a historic 2009 judgement by the Delhi High Court (*Naz Foundation vs. Government of National Capital Territory of Delhi*) and later in 2018 by the Supreme Court. Also see Keywords (pp. 329–44).

Naz Foundation (India) Trust: A Delhi-based non-governmental organization (NGO) working on HIV/AIDS and sexual health issues since 1994, and a key petitioner in the Section 377 hearings.

National AIDS Control Organization (NACO): A division of the Ministry of Health and Family Welfare set up in 1992 to direct the HIV/AIDS control programme in India.

Images

p. 49: Lalit Khatana and Parinay Mehra in Mandeep Raikhy's *Queen-size* (2016), created as a response to Section 377 of the Indian Penal Code; photo by Sidharth Sarcar.

p. 51: Photomontage of the text of Section 377 of the Indian Penal Code.

pp. 56–57: *Queen-size* (2016); photo by Sidharth Sarcar. (Inset) Text from Danish Sheikh's script.

pp. 64–65: (Background) Wall mural in Lodhi Colony, New Delhi, painted in collaboration with the city's transgender community; image courtesy Aravani Art Project and St + art India Foundation. (Inset) Text from the Transgender Persons (Protection of Rights) Act, 2019, which invalidates the right to self-determination and undoes effective access to many civil rights provisions that past rulings have enabled.

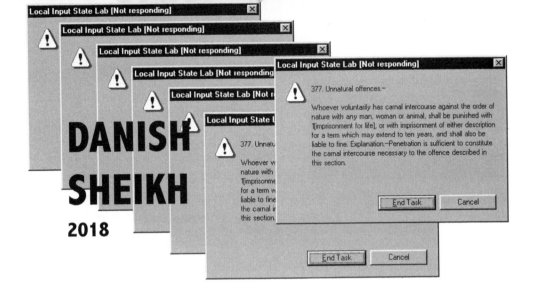

Local Input State Lab [Not responding]

377. Unnatural offences.—

Whoever voluntarily has carnal intercourse against the order of nature with any man, woman or animal, shall be punished with 1[imprisonment for life], or with imprisonment of either description for a term which may extend to ten years, and shall also be liable to fine. Explanation.—Penetration is sufficient to constitute the carnal intercourse necessary to the offence described in this section.

End Task Cancel

05 Contempt

A Note on Setting

Over a period of two months in 2013, the Supreme Court of India heard arguments on the constitutionality of Section 377 of the Indian Penal Code. This is a law which effectively criminalizes the intimate lives of LGBTQ individuals in the country. The Court ultimately found that it did not violate the Indian Constitution, leaving millions of queer persons vulnerable to state-legitimized persecution. This ruling was ultimately overturned by a larger bench of the Supreme Court in 2018.

The portions of the hearings that are featured in *Contempt* constitute a highly edited fraction of the exchanges in the Supreme Court in 2013. Little has been added to what the judges actually said in the courtroom: as John Berger observed, graphic caricature is dead because life has outstripped it.

The 'affidavits' that made their way into *Contempt* did not constitute a part of the hearings (with one notable exception). The architecture of the law often has little patience for lived experience.

Danish Sheikh, November 2018

SETS AND TRANSITIONS

The judges will be placed within the audience from the start of the play and remain there for the duration. The stage will have five chairs, arranged along two rows alternating with each other. The chair in the centre will be placed closest to the audience: when witnesses walk onto the stage for their individual monologues, this is the chair they will occupy initially before moving to one of the chairs towards the back. The exception to this is Witness 1 who will be on stage as the audience enters, and exit the stage after he finishes his opening monologue. The lawyer will stand centre stage during the courtroom scenes and sit on any of the unoccupied chairs when the respective witnesses enter to do their monologues. The play should be staged without an intermission.

CHARACTERS

The JUDGES are older men, speaking in a tired, bored intonation that veers into excitable territory when they start making their interruptions. The LAWYER will be a significantly younger man, displaying a calmness and vitality that wears down as the play progresses, until it comes roaring back into a more impassioned register in the final scene. WITNESS 1 is a man in his late twenties with an air of passionate intensity coupled with a gentle playfulness. WITNESS 2 is a young woman in her early twenties bursting with a nervous, excitable energy. WITNESS 3 is a woman in her early twenties flushed with a dreamlike optimism. WITNESS 4 is a transgender woman in her early thirties who displays a quiet but defiant reserve. These elements of their personality are only to be exhibited during their respective monologues: when they otherwise sit on the stage they are largely expected to remain impassive and still, unreactive to any dialogue that transpires in the court.

PRELUDE

WITNESS 1: I – love – you.
I love you. These words come way too easily to me. So I'll go on a date with this guy, second date, he picks one of those Time Out-featured restaurants, orders the cheapest wine on the menu, doesn't check his phone more than once in the evening, is reasonably non-disappointing in bed and then – the next morning – offers to make coffee.

And that's it, that's all it takes, and it just comes tumbling right out: thanks-for-the-coffee-I-love-you!

And then of course he looks all horrified and goes stumbling out of the house before I can explain that I really meant to say love with a small L – like font size seven – like the outer ring road of love.

You know who got this? The Greeks.

The ancient Greeks, they understood the big difference between the *I love you*s of good sex and the *I love you*s that lead to joint tax declarations.

They knew that no one word could capture the infinite messiness of love, and so they had several. Ludus – playful love. Pragma – long-standing love. Philia – love of the mind, Agape – love of the soul, Storge – love of the child, Philautia – love of the self – and then –

And then, there was another kind of love. A love rooted in erotic frenzy, a love that could shatter worlds. Eros, that's what they called it, and one night, thousands of years ago, a group of men gathered together in ancient Greece to honour eros.

There were seven of them that night at the house of Agathon. The tables groaned with food and goblets of wine. A gentle music serenaded them as the summer night-breeze wafted through the room, plucking beads of sweat glistening on their uncovered bodies.

There were seven of them.

A statesman, a doctor, a playwright, a poet, a philosopher, a lawyer. Outside the door of the house, there was another man listening, waiting, hoping. His name was Alcibiades, but he's not important just yet. For now, it's these men, getting drunk and delivering odes to the glory, the magnificence of eros. They tell us how eros is mania, how it is poetry, how it is medicine for the soul, how it is a quest for the other half of the soul. They agree that eros is crucial, that it is vital.

And finally, they come to Socrates. Who of course must have the last word, because he is Socrates, the great, Socrates the father of western philosophy. And he says well, eros, eh. Eros is fine, eros is good. But really, let's do away with the carnal pleasures of the flesh. Let's do away with this eros, let's climb the ladder of beauty. Let's move towards a higher good.

Let's reject eros.

Witness 1 walks offstage, the Lawyer enters.

ROUND II: WHAT GOES WHERE

LAWYER: Your Lordships, I stand before you today in the matter of Suresh Kumar Koushal versus Naz Foundation, a matter that affects the lives of millions of citizens in our country. We argue that Section 377 of the Indian Penal Code is unconstitutional, that it criminalizes the intimate lives of lesbian, gay, bisexual, transgender individuals in the country –

JUDGE 1: How exactly?

LAWYER: My Lordships, I represent a group of individuals who find that the law violates their basic Fundamental Rights guaranteed under the Constitution. Our argument is that the Section singles out one set of persons – the LGBT population – and holds them criminals for exercising their sexuality.

JUDGE 2: But how does it do that?

LAWYER: Because, your Lordships, it is used to specifically persecute LGBT persons and no other group, and so it treats them differently from the general population. In doing so, their constitutional right to equality and non-discrimination is violated.

JUDGE 1: That's not what my brother judge asked you, counsel.

JUDGE 2: No, counsel, tell us, why are you talking about lesbian, gay – why are you talking about these people in this case?

LAWYER: My Lordships, it is precisely these individuals who are targeted under Section 377 –

JUDGE 2: Counsel, who is this Naz Foundation?

LAWYER: Lordship, it is an NGO that works on HIV/AIDS –

JUDGE 1: Why do they care about LGBT?

LAWYER: They work with communities that are particularly vulnerable to HIV/AIDS transmission, and men who have sex with men are amongst these communities.

JUDGE 1: So they should focus on their work, why are they coming here?

LAWYER: Because your Lordship, when you criminalize certain sexual acts as 377 does, you make it very difficult to provide HIV prevention programmes relating to those acts, and this impacts the constitutional right to health.

JUDGE 2: And how exactly is that?

LAWYER: Your Lordships, think of how HIV prevention programmes work.

The organization employs healthcare workers to go to the field, and talk to people about safe sex practices and distribute pamphlets and condoms to them.

JUDGE 1: So who is stopping them, counsel?

LAWYER: The police is, your Lordships. A lot of the ground staff of these organizations gets harassed and picked up by the police for encouraging what they say is immoral and illegal activity.

JUDGE 2: And?

LAWYER: And so you see, organizations that do crucial work like this, that are helping with stopping the spread of HIV/AIDS, cannot do their work effectively because of the existence of Section 377.

There is a pause, the Judges confer amongst themselves.

JUDGE 1: Counsel, tell us something. How is this NGO funded?[1]

LAWYER: (*He is clearly taken aback.*) Your Lordship?

JUDGE 2: It is quite clear what my brother judge asked. How does this NGO receive funds? Are they foreign funds?

JUDGE 1: How much foreign funding?

LAWYER: Lordships, this is not about where the NGO's money is coming from.

JUDGE 2: Yes, but the NGO is making this argument, so we need to see who is behind this argument.

LAWYER: The government is behind this argument, your Lordship, NACO – the National AIDS Control Organization – has stated exactly the same thing.

JUDGE 1: Actually, where is NACO getting its funding from?

LAWYER: Lordships . . .

JUDGE 2: Okay fine, okay fine, you forget all that. Forget all this HIV. Tell us, what does Section 377 actually say?

LAWYER: 'Whoever has carnal intercourse against the order of nature'.

JUDGE 1: Carnal intercourse –

JUDGE 2: Against the order of nature –

LAWYER: That is correct, and it applies –

JUDGE 1: Wait. Tell us this, what is this carnal intercourse against the order of nature?

JUDGE 1: Wait. Tell us this, what is this carnal intercourse against the order of nature?

LAWYER: If we are to look at how it has been interpreted by the appellate courts, along with a historical reading of the Section, it's abundantly clear that it targets sexual acts done by LGBT individuals.

JUDGE 2: It's clear?

JUDGE 1: Abundantly clear?

LAWYER: It has been overwhelmingly used to –

JUDGE 1: Doesn't seem clear to us.

LAWYER: If we are to look at how it has been interpreted by the appellate courts, along with a historical reading of the Section, it's abundantly clear that it targets sexual acts done by LGBT individuals.

JUDGE 2: It's clear?

JUDGE 1: Abundantly clear?

LAWYER: It has been overwhelmingly used to –

JUDGE 1: Doesn't seem clear to us.

JUDGE 2: What is this order of nature?

LAWYER: Lordships, sexual or carnal intercourse within the order of nature would ordinarily refer to a situation where sex can result in the possibility of reproduction.

JUDGE 1: So penile-vaginal sex?

LAWYER: Essentially yes, your Lordship. So even the use of contraceptives would technically be against the order of nature.

JUDGE 2: So then this Section covers everyone?

LAWYER: If we are to just read it as it is, yes, but we have to take into account the question of how it's been used –

JUDGE 1: But counsel, we don't have an authoritative definition of order of nature? What is this carnal intercourse against the order of nature? What kinds of sexual acts are against the order of nature?

LAWYER: We don't have a specific list of acts –

JUDGE 2: What if . . . a boy inserts his tongue into another's mouth?

JUDGE 1: What if . . . a father inserted his tongue while kissing his child?

JUDGE 2: What about . . . the breast of a mother and child?

JUDGE 1: A mother puts her fist in the mouth of her child?

LAWYER: Your Lordships, it isn't a question of what acts, it's a question of which identities are targeted by this vague set of acts, it's a question of how LGBT individuals are associated with whatever acts are considered to be covered under Section 377 and that they are disproportionately impacted as a result of that.

A beat, and then he enunciates each word slowly, carefully.

It just isn't about the acts, it is about identities.

Pause, perhaps this idea has finally connected.

JUDGE 1: (*Continues as if the Lawyer hasn't said anything, clicks his finger in glee having come up with a great example.*) But what about when one person hugs another person very tightly? Could that be carnal intercourse against the order of nature?

Witness 3 enters.

WITNESS 3: Affidavit No. 8107 of 2012.
I have known Swapna since the time I knew that fire could hurt you.

We are ten and walking to school together. I am half a pace behind her, claiming each of her footprints as mine. We are one unit and they know it and see it before we do – look here come Swapna-Sucheta.

We are twelve and she is home, giving me tuitions for maths class, but I am not that bad and she is not that good, but she is giving me tuitions anyway because then after the tuitions she can stay with me and then we lie together at night, talking, confirming each event for each other, because what she sees I might see but it is always transformed by how she sees it and I want to know every last detail. Our conversations repeat themselves endlessly, but even that observation becomes another conversation and we talk and talk ourselves to sleep.

We are fifteen and sharing a mango and she slices it tenderly and she gives me a slice, the big slice, but her generosity is lost on me, I can only see that when she bites down into the flesh a thin line of the juice races down her chin, and past her throat – the thin defiant streak of orange disappearing into her crisp white blouse. She is gazing at a point in the distance, and I think how generous is my Swapna, she is letting me gaze undisturbed. I do not realize then how she takes just as much pleasure from me looking at her.

We are seventeen and she still gives me tuitions and this is just another night after just another tuition but this night we play a game where she traces equations on my arm, such is my teacher, and then she traces her name on my navel and we giggle at first but then she moves it down and I can't laugh and she moves further down and all I can do is move closer and let her disappear into me.

We are nineteen and she is home with me when the first boy's family comes to visit. She walks me with such confidence to the room they are sitting in, she even makes the tea for him, and he asks shyly if she is my sister. That becomes our joke, later that night, when we lie together and she whispers 'sister, dear sweet sister' into the nape of my neck.

And now we are twenty and our stories are coming to an end. I cannot be sure when it was clear we were on borrowed time, but we both knew at the same moment. She came to my house that night though there were no tuition excuses

left, but no one asked, no one suspected. And when it came to it, in those final moments, we didn't cry. It isn't that we were being brave for each other. We were sure that this would be just another conversation where we'd fall asleep and then wake up and find each other again.

When they find our bodies, they will see them tied together with a piece of cloth around our waists. We thought that would help. We asked for our bodies to be kept in the same place, together for all time, like we used to be, and we thought that the cloth would help – we thought it would remind them of how much this final request meant to us.

It may not matter to them or to you, but it is what we wanted in the end, and that should be enough. It should.

ROUND III: KOKILA SPEAKS

LAWYER: Your Lordships, I stand before you today in the matter of Suresh Kumar Koushal versus Naz Foundation, a matter that affects the lives of millions of citizens in our country. We argue that Section 377 of the Indian Penal Code is unconstitutional –

JUDGE 1: How, counsel? How are these millions of citizens affected?

LAWYER: If you will permit me, I would like to read out an affidavit to you. This is by Kokila, a hijra woman from Bangalore. It has been admitted into the Court record.

At the mention of Kokila, Witness 4 will walk on to the stage. The Judges are silent, look at the Lawyer.

LAWYER: My name is Kokila. I identify myself as a hijra, a member of a traditional male-to-female transsexual community in South Asia. Right from my childhood I have felt that I was a girl and liked to dress in girls' clothes, cook and put make-up.

Now Witness 4 will speak instead of the Lawyer. The Judges attempt to interrupt but Witness 4 speaks on without a pause.

WITNESS 4: On 18 June 2004 around 8 p.m., while I was dressed in women's clothing and waiting on the road, I was raped by ten men who forcefully took me to the grounds next to Old Madras Road.

JUDGE 1: Now, counsel –

WITNESS 4: They threatened to kill me if I wouldn't have sex with them. I was forced to have oral and anal sex with all of them. While I was being sexually assaulted, two policemen arrived and the men ran away. I told them about the sexual assault by the goondas.

JUDGE 2: But what about –

WITNESS 4: Instead of registering a case against the goondas and sending me for medical examination, they harassed me with offensive language and took me along with the two captured goondas to the Byappanahalli Police Station.

JUDGE 1: And why –

WITNESS 4: The police did not even allow me to put on my trousers and forced me to be naked for the next seven hours. In the station, I was subjected to brutal torture, I was stripped naked, my hands handcuffed to a window. They hit me with their lathis, they kicked me with their boots, they abused me using sexually violent language, they burnt my nipples with a burning coir rope.

There is silence as the Lawyer and the Judges look at each other. The Judges confer with each other. Witness 4 stands silently in her spot, looking at the Judges as well.

JUDGE 2: Counsel. One question. How do we know this happened?

Witness 4 and the Lawyer look at each other, their faces impassive. The Lawyer breaks the gaze after a few beats and looks back at the Judges.

LAWYER: Your Lordship, as mentioned, I am reading from an affidavit, made under oath, on penalty of perjury.

JUDGE 1: Yes, but is there any other evidence that this event happened?

LAWYER: There are multiple newspaper accounts and fact-finding reports which I can produce before you corroborating the events Kokila describes.

JUDGE 1: But do these reports talk about how this is a case about 377?

LAWYER: As you can see, Section 377 creates a situation where these abuses can happen. It legitimizes this behaviour.

JUDGE 1: Counsel, how does it do that . . .

JUDGE 2: From what we have understood it criminalizes carnal intercourse against the order of nature –

JUDGE 1: Are these instances of carnal intercourse against the order of nature?

A beat, **Lawyer** *is silent, looks at them intently.*

WITNESS 4: My name is Kokila. Kokila means cuckoo. This is not the name on my birth certificate. I will not tell you what that name is. It is not mine.

My name is Kokila. My parents use it for me now. It took some time, but they use it. After all, there is nothing else I will answer to.

My name is Kokila. I cannot remember how long I have known this, or when I realized it. I think I heard it first on a bus.

My name is Kokila. When we are lying in bed I make him whisper it to me as I am falling asleep. Maybe I am scared he will forget otherwise. When he leaves in the morning I make him repeat it. Don't say bye, don't say bye my love. Say bye Kokila, say it, say it again, bye Kokila, say it like that, yes. It means cuckoo, did I mention that? I don't know what cuckoo birds are like really, or if I am like a cuckoo, but when you say it to me it is the right sound.

My name is Kokila, Kokila *is* my name. They don't believe it. When I try to make them write it in black ink on green paper with a blue stamp they look at me like I have come to the wrong place. But there is one document that calls me Kokila. There is one place where you will say it, there is one place where you will allow me to say who I am, that I exist. It is an affidavit. It speaks about my rape.

My name is Kokila. If you repeat a word enough times, it loses its meaning.

I would still very much like you to say my name.

ROUND IV: ON MIRRORS

LAWYER: Your Lordships, I stand before you today in the matter of Suresh Kumar Koushal versus Naz Foundation, a matter that affects the lives of millions
JUDGE 1: In what way?

JUDGE 2: Where in this Section 377 does it actually say –

LAWYER: (*Raises his voice, cuts off the Judge.*) The point here, your Lordships, is that this is *not* a case about who does what acts.

JUDGE 1: Then what –

LAWYER: (*Voice goes even higher, cuts off Judge again.*) If we can just take a step back, away from the specific words of this law, and see what it is that it actually allows for. What does it mean for a person who is gay, lesbian, bisexual, transgender, what does it mean for them to wake up in the morning and look in

the mirror, and see a criminal, to see an unapprehended felon, to see themselves stripped of their dignity.

JUDGE 1: But who are these people? Where do we find them?

LAWYER: Lordship, we don't have to find them, it's not about how we identify them, it's about how they identify themselves – how they view themselves – which is as second-class citizens under the law. Being criminalized affects their right to dignity –

JUDGE 2: Can they be identified?

LAWYER: As I said –

JUDGE 2: If they can't be identified as such how is their dignity affected? Harassment can only happen if a person can be identified –

LAWYER: The norm is such that many individuals cannot come out, they cannot be open about their sexuality –

JUDGE 1: Of course you can, provided you have access to the media – then you will be glorified!

JUDGE 2: And otherwise, why do they have to be out like that? Who walks around saying, 'I am a heterosexual, I am a heterosexual?'

JUDGE 1: Exactly, dignity can only be compromised if your identity is revealed.

LAWYER: But your Lordships, we cannot ask people to hide their sexuality, whether it is visible or not. The point is this law means that you cannot express aspects of your sexuality –

JUDGE 1: That applies to everyone.

LAWYER: But for the others, for those who don't belong to the LGBT community, there is a way of expressing their sexuality that is considered within the order of nature, that is not condemned!

JUDGE 2: (*Highly irritable now.*) Community community community! What is this community?

JUDGE 1: Yes this community business, doesn't your argument also extend to someone attracted to animals only?

JUDGE 2: Someone will say I am attracted to animals only, now you protect my dignity.

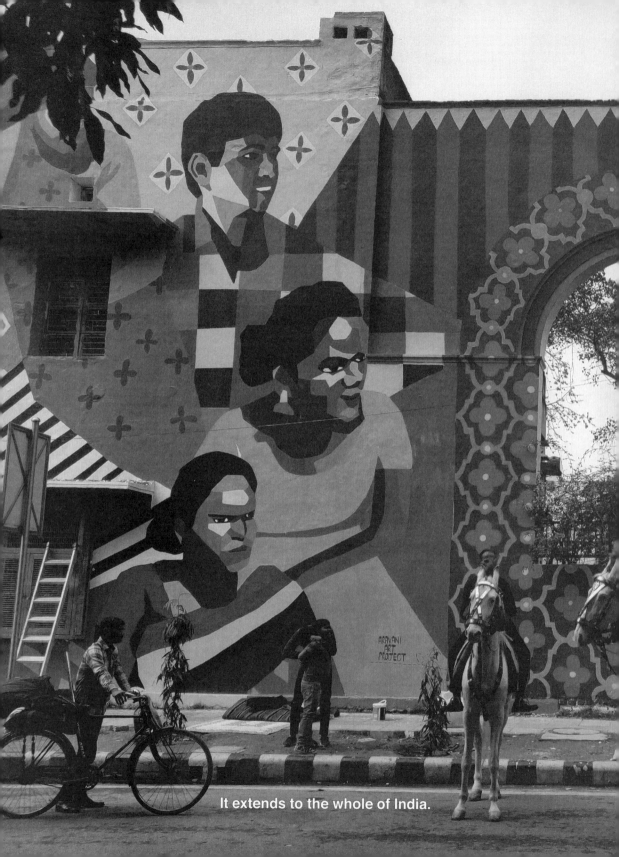

It extends to the whole of India.

THE TRANSGENDER PERSONS (PROTECTION OF RIGHTS) ACT, 2019;

An Act to provide for protection of rights of transgender persons and their

welfare and for matters connected therewith and incidental thereto.

BE it enacted by Parliament in the Seventieth Year of the Republic of India as follows:

It extends to the whole of India.

LAWYER: (*The shock on the Lawyer's face is evident, it is difficult for him to immediately process what the Judge has said.*) That . . . that's a very . . . different situation, my Lord, we're not on that . . .

JUDGE 1: (*Relaxes into a more casual mode, he's about to give an example that he's convinced will really settle the point and end this line of arguing.*) Let me tell you, there was this peculiar incident in Punjab. These three ladies were frequent pickpockets. One Robin Hood SP got hold of them and got tattoos engraved on their foreheads to mark them as pickpockets. Now will we also call them a community?

LAWYER: That . . . your Lordship. . . .

JUDGE 2: You are making arguments that are contradictory – how can dignity be compromised if people don't know your identity?

JUDGE 1: There doesn't have to be a special community. People are part of the general commune.

LAWYER: But it is this general community, this larger community, that has decided that LGBT people are criminals in the first place. Section 377 reflects the will of the community, it reflects popular sentiment, popular morality, and that is precisely the problem, your Lordships. (*Lends emphasis, says the words slowly.*) Our test has to be that of constitutional morality. Not popular morality. Our test has to be that of the values identified by the Constitution, the values we agreed to be constituted by as a nation – *not* those of popular sentiment.

JUDGE 2: But why should the law change this, opinions should be changed through other ways –

LAWYER: Your Lordships, at the time our Constitution was being drafted, B.R. Ambedkar said that constitutional morality was not a natural sentiment. It has to be cultivated, it has to be fostered on a topsoil that is essentially anti-democratic, it does not come to people naturally –

JUDGE 1: Speaking of natural, if you do natural acts, then you won't be a criminal!

LAWYER: (*Visibly exasperated, but continues after a breath.*) But that is the problem, how do you define what is natural and what is normal?

JUDGE 1: Exactly then, what is natural? What is normal?

JUDGE 2: What is this carnal intercourse against the order of nature?

LAWYER: *You* can decide this, my Lordships – *you* can say that there is nothing unnatural about sexual acts by LGBT individuals, that they are not against the order of nature. . . .

JUDGE 2: But which acts? Where is that in your pleadings? You say homosexuals are not unnatural – but which acts?

JUDGE 1: What about . . . hugging?

JUDGE 2: What about when a father puts his tongue –

JUDGE 1: What about when a mother feeds her child –

JUDGE 2: Actually hold on counsel, this is just not working, tell us one thing. Why are you here?

JUDGE 1: Yes, what is really your cause of action?

LAWYER: Why are we here. . . .

JUDGE 1: Yes, counsel.

JUDGE 2: Yes – why?

LAWYER: (*A long pause as he looks at both Judges.*) I don't think I know anymore.

JUDGE 2: What kind of an answer –

LAWYER: I don't know.

JUDGE 1: Counsel!

LAWYER: I do not know.

JUDGE 2: Counsel, are you mocking us?

LAWYER: Mocking? Not mocking, no.

JUDGE 1: Counsel, we will have to hold you in contempt!

Lawyer gives a sigh of resignation, looks up with a wry smile.

LAWYER: Contempt? (*In a monotonous voice, as if reciting from a statute book.*) Contempt. Whoever makes a statement which lowers the authority of the Court will be held in contempt.

JUDGE 2: We know what the definition of contempt is, counsel.

LAWYER: And yet. (*A laugh, a shrug, a nod of his head.*)

Before he can say anything else, Witness 1 speaks, from behind the audience.

WITNESS 1: And yet.

I need you to understand.
 No, wait. Understand – not understand – that isn't the right word, not for

me anyway. HE – he would use it, he would say it because to understand is to rationalize and think with reason and reason is good, and has its uses, but reason will only take us so far, and here really reason fails us.

So no, not understand. I need to take you . . . there.

I need to take you to this night that changed everything. Except, it's really two nights. The first is the night of the Symposium. The night when Socrates tells us we must do away with the carnal pleasures of the flesh, down with eros! And as he says it all these men of Athens around him applaud, Ohh Socrates you great smart man, doing away with eros, revolutionary! And then, at this celebratory moment, in walks Alcibiades.

Young, brash, inflamed by passion Alcibiades, crazed former lover Alcibiades, Alcibiades who tells us about how he has ached for Socrates only to be slowly destroyed in his breathless pursuit of this man, this man who casually makes him burn with love, and then, even more casually denies him.

You want to talk about eros, he says? I'll tell you about eros.

Eros is not pleasant. It is not beautiful. A hole is being gnawed in you, the lungs are being snatched out of your very chest, you are being grated out of existence. It is sweet-bitter, this eros, it is pain, it is pleasure, it is both and it is neither all at once. And every conversation we have, my Socrates and I, every single moment we spend together is a moment caught in that in-between space. Will you still deny eros? Will you still deny me?

But he does deny him. And that story ends there.

Which brings me to the second night. Thousands of years later, there was a night in 2012, a night where once again, eight of us are seated at a table, this time on a rooftop, getting drunk and talking about love. This night . . . I am seated here, at this edge . . . and diagonally across from me is my own flesh-and-blood tormentor, the subject of my breathless pursuit, my very own Socrates.

*As he utters the name Socrates, he looks at the **Lawyer**, who returns his gaze.*

LAWYER: Can you see us, seated around a table, insulated from the wintry night by steady intoxication and conversations about love?

WITNESS 1: Can you see us, and remember that we are sitting diagonally opposite each other?

LAWYER: Can you think of how the occasional wordless glance might hit with a physical force as the evening progresses?

WITNESS 1: And in the air, can you sense it, that manic hovering force apprised of its targets, eros itself, about to latch on any second now?

LAWYER: And now the wine is over –

WITNESS 1: And now conversations have come to a close –

LAWYER: And now eight of us walk to the elevator –

WITNESS 1: Eight, to an elevator that can hold six in one go –

LAWYER: And of all the permutations and combinations –

WITNESS 1: All the ways we could have arranged ourselves –

LAWYER: The six that walk into the elevator do not include you and me –

WITNESS 1: And so the others go ahead –

LAWYER: The others go ahead –

WITNESS 1: The others go ahead . . . and. . . .

LAWYER: . . .and we stand next to each other in silence.

WITNESS 1: And then the door opens and you walk inside first.

LAWYER: And you follow, your back turned to me.

And now the other Witnesses will join in so they all alternate lines with each other.

WITNESS 4: Even before the door closes, I feel your breath on my neck. Mere inches separate us.

WITNESS 3: One floor down, you take the faintest of steps backwards. Now my breath is stronger, and we are so close that I can feel the heat radiate from your body.

WITNESS 2: Another floor down, I turn around to look at you. Our proximity makes our noses brush. We are both looking at the ground. The air that separates the rest of our bodies from contact is surely, surely on fire.

WITNESS 4: Another floor down, this thin fire becomes cold sweat. We are immobile and trembling, and then the elevator comes to a halt.

WITNESS 2: And here, the door could have opened to show us everybody waiting outside, but they aren't there . . . and it could have opened to strangers waiting to use the elevator, but there is no one else either –

WITNESS 3: – and so of course it makes all the sense in the world when you reach from behind and push the button for the fifth floor once again. For the second time, the doors close on us.

And now the Lawyer and Witness 1 are as close to each other as you think they can possibly be.

LAWYER: And....

The Lawyer moves even closer to Witness 1.

WITNESS 1: And....

WITNESS 1 leans into the **LAWYER.** They kiss – a kiss that will continue until **WITNESS 1'S** next line.

WITNESS 4: You kiss me, like it will be the only kiss we will ever have.

WITNESS 3: You kiss me. Like we are discovering something new.

WITNESS 2: You kiss me. And I marvel at how your breath becomes my air.

WITNESS 1: And you kiss me. And there will be more as the evening passes. There will be time. Years perhaps. And then I will lose you, Socrates, and I will learn that pain has a vocabulary as varied as that of love. But for now, for this moment, will you stay in this elevator with me? Can you see the two of us, dissolving into each other that night? Can you see how this was the most beautiful thing – the most crucial thing in the world? Can you see why beauty is important? Can you see why it is crucial?

LAWYER: Can you?

END.

§

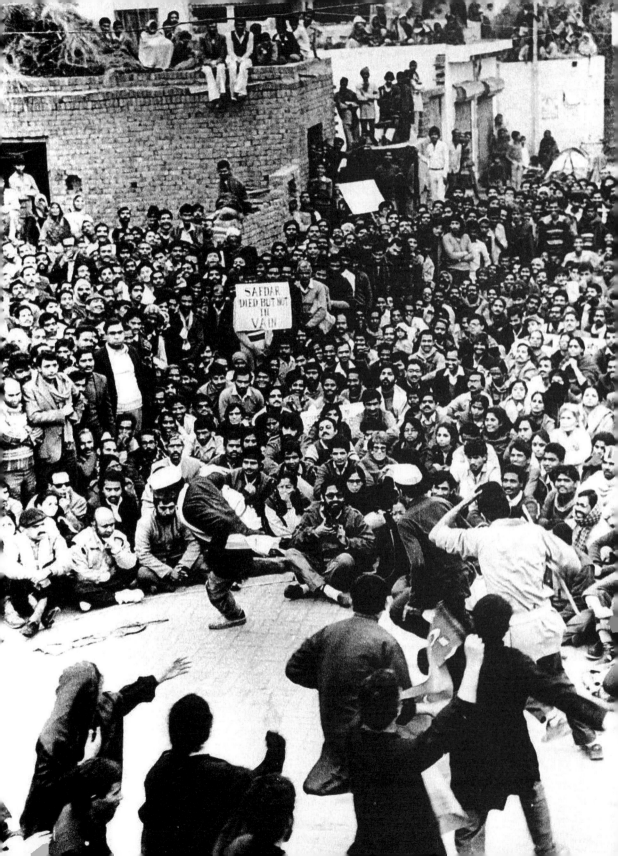

In November 1988, the Centre of Indian Trade Unions (CITU) led a week-long strike in Delhi and satellite cities where around 13 lakh workers struck work for a week, protesting against their minimum wage of Rs 562 a month and demanding a wage hike. While there was a government offer to raise the wage to Rs 601, CITU demanded that it be hiked to Rs 1,050. The large number of protesting workers made the strike a momentous one. The left-wing street theatre group Jana Natya Manch (Janam) wrote and performed the play *Halla Bol* (Raise Hell) in response to the strike, advocating for and elaborating on the issues raised by the workers. On 1 January 1989, while performing the play in Jhandapur village, Ghaziabad,[1] a city in Uttar Pradesh that shares a border with Delhi, Janam members were brutally attacked by local goons. Janam's founder-member and street theatre activist Safdar Hashmi died of his injuries in a Delhi hospital on 2 January. On 4 January, his partner and fellow Janam member Moloyashree Hashmi returned to the site with other actors of the group and completed the performance of the play.

English translation from Hindi by Neeraj Malick. Previously published in Sudhanva Deshpande, *Halla Bol: The Death and Life of Safdar Hashmi* (New Delhi: LeftWord Books, 2020). Reprinted with permission. Grateful acknowledgements to Sudhanva Deshpande and Moloyashree Hashmi.

Keywords

Indian People's Theatre Association, *Jana Natya Manch*: see Keywords (pp. 329–44).

Centre of Indian Trade Unions (CITU): A national-level trade union founded in 1970, politically affiliated to the Communist Party of India (Marxist).

Employees' State Insurance (ESI): A self-financed social security and health insurance scheme for workers in India.

*Jhuggi*s: Huts, often informal tenements, grouped as *basti*s (settlements) giving residents little to no access to civic services such as electricity, water or sewage facilities.

Abbreviations

ACP: Assistant Commissioner of Police

DCP: Deputy Commissioner of Police

DDA: Delhi Development Authority

ESMA: Essential Services Maintenance Act of 1968 that seeks 'to provide for the maintenance of certain essential services and the normal life of the community'

NSA: National Security Act of 1980 that allows for preventive detention of a person if he/she is deemed to be obstructing the 'maintenance of supplies and services essential to the community'

SHO: Station House Officer

Images

p. 71: Moloyashree Hashmi and other Janam actors performing *Halla Bol* at Jhandapur on 4 January 1989; photo courtesy Jana Natya Manch.

p. 73: Photomontage of news headlines announcing Safdar Hashmi's death and an image of Safdar during a performance; photo of Safdar courtesy Jana Natya Manch.

pp. 80–81: Safdar Hashmi and other Janam actors performing *Aaya Chunav* (The Elections Are Here, 1980), in Hisar, Haryana; photo by Surendra Rajan, courtesy Jana Natya Manch.

p. 87: Safdar Hashmi's funeral procession in New Delhi, 3 January 1989; photo by Ram Rahman.

Delhi bids farewell to Hashmi

JANA NATYA MANCH

1988

06 Halla Bol (Raise Hell)

Actors sit in a circle. One actor starts the slogans. The other actors join him in a procession. They hold red flags and shout slogans.

Narrator: Workers, stand up for your rights! Comrades, stand up to resist!
Song: Against oppression and exploitation, we raise our might
Hear our clarion call, we shall not cease to fight.
How long will you oppress us, how many imprison in your jails?
We shall fight, we shall resist, we shall surely prevail.

One actor gets up and blocks their way. He wears a police cap and holds a baton.

Policeman: Stop, stop, I say! Stop shouting!

Silence. The Narrator, unaware of the policeman, continues to sing. The policeman follows him.
Hey, didn't you hear me? What did I tell you? Hey, Mr Revolutionary, shut your gob! Oh, you won't listen easily. (*Strikes him with the baton.*)

You scoundrel, what are you up to?

Narrator: We are going to perform a play.

Policeman: *Pilay*! You think I'm a fucking idiot?

Narrator: No, sir.

Policeman: So?

Narrator: So what?

All: So what?

Policeman: Is this the way to do a *pilay*? (*Waves his hands*) Shouting slogans, raising red flags, holding posters. Get lost this minute, you bastards. Or I'll put all of you in jail.

Narrator: (*Laughing*) Please believe us, Constable sir. We are only doing a play. You can ask all these people. We are all artists, actors of Jana Natya Manch.

All: Yes, yes. Jana Natya Manch of international fame!

All the actors try to persuade him.

Policeman: Oh, I see. You were doing a *pilay*.

All: Yes, sir.

Policeman: Alright. Go ahead then. Do a real good one.

Narrator: Yes, sir. Just move aside a bit. We shall start now. Come on, everybody. (*Resumes the slogans, the actors take up the song.*) Long live the revolution, CITU long live!

Policeman: Hey, hey, what is this? Do your *pilay*; the *pilay*, I said. No slogan shouting.

Narrator: But, sir, our play calls for this action.

Policeman: Your *pilay* calls for slogans? But slogans are not allowed in this area. We have strict orders ever since the seven-day strike took place. It's an order from the SHO saheb. Arrest anyone who even mentions CITU! Immediately, without asking for explanation!

Narrator: But we have to raise slogans in our play.

All: Yes, yes, Constable saheb. Slogans are essential for our play.

Policeman: (*Shouting*) No, no. I will not allow it in my area.

Narrator: Then?

Policeman: Then what?

Narrator: How do we do the play then?

Policeman: You bastard! Do I have to explain, how? Do it as a normal *pilay*, with a love angle, with the lover courting his beloved, some song and dance, some jokes and comedy, some this, some that. (*He walks suggestively towards a female actor.*) Understand?

Narrator: Yes, understood.

Policeman: What?
Narrator: A play about lovers?
Policeman: Yes.
Narrator: But no slogans?
Policeman: No slogans.
Narrator: All right, sir. As you order. We'll show you a play about lovers. So friends, Constable saheb does not allow us to do a revolutionary play, so we'll show you a play about love.

All actors confer. They make the formation of a garden. Two lovers are cavorting and dancing. They sing a parody of a popular Hindi film song.

Chorus: Come, my beloved, come
Let us play hide and seek, come
In the lanes, and in gardens
Let's dance around the trees, come.

Jogi and Ashsho play hide and seek.

Jogi: Shall I come?
Ashsho: No. no.
Jogi: Shall I come?
Ashsho: No. no.
Jogi: Shall I come?
Ashsho: Yes, my beloved, come.
Jogi: My beloved is playing hide and seek
There she is, behind the hut . . .
There, I caught you . . .
Chorus: There, I caught you!
Ashsho: Jogi?
Jogi: Yes, Ashsho?
Ashsho: When will you speak to my father?
Jogi: Just wait a few more days, Ashsho.
Ashsho: But why? You've been saying the same thing for two years. Wait a few more days, wait a few more days.
Jogi: Please try to understand, Ashsho. My salary is so meagre, how will I maintain you?
Ashsho: But when will your salary increase? You told me that you'd know for certain after the seven-day strike. Jogi, I can't wait any longer.
Jogi: See Ashsho. This was such a big strike. Thirteen lakh workers kept the factories shut for seven whole days. Don't you see, the factory owners are totally

shaken. Now we only have to intensify our struggle. You'll see, the government is bound to give in after our next action.

Ashsho: Really?

Jogi: Yes, really!

Ashsho: You swear!

Jogi: I swear!

Ashsho: Swear by me!

Jogi: I swear by you!

Ashsho: By god?

Jogi: By god!

Policeman: Hey, hey! What's happening here? You bastards, you've started your propaganda for CITU even in your love story. I won't allow it.

Narrator: Oh, oh, Constable, sir. You really are the limit! After all, our hero is a factory worker. For seven days, he has fought so bravely under the CITU banner. How can he not talk about CITU? And how many people will you ask to shut up? Today, every worker is talking only about CITU.

Policeman: No, no. Not allowed in my area.

Narrator: Meaning?

Policeman: Meaning, in my area the lover will have to behave like a lover. If he dares to talk of anything else, I will arrest him on the spot.

Narrator: Okay, as you say, Constable saheb. He will not speak about CITU but can't he at least talk about his salary?

Policeman: Why should he talk to his beloved about his salary? Is he a lover or an accountant? If he wants to do a love scene, tell him to do it properly. Or else I'll show him how to do it.

Narrator: No, no sir. Please don't trouble yourself. He can do it. You can do it, mate, can't you?

Jogi: Yes, yes, of course. I will do it.

Narrator: Ladies and gentlemen, since Constable saheb has censored our play, we are again making some changes to the play. Okay, come on, everyone. Let's start again.

Ashsho: Jogi!

Jogi: Yes, Ashsho.

Ashsho: You will speak to Father today, won't you?

Jogi: Yes, Ashsho. I have given you my word. I'll do it.

Ashsho: Good! And don't be nervous. Just be firm and assert yourself. Just like Comrade Nathu when he talks to the management.

Policeman: What? What did you say, girl? What is this comrade-*shomrade*?

Ashsho: Sorry, sir. Sorry . . . Listen, don't be nervous. Be firm and assert yourself.

Just like Lord Rama used to before King Janaka.[2]

Jogi: Don't you worry at all. I will just wrap your dear father around my finger, like this. You'll see the true mettle of your Jogi.

Ashsho: Baba, baba . . .

Father: (*Off*) What happened, Ashsho? Why are you screaming like this?

Ashsho: Someone is here to meet you.

Father: Must be a creditor. Tell him I'm not at home.

Ashsho: No, no. He is not asking for money. It's someone else.

Father and Mother enter.

Father: Who is it?

Ashsho points to Jogi. Both parents circle Jogi, scrutinizing him.

Father: Who are you, young man? I don't think I know you. (*Jogi is silent.*) Will you say something, or will you just stand here like a statue?

Jogi: Jogi . . .

Father: Jogi?

Jogi: Jogi – my name is Jogi. I mean Joginder, I mean . . . no, I mean Joginder Singh . . . meaning Jogi, Joginder . . . Jogi, Joginder . . .

Father: What is this Bogey, Bounder, Bogey Bounder? Don't stand there stammering? Tell me what you want with me.

Jogi: No, no. I mean, just like that. I mean I was just whiling away time. I mean, I'll go now.

Father: (*Holds him by the collar*) Where are you going, you scoundrel? Tell me, why did you come here? He must be a thief or some such.

Ashsho wails.

Father: Just shut up! What has come over you now?

Ashsho: (*Crying*) He's not a thief!

Father: How do you know him?

Ashsho: (*Sobbing*) I mean Jogi . . . I mean he . . . I mean he came to you to . . . I mean . . . O Amma! (*She hugs her mother. Both weep together.*)

Father: What the hell is going on? Can you speak clearly?

Mother pulls Father aside.

Mother: You are the limit! Whisper, whisper.

Father: Whisper, whisper . . .

Mother: Yes, and listen. Whisper, whisper . . .

Father: Whisper, whisper . . . whisper, whisper. (*To Jogi*) Oh, so this is the matter. You want to marry my daughter?

Jogi: Yes, I . . . I mean that's what I wanted to say.

Father: Stop this I mean, I mean. Come to the point.

Jogi: Yes, sir. I will treat her like a queen; her every wish shall be a command; she will never lack . . .

Father: Dispense with these filmy dialogues. Tell me what work you do.

Jogi: Sir, I work in a factory.

Mother: What is your designation? Are you the manager?

Jogi: No, madam. A little below that.

Father: Supervisor?

Jogi: A little lower.

Mother: Department-in-Charge?

Jogi: Just a little lower.

Father: Accountant?

Jogi: No, no . . . er . . . a little lower.

Both: A little lower? Are you a factory worker?

Jogi: Yes, Machine-man.

Chorus: Yes, Machine-man.

Father: I knew it! My daughter would get proposals only from such down-and-outs!

Mother: Whisper, whisper.

Father: Whisper, whisper.

Jogi: So, sir. Should I take it that you agree to my proposal?

Father: (*Picks up his shoe, chasing Jogi*) Come here. Let me show you how I accept your proposal! You bastard, you worthless factory hand, you son of a beggar! You earn a measly wage of 562 rupees, and dream of marriage?

Mother: (*Chases Jogi, behind Father*) Look at your cheek. Do you think we'll destroy our daughter's life by letting you marry her?

Ashsho runs after them.

Ashsho: Baba, oh Amma, don't beat him. Let go of him.

Father: Hit him with my shoe!

Chorus: 562

Father: Slap him hard!

Chorus: 562

Father: Kick him hard!

Chorus: 562

Father: Go to hell!

Chorus: 562

Father: Let me show you!

Chorus: 562

Father: You'll never forget this!
Chorus: 562

Suddenly Jogi stops, turns and faces Father.

Jogi: Don't you dare raise your hand on me. Or else.
Father: I will, I will. I'll beat you a hundred times. 562 times.
Jogi: I'm warning you! Ashsho, tell your father to stop, or I'll teach your old man such a lesson . . .
Father: You bastard! You dare to threaten me? I'll mash you to pulp.
Ashsho: Baba, take out your anger on me. Hit me. But please don't beat Jogi.
Mother: Come here, Ashsho. Don't meddle in men's affairs.
Ashsho: Let go of me. And I'm telling both of you. I'll only marry Jogi. And I'll never marry anyone if you don't let me marry him.
Mother: Don't say such things, my dearest. Don't even utter such inauspicious words. And get this idea out of your head. How can you think of marrying this good-for-nothing factory worker of 562.
Father: Think rationally, daughter. With 562, how will he feed you and run a whole household?
Mother: Ashsho, anyone earning such a meagre salary is sure to kick the bucket in a year or two. Imagine, you will become a widow at such a young age!
Father: My dear, you don't know the state of Delhi factory workers.
Mother: Employed today, out tomorrow.
Father: Shutters down in one factory today, lockout in another tomorrow.
Mother: Life spent in dirty slums. No water, no electricity.
Father: Place infested with criminals and no-gooders.
Mother: Facing police violence as a matter of routine.
Father: Spending nights in Tihar jail. (*Silence*) Use your brain, my dear. Forget this idea.
Mother: You know what marrying a worker means – choosing a living death.
Ashsho: No, I can't live without Jogi. And I'll kill myself if you don't let me marry him.

Mother weeps.

Mother: (*To Father*) Whisper, whisper.
Father: Whisper, whisper. (*To Jogi*) Jogi, son, please understand we have nothing against you. You seem to be an honest, hardworking boy.
Mother: But we have to think about our daughter's well-being. You understand?
Jogi: I have thought about it, Ammaji. I'll give up everything – bidi, cigarette, tea . . .

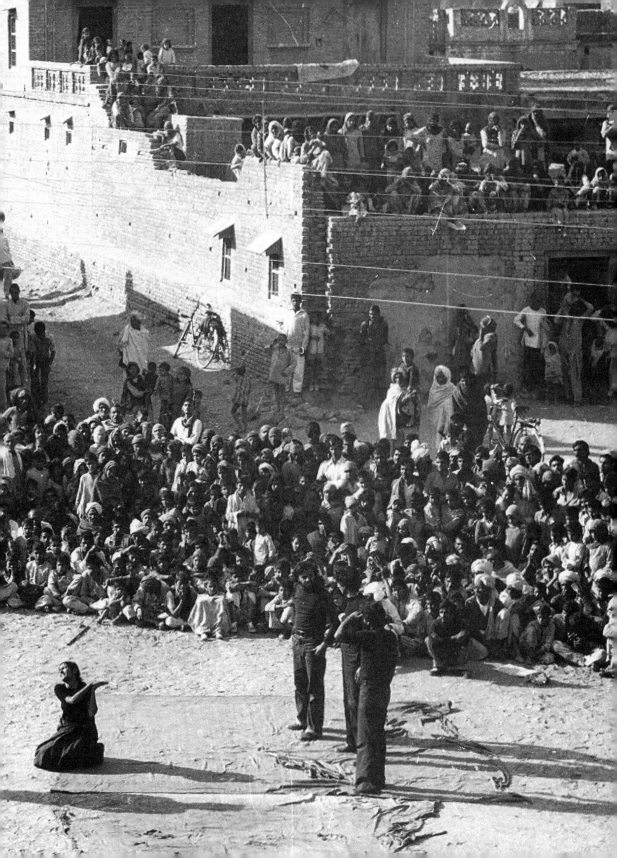

Father: Don't be childish, son. How will a worker survive eight hours of hard labour if he gives up tea and smoking?

Jogi: I will stop sending money to my parents. I won't take the bus, I'll walk to the factory. I will take up another job in the evening.

Father: (*Mocking*) Of course! So, I can bid goodbye to the world in two–three years!

Mother: (*Mocking*) So that my wife becomes a widow!

Father: All this is meaningless, idle talk. I have made my calculations. No one can live on less than 1,000–1,100 rupees in this city.

Mother: Even animals can't survive, let alone human beings.

Jogi: Yes, our Union also says that our wages should be at least 1,050 rupees.

Mother: And they are right.

Father: So, dear boy, take up a job that gives you at least 1,050. And we'll be happy to let you marry our daughter.

Ashsho: But where will he find such a job?

Jogi: They all pay 562.

Mother: Son, why don't you talk to your boss and persuade him to increase your salary?

Jogi: You think it's easy, Ammaji? With great difficulty, the bastards gave us an increase of 73 rupees after two years. That, too, after a long struggle. This recent seven-day strike—it has brought pressure on the bosses and they are ready to increase our wages. Only the government is sitting quiet till now.

Both: So, don't give in. Intensify your struggle.

Jogi: But that's exactly what we are doing. Now all the workers are ready to join CITU and wage a long struggle under its banner.

Policeman intervenes.

Policeman: Again! You are up to it again, you scoundrels! Just because I am not saying anything, you think you can take liberties. Come on, enough! Pick up your stuff and scram! Get out of here.

Narrator: Constable, sir, you had said no to shouting slogans and raising banners. See, we have put these aside. Now, what's your problem, sir?

Policeman: You good-for-nothings! How did I know that you are capable of inciting the workers even without raising slogans and banners? That's it now. I won't listen to a word more. Scoot! Just get out!

Narrator: Constable, sir. Why can't you get this simple thing into your head that a worker has to struggle to be able to live. If we do a play on our own lives, it does not matter whether we raise banners or not, or shout slogans or don't shout slogans. It boils down to the same thing. A worker's life is a big struggle. We have to fight to be able to live.

All: Have to fight to be able to live.

Jogi: And we have to fight to be able to love.

Policeman: Oh, I see. Then you'll have to fight me to do your play. Who's ready?

Narrator: Go to hell! We refuse to do the play. The government has not imposed any Emergency, but you must start your censorship. Come on, friends, let's go. We will not do our play.

All move to pack up.

Actor 1: One minute! (*All pause. To Policeman*) You said that you will not allow the red flags, slogans, or any mention of CITU. But what if we do a play against all these?

Policeman: Look, the SHO sir's orders are that there should be no talk of CITU. (*Starts to dream*) But if you do a play against CITU, then there is a good chance that I'll be promoted to the post of a Sub-Inspector . . . Then Inspector, then ACP, and of course DCP some day soon . . .

Actor 1: Mr Baton, sir! Please descend from the land of your dreams to this poor earth of ours. All right, so should we begin our play? Constable sir! . . . (*Policeman in dreamland.*) ACP sir! (*Shouts*) Excuse me, DCP sir!

Policeman comes out of his reverie.

Policeman: Yes, yes. Alright, begin.

Actors confer. The play begins. Jogi enters with the CITU flag. He is limping and crying in pain.

Jogi: We are the victims of hunger
We have no fear of death!
Lift the banner high!
Strike for freedom!

Four union leaders move in a circle around him.

All Four: What Jogi? Have you learnt your lesson now?

Leader 1: Hope you enjoyed the batons of the police.

Leader 2: Did they give you any food in jail? Or did they make you starve the whole day?

Leader 3: Poor thing. Got a real taste of what happens when you go with the CITU *walas*.[3]

Leader 4: Why talk about him? He's small fry. Even their MP got beaten up in jail.

All Four: Ha, ha, ha . . .

Leader 1: Didn't we tell you not to fall into the trap of these CITU*walas*.

Leader 2: But of course, you wouldn't listen! They misled you and you went in for a seven-day strike.

Leader 3: And what did you get out of it? Zero!

Leader 4: And to top it all, now you'll get a wage cut.

Jogi: Wage cut?

All Four: Of course. For a full seven days.

Jogi: But the CITU*walas* were saying that we'll get a wage increase of 1,050, and a two-rupee per point dearness allowance.

Leader 1: This is called 'leading up the garden path'. These CITU*walas* know how to serve their interests by misguiding innocent workers.

Leader 2: Why don't you ask them now? What happened to all their promises? They had said that they would end the contract system. What happened to that?

Leader 3: They promised you housing, childcare services for women workers. What did you get?

Leader 4: Not only that – they boasted that all anti-labour laws would be withdrawn, closed down factories would be reopened, and police repression would end forever.

All Four: Ha, ha, ha. In effect, they had promised turning Delhi into a utopia for workers.

Leader 1: Jogi, come to your senses now. You still have time. Have nothing to do with the CITU*walas* anymore.

Leader 2: Yes, join one of our unions. We have all joined together now.

Leader 3: And if you don't want to do that, just quit all union activity. We are always there to help you if there's any trouble.

Leader 4: Come, let us take away this flag. We'll tear it up and throw it into the dustbin.

All Four: Yes, do away with the flag. And you'll be rid of your troubles forever.

They try to take away the flag. They pull at it. Jogi is holding the pole. He doesn't let go and pulls back the flag.

Jogi: Don't you dare! You pimps of the owners. Don't you dare touch the workers' flag with your soiled hands.

The rest of the actors stand up.

All: Hey, Jogi, what are you doing? We are doing a play against CITU. Constable sir is sitting here. Why are you intent on getting us all beaten up?

Jogi: No, I will not do a play against CITU. CITU is my union. The CITU flag is my flag. I know now that CITU is the only union which fights for the workers.

In these last seven days, CITU has shown me the way to fight for my rights, to fight for a life with dignity. Where were these other unions when the police were showering their lathis on us? Where were they hiding when I was starving in jail? The police were beating up women, arresting our leaders, and these people were quiet as mice. No, in fact, they were issuing statements against CITU in newspapers. They were stopping workers from coming out of the factories. I have seen the true character of these traitors. Now there is only one union for me – CITU. Now I am CITU. I will not speak one word against CITU. I am not afraid of the constable. I am not afraid of the whole might of the Delhi Police. They may beat me, torture me, but I will continue to say – Long Live CITU. Long Live Revolution!

Policeman: You bastard! You've started your tricks again. You need a few lathis to bring you to your senses.

Jogi: Go on, beat me as much as you want. I will no longer be silent. The workers of this country will not remain silent. The worker is ready to lay down his life, why would we fear your lathis?

Sings.

We are the prisoners of starvation
We have no fear of death.
Roll the drums of freedom
Raise the flag of Revolution.
Listen to the call of class struggle
Reverberating through this land.
Prepare, prepare, united we stand!

All the actors stand behind Jogi. Enter a local leader and his sidekick.

Leader: Who's creating this racket?

Policeman: So good you came, sir. (*Pulls Jogi towards himself.*) This bastard is making provocative statements. When I told him to stop, he turned on me.

Leader: You bastard, you used to cower before me till yesterday. Now you think you can look me straight in the eye just because of your seven-day strike. You think you can threaten me with your red flag? Don't forget that it is because of me that you are allowed to live in your *jhuggis*. If I want, I can have the DDA send their bulldozers and demolish your whole *basti* in a minute.

Sidekick: Sir is right. It is because of him that we are living here today. If you hobnob with CITU, we'll all lose our houses.

Jogi: You call them houses. They are a pile of garbage.

The rest start to speak.

Worker 1: He's right. Look at the muck around us.

Worker 4: There's no difference between the water flowing in our gutters and our drinking water.

Worker 3: Most of our homes don't have electricity.

Worker 2: And those who have electricity have to pay regular bribes to the goons and the electricity people.

Narrator: There's no government hospital for miles.

Jogi: CITU has told us not to pay bribes for our houses to goons like you.

Leader: You bastards, you'll learn only when houses are torn down. You'll be out on the streets. And don't come to me then saying I didn't warn you.

All: Get lost! We know the likes of you. You speak one word more and we'll show you good and proper.

Leader, Sidekick and Policeman run out. The rest of the actors raise slogans.

Jogi: We'll fight till our demands are met.

Narrator: We demand pukka houses from the government.

Worker 1: Where there is no garbage or dirt.

Worker 2: Where there are clean water and electricity.

Worker 3: Where we have schools for children and hospitals for the sick.

Worker 4: Where there are parks for our children to play.

Chorus: We shall intensify our struggle until all our demands are met.

Narrator: Today all the workers of Delhi are united in their resolve. They are no longer willing to stay silent. They are fighting for a sustainable wage in the factories, they are fighting to protect their jobs. They are fighting for decent housing.

Chorus: Every day, everywhere, they are fighting for a life with dignity.

Narrator: And that's not all. The women workers of Delhi have also taken up the struggle. Here is one such woman worker.

All sit down. Enter Parbati with a child in her arms.

Parbati: A thousand curses on you! I hope you die a dog's death! May your corpse rot! And the dogs piss on it! May your body be disease-ridden! The bastards think they can order everyone about. They refused to let me take my child with me. 'Children are not allowed inside the factory,' he says. You tell me, brother, what should I do with my child? Throw her on the garbage pile? You tell me, isn't this downright unjust? How is a working woman supposed to work if she can't take her child with her? My husband was looking after her till yesterday. Now he has got a job so I brought her along with me. That damned time-keeper stopped me

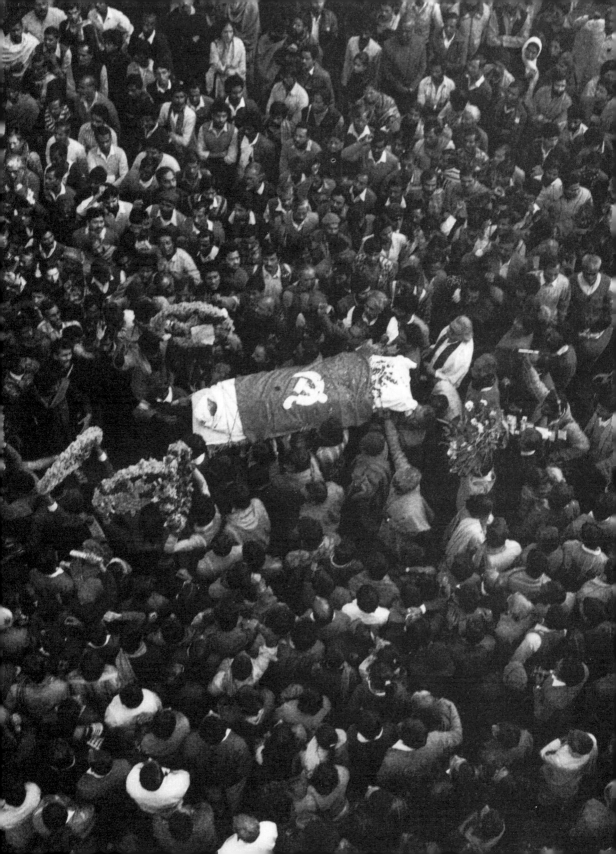

at the gate. Said, there are orders not to allow children inside. Alright, so I'll just stand here at the gate. When the shift gets over, I'll tell the union people what's going on here.

The sound of the hooter. Workers come out of the factory.

Parbati: Hey, Jogi . . . Rampal! I'll lose my job. The time-keeper didn't let me enter the gate today.

Jogi: But why? Why did he stop you?

Sidekick: Parbati, don't tell a lie. I saw everything. The time-keeper did not stop you, he only stopped your child.

Parbati: This ass-licker has to pipe up every time to defend his masters. Should I have thrown my child on the street if I was not allowed to take her in?

Rampal: But why did you bring your baby with you?

First Woman: Her husband has got a job. Where could she have left her?

Parbati: Exactly. There is no one at home to look after her.

Rampal: I understand that Parbati, but where would you put the child inside the factory.

Parbati: She will just sit in one corner. The poor baby doesn't ever trouble anyone.

Sidekick: How can this be allowed? Today she has brought her child, tomorrow several others will do the same. Those who have children should stay at home.

Parbati: You just keep your gob shut. Or I'll show you what I can do. I should sit at home? Will you feed my family and pay my salary every month?

Second Woman: I am also forced to leave my kid with the neighbour. The poor baby has to stay hungry the whole day.

Third Woman: My little daughter also spends the whole day loitering in the lanes with nobody to look after her.

Parbati: You people run the union. Can't you do something about our problem?

Rampal: But what can the union do in this?

Parbati: Why can't you do something? There should be a crèche in the factory. Wasn't that one of our demands in the strike?

Rampal: Listen, Parbati. We have fought a long battle – a seven-day strike – for important issues, like a 1,050 rupee wage, 2 rupees per point dearness allowance, and for ending contract labour. The factory owners are feeling shaken now. We only have to intensify our struggle a little bit more and they'll have to concede to our demands. If we raise these trivial issues now, our fight will become weak.

Parbati: Trivial issue? This is not a trivial issue, Rampal. It is a question of my job.

Women: She's right. This was our demand in the strike.

Parbati: Jogi, show me the campaign leaflet. It clearly says that the owners have to make arrangements for a crèche wherever women are employed.

Rampal: Jogi, please think carefully. I feel our struggle will weaken if we raise this issue.

Sidekick: Yes, he's right.

Parbati: You shut up! Rampal, don't twist things. What kind of a CITU leader are you? It was CITU which had raised the demand for crèches. Our union also put forth this demand. That is why all of us women joined in. What do you say, sisters?

First Woman: Yes, of course.

Second Woman: I joined the strike especially for this reason.

Parbati: Isn't it a fact that our participation made the struggle stronger? You must be crazy to think that our fight will become weaker because of our demand.

Second Woman: Women workers demand . . .

Women: A crèche in every factory
A crèche in our workplace!

Narrator: Our struggle is against injustice!

All join in a procession.

Jogi: Ghulam Rasool, Raghavan, won't you join the procession?

Both quiet.

Jogi: Come on, brothers. Everyone is joining. Even the women. You should also come.

Still quiet.

Jogi: Why, what's the matter?

Raghavan: Comrade, we had joined the seven-day strike only because you asked us to. We were not going to gain anything from the wage increase. We are employed by the contractor, you see.

Ghulam Rasool: You know very well that the contractor refused to take us back when we tried to join duty on the eighth day.

Rampal: And you got back your jobs only because CITU intervened on your behalf. Don't you ever forget that.

Raghavan: And later the contractor's henchmen threatened us. They said they would teach us a lesson if we ever joined in CITU's actions.

Jogi: That is precisely why I'm telling you to join the union. If you are isolated, they will crush you.

Ghulam Rasool: You may be right, brother. But if we join the union, the contractor will dismiss us immediately. Our children will starve if we don't get work. Come, Raghavan, let's go for duty.

Both start to leave.

Rampal: (*Advancing aggressively towards Raghavan*) You bastard, I'll see how you join work. I warned you, Jogi, don't trust these scoundrels. (*Fisticuffs*) They take away the jobs of permanent workers by agreeing to work for 250–300 rupees. (*Fisticuffs*) You can't trust them, they are like rolling stones. (*Fisticuffs*) I'm going to break your legs, you bastards, before the contractor gets to you. (*Fisticuffs*) Let go of me, Raghavan.

Raghavan: Who do you think you are? I'll be the one to break your legs.

Jogi separates them.

Jogi: Don't be insane, Rampal. I didn't expect such behaviour from a responsible person like you. We have worked so hard to unite all the workers. Now our struggle is gaining strength and you are preventing our brothers from joining the fight. Don't forget that the factory owners are waiting for the slightest opportunity for creating divisions among us. They will make the most of it. Use your brains. Ghulam Rasool, Raghavan, come and join the procession.

Jogi goes to the contract workers.

Ghulam Rasool: But brother, you tell us what we would gain by joining your struggle. Whatever may happen, we will get only 300–350 rupees.

Jogi: There you go again. I told you earlier too – our charter says all workers should get equal wage for equal work.

Chorus: Equal work, equal wage.

Jogi: Whose demand is this?

Ghulam Rasool: Yes, but . . .

Jogi: Yes, this is what the contract workers like you are demanding. You all work as much as the company workers but you get barely three-fourths of their salary.

Ghulam Rasool: Not only that our wages are less, but we don't get ESI, bonus, insurance, gratuity – none of these things.

Raghavan: And we are shunted out like sheep and goats whenever it suits them. Even the Labour Office does not pay any heed to us.

Jogi: Precisely. That's why we want an end to the contractual system.

Narrator: Down with the contract system!

Chorus: Weed out this disease!

Ghulam Rasool: Regularize the contract workers! Register them on the rolls of the company!

Raghavan: We will fight for equal pay! We will fight for ESI, bonus, insurance, gratuity!

Rampal: You think they will give you ESI, bonus, insurance and gratuity so easily? We'll have to put up a united fight for each one of these.

Jogi: All the workers will have to stand together.

Narrator: Everyone will have to become a member of CITU.

Woman: United struggle for all workers.

Parbati: Man or woman.

Narrator: Temporary or permanent.

Rampal: On the muster roll or on contract.

Ghulam Rasool: Those bastards will never concede this demand even if they agree to the rest.

Jogi: Why do you think so, brother?

Ghulam Rasool: Because all the workers are united on the rest of the demands. But this is only our demand. Tomorrow they may concede your demands and you'll conveniently forget us. We know it. Therefore, our best bet is to keep the contractor on our side.

Second Woman: Why do you say that, brother? This is not just your demand, it is our demand too. Women work as hard as the men but they get paid less.

Narrator: The owners do the same even to permanent workers in factories where the workers don't have a union. They make them sign on 562 and only give them 300–400 rupees.

Raghavan: True, but there is no one to protect us till we are made permanent. Come, let's go, Ghulam Rasool.

Both start to leave.

Parbati: Ghulam Rasool, Raghavan, stop. Only the workers can protect workers. Let go of your fear. Join CITU. That's the only way all of us can succeed.

Song: Let us stand as one, my brothers
All for one and one for all.
Like a hundred sparks that make a fire,
Like a hundred streams that make a river,
Like a hundred lamps lit together.
We stand as one
All for one, and one for all.

All form a procession, including Ghulam Rasool and Raghavan.

Narrator: Friends, we have presented before you a picture of the life of the workers.

Chorus: But before we take your leave, we again want to tell you something.

Narrator: That the biggest need of the hour is to intensify our struggle for our rights.

Chorus: We stand here together,
We who toil hard,
We who are the oppressed
We, who live at the mercy
Of contractors and factory owners,
CITU stands with workers,
CITU's voice is our voice.
It is the voice of every factory hand
Of those who sweat and toil.
Put an end to closures and lockouts,
And retrenchments once for all.
Two rupees per point allowance
To keep up with inflation.
Clean and decent living,
And, freedom from deprivation.
Take back all the black laws
That keep us in their thrall,
ESMA or NSA,[+] we demand you repeal them all.
Crèches for all the working women,
No to contractors and middle-men.
End to police repression,
To daily beatings and threats.
We stand as one, we shall not rest
Till our demands are met.
We raise our banners high
To fight against oppression.
We workers stand together
With courage and resolution.
Narrator: We raise our banners high
To fight against oppression,
The workers stand together
With courage and resolution.

〴

ANNIHILATION OF CASTE

SPEECH PREPARED

BY

Dr. B. R. Ambedkar

M. A., Ph. D., D. Sc., Barrister-at-Law.

FOR

The Annual Conference of the

JAT-PAT-TODAK MANDAL OF LAHORE

BUT

NOT DELIVERED

*Owing to the cancellation of the Conference by the Reception
Committee on the ground that the views expressed in
the speech would be unbearable to the Conference.*

15th May 1936 Price As. 8;-

Graphic narrative originally published as 'A Travancore Tale' in the e-journal *Guftugu* (January 2017), issue titled 'Remembering Nangeli on Rohith Vemula's Shahadat Day'. Reproduced with permission of the author. Grateful acknowledgment to Orijit Sen.

Images

p. 93: Cover of the first edition of B.R. Ambedkar's *Annihilation of Caste* (1936), text of a self-published speech addressing India's oppressive caste hierarchies; image from Wikimedia Commons.

p. 95: Artwork and slogans at the Shaheen Bagh anti-CAA protest in Delhi.

pp. 98–99: The full text of Rohith Vemula's suicide letter, published across the media in the wake of his suicide.

ORIJIT
SEN
2017

07 A Travancore Tale

In January 2016, research scholar Rohith Vemula died by suicide at Hyderabad Central University,[1] after being at the receiving end of systemic caste-based discrimination that had adversely affected his personal life and academic standing. In his suicide note, Vemula wrote,

> The value of a man was reduced to his immediate identity and nearest possibility. To a vote. To a number. To a thing. Never was a man treated as a mind. As a glorious thing made up of stardust. In every field, in studies, in streets, in politics, and in dying and living.

His death drew attention to the prevalence of casteist inequity within university spaces, sparking widespread outrage and a wave of protests across the country. On Vemula's first death anniversary, artist Orijit Sen draws the tale of Nangeli, a nineteenth-century Ezhava woman who cut off her breasts to protest against the breast tax imposed by Kerala's rulers on those lower down in the caste hierarchy.

A TRAVANCORE TALE ORIJIT SEN

I believe my ancestor Nangeli knew what would happen if she continued to cover her breasts like the Nair women, and she was prepared for it.

In those days, we people were not allowed to cover the top halves of our bodies. This was one of the ways that the high caste Nairs and Namboodris marked us as lower, and separate from them.

To enforce the practice, there was the 'breast tax'— Mulakkaram—which all low caste women had to pay if they dared to cover their breasts. To add insult to injury, the tax was calculated according to the size of their breasts: The larger the breasts, the higher the tax!

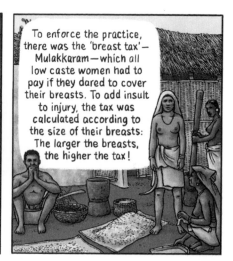

She was as headstrong as she was beautiful, and despised the men—particularly the upper caste men—who leered at her on her way to work

Our people hated this tax, but there was nothing to be done, as they had no rights. But Nangeli, a poor Ezhava like me, would walk out with a top cloth on as if she was as good as any Nair.

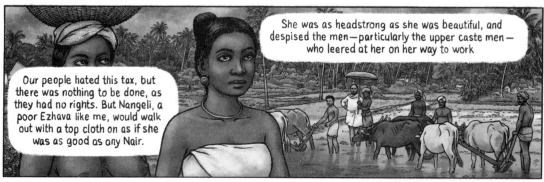

Sure enough, the day arrived when the Pravathiyar showed up to 'assess' Nangeli's dues and collect the tax. He came with a group of hangers-on, all eager to have a look.

She was expecting him, and had cut fresh plantain leaves in which the rice for the tax payment was to be offered...

Although there was not enough rice in the house.

Alongside the leaves, she had also placed her recently sharpened sickle.

Having submitted herself to the Pravathiyar's examination, Nangeli picked up the sickle ...

and without waiting for his tax assessment, she made the payment.

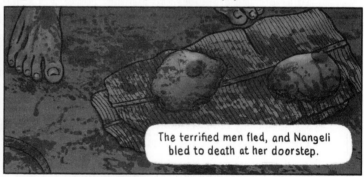

The terrified men fled, and Nangeli bled to death at her doorstep.

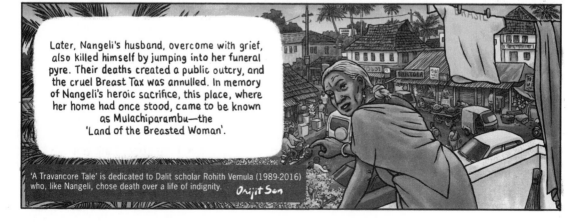

Later, Nangeli's husband, overcome with grief, also killed himself by jumping into her funeral pyre. Their deaths created a public outcry, and the cruel Breast Tax was annulled. In memory of Nangeli's heroic sacrifice, this place, where her home had once stood, came to be known as Mulachiparambu—the 'Land of the Breasted Woman'.

'A Travancore Tale' is dedicated to Dalit scholar Rohith Vemula (1989-2016) who, like Nangeli, chose death over a life of indignity.

Orijit Sen

Good morning,

I would not be around when you read this letter. Don't get angry on me. I know some of you truly cared for me, loved me and treated me very well. I have no complaints on anyone. It was always with myself I had problems. I feel a growing gap between my soul and my body. And I have become a monster. I always wanted to be a writer. A writer of science, like Carl Sagan. At last, this is the only letter I am getting to write.

I loved Science, Stars, Nature, but then I loved people without knowing that people have long since divorced from nature. Our feelings are second handed. Our love is constructed. Our beliefs coloured. Our originality valid through artificial art. It has become truly difficult to love without getting hurt.

The value of a man was reduced to his immediate identity and nearest possibility. To a vote. To a number. To a thing. Never was a man treated as a mind. As a glorious thing made up of star dust. In every field, in studies, in streets, in politics, and in dying and living.

I am writing this kind of letter for the first time. My first time of a final letter. Forgive me if I fail to make sense.

My birth is my fatal accident. I can never recover from my childhood loneliness. The unappreciated child from my past.

May be I was wrong, all the while, in understanding world. In understanding love, pain, life, death. There was no urgency. But I always was rushing. Desperate to start a life. All the while, some people, for them, life itself is curse. My birth is my fatal accident. I can never recover from my childhood loneliness. The unappreciated child from my past.

I am not hurt at this moment. I am not sad. I am just empty. Unconcerned about myself. That's pathetic. And that's why I am doing this.

People may dub me as a coward. And selfish, or stupid once I am gone. I am not bothered about what I am called. I don't believe in after-death stories, ghosts, or spirits. If there is anything at all I believe, I believe that I can travel to the stars. And know about the other worlds.

If you, who is reading this letter can do anything for me, I have to get 7 months of my fellowship, one lakh and seventy five thousand rupees. Please see to it that my family is paid that. I have to give some 40 thousand to Ramji. He never asked them back. But please pay that to him from that.

Let my funeral be silent and smooth. Behave like I just appeared and gone. Do not shed tears for me. Know that I am happy dead than being alive.

'From shadows to the stars.'

Uma anna, sorry for using your room for this thing.

To ASA family, sorry for disappointing all of you. You loved me very much. I wish all the very best for the future.

For one last time, Jai Bheem.

I forgot to write the formalities. No one is responsible for this act of killing myself.

No one has instigated me, whether by their acts or by their words to this act. This is my decision and I am the only one responsible for this.

Do not trouble my friends and enemies on this after I am gone.

Sharmila Rege's 2002 essay produces a radical argument for the origins of popular culture, and the history of their appropriation. She looks at two major and controversial forms of performance. One is the feminine lavani – performed by women, and increasingly, also by men, a significant cultural influence on bar dancers, viewed at once as decadent and as representing cultural heritage in Maharashtra. And the other the powada – a rousing male ballad, used alike by right-wing Hindutva forces to retell the exploits of the 17th C. Maratha emperor Shivaji and by Communist poets. Rege takes us through two centuries of their history, as both forms tell of a deeply complex and conflicted history of caste, religion, region and gender. Both forms have made it into modern popular cultures, the lavani being performed by major Hindi movie stars in 'item numbers' well into recent times.

Rege's essay intends to take on the valorization of popular culture and what she sees as an oversimplified conception of 'pleasure'. Such valorization makes it almost impossible to think of the conflicts within popular culture, and its own struggles in the entire history of modernity in India. This excerpt focuses on the central argument. It is an abridged version of a text originally published in *Economic and Political Weekly* (vol. 37, no. 11, 16–22 March 2002, pp. 1038–47). Reprinted with permission from the journal. Grateful acknowledgment to Anil Saini for his support.

Images

pp. 100–01: (Background) Lavani performers Shakuntala Nagarkar and Akanksha Kadam on stage; (inset) Lavani performer Anil Hankare preparing for a show. Photos by Kunal Vijayakar.

pp. 103, 111: Hindi movie star Rekha in a lavani sequence from the film *Fatakadi* (Firecracker, dir. Dutta Keshav, Marathi, 1980).

p. 107: 1950s movie star Hansa Wadkar in the hit *tamasha* musical *Sangte Aika* (Listen, I'm Telling You, dir. Anant Mane, Marathi, 1959) and the credits of *Bhumika* (The Role, dir: Shyam Benegal, Hindi, 1978), based on the life story of Hansa Wadkar, played by Smita Patil.

pp. 116, 117: Scenes from *The Amorous Adventures of Shakku and Megha in the Valley of Consent* (dir. Paromita Vohra, English/Marathi, 2016), a short film that uses lavani to open up conversations about consent, featuring Shakuntala Nagarkar, Megha Ghadge and Gaurav Gera.

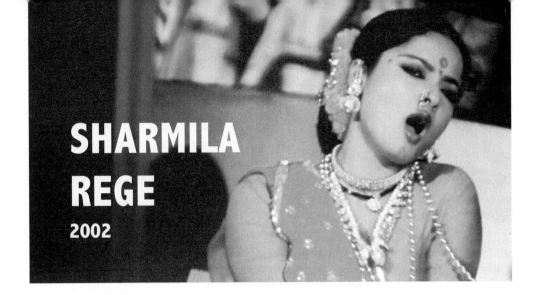

SHARMILA REGE
2002

08 # Conceptualizing Popular Culture
Lavani and Powada in Maharashtra

This essay views the famous dance and musical forms of Maharashtra – of the lavani and the powada – as caste-based forms of cultural labour on which major cultural and political struggles have been worked out. Struggles over cultural meaning are, I argue, inseparable from struggles for survival. And there are ways by which these forms – produced by women and men of lower castes – become popular forms for the people.

Popular forms, we shall see, possess moments of discovery and rediscovery that underline cultural struggle. Cultural distinctions are differently produced and reproduced for different castes, classes and genders. The popular is not outside of relations of power and domination. The hierarchies and tensions *within* the popular thus need to be highlighted. Here we shall do so as we look at the tensions between the feminine lavani and the masculine powada.

The Lavani of Eros and the Powada of Courage

Key commentators on the folk traditions (the shahiri) of Maharashtra have argued that the powada is the man and the lavani the woman. The former is a recitation of ballads of bravery, and the latter is music and dance that is either spiritual, devotional or erotic.

The earliest traceable lavani dates back to the seventeenth century. While over 300 powadas of the early Maratha period (1640–1700) have been traced,[1] the erotic (shringareek) lavani with explicit descriptions of the sexual, has been traced collections of what are known as Prakrit verses (verses composed by the masses) about their everyday lived practices, including the sexual, and dated between 1–7 BCE.[2]

In the thirteenth-century text, the *Dnyaneshwari*,[3] there are references to the performances of tribal Domb and Matangi songs both in the court and the marketplace. At the same time as the Dnyaneshwari describes the early lavani as an expression of the everyday desire of the common people, it also speaks of it as a performance with the explicit aim of 'provoking wealthy men into parting with their money'.

The powada on the other hand is referred to in the *Dnyaneshwari* as a *eulogy*. It is seen as emerging from the cultural practices of the bards and genealogists who belonged to the bard (gondhali), cowherd (gavli), Mahar, Mang, weaver and gardener (Sali-Mali) castes, celebrating the brave deeds of Maratha heroes in battle.

All of this literature was first collected and compiled only around the mid-nineteenth century. In 1868, several magazines published such collections.[4] Primacy was explicitly given to the powada, mainly for its ascribed ability to recollect the past (the golden era of Maratha warriors) and to frame a new future. An early collection, *Ballads of the Marathas*,[5] suggests that the powada had also become a symbol of group loyalties. By the late nineteenth century, it became one of the grounds for working out conflicting social and cultural identities, as O'Hanlon shows.[6] It was only as recently as the second decade of the twentieth century that collections of lavani were first undertaken. The reformer Vishnushastri Chiplunkar[7] justified this delay, and the necessity of giving priority to the political powada over the cultural lavani.[8]

Early collections of lavanis are, in contrast, almost always erotic – most of these erotic forms traceable to the Peshwa period (late 18th-early 19th century). One such collection is interestingly titled Lavanis of the Dark (*Andharatil Lavanya*). A popular Marathi proverb –'the Peshwa rule collapsed due to the lavani and women' (*lavani va bai chya nadane Peshwai budalee*) – blames lavani performers for bringing about the decline of the Brahminical rulers of western

India. The erotic lavani of this period was produced as a means for constructing the sexuality of lower-caste women, their bodies viewed as either arousing or satiating male desire.

Such a construction was crucial to the pre-colonial Peshwa state in the appropriation of the labour of lower-caste women – through the institution of slavery. The reign of Bajirao I (1796–1818) saw the pauperization and increasing indebtedness of the peasantry. One of the worst famines was in the year 1803, and this, it has been noted, had led to an increased sale of lower-caste women.[9] A prominent feature of the period was the predominance of female slaves – an important source of revenue for the Peshwa state, especially during the famine.

Conventionally, there were two major means of procuring slaves. One was by abducting women in wars. The other was by enslaving lower-caste women by charging them with adultery. Since Bajirao II did not wage even a single war, the majority of female slaves were from the latter category. Absconding slaves were arrested and forced into enslavement. Adultery by women of the upper castes was, in contrast, punished by excommunication from the caste.[10]

The Lavani of Eros and Sexual Economies

The lower-caste women enslaved by the Peshwa state were employed in the courts, dancing houses (*natakshalas*), in homes, stables, granaries, cattle houses, stores, communication and construction works.[11] They were often gifted to officials in lieu of their salary. Fukazawa[12] notes that the caste of the slaves played an important role in the kind of services forced upon them. Errant women of the lowest castes were made available to men of higher castes through state intervention.[13] The revenue, collected through taxes levied on their both sale and their labour, was appropriated by Peshwa government factories (*karkhanas*).

The female slaves of the Peshwa state appear to fall into two categories: those who were bought for domestic and agricultural labour (the *kunbinis*) and those bought for their sexual labour (the *bateeks*), either by individuals or for state dancing houses. The *kunbinis* who performed domestic labour could not be from the very lowest (the ati-Shudra) castes. The *bateek, on the other hand,* came from both Shudra as well as ati-Shudra castes. Road building and ammunition work both required labour, and there are records of the Peshwa office (the daftar, now available at an archive in Pune) which imply that *kunbinis* who had illicit relations outside of their caste were banished into doing such work.

A preliminary reading of the erotic Lavanis of the Dark[14] composed during the later Peshwa period conveys an overt female sexuality. They further reveal

a clear endorsement of the dichotomy between the sex worker (*bateek*) as against the good housewife (the *soubhagyavati*). Lavanis overtly expressing women's insatiable desires are usually composed in the voice of the lower-caste sex worker, while those that express pain of separation (*viraha*) are in the voice of the wife. The *bateek typically* has intense bodily needs. She relentlessly seeks pleasure from men and wants to watch the intercourse in a mirror. The wife is, on the other hand, often in awe of her husband's virility, and her sexual desire is cast as a desire for motherhood. The only note of complaint by the wife, if any, is when the husband is not 'man enough' to father her children.

Adultery by lower-caste women was thus the major ground on which their sexual and productive labour was appropriated – and the lavani was one important way to construct them as adulterous. Even as it became a popular form of entertainment of the masses (*bahujan*s) at the court of Bajirao II, it also produced an ideological justification for the enslavement, through taming, of lower caste women.

The public performance of the lavani was a part of the tamasha folk theatre. A typical performance began with *gan* (devotional offering to Lord Ganesha), a *gavlan* (a comical act performed by 'effeminate' male artists through exaggerated feminine gestures) followed by the performance of lavani and mujra. The vag (or spontaneous theatre) of the satirical is a later addition that, we shall see, becomes critical to the development of the form.

Powada of Valour and Politics of Identity

The powada, as the male form of expression, has been labelled as 'not emotional but of bravery; not soft but straightforward as against the feminine lavani which is beauty, eros and emotionality put together'.[15] The Peshwa period saw the composition of over 150 powadas in praise of the state. Earlier powadas about the valour and bravery of the Marathas were lost from public memory.[16] Most of the popular powadas of the Peshwa period were composed in praise of Brahminical rule. There are additions and deletions made in the compositions of the *poet* Anantaphandi[17] in which he holds Bajirao II responsible for the downfall and the dire poverty of the people.

It was only in the second half of the nineteenth century that the powada was repurposed to create group identity, when it began to be used to revive the glorious history and culture of the Marathas in overtly political (if contradictory) ways.

Although caste antagonisms certainly existed prior to British conquest, there had been no concerted effort to build a united challenge to Brahminical

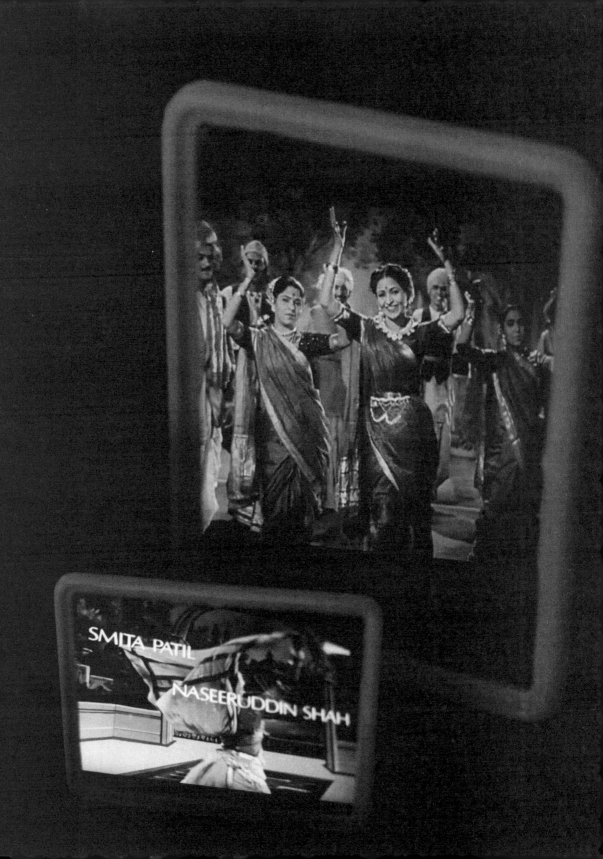

dominance. Most late nineteenth century historiographies sought to establish national superiority, usually understood both as the Maratha country and as India. As Omvedt[19] has argued, this nationalism arose in response to the non-Brahmin challenge, the roots of which are located in the life and works of Phule.[20] Both Brahmins and non-Brahmins turned to the figure of the Maratha Emperor Shivaji as they sought their own claims to the past.

O'Hanlon has juxtaposed three accounts of the period, all centering on Shivaji.[18] Jyotiba Phule's powada 'A Ballad of the Raja Chhatrapati Shivaji Bhosale', Rajaramshastri Bhagwat's 'The Community of Maharashtra' and Eknath Annaji Joshi's 'The Advice given to Maharaja Shivaji by Dadaji Kondadev' were all published during the period from 1860 to 1890. It is worth looking at the contradictory claims of each.

Phule's powada presents Shivaji as the leader of the lower castes, and attributes his achievements to the strength and skill of his Shudra and ati-Shudra armies rather than his ministers. It thus becoming a vehicle for lower castes to stand as the rightful leaders of Maharashtra and as the true representatives of its tradition. It is composed in eight sections, and as Phule himself declares in the preface, has the explicit aim of reaching out to the Mang, Mahar, Mali and Kunbi.[21] Phule reinterprets Duff's history of the Marathas,[22] especially the role played by the Brahmin Dadaji Kondadev and Saint Ramdas in the life of Shivaji.[23] 'The fish swims in water; does the fish have a guru?' he asks, thereby minimizing Dadaji's role, even as he clarifies that it is for the love of the people that he established the temple of Bhavani Mata at Raigad, and accepted Ramdas as his guru. In Phule's powada, Shivaji emerges as the Pride of the Shudras (*kulwadi Bhushan*). In another powada, Phule critiques the Brahmin-ridden policy of education – the educated Brahmin teacher who has no qualms while shaking hands with the British but condemns the Mahar students as polluters.

In contrast, Sanskrit scholar and reformist Rajaramshastri Bhagwat questions the division of society based on birth. He argues that Shivaji represented the second rise in the pre-eminence of the Marathas; emphasizes the role of Brahmins as religious advisers; asserts the absence of caste divisions; and reiterates their overall concern for the good of the community.[24] Bhagwat sought to establish the notion of a united Maharashtra with its own identity – drawn upon local traditions as against a homogenized Hindu tradition. Phule, in contrast, saw the Marathas as strictly a community of non-Brahmin castes, and he did not see any integration possible between a Brahminic religion and a popular culture.

Eknath Annaji Joshi's composition shows how a popular form comes to be sanskritized – as the traditional powada meter is replaced by a Sanskrit verse, as

Dadaji Kondadev, Shivaji's Brahmin teacher, calls upon his disciple to rescue India from Muslims. Entitled 'The Advice given to Maharaja Shivaji by Dadaji Kondadev',[25] it assimilates Shivaji directly into a classical Hindu mythological tradition in line with the great Kshatriya heroes. The demon kings (*daitya*), who had been invoked by Phule as the original and just rulers are compared with Muslims, as Shivaji is called upon to take the role of *narasimha*.[26]

Both locations that published Bhagwat's and Joshi's versions – the journal *Vividhyanvistar* and Dakshina Prize Committee fund – had rejected Phule's work. As Brahminical conservatism was assimilated into new political activity, especially into the nationalist struggle, the popular powada too was appropriated. The upper-caste distinctions of Joshi's powada would be underlined in the use of a sanskritized (*panditi*) style of composition, in contrast to Phule's popular Shudra tradition that claimed pan-Indian representation.

The powada now became a ground for working out political identities and struggles. If it had earlier been composed by lower-caste Gondhalis, and themed around bravery and valour, by the second half of the nineteenth century Brahminical appropriation invoked the popular mainly to underline a cleavage between pan-Hinduism set against the Muslim and the British. This project defined the growing process of collection and publication of traditional powadas in literary and political journals. A popular expression of the masses now became a vehicle for underlining caste contradictions, as it was distorted, enlarged and polarized.

The lavani, as the expression of eros and devotion, on the other hand remained beyond the purview of these political processes, which had rather different consequences. With the emergence of a metropolitan bourgeois theatre, many lavani performers faced a threat of marginalization and extinction.

Desexualized Theatre and the Sexualized Lavani: Emergence of the Sangeet Barees

After Peshwa rule ended with Bajirao's surrender at Vasai,[27] tamasha performers were forced to seek new patronage, and many troupes moved to the princely state of Baroda. Market forces found themselves entrenched in agriculture. The bureaucracy of the colonial state also expanded. Both combined to create a class of middlemen and the middle classes, which in turn produced, directly and indirectly, a 'popular' lavani catering only to certain classes even as it came to be declared as immoral for others. Indeed, the processes that produced the 'popular' came to be intertwined with the self-definition of these classes.

In 1853 Vishnudas Bhave presented the first theatre performance of a Marathi play at the court of the King of Sangli,[28] heralding thereby a new theatre of the middle class and the upper castes placed in opposition to the folk theatre or the tamasha. The *Bombay Times* claimed that 'Bhave's plays are of native origin – from the early classic dramas of Hindoostan. They are void of everything approaching licentiousness and indecorum and are images of the moralities in which the Christian church in older times used to rejoice'.[29] The two decades that followed saw English and Sanskrit plays translated into Marathi, with an increase in the patronage of Marathi theatre by a newly educated middle class. Male performers called the *stree party*[30] performed the female roles, thus also bestowing on this theatre the sanction of morality. The dichotomy between the dancing girls (*nachee/nartaki*) and the folk-performer/artist (*tamasagir/kalakaar*) intensified, as lower castes were displaced from their hereditary roles in the performing arts.

The growing popularity of a new middle-class theatre and its mark of morality also led to changes in the structure of the tamasha. As metropolitan theatre gradually excluded female performers, who had come to be marked as immoral and licentious, the theatre of male performers would be marked as cerebral, as against the sensuous lavani. This may have been one of the major reasons for which the tamasha of the period preferred the spontaneous theatre of the vag over the lavani. The vag, although no doubt a part of tamasha performance, would now replace the lavani as central to the performance.

The history of Marathi theatre for this period records attempts by women of the lower castes (probably displaced tamasha performers) to start theatre companies in which women enacted both male and female roles.[31] These attempts by popular artists to stake their claim over the newly emergent Marathi theatre were severely criticized and ridiculed.

It is possible therefore that the sangeet barees, a reformulated version of the tamasha, emerged as an offshoot of these companies. Women of the nomadic Kolhati caste (of professional entertainers and acrobats) commonly referred to as women who move around with their thighs bare (*ugadya mandichi jaat*), formed most of these sangeet baree troupes. These women were known to be the breadwinners, and dancing and prostitution came to be recorded as a caste-based profession. They were commonly ascribed the ability to cure sexually transmitted diseases and impotency.

There were now at least two kinds of tamashas: one, the respectable dholki-phad tamasha in which the vag was central, and the second, the sangeet barees that centred on the erotic lavani. The sangeet baree performance evolved its own form – including lavani forms dedicated to expressiveness (*ada*), displays

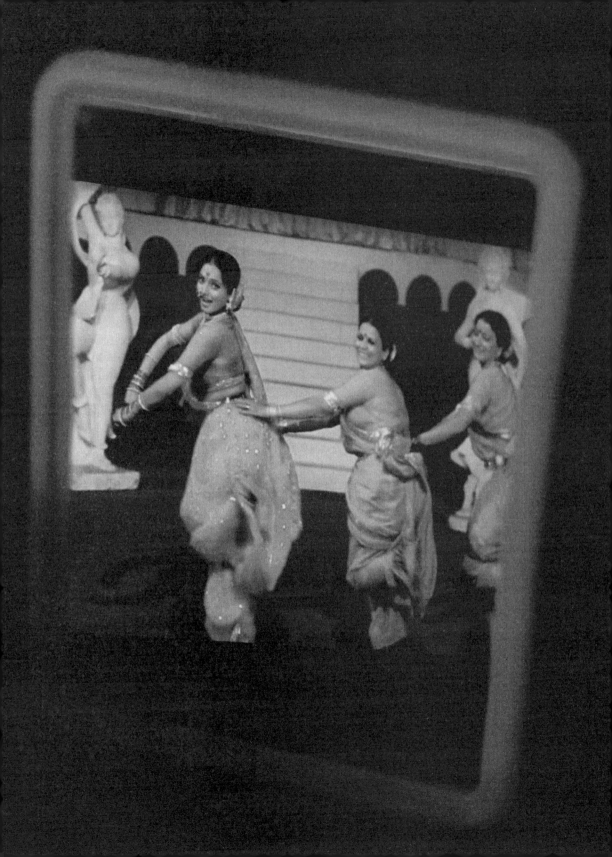

of emotion (*baleghati*) and erotic ability (*chakkad*). Their performances were marked by a process of bidding by some persons from all-male audiences for the *nachee*, or the dancer, to perform the lavani of their choice (*daulat jadda*).

While the former, more respectable and financially better off form of the dholki-phad tamasha is managed by men, the sangeet barees are planned, financed and organized mainly by Kolhati women. These women do not marry (and are not permitted to by the caste panchayat),[32] while the women of the dholki-phad tamasha are most often married to troupe members, and subjected to familial-patriarchal regulatory controls. The latter usually look down upon the sangeet barees as 'immoral' and not representative of the 'true tamasha tradition'.

By the early 1890s, tamasha theatres had been established in Mumbai and Pune, and a contract system had emerged in which theatre owners became middlemen, employing troupe members on salaries, or against advance payments. Theatres also organized private performances (*baithaks*), the audiences of which were regulated by the contractors. Only the wealthy could have access to private *performances*, which were associated with the authentic unadulterated lavani. The *nachee*s (or the dancers) claim that such private performances have been the major means for 'saving the tradition' from the near-complete influence of the Hindi cinema.

Paralleling the rise of the powada as bearer of contested political identities, was the marginalization of the lavani by an emergent bourgeois theatre that stigmatized it as immoral and vulgar. Both the content and form of tamasha was now modified, as it centered around the vag, and came to be considered both more moral and a form of political expression – as against the sangeet barees which were viewed as sheer sensuous entertainment (*aatishbaaji*). The content of both elite and popular theatre was in the process reformulated, the former marking its distinction from the folk via a process of de-sexualization, so that only men performed on the stage, the latter recast into the overtly political and theatrical dholki-phad tamasha and the overtly sexualized sangeet barees.

The first three decades of the twentieth century came to be marked as the golden period of the vag, while the lavani, equated with immorality and sensuous entertainment (*ranjan*), would be recast into contractually employed sangeet barees by theatre owners – with audiences intervening in performances by bidding for different performers. Such a recasting became a distinctively 'immoral' feature of the sangeet barees, even as other popular forms marked their distinction from them. Even though the exclusion of women from stage performances has ceased to be a defining feature of high cultural values, the marking of lavani performers as vulgar and as veiled prostitutes continues. Cultural distinctions, usually revealed in bourgeois Marathi theatre between the

vag and the sangeet barees, become ways for new forms of power and control rooted in caste, class and gender hierarchies to be legitimized. Capital has a stake in the culture of popular classes, since it holds the potential of resistance,[33] and it may be argued that in a caste-based society in which sexual regulation and control are crucial to the maintenance of caste and class boundaries, the stakes are only further intensified. Both the rise of bourgeois metropolitan theatre and of the contract system in the tamasha saw the active destruction of the ways of life in which the performances were rooted.

From the late nineteenth century a working-class district emerged in Bombay, in which the tamasha flourished as the working-class man's theatre.[34] Narratives of senior tamasha artistes reveal that there were more than nineteen tamasha theatres in the city's working-class quarters. By the 1930s, in the early years of the regional cinema, mythologicals and socials were made targeting middle-class audiences. The coming of the Second World War saw restrictions on imports and preferential access to raw stock given to the Hindi cinema, which had emerged by then as India's major national cultural form.[35] On the other hand, a post-war regional cinema in Marathi sought to produce the lavani as the popular regional culture in films like *Jai Malhar* and *Lokshahir Ram Joshi*[36] that became successful at the box office, and Marathi cinema revived a tamasha genre of films as the regional popular. The same period also however saw a ban on tamasha groups by the Bombay state in the 1940s. Its lyrics, it was argued, were lewd, and prostitution was being practised in the name of art.[37]

As Hindi films wooed urban audiences, the tamasha too sought to reclaim a regional popularity. The Marathi cinema, dominated by Brahmins and Marathas, drew its raw material from the lavani tamasha of the Kolhatis, Mahar and Mangs, converted the form into saleable goods and took their films back to the audiences in small towns at double the price. The film actresses in the tamasha genre most often came from outside the Kolhati caste, and only a few tamasha artists could make a space for themselves in the Marathi cinema. The cinematic lavani dancer would typically be presented as with the metaphor of a bird (*pakhru*), or lightning (bijlee) or as garden of youth (*jawanichi baag*):[38] a native, of wild and rustic sexuality, tamed and reformed by the hero (invariably either the village headman's son, or the school master, i.e., always an upper caste male figure).

After the 1960s, as Maharashtra's famous 'sugar lobby' consolidated its economic and political gains[39] and the Marathi cinema began acquiring finances from newly emergent capitalist forces in agriculture, the lavani too began to use the metaphors and double entendres of wells, pump sets, engines, sugarcane, mangoes, coconuts and papayas to describe the bodily features of the dancers:[40]

the well would refer to the vagina, mangoes the breasts, ripe sugarcane virginity, etc. An exaggerated sexualization of lavani dancers took place, categorizing them as wild, too hot to handle or uncontrolled. The dichotomy of passive and pure wives as against wild and impure dancers was underlined, and the inability of lower-caste men to control the sexuality of their women reiterated, thereby continuing to legitimize the hegemony of dominant castes. The patriarchal caste-ideology that orders the sexual division of labour also regulates such a division of labour. Popular cultural forms of the Kasbi (performing) castes were so produced that women were framed as pigeons (*kabnurkarin*) in the sphere of the erotic and denied familial spaces. On the other hand, upper-caste women – whose reproductive and domestic labour was appropriated within the space of the familial – were constructed as pure and moral (*gharaandaaz*) and passive, and thus denied the space of the erotic.

The overt sexualization of lavani dancers in Marathi films had serious consequences for the performers in both the sangeet barees and the tamasha. Tamasha theatres faced the threat of closure following an increasing encroachment by both regional and national cinemas. Contractors demanded that *nachee*s dance to the film lavani and add erotic and provocative dance steps. The raw material that went from the Kolhati women to films came back to them, ironically in forms they could hardly recognize as their own. Some troupes were recast as musical orchestras, in which the lavani was entirely absent. Dancers attired in trousers and caps danced to film numbers. In the 1960s, after the formation of the state of Maharashtra, there was an expansion of the Marathi cinema and several tamasha troupes were forced to go part-time,[41] as *nachee*s of the dholki-phad tamasha were forced to turn to seasonal agricultural labour and to domestic service in towns, in order to make ends meet.

The Political Appreciation of the *Tamasha:* The Jalsa

In 1873 the reformist Satyashodhak Samaj (Truth-Seekers' Society) was founded by Jyotiba Phule, addressing untouchability, oppression of women and the peasantry, blind faith and the oppression by the village Brahmin.[42] Such issues, debated in the newspapers of the day,[43] would be conveyed to the masses through a new genre of tamasha – the public musical gathering (or jalsa).

This was a new form, in which people from neighbouring villages, often between ten and twenty villages, gathered to participate, including women,[44] and the content was significantly altered: the traditional offering to the god Ganesha (gan) was replaced with a verse in praise of the creator, the *gavlan*[45] (a comical

act, traditionally a dialogue between Krishna and the milkmaids) transformed into an encounter of a non-Brahmin hero with the daughter of the Brahmin priest of the village, a mode of critiquing Brahminical practices. The vag too took on an instructive role, in praise of modern science and education and a mockery of oppressive religious practices. Omvedt notes that the jalsa played a prominent role in forming and spreading a popular Maharashtra culture of religious and caste revolt.[46] In Satara district, where the Satyashodhak jalsa were concentrated, it was closely linked to the tenant rebellions of the 1920s.[47]

The jalsa often took up issues of enforced widowhood, tonsure, prostitution and education. One of the famous compositions which critiqued the Brahminical practice of tonsure, was

> Dear father, I am your dear and loved one,
> How can you force me to shave off my hair?
> ...
> Why don't you change your mind and arrange a *pat* (second) marriage for me instead?

This composition especially assumes importance in the light of the fact that there was a rebellion of the barber community under Phule's leadership,[48] in which they refused to shave widows' heads.[49] Another popular composition entitled 'The Notice Given by Rukmini and the Reply Given by Vithoba' was about the Brahminization of the Bhakti cults in Maharashtra. The composition, entitled 'The World Leans', critiqued rich men who bid for the sexual services of tamasha dancers. The accounts of the jalsa do not however mention women performers – in fact it seems that the jalsa highlighted its difference (its reform character) from tamashas through showcasing its exclusion of women performers. It is, in this, important to note the form of the jalsa commonly presented, as a means of critiquing Brahminism, a 'dialogue' between Brahmin women (enacted by men) and the non-Brahmin hero of the village. Notwithstanding their political intent, the division of roles – between the non-Brahmin hero and Brahminical women – often ended up making invisible both cross-caste Brahminical patriarchies as well as the revolutionary potential of non-Brahmin women. What might have occurred had a simple inversion taken place, and the interrogator been played by a non-Brahmin woman critiquing a group of Brahmin men!

The jalsa form received the patronage of Shahu Chatrapati, and several meetings of jalsa representatives were held in Kolhapur.[50] The *Kesari* of the Tilakites ridiculed the jalsa as the low culture of the tamasha, and would refer to composers as *tamasgir*s (lowly tamasha performers) and not as jalsa *shikshak*s

(teachers) as they were named in the Satyashodhak tradition. A non-Brahmin challenge to this characterization, in Pune in the 1930s, sought to resist the hegemony of the Ganapati festival through yet another recasting of the tamasha, the *Chatrapati Mela.*[51]

Between 1920 and 1956, a new genre of proletarian Ambedkari jalsas arose in the shahiri tradition of Maharashtra. With their message of opposing Brahminism's caste-based oppression, these jalsas also addressed issues of dowry, indebtedness, prostitution in the name of religion, and the need for education, organized effort and struggle.[52] The entertainment (*ranjan*) motif of the tamasha was dropped: thereby excluding female performers, and a central role was accorded to the comedian (*songadya*). The politically progressive appropriations of the genre could not result in any reformulation of the *nachee*'s role – and, to that extent, the patriarchal ideology of dominant castes and classes was again reiterated. Babasaheb Ambedkar's refusal to accept any financial grant from Patthe Bapurao[53] – a Brahmin, and famous vag performer of the period – on the grounds that the money had been earned at the cost of lower-caste women's dignity, is understandable.

Nevertheless, the complete absence of women in the new jalsas posed a problem. While the popular cultural forms had been politically appreciated and, indeed, recast, the role of lavani dancers was not reformulated but, rather, excluded. The Victorian theatre emerged as the epitome of civilized culture as against the 'licentious' and 'immoral' folk forms of the natives. In this, it was emulated by the Marathi metropolitan bourgeois theatre which labelled the tamasha as obscene, and constituted the vag as superior to the sangeet barees of Kolhati women. Both the Satyashodhak and Ambedkari jalsas defined their distinctively political (as against entertainment) content *through* the exclusion of women. Such a reaction reveals the dangers of seeing sangeet barees as a form of women's culture and therefore as a resistance to patriarchy. The communist and socialist movements in Maharashtra also politically appreciated the tamasha genre in their cultural squads (*kalapathak*), and indeed, as we shall now see, this genre would become central to the expression of the Marathi identity in the movement for the formation of Maharashtra state based on a common linguistic identity (Samyukta Maharashtra movement).[54]

The Powada and Contesting Claims of Identity

The United Maharashtra movement marked folk shahiri as a strong cultural base. It saw a combined front of Communists, Dalits and socialists and a distinct

tradition of powada that emerged within each of these ideological positions. Though powada was produced as the bearer of an authentic Marathi identity, different forms of powada reveal contesting claims and tensions.[55] *Lokshahir* Vaman Kardak, for example, gives primacy to the annihilation of caste, and is therefore critical of an alliance with Communists, even though several of his compositions demand a redistribution of resources.[56] Consider for example the following two compositions:

> Oh the woman in red with her lover in Moscow. Beware or else you may be fooled!

And,

> Tell us oh Tatas and Birlas,
> Where is our share of foodgrains and wealth[57]

Annabhau Sathe from the Communist Party claims,

> With the red flag,
> comes a new generation of workers,
> they move on ahead,
> to change the lives of the oppressed
> they shall emerge victorious in this battle.[58]

Annabhau's performance began with a salute to Tilak, Phule and Ambedkar (the Hindutva claims of Tilak sitting awkwardly with the tradition of Phule and Ambedkar),[59] and then often went on to praise both Lenin and Ambedkar. Sathe locates the United Maharashtra struggle as between the working class and the non-Marathi capital.[60] In his famous composition, 'My Maina Got Left Behind in the Village', Maina, the beloved, becomes a metaphor for the separation of Maharashtra from the city of Mumbai. Says Annabhau,

> My Maina is left behind in the village my heart yearns for her,
> shapely, dusky and virtuous,
> she has a broad mind,
> in fact, she is the Sita of my Ram[6]

Annabhau interprets Shivaji, as a democratic and just ruler of the masses. He writes:

He distributed all the land amongst the tillers. All the parasites
were finished.

Annabhau died in dire poverty and his monumental contribution remained
marginalized.[62]

The socialists, on the other hand, recast the powada in the troupes of the
Rashtra Seva Dal (Serve the Nation Party). The modernist Brahminical poet
Vasant Bapat performed a 'powada of the courageous men'. The lavani itself, in
praise of sensuous beauty, was performed through shadow play. Meanwhile, a
theatrical presentation by the Rashtra Seva Dal of the culture of Maharashtra,
which sought to trace the great shahiri tradition, censored out the noted Dalit
composer Bhau Fakkad. Bapat's 'The Sun of Freedom has Risen' claims that
'Hindu, Muslim, Sikh, Parsee, do not fight amongst yourselves Let's love
each other, let's be brothers'.[63] In another composition, Shivaji comes to be
invoked as a Hindu King:

> Allah's name on their lips
> but the devil in their thoughts
> why spare them –
> just hack them – Oh soldier
> For they are the progeny of Afzulya, Hack them, in the name
> of Shivaji Raja Come – Take this vow – now![64]

In thus marking the powada as a unifier of the Marathi identity, internal tensions
in the genre are glossed over, as it gets invoked as the symbol of the cultural
integration of Maharashtra. As special powadas came to be composed for All
India Radio, Bapat recast both powada and lavani for middle-class and upper-
caste audiences. It was an aestheticization of the popular, a trend that would be
consolidated both by Hindutva politics and more generally by a popular music
market.

As both Sathe and Kardak were marginalized by a mainstream literary
tradition, the theatrical performances of the powada of Shivaji came to be
associated with the right-wing, firmly established by middle-class and upper-
caste as the icon of Marathi male bravery, and later as the saviour of the Hindu
religion. Shiv Shahir Babasaheb Purandare would – with the blessings of
Hindutva forces – run to packed theatres of middle-class audiences, and reach
their homes and their public ceremonies via the audio-cassette industry. The
phrase popularized by the political party, the Shiv Sena, bringing the 'sons of
the soil' phrase together with 'saviour of Hindus' is not accidental. The *rasa*

of valour (*vira rasa*) becomes synonymous with popular pride, self-respect and aggression of a Marathi, and later, Hindu identity, marked as distinct from the effeminacy of the Congress and elitism of the socialists, Communists, Dalits and Muslims, all of which are rendered anti-Hindu and anti-national.[65] This *rasa* challenges young men to recuperate their masculinities – something that now merits further exploration.

The emergence of powada as a masculine form gradually becomes an unadulterated, authentic political expression of both a Marathi and Hindu identity. The lavani, the feminine form, remains associated with *ranjan*, produced as the commercial popular in the tamasha genre, mainly in the cinema. Cultural distinctions between the political powada and commercial lavani, between Annabhau's compositions in the slums, Kardak's on the outskirts of the village and Bapat's for the middle classes, legitimize forms of power and control rooted in caste, class and gender inequalities. Bapat's aestheticized presentations set the base for their further appropriation by electronic media.

Globalization has had a dramatic effect on the tensions between particularism and universalism, that is at the core of the concept of culture. Under globalization, media emerges as the legitimate bearer of commercialized symbolic forms so that all cultural integration is only seen as possible through media, uprooted from its territorial base and re-embedded in a mass-communication frame. The forces of Hindutva have contested globalization at a populist level, seeking the cultural integration of an 'authentic Hindu community' as something opposed to mass-mediated (and so western) mediations. Globalization is then viewed as a cultural invasion separated from the economic. Advertisements of shoes are burnt on the grounds of obscenity, while barmaids and sex workers are regulated in Mumbai in the name of 'our culture'. All issues, from obscenity in the media to trafficking, are rendered 'cultural'. The controversies around the Michael Jackson show in Mumbai and the Miss World show in Bangalore (both in 1996), and the debacle of the Enron power multinational in 1992, are in contrast posed as fund-generating and therefore economic. The powada as an apparently authentic local form, removed from the global, is invoked to generate a sense of community in times of the free-market economy.

Culture is thus used to underline characteristics that distinguish and create hierarchies.[66] In a world that is ceaselessly changing, popular cultural forms appear to assert unchanging realities, even as distinctions within the popular become justifications for keeping inequalities unchanged. The powada – as characteristic of a Marathi and Hindu culture, as against other cultures and other identities – becomes a curious assertion of unchanging reality within a free market. The differentiation both *within* the powada, and *between* the lavani

and the powada, marking the one as more political, authentic and moral than the other, becomes at once a justification for inequality even as it freezes it into timelessness. Conceptualizing popular culture for a project of radical cultural studies cannot be limited to social histories of texts and audiences. It requires that histories, and forms, defined both by caste and region be traced and analysed, their struggles over meanings and resources comprehended within capital and politics.

Such struggles, taking the form of rural Dalit and Adivasi literary conferences (*sahitya sammelans*) have been active since 1987. In the last two years, integrated (*sakal*) and rebellious (*vidrohi*) literary meetings and cultural movements have sought to negotiate differences between the left, Dalit, feminist and Adivasi cultural activists, and to initiate the cultural front.

Sections from this essay have appeared in Rege (1995)[67] and Rege (2000).[68] An earlier version of this essay was presented at a workshop organized by Vikas Adhyayan Kendra, at Vagamon in September 1998. Suggestions and comments by Ram Bapat, K.N. Panikkar, Gopal Guru, Vidyut Bhagwat and Sandeep Pendse have helped in the reworking of the essay. This work is a part of a long-term project on 'Dalits and Public Culture in Maharashtra' which began in 1995 with a documentation of the tamasha and at present seeks to document the Dalit popular writings, gatherings, meetings, jalsas and gayan parties in the region.

An account of the notorious Mumbai dance
bar ban of 2005 through press coverage
and statements made by stakeholders.
Anna Morcom draws parallels between
the ways in which women from hereditary
communities of performers were targeted
during the anti-nautch movement in
the early twentieth century and the
representation of bar dancers in the media
at the time of the ban.

Excerpt from Anna Morcom, 'Mumbai
Dance Bars, Anti Nautch II and New
Possibilities', in *Illicit Worlds of Indian
Dance: Cultures of Exclusion* (London:
C. Hurst and Co., 2013). Reprinted with
permission. Grateful acknowledgements to
Anna Morcom and Michael Dwyer.

Keywords
Bar dancers, Devadasi, Nautch: see
Keywords (pp. 329–44).

Images

Images from Saba Dewan's documentary
Delhi–Mumbai–Delhi (Hindi, 2006),
where the filmmaker shadows a Bombay
bar dancer and her friends, spending long
hours in their domestic spaces, making
train journeys with them, and following
them to their work in the dance bar.
The film witnesses their claim to autonomy
and agency even as their work casts them
into fragile negotiations with gender
and sexuality.

pp. 130–31: The dancer Riya, protagonist
of Dewan's film, and her friend and
colleague Nisha.

ANNA
MORCOM
2013

09 The Continuation and Repetition of History
The Dance Bar Ban as Anti-Nautch II

Exploitation of Women and the Ruin of Society and Culture

The campaign to ban dancing in bars essentially focused on the same two arguments as anti-nautch:[1] the girls were victims of exploitation and/or they were 'evil' forces bringing about the destruction of 'good' people.[2] In terms of the dance bars, essentially the same arguments as anti-nautch are expressed in a paid-for advertisement by the pro-ban lobby,[3] which attempted to rally support for the campaign. Entitled 'Sweety vs Savitri', the subtitles read, 'Should dance bars be banned or not? Is it a fight between bar owners and R.R. Patil?[4] Or a fight between bar culture and Indian culture?'

The article pits the (westernized and) seductive bar girl 'Sweety' against the idealized (Hindu) wife Savitri, and 'corrupt' westernized culture against 'pure' Indian (Hindu) culture.⁵ It challenges those who support dance bars to ask, 'Why are they supporting dance bar owners and the vulgar culture that goes with it, instead of families that are ruined because of it?' The piece also expresses compassion for the bar girls, but calculates – literally – that although 'our sympathies are with them', the harm they do is effectively ten times more than the harm they will suffer: if each bar girl has ten customers, she therefore wrongs ten wives (the calculation assumes all the customers married), and so if there are 75,000 bar girls, then there are 750,000 wronged wives. A highlighted box asks, 'Why should dance bars be banned?', and lists a number of reasons, mostly based on the idea that the bar girls are exploited, degraded and in some way 'forced' or 'compelled' to dance:

> • It is the biggest atrocity against women, making them dance seductively, compelling them to make suggestive gestures, and exploiting their sex appeal to make money (even if they resist prostitution).
>
> • It is greatest lie to say that bar girl loves it. It is like saying that teenage girl loves prostitution and women love being beaten up or abused.
>
> • It is sex shows by dance girls and vulgar money show by visitors.
>
> • Because many of these bars indirectly promote prostitution, though the method differs.
>
> [...]
>
> • It debases the person and creates urge and desire that generally a wife cannot fulfil, thus worsening the situation.
>
> • It is an addiction that ruins man's family and home. When thousands and lakhs are spent in bars, what is left for home?
>
> • In such homes kids grow up in wrong influences. In some cases causes for crimes [sic].

The article concludes, 'Finally the issue boils down to this. Either you are for women sexploitation or for women's liberation. Please stand up and be counted'.

Another advertisement, issued by the Maharashtra State Commission for Women,⁶ gives a similar pro-ban view. Issued seven days after the ban came into force, the advert was responding to those either tempted to feel pity for the bar girls or critical of the government's actions following stories in the news of the plight of unemployed bar girls. Entitled 'The bar-girls issue – the exploitation behind the tinsel and the makeup', the article states:

The past few days have seen several sob stories being purveyed in the media about the broken lives and the desperation of the bar girls facing unemployment after being used to a lifestyle of earning twenty thousand rupees a month.[7] These bleeding-heart stories have ignored some basic societal issues.

• What about the untold stories of families ruined by this multi-crore industry when men spend their earnings on liquor and sex in these joints? … The tears of the women left at home, who suffer abuse from alcoholic husbands, the children whose lives are ruined by a parent sucked into alcoholism and moral ruin have no news value. But their agony is also as real as the story of the bargirls looking for new jobs. [...]

• Artistes can stage performances in theatres and earn a living with the dignity of such a profession. But those who want to commodify women's bodies would rather have women dance in a bar as 'objects of lust' for men. This is against women's status and dignity. CEDAW (the international convention on eliminating all forms of discrimination against women) to which India is a signatory, binds us to prevent the commodification of women's bodies. [...]

• The Maharashtra State Commission for Women does not want women to be driven to this 'profession' of dancing in bars. Instead, women should be provided opportunities to work with dignity and earn a decent livelihood.

Again, there is a tension between presenting the girls as people who are harming society and ruining lives, and thus for whom pity is out of the question, and on the other hand, as themselves victims of exploitation. As with 'Sweety vs Savitri', it states that girls do not choose to dance, but are 'driven' to do so. This article directly implies that the girls are not artistes, they are simply 'commodified women's bodies' (the Marxist–feminist view)[8] and, for them, dance is not something that can be called a profession.

These two direct statements of the pro-ban lobby can be compared with writings that targeted courtesans and devadasis around a century earlier. For example, in 1894, a nautch girl is described as:

a hideous woman . . . hell is in her eyes. In her breast is a vast ocean of poison. Round her comely waist dwell the furies of hell. Her hands are brandishing unseen daggers ever ready to strike unwary or wilful victims that fall in her way. Her blandishments are India's ruin. Alas! Her smile is in India's death.[9]

The language is that of fire and brimstone Christian morality whereas the pro-ban lobby appealed more to 'rational' rights and (Hindu) family values. However, the sense of the nautch girl or bar girl as evil and destructive, not just to men, but to India or 'Indian culture' is the same.

The more sympathetic presentation of the bar girls as victims, as exploited, and as forced to dance also has its parallel and predecessor in anti-nautch (and indeed in the wider debates on women's issues), and can be seen in Muthulakshmi Reddy's[10] statements in 'The Devadasi Question', written in 1930:

> I have been feeling all along and feeling most acutely too that it was a great piece of injustice, a great wrong, a violation of human rights, a practice highly revolting to our sense of morality and to our higher nature to countenance, and to tolerate young innocent girls to be trained in the name of religion to lead an immoral life, to lead a life of promiscuity, a life leading to the disease of the mind and the body.[11]

Although the view is ostensibly sympathetic to devadasis as victims, a more accusatory undertone can be sensed, since devadasis, although forced into their position, were, once they embarked on it, leading 'an immoral life . . . a life of promiscuity, a life leading to the disease of the mind and the body'. The idea that the devadasi or nautch girl is evil and has 'mysterious' power over helpless men is present in both the bar girls' case and anti-nautch. Reddy mentions people 'who have been addicted to the custom and who take their stand behind religion'.[12] The term 'addiction' was also used in reference to customers of the bar girls. For example, a press article reports a father describing how his son was saved by the dance bar ban after nearly ruining the family: '"His addiction grew on him and I was on the brink of insolvency. Then came the ban and everything changed", Shah says with a grateful glint in his eyes. "After the ban, he has mended his ways and is leading a normal life".'[13]

The anti-nautch campaign essentially used appeals to rights and 'liberation' of women as well as the need to protect 'morality' and 'Indian culture', as did the pro-ban lobby in the case of the bar girls. At the time of the anti-nautch campaign, the overt conflation of women, nation, honour and culture with discourses of purity, status and nationalism was rather more readily accepted than in twenty-first century Mumbai. Hence, while the 'immorality' of the nautch girl or devadasi was directly confronted, sometimes with very fiery language, during [the] anti-nautch [campaign], in the case of the bar girls, the expression of sexual morality was generally rather more muted. It was claimed by some key players, there was no moral stand against the girls at

all, just concerns about 'trafficking', harm to the girls, and/or harm to the wronged wives.[14] This reflects a very different balance of attitudes towards sex in the late twentieth- and early twenty-first-century India compared to the days of anti-nautch. There were many vociferous objections to moral policing and hypocrisy in the debates over the dance-bar ban, with issues over liquor licensing compounding these.[15] Whereas anti-nautch was a social campaign against moral wrongs, the heavier emphasis in the dance-bar ban on violations of human rights also reflected the fact that the ban involved amending a law: and there was thus a legal dimension to the campaign. However, as I discuss below, both moral and human-rights based arguments, resting on absolutes and universals, served many of the same purposes, and the victimhood trope loomed large in both, although with different configurations.

Liberalism, Human Rights, Victimhood and Dogs Chasing their Tails

When looking at these two campaigns, I was struck by the extent to which history was repeating itself. Girls from the same (north Indian) communities that had been under attack by anti-nautch from the late-nineteenth century were being targeted by essentially the same arguments again in twenty-first-century Mumbai. Yet what struck me more was that this glaring parallel was not being reported in the press, and did not form any part of the debates on the bar girls. The BBU (Bharatiya Bargirls' Union)[16] told all journalists, as they had told me, of the hereditary performing background of the vast majority of the girls, and the lawyers representing the BBU were also well aware of it.[17] There was a large amount of sympathy for the bar girls, in particular in the English-language press. But their specific history and sociology, which was so relevant to the how and why of their circumstances, was not reported.[18] The debates by the pro-ban lobby focused on issues of prostitution, exploitation, choice/free will/helplessness and trafficking, and those of the anti-ban lobby were largely monopolized by these same topics. The positions can be summarized as follows:

> *Pro-ban*: a) The girls were a social evil, prostitutes who were making easy money while ruining homes and society, and so should be stopped; b) the girls were helpless, trafficked, prostitutes; they were exploited and needed to be saved.

> *Anti-ban*: The bar girls have no choice but to dance, they are not prostitutes and they are not making easy money; they are victims of

society/family breakdown, and to lose their jobs would make them (more) destitute.

These issues were discussed endlessly and resulted in some daring and witty investigative journalism. For example, in one piece, a journalist went undercover in order to find out whether or not the girls were prostitutes. He reports describing his experience in a bar:

> I have eyes only for the pretty girl in blue. I beckon her, spray out some notes, and that sparks off a duet that I guess usually plays out at dance bars. More the money I shower, harder the girl dances. I try to grab Sunayna's hand, she shies away. I tell her she's very sexy, she blushes and dances some more. I tell her I'd like us to meet after hours, she only smiles mysteriously. Encouraged, I dance with her. . . . I quietly slip a post-it into Sunayna's hands. It has my cell number. She winks, and promises to call. We leave Deepa with great hope. I'm still waiting for my phone to ring.[19]

Three girls at other bars similarly shun him, and the article challenges the view of bar girls as prostitutes, carrying the title and headline 'They did not sleep with me, Mr Patil. Four bar girls turn down correspondent Anil Thakraney. Still think dance bars are a front for prostitution, Mr Home Minister?' In another article, *Mid Day* reporter Swati Ali went undercover, dancing in two bars over two nights in order to find out the truth about being a bar girl. When she sits next to a man on a sofa in order to hear him, she reports, a girl tells her off, saying 'You are not here to get physical with your customer. You have to only dance for him.'[20] Another advises her, after a customer sends her a note asking if she'll stay the night with him, '"Who sleeps with these men? Just say yes and let him spend some more money on you." She tells me that after work, the girls all leave in taxis provided by the bar, and nobody dare touch them.'[21] Her experience leaves her with 'unadulterated admiration' for the bar girls.

However, a brief consideration of the specific sociological background of the bar girls makes it clear that these debates on prostitution, and the other 'headline issues' of 'free choice' and 'exploitation' miss some fundamental considerations:

> a) The bar girls were overwhelmingly from hereditary performing backgrounds, so dancing was neither free choice, nor coercion in the sense of 'trafficking', but a *khandani pesha* (hereditary occupation). With

some communities having turned almost entirely to a system of family sex work, dancing in bars was in fact for many girls a rehabilitation from sex work.

b) As public/erotic female performers, these communities have an alternative system to mainstream society whereby girls who dance do not marry and those who marry do not dance. Thus, normative questions of 'choice' or 'force' are no more relevant to their occupation as erotic performers than they are to the system of more or less compulsory marriage for mainstream society. Rather than being destitute or abandoned by husbands, their society is matrilineal in many ways – they do not marry, and their fathers are often unknown to them or not significant to the family unit.

c) The bar girls and other erotic/public female performers are not accurately described as prostitutes (as long as they are able to perform). At the same time, however, they operate outside the bounds of mainstream honour and respectability. They look for longer term, advantageous relationships with men which, in the case of the bar girls, depend on flirting, seduction and tips. They do not undertake transactional 'per shot' sex work when they are earning well from dance, and classify themselves as different and superior to prostitutes. Outright prostitution in these communities has historically resulted from a loss of performing livelihood and identity, rather than being concomitant with it.[22]

d) Such performers have been fundamental to large swathes of 'Indian culture', up until the early or mid-twentieth century, before 'respectable' women were able to be professional performers.

Without their social and historical context, the key debates were seriously compromised. Despite a clear repetition of history, the link with the past, and indeed, the cycles of stigmatization and exclusion which this campaign was in fact repeating and continuing, were not mentioned, and history continued.

Crucial matters concerning the specific history and sociology of the bar girls were rendered unsayable, irrelevant or foreclosed (even by those sympathetic to them). The reasons for this are partly grounded in the anti-nautch legacy and the broader social reform upon which Indian nationalism was founded. These movements set the terms of the debate over these kinds of dancers. The pro-ban lobby continued these arguments, and the anti-ban lobby responded on these terms. Yet the problems with the bar girls' debates also stem from the

characteristics of modern knowledge and ideology. The blanket category of 'prostitution' is inappropriate when applied to hereditary performers, whether they are devadasis and courtesans in the nineteenth century or bar girls in the twenty-first. Colonial modernity rigidly classified them as prostitutes, because of a lack of understanding, but also because of the drive to categorize everything 'scientifically'. The contemporary world has continued to rely on categorization to produce authoritative knowledge with universal application, and terms such as 'prostitution', 'sex work' and 'trafficking' have been globalized by the arenas of development and human rights (with international development increasingly connecting professionals that transcend specific place and region).[23] So authoritative are these terms that it was almost inevitable that the anti-ban lobby should also use them as a basis for its arguments. Thus, even though they were far off the mark, they constituted the terms of the debate, and the finer details of history and of social or cultural context were elided.

In 2005, in the state of Maharashtra, female dancers were banned from performing in dance bars, which largely catered to a male clientele. Eight years later the dancers won a Supreme Court ruling that asserted their right to their livelihood. Sameena Dalwai writes the following piece as a response to an essay that framed the dance bar ban as an example of how the government sought to use cultural politics as a substitute for a lack of economic and political power.

Earlier version published in *Economic and Political Weekly* (vol. 48, no. 48, 30 November 2013, pp. 131–32). Reprinted with permission of the author and publisher.

Keywords
Bar dancers: see Keywords (pp. 329–44).

Images
pp. 135, 137: Scenes from Saba Dewan's film *Naach* (The Dance, 2008), made after the 2005 dance bar ban, where she follows a group of dancers from Delhi to performances around the country. Seen here are dancers in a performance at Sonpur, Bihar.

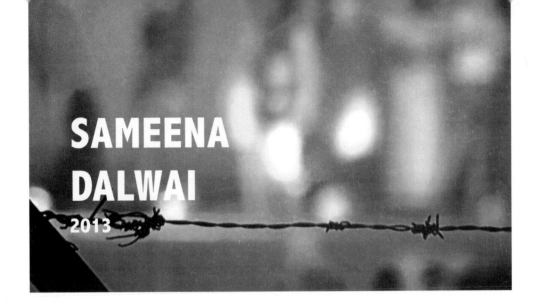

SAMEENA
DALWAI
2013

10 Caste and the Bar Dancer

Maya Pandit's article 'Gendered Subaltern Sexuality and the State'[1] offers a perspective on the Maharashtra ban on bar dancing[2] that weaves legal prohibition, lower-caste female sexuality and the processes of globalization in India, within which the state's role in cultural identity-creation has become a crucial component. Pandit identifies the state's wrath against lower-caste female sexuality as the root cause of the ban on dancing. She asks for the reasons for fear of the sexuality of the lower-caste girls – why their sexuality becomes a threat. The answers are sought in 'good governance', where the Indian state is pushed to take action against trafficking. While the state in globalizing India withdraws from welfare commitments, it seems to play an enhanced role in cultural politics. Further, the climate of globalization demands a solid and distinct national cultural identity, which gets carved out of upper-caste/class Hindu familial ideology. Pure, unblemished Indian womanhood is central to this theme and bar girls – the antithesis – threaten the very notion of India.

While other authors also reiterate this line of reasoning,[3] it does not explain the scale of the threat that lower-caste female sexuality poses, at least within the dance bar's purview, to the very hierarchy of the caste structure. I argue[4] that the very reason for the legal ban can be found in the caste and gender politics in globalizing India and 'caste governance' by the Maharashtra state government.

Alternative Standpoint

Pandit states that bar girls are the traditional breadwinners of their extended families. In feudal times their sexuality was exploited, and now in market times their dance skills are exploited. This overview does not recognize the curious labour pattern in dance bars. It also erodes the agency of women and reproduces them as passive victims, failing to recognize that bar girls strove to find employment in dance bars, and organized rallies to keep them from shutting down. As an alternative standpoint, I propose that the dance bars have been a site of opportunity. First, for enterprising bar owners who put together alcohol, music and dance, and earned profits. Second, for the consumers, who were exposed to the novel world of lavish erotic entertainment and experienced new identities. Customers' interviews[5] reveal that they see dance bars as spaces of dreams, adventure and freedom, competition, love and intimacy, an opportunity to feel like a king! And third, for the bar girls, a majority of whom come from the Bhatu caste clusters such as Bedia, Nat, Deredar[6] communities of north India, and traditionally earn the family livelihood through sexual and erotic labour, including dancing, singing, entertaining and sex work. They redeploy these hereditary skills to suit the new market of the dance bar provided by globalization and earn unprecedented amounts of money. The money, in turn, offers possibilities of freedom from poverty and sex work, a chance at a middle-class lifestyle and opportunities of education for the next generation. The bar girls from Bhatu communities excel in the dance bars by redeploying their 'caste capital', i.e., a set of skills that members of a caste or a community acquire and possess while fulfilling their caste-based occupations. With the advent of the modern market and state systems, this caste capital has been noted to be redeployed to mark certain occupations as strongholds of particular caste groups, e.g., Brahmins in educational and administrative positions, Vaishyas in business. Bar girls from hereditary dancing communities tend to excel in the dance bars as they have family and clan support, skills of emotional management such as handling intimacy, along with a basic knowhow of dance, music and erotica.

Dilemma in the Debate

This is where the dance bar debate poses a dilemma. On the one hand, this scene of the lower-caste female performer dancing before the upper-caste male patron has a disturbing similarity to feudal caste oppression, and explains why Dalit feminists in Maharashtra supported the ban. They demanded an end to the humiliation inherent in caste relations,[7] what Anupama Rao calls the 'informal sexual circuits of caste',[8] whereby lower-caste women are sexually exploited by upper-caste men, routinely and as a matter of right. Yet, this relationship seems to change in the dance bars. Mediated through the globalized market, the paradigm has shifted away from obligation and birthright to one of employment and wages. Bar girls are able to challenge the caste order by performing caste. This poses the crux of the threat. Accusations of obscenity and easy money were used to create a harsh public opinion against bar girls who had overstepped their boundaries and were earning more money, power and status than their caste positionality allowed them. The state was called upon to protect the family and 'good wives', 'helpless youth' and the Maharashtrian/Indian culture from the dangerous 'lure' of bar girls. In the Maharashtra legislature, the need for the new law was justified as a need to discourage men from going to the bars and throwing money.[9] In this scheme, upper-caste/class men seemed to need the protection of the state from lower-caste/class women.

Banning Music and Dance

The new legislation did not ban alcohol or even dance bars. It banned dance! It prohibited the subversive power of music and dance. By banning the 'musical power'[10] that a performer has over her audience and patrons,[11] the ban on dancing closed this space of the erotic to lower-caste women. The obscenity and easy money, then, can be seen as an apparel of the politics of caste and gender that determines the value of labour of the lower-caste women at the lowest monetary denominator. While banning dance in bars, the state allowed prostitution to continue, effectively encouraging women to replace dancing with prostitution. In this scheme, the government reinforced the right of upper-caste men to have sexual access to lower-caste women, and for free. The real objection was not to men accessing the sexuality of these women, but to men having to pay for it. The state's action was for maintaining a traditional caste-based status quo between upper-caste men and lower-caste women. In doing so, the Government of Maharashtra – Maratha Rashtra as Rajendra Vora called it[12] – performed caste.

Not recognizing this caste and gender politics reproduces an old rhetoric in the dance bar debate, even by well-meaning feminists like Pandit. The globalization angle here is not about *culture*, but about *occupation*, the scope of which is predetermined for each caste group within the occupational ladder. It is not the threat of 'subaltern female sexuality' as Pandit proposes, that the Maharashtra government responded to. It is occupational and class mobility. It is important to recover lower-caste women's agency from the discourse around the dance bars that attach the women-as-victims narrative to a context which allows for much more complexity and upward and outward mobility for lower-caste women.

MADRAS

कौसल्या सुप्रजा राम पूर्वसंध्या प्रवर्तते ।
उत्तिष्ठ नरशार्दूल कर्तव्यं दैवमाह्निकम् ॥ १ ॥

BAY

OF

BENGAL.

MYLAPORE

M.S. Subbulakshmi (popularly known as MS) is perhaps the best-known Carnatic musician of the twentieth century in India. She was also much else: a major movie star (although she acted in only five films), occasionally a style icon, an artist of considerable cultural stature in both the Tamil and Indian nationalist movements, an authoritative purveyor of the tradition of saint-poetry in multiple languages. An intriguing aspect of the mystique, often centrally featured in her biography, was her husband, T. Sadasivam, widely viewed as having masterminded her career. In this essay, T.M. Krishna, known as a leading vocalist in the Carnatic idiom in India, but even more so for his radical political positions opposing the ruling elites at the national and state levels, inquires into the myth of MS, and the trajectories that would shape the genteel cultural narratives of post-Independence India. This text is placed (in the three essays that follow) alongside another female musician of equal stature and occupying the same moment in history – Lata Mangeshkar.

An earlier version was published in *The Caravan* (1 October 2015). Reprinted here with permission from the author and *The Caravan*. Grateful acknowledgement to T.M. Krishna for his support.

Keywords

Bharatanatyam, *Carnatic music*, *Devadasi*, *Madras Music Academy*, *Rasa* and *Rasika*: see Keywords (pp. 329–44).

Images

p. 141: The cover image sums up the transformation of Madurai Shanmukhavadivu (MS) Subbulakshmi from her origins in the Isai Vellalar community, a matrilineal and hereditary courtesan community (referenced in Krishna's writing through the term 'devadasi'), to a 'Brahmin musical superstar'. The Sanskrit text is the first verse of the *Venkateshwara Suprabhatam*, an early morning prayer recited to awaken Venkateshwara, an incarnation of Vishnu, at the Tirupati temple in south India. MS's rendition of it is iconic. A rough translation is as follows, 'O Rama [another incarnation of Vishnu], Kausalya's glorious son, it is dawn / Please wake up, for you have to do your daily duties.' Mylapore, a prime locality in erstwhile Madras (now Chennai), also marked in the cover, represents for Krishna the conformism that defined MS's new identity with multiple temples, a huge Brahmin community, and a number of *sabha*s, or performance venues, with staid views about the classical arts.

pp. 143, 147, 152–53: Screen-grabs of MS from Ellis R. Duncan's *Meera* (1945).

pp. 158–59: A montage of frame-grabs from a recording of MS's concert at the United Nations in 1966.

T.M. KRISHNA

2015

11

MS Understood

The Myths and Misconceptions around M.S. Subbulakshmi, India's Most-Acclaimed Musician

In a private conversation sometime in the late 1980s, a sharp-tongued young aspiring musician made an extraordinary statement about Carnatic music's most iconic figure. 'MS Subbulakshmi,' he said with disdain, 'is the greatest hoax of the twentieth century.' Many readers will leap to accuse me of blasphemy for even citing this rather obnoxious remark. But it has stayed with me ever since, and I have a somewhat severe explanation for why.

This musician's assertion was based on the argument that it was packaging and marketing that made Madurai Shanmukhavadivu Subbulakshmi the global face and voice of Carnatic music; her music was otherwise intrinsically hollow, and lacked 'stuff'. The Carnatic hinterland would not employ the word 'hoax' to describe her, but would consider, with varying levels of empathy, the hypothesis that she was stage-managed. The marketing of MS – orchestrated, as is well-known – by her mentor,

husband and business strategist, T. Sadasivam, was undoubtedly astounding, and far ahead of its time. But to claim that what he sold to the world was intrinsically empty is unacceptable.

The world of Carnatic music, and its nerve centre, Chennai, is an intense and intensely insular world. Its norms of adherence, practice and evaluation are unforgiving. Through conversations, informal criticism, even hints, learned musicians and seniors, working in tandem with informed listeners, bestow various degrees of so-called classical value upon musicians. These value judgements become harsher as the popularity of a musician rises. Some of these musicians have publicly offered MS gestures of admiration, even adulation. Many use her performance techniques to enhance their own. But serious critical and technical appreciation has been rare. MS's contemporaries, and even her juniors, have received weightier musical approval.

This was as true at the crest of her fame as it is now, over a decade after her death – and in this (she was born in 1916), her centenary year. Quintessential Carnatic connoisseurs and musicians differentiate between the real *rasika*, or aesthete, and the *janata* (public) who attend concerts to hear merely melodious music. The only praise that the hardcore section of this small universe bestows upon MS with honesty is that she had the most beautiful and pitch-perfect voice, and immaculate presentation skills. But let me make this clear: musicians don't consider that combination a compliment. It usually means that there is nothing in the music to really write home about. I gather, from those close to her, that MS herself used to get quite upset when people only admired her voice – or worse, went on and on about the exquisite *sari* she was wearing.

There are also those who may want me to stop right here, because this is not the MS they venerate, a figure through whom every god spoke, and continues to speak. That MS is the voice through which Shakuntala and Meera sang.[1] Through her renderings, the works of the poet saints Tyagaraja, Kabir and Surdas came alive.[2] Every *swara*, or note, she sang is a precious gem; every musical rendition a jewel of grace and dignity. This MS is a divine vehicle to the deities – so divine that she has become a deity herself. This is MS as seen by people whom the aesthetes are likely to call ignoramuses and outsiders.

The narratives around MS have usually followed one of two paths. The most popular and sociologically captivating is that of personal history. The dramatic emergence of a Brahmin musical superstar with a devadasi background is a storyteller's dream. Comparisons with Bharatanatyam's great diva, T. Balasaraswati,[3] are inevitable: Balasaraswati, born in Chennai in 1918, stuck to her devadasi roots, and, in fact, flaunted her antecedents.

The second strain of writing about MS has focused on her music. This has been mostly hagiographical. Words have failed almost everyone who has tried to describe its effect, considered transporting and transcendental by many. But can we look at her life and her musical movements as a single thread, trying to understand one by the other?

Both the life and the work of M.S. Subbulakshmi bear investigation, to see whether it were her choices or compulsions – I use these words, which mean the opposite of each other, deliberately – that are responsible for the two differing views of her. There was a constant friction between MS's choices as an artist of great resources, and her compulsions as a woman of equal vulnerability. The early MS sang in the idiom of her inheritance, to popular acclaim. The later MS sang in the syntax of a spiritual revisionism, to popular worship. It was an extraordinary transition from what was great to what became grand.

The basic facts that can be retrieved from the mythology surrounding MS's early life run thus: Subbulakshmi was born in Madurai in 1916 to a senior devadasi, known and respected in the town as a veena player. In keeping with devadasi practice, Subbulakshmi retained her mother's name, Madurai Shanmukhavadivu, which formed her famous initials. Shanmukhavadivu was an unwed single mother, the father of her daughter having retreated into the mists of anonymity. According to MS, he was Subramania Iyer, a Madurai-based Brahmin lawyer.

MS was introduced to the world at the age of ten on an HMV *thattu* (in Tamil, records used to be called *thattu*, meaning plate) rendering the Tamil song 'Maragathavadivu' (addressed to Murugan, the son of Parvati and Shiva) in raga Jenjooti.[4] It would be unfair to judge her music at that stage, but there are some remarkable aesthetic indicators. In that recording made in 1926, she comes across as a young girl with a sharp, brave musical expression. Her voice is already fast-moving, with the ability to render speedy phrases with aplomb. Her musical accent is natural and free; there is nothing contrived in the way her voice negotiates the twists and turns of the composition. Today, when I replay that recording, I imagine in my mind's eye a girl with oiled, plaited hair, dressed in a *pavadai-sokka* (long skirt and blouse), singing with the calm nonchalance of a maestro in the making.

Her strength of character is evident in her delivery. It is the work of a tough, almost audacious aspirant, singing with abandon, knowing full well that she is exceptional. There is also the innocence of a child who probably knew of nothing but music. She sings without an iota of self-doubt.

These very qualities gave her the courage to exit her mother's vulnerable home, on Madurai's Hanumantharayar Koil Street, when she was just twenty,

in 1936. She left for Madras and chose the settled rhythms of the household of T. Sadasivam, a middle-class Tamil Brahmin. Sadasivam was an enterprising advertising manager for the celebrated Tamil magazine *Ananda Vikatan*, and a close friend of its famous editor, (Kalki) Krishnamurthy.[5] Sadasivam was deeply involved in the Indian Independence movement, and both he and Krishnamurthy were devoted adherents of C. Rajagopalachari,[6] the Tamil statesman whom Mohandas Gandhi referred to as his conscience-keeper.

MS had briefly met Sadasivam on an earlier visit to Madras, when she had performed at the city's renowned Music Academy. Now, upon her return, she was undoubtedly seeking Sadasivam's protection, taking a huge risk by placing herself in the hands of a man she hardly knew. That she did so with conviction is quite astonishing. Theirs became a partnership of two very independent and strong individuals. Each knew what he or she wanted, and knew, too, the potential of the other.

Shanmukhavadivu had done all that she could to advance her daughter's career opportunities, but MS had outgrown her environment in Madurai. Madras was becoming the hub for all things Carnatic, and MS's thirst for music was certainly as compelling a reason for her move as the obvious fantasy of making it big.

Sadasivam, for his part, was a married man when he started to provide shelter to the young devadasi from Madurai. I am certain the conservative (Tamil) expression – '*ellarum yenna sholluva?*' (what will people say?) – flashed across his mind. Apart from his love and affection for her, and beyond his progressive zeal, Sadasivam probably saw musical greatness in MS, and knew he had to be by her side.

The musical voice is a complex phenomenon. Just as every person speaks at her own pace, every musician has a range of speed at which her voice is most comfortable. A vocalist's musicality emerges from physiological as well as psychological traits; each voice is unique in its malleability. This does not remain constant even within an individual musician's practice, however. Musical maturity, and the wear and tear on the vocal muscles, lead to unconscious adjustments to her thoughts and actions. Nevertheless, unless some serious damage occurs to her voice, any change in a singer's musical direction is likely to be in the form of a progression.

MS's music in the early years of her stardom is a continuance of what we hear in the voice of the ten-year-old. She had what we would call a *briga* voice, a voice that could render a musical phrase fast, irrespective of its complexity, with precision, elan and finesse. Her renditions moved with great accuracy without ever compromising on musical definition. There was no apparent conscious effort, no contrived intellectualization – this aesthetic seemed second nature to her.

There was something in her singing then that was very avant-garde, stylish, modern and carefree. This should not be taken to mean it was free of care, but free of fear – that is, the fear of going wrong or falling short. Her style had a quality that was fleet but not hasty, quick of movement but not jerky. The modern and the avant-garde are, after all, born from unbound flight: musicians achieve the most elusive artistry when they reach out for the skies without a second thought.

Her early recordings create the impression of a very contemporary young musician, liberal and feminist, who didn't care a damn for what people thought. This attitude, as others have observed, is well in keeping with the devadasi tradition of music. Artists of devadasi origin had to be, if anything, supremely assertive and artistically self-confident, in a bid to protect their lives from exploitation as far as possible. They were not to be fooled around with, or taken for casual performers. In aesthetic terms, this meant their work was to be respected; they were to be given time and space to perform, to create that unmarked zone in which they were sovereign. There is a clear streak of a non-patriarchal, non-conservative musical democracy born out of the organic nature of devadasi learning.

But MS's music was strikingly different even from that of the dominant devadasi musical tradition in Madras, from the school of the legendary Veena Dhanammal,[7] who rose to prominence at the turn of the twentieth century. This music was slower, with a focus on softer curves and gentler phraseology, with intricate aural filigree. For the Carnatic community, the Dhanammal variety of music later propagated by her grandchildren – T. Brinda, T. Mukta and T. Vishwanathan – has come to be accepted as the universal representation of the devadasi tradition. We seem to have forgotten that devadasi homes nurtured diverse ideas of musical aesthetics, but the early MS reminds us of this reality.

There are also musical reasons for the difference of texture. Some of MS's biographers, including the journalist T.J.S. George,[8] have speculated that her father may have been the star musician Madurai Pushpavanam,[9] a contemporary of Shanmukhavadivu's, said to have had a very racy and dynamic interpretation of Carnatic music. It is at least possible that MS heard about his approach from her mother. Shanmukhavadivu herself seems to have taught MS music that packed a punch. And then there was G.N. Balasubramaniam,[10] or GNB, as he came to be called – a dashing musician six years older than MS, whom we now know she not only admired, but was also infatuated with. The feeling was mutual, as evident from the fact that he kept all her love letters safe until the end of his life.

GNB's love for MS has been underplayed, thanks to the latent patriarchy of Mylapore, the Brahmin neighbourhood at the heart of Chennai where music and temple rituals merge like the warp and weft of Kanjeevaram silk.[11] By the

late 1930s, GNB had revolutionized the tone, thought and method of rendering Carnatic music. He brought into its practice a kind of western analytics, which is often attributed to the fact that he was the first Carnatic musician of note who was also a college graduate – he took an honours degree in English literature.

GNB had a magical voice. Unprecedentedly, he sounded most Carnatic when he sang at stunning speeds. All of a sudden, this genius had given the music an exciting, youthful expression, and he became the rage among Madras's young upper classes. MS's music from this period through to the 1950s sounds akin to GNB's sound. This was probably the result of her conscious internalization of his music, as well as his subconscious impact.

MS and GNB can be said to have collaborated, although not in the sense that they sang together regularly. In 1940, both starred in the film *Sakuntalai*, in which GNB played the king Dushyanta, and MS his love, Shakuntala.[12] Their duets in this film bear testimony to my observations. If anyone could match him, phrase for phrase, it was MS. I am certain that anything he might have thrown at her, she would have given back with interest. In colloquial Carnatic parlance, we would use the Tamil phrase '*sangati ellaam palapalapalannu vizhum*' (her *sangati*s, or musical phrases, unfurl with clarity and lustre). There are no approximations or sly escapisms in MS's execution. Her voice and her music are perfectly paired – and propelled by her tenacity.

There is a 78 rpm recording released around this period on which MS sings a brief *alapana* – a kind of improvisational form – of raga Harikamboji. Just before concluding it, she sings a sparkling, ascending musical phrase that is utterly GNBesque. I bring it up to highlight just how razor-sharp and adventurous her music was, and not superficial by any standard. This is exactly what we would say about GNB too.

By the mid-1940s, MS had become a name to reckon with, both as a singer on the rigorous stage, and as an actor on the fluid screen. Both roles were complementary; on both, she became, quite simply, a star. In July that year, she and Sadasivam were married, after the passing away of Sadasivam's wife. It marked the officialization of their relationship, and the point after which everything began to change.

What happened next can be called the transformation, or the psychological realignment, even the taming, of Subbulakshmi. The free-spirited young woman was to become the embodiment of the ideal Brahmin housewife, seen among the elite as the epitome of purity and devotion.

The patriarchy that surrounded the Carnatic world governed every aspect of MS and Sadasivam's social and cultural life. Sadasivam's politics was emancipatory, but he was personally a conservative patriarch. He was

instrumental in choreographing MS's transformation. She may have wanted the legitimacy that came with it herself, of course. The security of social respect and acceptance among the cultural elite was probably important to her.

MS's own baggage was her life and past in Madurai, and the contrast between it and being with Sadasivam. On the practical side of things, she was aware that Sadasivam knew exactly what to do professionally. She was on the verge of something really big, and he was, after all, a master of marketing. *Ananda Vikatan* had reaped the benefits of his savvy; so would *Kalki*, a popular Tamil magazine he had promoted with his friend 'Kalki' Krishnamurthy.

For MS's transformation to occur, the social memory of her had to be redrafted, and then filled in with new details, which meant MS had to be redesigned, both in image and in music. We can see clearly how MS's style changed just from her attire. Gone were the puffed sleeves and casual saris. Even more dramatically, gone was the MS of that early, fun photograph in which she is pictured with a young Balasaraswati, in western-style sleeping suit, sporting an unlit cigarette in her mouth. We can now only visualize her in conservative *smarta-brahminkattu*, the style in which she draped her sari.

Between 1938 and 1947, MS acted in five movies: *Sevasadanam, Sakuntalai, Savitri, Meera* in Tamil, and *Meera* in Hindi.[13] In those early years, it was the norm for south Indian films to star Carnatic musicians, as they (the films) depended heavily on their music for success. Her movie career was also a business endeavour for MS. She played Narada in *Savitri* to raise money for the launch of *Kalki.* Then came *Meera*, a point of inflection in the lives of Sadasivam and MS.

There are two sides to the *Meera* story, one personal and the other professional. Close associates of MS have said that her experience of playing the title role was deeply emotional, even spiritual. In her mind, she had become the '*dasi* Meera', the poet-saint known and revered across India, and that connection would never leave her.

Professionally, of course, *Meera* was a national success, launching a small-town south Indian singer into the headlines. For the first time, a Carnatic musician was recognized in the corridors of power up north. Political and corporate leaders bowed before MS now, and she became known by the titles conferred on her by Jawaharlal Nehru – 'the Queen of Song' – and by the nationalist and poet Sarojini Naidu, who, it is claimed, said she surrendered her own title to MS – 'the Nightingale of India'. They and the general public must have seen echoes of MS's experience of transcendence in the role – the feeling of actualizing Meera in herself.

But this was only the beginning. In what turned out to be a brilliant marketing move, Sadasivam ensured that MS never acted again, thus etching the

image of Meera forever on the frame of MS. After 1947, I don't believe MS ever presented a concert that did not feature Meera's bhajans. The decision to drop out of cinema also erased a potential conflict: a woman becoming the perfect Brahmin housewife could not, after all, also remain in the film industry without creating contradictory images. Ending that chapter of her life only further established MS's Mylaporean conformism.

There was, however, more to this transformation. Just a decade after *Meera*, MS's aesthetic transition was clearly visible. By the late 1950s and early 1960s, her concert tours across India had become processional, like Dasara in Mysore.[14] They were great events, replete with social celebration and musical rejoicing. Here, the striking changes in her music are first discerned in the texture of her voice. It starts sounding heavier, even a little suppressed, as though forced into containment. Musically, the carefree abandon disappears. She still does sing those beautiful 'runs', but they sound more structured. All of a sudden, the kite is tied down by a heavy boulder.

Some may argue that this was the result of Subbulakshmi's maturing, but I beg to differ. In the maturing of a musician, the spirit behind her music is not manipulated. With MS, there seems to have been a kind of reverse engineering: the core was dislocated in order to accommodate the realignment of mind and voice. After *Meera*, and her becoming a quasi-saint across India, her music had to reflect her new status.

We cannot pass judgment on matters of personal faith. But the change unquestionably affected MS's music. She did not stop at Meera's bhajans; encouraged by her husband, she acquired and recorded a wider repertoire of religious music, including the work of Tulsidas, Kabir, Nanak, Surdas and Tukaram.[15] She also learned Rabindrasangeet.[16] She acquired many identities in her music. When in Kolkata, she was Tagore. In Pune, she brought Tukaram to life. In Delhi, Tulsidas was reincarnated. On her home turf, in Madras, Tyagaraja sang through her.

Being all these characters was not just about surrendering personally to a godhead or philosophy. It also meant that she was reorienting the aesthetics of her art. It is one thing to learn an assortment of compositions, completely another to have to perpetually juggle musical approaches. MS was intensely involved in every work she rendered, which meant giving up something of herself to its composer, form and intent.

She was also simultaneously updating her Carnatic repertoire and expression. She learned from many greats, including K.S. Narayanaswamy, and, before him, Musiri and Semmangudi.[17] It is said that a leading musician from Madurai, a member of the Isai Vellalar community, once remarked that MS used to sing

beautifully until she came under the tutelage of two Iyer [musicians]. The story is unsubstantiated, but even concocted tales can reveal something of the inner workings of the environment that produced them. It points to the underlying friction between communities in the Carnatic world. As a musician, I can only interpret it to mean that the musician felt that sparkle and spirit had given way to predictability.

MS loved to sing, and to learn more and more music, whether it was Carnatic, Hindustani or even – unfortunately – English.[18] In 1966, she was given 'Here Under This Uniting Roof' to sing at the United Nations on the occasion of UN Day. The song was written by C. Rajagopalachari and tuned by the respected Chennai-based western classical musician Handel Manuel. But whatever the value in their contributions, the song was musically hollow, and aesthetically limp. Did these frequent shifts cause any internal conflict? Did MS view all these roles as one and the same, or was she painting and peeling identities constantly? We cannot know how she reconciled the contradictions within herself.

Still, her expanded repertoire demands recognition for one astounding quality. Even as MS was singing songs of great diversity, she had the capacity to prevent each from being marred by the aesthetic dimensions of the other. Never was her rendition of a Muthuswami Dikshitar[19] composition muddled by the musicality of Rabindrasangeet; nor her offering of a Meera bhajan by lapses into the heaviness of the Carnatic accent.

This was a tremendous achievement, but one that has gone entirely unnoticed. Her hopscotch between genres gave her music a stronger emotive layering. People may have complained about MS's accented Hindi, but they adored her music, its mellifluousness and its sanctity. In the eyes of the public, she became the spiritual heir to the rishis of this land, or even something more, perhaps: the goddess Saraswati incarnate.

Fame had its repercussions in the inner world of Carnatic music, where MS's national positioning began to skew people's perceptions. She was soon thought of as a bhajan singer, which led to a certain amount of trivialization. For a serious musician of any form, respect from her own contemporaries, seniors and connoisseurs is essential. By the time MS received the coveted title of Sangita Kalanidhi[20] from the Madras Music Academy in 1968, that respect, paradoxically, had begun to dwindle.

Even after *Meera*, MS's concerts contained all the elements that would pass muster with the Carnatic world. She presented many rare compositions, such as Maha Vaidyanatha Iyer's magnum opus, the *Melaragamalika*.[21] She rendered numerous *ragam-tanam-pallavi*s – three-part improvisational presentations, considered the greatest test of a Carnatic musician's abilities – set to challenging

tala structures, in chaste Carnatic ragas such as Begada, Todi and Bhairavi. Very rarely was she applauded for them. It was most unjust, but the *ragam-tanam-pallavi*s were simply drowned out by bhajans such as *Morey to Giridhara Gopala*.[22]

I will say that it was MS who increased the importance of what we call the *tukkada*, or ostensibly lighter section of a Carnatic recital, which follows the virtuoso performance. In the minds of *rasika*s, the focus of MS's concerts moved away from the first two hours of art music to the last half-hour of *tukkada*s, during which she sang devotional music. She rendered every piece with great beauty, but listeners became obsessed with the religiosity of the shorter pieces, and forgot her musical acumen. Even her rendering of serious Carnatic compositions began to be received by many listeners as some form of divine deliverance.

MS's contemporary, D.K. Pattammal,[23] was the first Brahmin woman to become a celebrated concert performer. In particular, Pattammal was considered a master of the *ragam-tanam-pallavi*. This conferred on her the status of being, somehow, equal to men in the eyes of Carnatic musicians and connoisseurs. She also uncovered many unknown compositions by Muthuswami Dikshitar, but, unlike MS, she was constantly lauded for these and other efforts by the critical core of the musical world. This must have really hurt MS.

The release in 1963 of MS's recording of the *Venkateshwara Suprabhatham* was a popular coup. But it was musical free-fall as far as the serious listener was concerned. This, however, did not prevent MS from continuing to release many recordings in the religious and devotional genres. I am certain Sadasivam knew of the *rasika*s' perceptions of these. He may not have cared, since by now MS had escaped the clutches of Mylapore. But we may not be able to say the same of MS's feelings.

Sadasivam's control over MS and her music was not only that of a producer; he was also her director and screenplay writer. It was he who decided which ragas and compositions to present at any concert, and even stipulated the duration of each rendition. She also received instructions from him during concerts. The worst of these interruptions would occur when someone of importance was part of the audience. MS would be deep in the Carnatic idiom, preparing to elaborate a raga, when Sadasivam would suddenly ask her to render, say, a Surdas bhajan. The reason: some Hindi-speaking dignitary was leaving early, and would not be present to hear her sing the bhajan towards the end of the concert. Those who knew the workings of MS's mind during her concerts have told me that this irked her no end.

These manipulations affected both her own flow, and the image of Carnatic music itself, since she was its best-known symbol. Stipulating the duration of an interpretation is not prudent planning. In fact, it dismantles the essence of what

drives not just music, but every creative art. A concert's balance is calibrated by an invisible inner gauge that an artist develops over time. Each concert is an experience in itself; every composition or improvisation is born from the creative impulse of the day. To destroy this was simply another way of belittling MS's musicianship. It is quite unfathomable that an artist of MS's calibre was tied down by rules set by a non-musician, even if it was her husband.

To top it all, there was the Shankarabharanam quagmire. If ever a person can be said to have epitomized a raga, MS epitomized raga Shankarabharanam.[24] It is said that Sadasivam invariably wanted her to present it as the main feature of her concerts, believing that this would lead to the success of the performance. MS would gently protest now and again, expressing a desire to sing perhaps the Bhairavi or Saveri ragas instead, only to be vetoed.

Ragas such as Shankarabharanam and Kamboji possess the *swara*, known as *anthara gandhara*, a sharper variety of the *swara* we sing as 'ga'.[25] *Anthara gandhara* can be used as an anchor in the higher octave, especially while rendering the *alapana*. Using it as a sustained note, an artist can weave multiple phrases, particularly in faster speeds, leading to a theatrical climax. In MS's music, almost every time, as she ended her dramatic explorations at the *anthara gandhara*, she sang a final flourish that took her to the *panchama* (the *swara* 'pa') in the higher octave. This always won applause.

Perhaps Sadasivam's fascination with Shankarabharanam came from its capacity to generate applause, rather than any real musical feeling for it. It led to the perception that MS was incapable of rendering other ragas with the same ease as she did Shankarabharanam. She changed the *kirtana* [an elaborate musical composition, often the central component of a performance] that she presented in the raga every time, but some listeners began to grow bored. Everyone forgot that her interpretations of Anandabhairavi or Kharaharapriya were just as gorgeous.

A fundamentally more serious charge was levelled against her creativity. Many Carnatic musicians and *rasika*s will say that MS's improvisations were rehearsed and pre-planned; that she was a mere reciter. At face value, this rings true. There is no doubt that her *alapana*s, *neraval* and *kalpanaswara*s – all types of improvisational techniques – operated within a frame, and with a kind of route map already drawn within the outlines. She was certainly not a creative genius of the order of, say, the *nagaswara* maestro T.N. Rajaratnam Pillai.[26]

But the truth is more nuanced. This did not mean that every *alapana* MS sang was a photocopy of a previous rendition. It is worth noting, too, that others of great repute have followed the same custom no less assiduously. The improvisations of Ariyakudi Ramanuja Iyengar,[27] the godfather of twentieth-

century Carnatic music, also adhered to a plan and structure. There was most certainly ideational repetitiveness in his performances. But I have rarely heard anyone bravely proclaim that he lacked the creative spirit. Instead, Ariyakudi is revered as the *margadarshi* (pathfinder). No musician would dare question his abilities. Musicians such as D.K. Jayaraman and K.V. Narayanaswamy also followed templates, but their music is seen as spontaneous, in-depth and thoughtful.[28]

MS was, and is, an easy target. She was often considered more of a parakeet than a nightingale, though her *alapana*s, *neraval* and *tanam* renditions were free-flowing and intuitive. There was never any indication of artificiality in her vocalization, or in its creative development. I would argue that the same cannot be said of D.K. Pattammal, the critics' favourite, whose *alapana*s were creatively limited, and whose articulation was laboured. *Rasika*s do not complain about this.

A third front of criticism had to do with the fact that MS practised regularly with her accompanists. Customarily, Carnatic musicians do not sit together and practise; they meet on stage. In fact, such rehearsals are scorned: the assumption is that musicians who require them are incapable of creativity on the fly. But MS and her team practised extensively, and the overall effect in performance was impeccable.

This was especially evident in the 1960s, when her accompanying musicians were V.V. Subramaniam on the violin, T.K. Murthy on the *mridangam*, V. Nagarajan on the *kanjira* and Vikku Vinayakram on the *ghatam*.[29] Listening to this team can sometimes give the impression that there are three human voices: that of MS, of her step-daughter Radha who provided vocal support, and of V.V. Subramaniam's violin. The percussionists always seem to know exactly how to respond to every movement in the melody.

While devotees of MS will argue that the rehearsals only enhanced the listening experience, I must accept that there is some weight to this criticism, since, to my mind, there is a flaw in this conception of what is perfect. MS sought a unified, error-free concert presentation, and accomplished that. Whether that made her concerts great art is another question. The experience of life, after all, is not one of correctness. Perfection is the search for the pure, experiential quality born from surrendering oneself to art. The artist gives her all, and stumbles upon perfection by accident. It is quite possible that there will be moments of technical imperfection in that process. Yet, when such perfection is attained, it takes us beyond the personal to the abstract.

But what was behind this obsession with practice? Over time, MS had come to represent a flawless human being, and become, in the public eye, a haloed personality, complete in every sense. Her graceful saris, her measured words,

Ye peoples of

her hair-do, even the way flowers adorned it – everything was perfect. South Indian Brahmin women began to emulate the MS demeanour. The music of such a blemish-less person had, of course, to be mistake-free. A false note from MS was unimaginable. There could not be a stumble, let alone a fall. Her concerts had to be as impeccable as her personality. Repeated practice was the best way to achieve this.

MS never tired of it: she was willing to sing a song a hundred times if needed, and she did. Her moments of ethereality came in spite of this, not because of it. Throughout her musical life, there were unmonitored moments in which the MS of Madurai made a guest appearance, stunning us with a phrase that illuminated the horizon, like a flash of lightning over the open seas. If the initial freedom heard in her music is anything to go by, we may well have witnessed spectacular creativity from her if she had been allowed to just be.

By 1970, MS had been singing for nearly four decades. She was also constantly doing what someone or the other expected of her, rather than what her genius expected of her. The songs she sang on stage were always meant to please some constituency. Her singing itself was about satisfying what her husband saw as music. She had become mother, woman-saint, deliverer and model, as well as singer.

Sadasivam was a man of great integrity and self-respect, but he submitted himself to the political and corporate hierarchies of the time. His long and close association with Rajagopalachari, and his involvement in the latter's Swatantra Party, drew him into many circles of power. MS was constantly singing, both informally and formally, at gatherings organized by her husband, either in their own large residence, Kalki Gardens, or at those of others in their circle. Ever so often, it was to please or felicitate visiting bigwigs from elsewhere in India or abroad.

No count exists of the number of such performances; they must run to several hundreds. I wonder what the musician in her felt about these indulgences. I don't have an answer, but I can speak as a musician myself: such concerts most certainly belittle the seriousness of music. I am referring not to spontaneous renditions of a song, but to situations in which MS's art was taken for granted.

By the 1980s, she had toured and been honoured across the globe. She had sung at the United Nations. She received the Ramon Magsaysay Award in 1974. In 1998, she was awarded India's highest civilian decoration, the Bharat Ratna, becoming the first musician to receive that recognition. It would have pleased Sadasivam immensely, but he was no more by the time she received it. The Carnatic community may have criticized her art, but it had to accept her stardom and offer her recognition, even if murmurs about her musical ability continued. Since unabashed adulation had come from the outside, she received grudging acceptance from within.

But in all this, where was MS? Did she even know where to find herself? These are difficult questions, and I do not raise them as an insider who was privy to her personal life. A musician's personality is revealed from the music she offers us. In MS's case, the signals were all too confusing. Her sincerity was unquestionable, yet there seemed to be so many acts and facades. These were not put on to cheat her listeners; she internalized her roles to such an extent that she was subsumed within them.

It is unanimously agreed that MS was a kind, humble human being, who bore no one any malice. She was soft-spoken, and never rude. Her laughter occasionally lit up a room. But she was also a mystery. Access to her was restricted. The outside world knew nothing of her musical process. We may never know how deeply she thought about her music.

MS was certainly not a tortured soul, but there was a sadness in her, and I think it may have emanated mainly from the restrictions on her musical life. I am not saying that she did not love all that she sang, but she knew that it was not on her terms. She knew, moreover, that she would die without getting her real due from the Carnatic world. It was in singing bhajans and thumris that she received approbation, but it was in the *kirtanas*, *padams*, *thillanas*, *varnams*, *viruthams* and *javalis* – all types of Carnatic composition – that she sought validation.[30]

Set everything else aside for a moment, and try and inhabit the 'MS space' – where an intangible, intense, deeply moving moment arises, and takes your breath away. There is something there that comes from the depth of a partnership between the singer and the sung, the two in a union that is both private and open for all to hear and witness. When MS sang with all her being, which was invariably the case, she sang with her eyes closed, lost to us.

What was she? What did she find? I have dissected her music, even said that she performed to please others, and gave herself up to do what her husband said. I am now saying something that contradicts all that – or am I? Once engulfed by the music, an artist finds a freedom and openness within, even if everything constructed on the exterior is limiting. So, is there more to the 'divine MS' experience?

I have struggled with this question for a very long time, because the power of MS's music is irreplaceable, and incomparable. I have one probable answer. I do believe she was unable to be fully herself. The scaffolding around her was Sadasivam's construction, and she had to remain within it, grateful for the security that it provided. Musically, too, she was locked in a vault. But when she sang, forgetting everything around her, all her suppressed sadness, regrets and experience burst into music.

It is this honest and pure outpouring that still shakes us. Her art was MS's only outlet. Every time she sang, she allowed every moment of her life experience to imbue the melody, letting go of all her inhibitions, abstracting herself into the raga. Once in a great while, we experience an unadulterated sense of what is real, so tender and vulnerable that our fences break down when it touches us, and we see ourselves like never before. MS, more than any other musician, can gift us these moments of self-realization.

She is an unsolved mystery to me. Every time I engage with the idea of her, a new strand appears. Her life and history is open to many interpretations. Since she herself said so little about it, we can only grapple with third-person narratives, and use her music as a window into who she was. Her emotions were bundled up so tightly that even her closest friends and family saw only glimpses of her inner struggles, each one taking away his or her own personal impression like a private trophy.

She was determined, strong, focused, committed and brave. She was also introspective, innocent and fragile. The Carnatic world, for its part, has simplified her music and boxed it into either of two categories: the celestial, or the ordinary. But her music was both, and everything that lies in between. She, and her music, will never cease to bewitch us. They will only ever continue to raise the unanswered question about where the real MS resides.

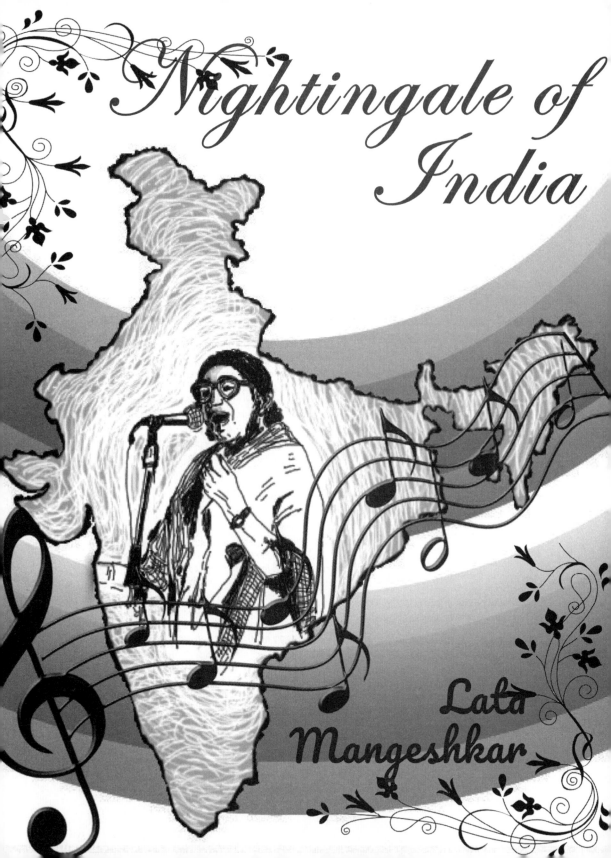

Lata Mangeshkar (b. 1942) is renowned as India's most famous female singing voice with a career that dominates popular music in post-Independence India. Her fifty-year career, known primarily for doing 'playback' singing (with her songs lip-synced by female stars), has been controversial for several reasons. Among these reasons is her widely emulated production of a 'clean' femininity, at a voice pitch many consider unnatural, and a style of enunciation that sharply differentiated her from what many in post-independence India saw as a fraught style of female singing often associated with courtesan performance traditions.

This is an arc of three texts, comprising a long and spirited debate on Lata Mangeshkar's vocal persona. Sanjay Srivastava argues that Lata's voice and persona is as though a manifestation of Nehruvian 'five-year plan' developmentalism. Ashwini Deshpande's response delves deeper into Lata's repertoire, gesturing to the range of characters the latter has voiced. To conclude that her voice represents only one kind of Indian woman is to flatten this heterogeneity. Lakshmi Subramanian joins the conversation to highlight a longer history of the ways in which women's voices have served to frame gender identity. The three texts must be read not only for the arguments they proffer, but also as performances in themselves, for the ways in which each new text unravels the other.

Earlier version published in *Economic and Political Weekly* (vol. 39, no. 20, 15–21 May 2004, pp. 2019–28). Reprinted with permission from the journal. Grateful acknowledgment to Sanjay Srivastava for help and support in assembling this version.

Keywords

All India Radio, Bhakti, Gharanas, Ghazal, Hindustani Sangeet, Kotha, Playback singing, Sanskritic/Sanskritization, Tawaif: see Keywords (pp. 329–44).

Five Year Economic Plan: A showpiece of both the independent Indian state and a nationalist modernism, the Five Year Plan was launched in 1951 and lasted till 2014.

Meerabai: Sixteenth-century saint-poet, author of several popular devotional songs in praise of Krishna, sung by Lata Mangeshkar and also by M.S. Subbulakshmi (see T.M. Krishna's essay in this volume).

Sangeet shastra: The rules that define classical music or *shastriya sangeet* (see Keywords, pp. 329–44, for more).

Images

p. 163: Montage of Lata Mangeshkar as the 'Nightingale of India'.

pp. 165, 168: Actors Jaya Bhaduri and Amitabh Bachchan in scenes from a Lata song in *Kabhi Khushi Kabhie Gham* (dir. Karan Johar, Hindi, 2000).

p. 173: Playing a courtesan, the actor Meena Kumari dances in *Pakeezah* (dir. Kamal Amrohi, Urdu, 1972), for which Lata sang seven of eleven songs.

p. 177: (Background) Zeenat Aman in the title track of *Satyam Shivam Sundaram* (dir. Raj Kapoor, Hindi, 1978), voiced by Lata. (Inset) Zeenat Aman in 'Chura Liya Hai Tumne Jo Dil Ko' (You Have Stolen My Heart), voiced by Lata's sister Asha Bhosle for *Yaadon ki Baaraat* (dir. Nasir Hussain, Hindi, 1973).

p. 181: Madhuri Dixit and Renuka Shahane in Lata's 'Wah Wah Ramji' (Wow, Lord Ram!), sung for *Hum Aapke Hain Koun* (dir. Sooraj Barjatya, Hindi, 1994).

SANJAY
SRIVASTAVA
2004

12 Voice, Gender and Space
in the Time of Five Year Plans
The Idea of Lata Mangeshkar

This article explores Lata Mangeshkar's artistry to
investigate the processes through which her voice and
singing style became the ideal of Indian performative
femininity. It examines the stabilization of gender
identities through a number of elements of Indian
modernity, including nationalism, Hindu identity, the
'woman question', representations of space and also,
the cultural meanings of the Five Year Plans.

This is a comment on how, over four decades or so, a
particular female singing voice, with its specific tonality
and modulation, became an expression of gender
identity in India. And, given the interactional nature
of gender, it is also about the cultural politics of Indian
masculinity. The intent is to explore the stabilization of
gender identities through specific elements of Indian
modernity: a nationalist discourse in which 'woman' as a
sign has fluctuated between the poles of the mother and
the sexually dangerous being; cinematic representations
of Indian culture; the relationship between performer
and audience in Indian music; the cultural production

of space; the relationship between India's provincial and metropolitan cultures; the discourse of centralized economic planning; and the relationship between orality and literacy in popular culture.[1] These topics are explored through the career of India's most famous 'playback' singer.

Lata, Femininity and the Space of the Nation: Sweetness and Style

This discussion is not concerned with whether Lata's voice is 'good', 'bad', 'authentically' Indian or otherwise. Rather, it looks at tendencies that have gathered around her singing style that attribute to it the characteristics of both 'good' and 'authentically' Indian-feminine. What follows is not an argument about causality.[2] And though the discourse of nationalism looms large in what follows, this should not be taken to mean that projects of modernity can simply be reduced to it. Clearly, nationalist ideology is only one of the grids upon which post-colonial modernity is situated.[3] So, while I primarily concentrate on pleasure as a nationalist project, it clearly does not exhaust inquiry into the topic.

During the last as well as current century, Indian popular music has mainly been connected with films, and while in early films many songs were sung by the actors themselves, during the 1940s, this practice gave way to 'playback' singing where the actors' singing voice was provided by someone else.

As is well known in India, singers are not necessarily stars in themselves and, till quite recently, commercial music was sold in the market under the banner of the film with which the songs were associated. Singers cultivated little public presence, and rather than the personality of the singer, it was their voice that functioned as a sign. This situation has only recently begun to change, and still can't be compared to that of western pop music.

Born in Indore, as a child, both Lata Mangeshkar (b. 1929) and her sister Asha Bhosle[4] learnt music from a series of accomplished musicians. Lata recorded her first song in 1942 and since then has, reputedly, sung in eighteen Indian languages. One source estimates that by 1991 she had recorded around 6,000 songs,[5] while journalistic accounts speak of a substantially greater corpus. Among female playback singers, then, Lata's voice has dominated the Indian popular music scene.

Along with this dominance, she established a specific vocal style: and if 'vocal style (aside from the language) is the single most important marker of aesthetic identity',[6] then it can be argued that Lata's singing voice has instituted a very specific identity for Indian womanhood, which has almost no precedence in traditional forms of Indian music. In other words, the 'woman' conjured by Lata Mangeshkar's singing voice was the product of certain developments peculiar to the processes of Indian modernity.

One music critic has noted that Lata's style has become 'the ultimate measure of sweetness in a woman's voice. (And that) its chief characteristic was the skilled use of a particular kind of falsetto which did not exist in quite the same way before her coming'.[7] Another suggests that, as singers from musical genres with their own distinct style began to mimic Lata's voice, it soon 'became difficult to imagine a female voice that is not Lata Mangeshkar's'.[8] There is, it could be said, almost no precedence for Lata's voice – in the wider sphere of female singing styles in India, notwithstanding their extraordinary diversity of expressive traditions. Such diversity is especially significant as we think about just how Lata Mangeshkar's shrill adolescent-girl falsetto would come to establish itself as the 'ideal' in 'Indian popular music and film culture in general'.[9]

My illustrations cannot of course do justice to the constant play of historic inventiveness that is grouped under the rubric of Indian music; and hence, the random sample presented here should only be regarded as a niche in a complex landscape. The mélange of female singing styles found in the subcontinent ranges from group singing at family ritual occasions (a wedding being the most common), to organized public performances. In some instances, many earlier ritual-linked performances have become part of the commercial performance milieu.

No matter what the context, women's singing in India – at least those not connected with the film industry – has been marked by a striking heterogeneity of tonal and other styles. So, if the *dholi gayikayen* of Jodhpur[10] sing of a wife demanding jewellery from her husband in 'heavy' and nasal tones, then the Hindustani classical music singer Gangubai Hangal's[11] delivery ranges between the low alto and the upper tenor ranges, frequently confusing unacquainted listeners as to her gender. And, though the artiste's gender is not difficult to determine in the case of an early (1911) recording by the Hindustani classical music virtuoso Zohra Bai,[12] her voice is nevertheless imbued with a quality best described as playful aggressiveness.[13] The ghazal singing of Pakistan's Farida Khanum[14] provides another example of this heterogeneity. Khanum's voice, alternately sensuous, pleading and cajoling, manages to reproduce the complexities of a subject position that is a combination of 'a desperate lover intoxicated with passion, a rapt visionary absorbed in mystic illumination, (and) an iconoclastic drunkard celebrating the omnipotence of wine'.[15]

One perspective, which seeks to account for the dominance and the subsequent stylistic homogeneity ushered in by the Lata style, speaks of the 'creation of film music as a common-denominator mass-music style, produced in corporate, urban studios and superimposed on a heterogeneous audience; this audience has no active role in the creation of this music, and can exercise only indirect influence by choosing among the songs and styles proffered by the

industry'.[16] However, this standpoint can only be usefully supplemented through an analysis of the wider cultural and historical dynamic that constitutes the field of the aesthetic, thus influencing the representation of identities, including gender identities. A consideration of the discourse of early Indian nationalism may be a good starting point towards such an objective.

Feminist scholarship has pointed out that 'woman' functioned as an important sign in the masculinist constructions of the idea of nation-to-be, in turn represented by the 'mother-who-is-the-nation'.[17] In some versions, this was achieved through representing India as a Hindu goddess.[18] However, this formulation engendered a specific problem for nationalists, in that 'the image Woman (could) be perceived to contain a charge of sexuality which always threatens to run free'.[19] How, then, to deal with this dilemma? In part, it is suggested, the resolution of the 'woman question' was achieved through identifying women not just as the *carriers* of 'tradition' but as *tradition itself*: women's *bodies* became the site on which tradition was seen to be.[20] I have suggested elsewhere[21] that, persuasive as it may seem, this formulation bodes caution, for it may capture only one of several scenarios; that the *public* life of the Indian *family* – and 'its' women – also had a role to play in debates about engagements with modernity. The following discussion seeks to explore this very public dimension of the 'woman question' in the career of Indian modernity through the pervasive influence of a singer who has, as if, crafted an entire structure of emotions in the post-colonial era.

With the coming of cinema, the tableau of public forms became inextricably attached to the possibilities of cinematic representation and men and women becoming public figures attached to both natural and human topographies. This might have been a result of the particular interpretation of the term 'culture' that emerged during the modern period, an interpretation to which filmic techniques had almost a natural affinity. I refer to the understanding of culture as linked to geographical places,[22] and to landscape,[23] attached to specific natural and human-made sites: so Indian culture is linked now to the Himalayas, to hill-stations, to the Ganges and the Taj Mahal, and to ruins of past 'civilizations', religious sites, and office buildings, all of which constituted the representational iconography of the fledgling nation state.

The relationship between geography and the nation may have received scant attention from scholars of India, but was explicitly recognized by nationalists of various hues. One of the pithiest examples occurs in the article 'Future Education of Indian Woman' by Sister Nivedita (Margaret Noble).[24] A fundamental aspect of women's education in India, Sister Nivedita was to say, must lie in making women more 'efficient'. This called for, among other things, the making of 'queen and housewife, saint and citizen'. Such an

'efficiency drive' towards a new society, the Sister noted, required that women be imparted a geographical sensibility, for geographical knowledge constituted the fundamental building block of the consciousness of national feeling. This might be achieved through resources already at 'our' disposal: 'the wandering *bhagabata*s or *kathaka*s, with the magic lantern, may popularize geography, by showing slides illustrative of various pilgrimages':[25] 'Picture, pictures, pictures, these are the first of instruments in trying to concretize ideas, pictures and the mother-tongue. If we would impart a love of country, we must give a country to love. How shall women be enthusiastic about something they cannot imagine?' It can be argued that the above derives from a 'modern' view of culture as a territorialized and fixed concept,[26] rather than as the relationship between human beings. It is precisely this modern – 'realistic' – sensibility of landscape and territory that found play in early cinema.

However, a sensibility of culture as a relationship *between humans* rather than with *fixed space* could be found even during the modern period. A Marathi book published towards the end of the last century provides a tantalizing glimpse into this alternative world view. The book – *Majha Prawas* (My Journey)[27] – is an account of the travels of the Brahmin Vishnubhatt Godse from Pune to Mathura sometime in 1857. For the modern reader, Godse's travelogue can be strangely disorienting. Familiar and comforting descriptions of scenery and landscape are almost entirely absent in an account that is, instead, teeming with people, procedures and transactions. We can only begin to comprehend this transactional sensibility if we think of it as part of a very different understanding of culture to what we have become accustomed. It is, in fact, a different way of organizing culture.

When Indian culture becomes attached to landscape and territory, Indian cinema's heroes and heroines also meet, and sing and dance, in places that come to constitute India's cultural and national spaces. Herein lies one of the problems for the 'woman question' in India, in which Lata Mangeshkar has been particularly helpful.

Many of these spaces of Indian culture were public spaces, i.e. 'not home'. An important aspect of 'culture', once it becomes attached to territories and landscapes, is its public nature. How, then, was the 'fraternal contract'[28] of nationalism to deal with an increasingly visible filmic woman who was so clearly 'out of place' in public spaces? What was at issue was not just *visibility* but also – given the 'musical' nature of Indian cinema – the *audibility* of women in public spaces. Indian films at once contributed towards the consolidation of a national imagination on a mass scale – these sites are India, they said – yet simultaneously seemed to pose a threat to one of nationalism's fundamental organizing principles – the positioning of women within it.

It may well be that Lata's stylistic innovation offered a viable solution to the problem of representation in the public sphere: for, as women's bodies became visible in public spaces via films, their presence was 'thinned' through the expressive timbre granted them. The heroines for whom Lata provided the singing voice may well have been prancing around hill-sides and streets while performing a song-sequence, but this gesture, which otherwise threatened male dominance of these spaces, was domesticated through the timbre, tonality and stylistic stricture that marked that presence. The potentially powerful image of the heroine enjoying the freedom of public spaces in equal measure to the male hero, and singing in a voice that may express an ambiguous femininity, was, through Lata's voice, undermined.

However, it is not enough to say that Lata provides the bridge between colonial–nationalist history and modern cinematic problematics of representations. Her 'art' is fundamental to another process of modernity: the recasting of the relationship between performer and audience. Writing at the turn of the century, Ananda Coomaraswamy made a profound observation about Indian music, that the relationship between performer and audience is one where the audience also brings an *artistry to listening*: 'the listener (responds) with an art of his own',[29] and further, that 'the musician in India finds a model audience – technically critical, but somewhat indifferent to voice production'. The artistry of the performer, in other words is not (or was not) hegemonic, since it faced the skill of the audience in receiving the performance. It is not, therefore, 'the voice that makes the singer, as so often happens in Europe', Coomaraswamy noted.

Lata Mangeshkar manages to break this dynamic relationship between the performer and the audience,[30] imposing a code of interpretation through the dramatic emphasis on the singing rather than the song, through the 'sensuous perfection of the voice',[31] where the feminine can only be articulated through a constricted timbre and style. The audience is now instructed on what femininity is.

One of the ways to achieve such dominance is illustrated in the relationship between orality and literariness.[32] The wider context in which the audience exists as an active entity, with *its* own artistry, is also one where 'orality' remains a valued mode of interaction: the performative contexts of orality are situations where the listener may talk back, interrupt and re-interpret. Here, the artistry of the performer is not reduced to any singular characteristic, and certainly not the voice. Such a mode finds strong support in contemporary scholarship in the absence of any discussion that seeks to define a norm for voice quality in Indian performative traditions. Susan Wadley's discussion of the 'performance strategies' of the artists of the north Indian epic of dhola is a case in point. The great popularity of the most highly regarded of these, Ram Swarup Dhimar, is

due to 'his magnificently expressive voice – *covering a range of performance styles*'.[33] There is no suggestion here that any one particular type of tonality is considered to be the mark of 'good' singing. Effective performances of dhola depend on two things: 'telling the story in a clear fashion and providing variety'.[34] Since 'traditional' Indian music was not written music, it belonged to this milieu.[35]

Lata's music, however, derives from a 'compositional' context: for 'the elaborate arrangements (of Indian film music) reflect a precomposed and notated (i.e., written) approach to music composition and performance'.[36] The compositional (or literary) mode of performance defines a new relationship between performer and audience, between reader and text – a sensibility that potentially privileges the 'expert' and disenfranchises the 'lay-person'. In this sense, Lata's voice becomes the unquestionable authority on the feminine ideal and, inasmuch as that ideal becomes entrenched, it limits the artistry of the audience receiving the performance. Here, the consolidation of 'literariness', as an aspect of Indian modernity, served to codify representations of femininity.

Lata's adolescent-girl-voice for the adult-woman comes to establish the *authority of the written word* over the recalcitrant possibilities of *orality*, overriding the 'substantial amount of melodic, rhythmic, and textually expressive play'[37] that marks the latter's expressive universe. Through the historical association of writing with men, this also legitimized the authority of male notions of the sign 'woman'. Simultaneously, this established the dominance of bourgeois notions of gender, communication and being in the world, marginalizing other existing world views. In this sense as well, it was expressive of certain contexts of Indian nationalist discourse, making Lata's voice the simultaneous site of both gender and class.

When Lata did give public performances it was, as Manuel points out, just as likely that she would stand rigidly on stage, singing with her head buried in a notebook. Firstly, what matters here is the voice and the way it is defined by the 'notebook' and the authority of the written text. And secondly, Lata's own public persona (on record, cassette and CD cover sleeves, and in magazines) is of the respectable housewife, perhaps even a mother, though a mother of the nation who has given that nation a voice; '[f]or the very heart of India throbs in your voice', as the lyricist Naushad Ali was to write in a ghazal in praise of Lata.[38] Lata's motherhood lies, however, within the realms of the 'virgin mother'. It is important to note that Lata has almost never been dogged by relationship-linked gossip that surrounds many other women in the entertainment industry. In addition to the virgin mother thematic, there is (to resort to culturally mixed metaphors) also an aura of the cult of Meera – the medieval princess-poetess and an iconic figure in the Bhakti movement – about her. Like the Bhakti poets, Lata too has forsaken her sexuality and domesticity for devotion to a greater cause –

the endowment of national pleasure through a redefinition of modern Indian feminine identity. And, in the process, she has become iconicized as the virgin mother (sister?) of the nation.

Reclaiming the Past, Cleansing the Present

The processes through which Lata's voice became established as the aesthetic epitome of Indian feminine identity can also be seen as part of the making of the 'modern' Indian woman within an upper-caste Hindu milieu. It was, thus, part of the broader processes of nationalist thought in which the figure of the woman-citizen, as object of debate and discussion, emerged out of the skein of colonial and post-colonized caste and communal politics.

Discussing radio broadcasting in India, David Lelyveld suggests that the Hindu-Muslim context is important for understanding 'national programming', and the attempt to inculcate a 'national' culture through the All-India Radio (AIR).[39] Though Lelyveld mainly explores the manoeuvres through which Indian classical music was sought to be Hinduized in the immediate post-Independence period, there is also an important link to be made between that discussion and the case of Indian film music.

Post-Independence, the 'Hindu-Muslim' angle, in the context of producing a 'national' music culture, came to the fore in several ways. And, inasmuch as the post-colonial nation-state's cultural capital[40] – its 'ancient heritage', its various architectural landmarks, its philosophical and cultural achievements, etc. – received as much attention as the debates around its economic capital, the task of producing a 'national' musical culture became especially prominent. These debates were intrinsically linked to the supposed fate of Indian music during colonial rule. So, B.V. Keskar, Minister of Information and Broadcasting between 1950 and 1962, would suggest that 'only with national independence, and indeed, primarily through radio broadcasting . . . could the musical heritage of India be saved'.[41] Keskar did not believe that the blame for the lamentable state of Indian music could be traced exclusively to occidental disdain for oriental cultural forms, or to 'imperial neglect' of native traditions. He unequivocally believed that the deleterious effects to which it had been subject also derived from the actions of north Indian Muslims. This community, he suggested, 'had appropriated and distorted the ancient art, turning it into the secret craft of exclusive lineages, the gharanas, and ignorant of Sanskrit, divorced it from the religious context of Hindu civilization'.[42]

Keskar's thinking on Indian music was, then, heir to the history of a 'Hindu contextualism'[43] of the late nineteenth- and early twentieth-century nationalist

discourse in India. He was not alone in his elaboration of this theme.[44] These ideas formed an important sub-text in debates regarding the development of a 'civil' post-colonized identity, and constituted the backdrop to the attempted Hinduization and gentrification of Indian culture. Lelyveld points out, for instance, that under Vallabhbhai Patel's reign as minister for information and broadcasting (1946),[45] the effort towards producing a purified national culture was manifested in the prohibition of 'singers and musicians from the courtesan culture' – any one (as one source put it) 'whose public life was a scandal'.[46] As well, during Keskar's tenure as minister, there came to be instituted a bureaucratic selection procedure for the All-India Radio musicians whose most explicit aim appears to have been the undermining of the gharana system. An important outcome of this process of linking employment possibility within AIR with 'certification from recognized music academies'[47] was the entry into the profession of many who were described as being from 'respectable' backgrounds; those, in other words, who had skirted the illicit influence of the Muslim-dominated gharana, and allied systems of performance.[48] All this is to say that within early twentieth-century nationalist discourse there existed a strong theme which linked the emergence of the modern Indian self to a 'pure' and 'ancient' Hindu genealogy[49] and a 'respectable' bourgeois milieu.

An additional way of thinking about this issue is to suggest, as Lelyveld does, that 'the great enemy in this effort to construct a new music by administrative decree was the increasingly popular new style of film songs'.[50] However, it is possible to say that the ideology of a 'pure' and 'respectable' national culture found voice in the realms of popular (that is film) music itself, Lata Mangeshkar's singing style being the most obvious manifestation of that process. The gradual development of her singing voice into what it became at the peak of her popularity (her very early singing style carries strong resonance of the Pakistani singer Noor Jehan's[51] nasality) was part of the process of purifying – both *Hinduizing* and *gentrifying* – the 'ideal' post-colonial Indian woman, the woman fit to carry the mantle of 'bearer of our traditions'.

From the beginning, the make-up of the Indian film industry caused consternation among the votaries of a national 'purification' project linked to a 'great' Hindu past. The grounds for such disquiet had been well prepared. The nineteenth-century journalist and cultural critic Bhartendu Harishchandra (1850–85) had lamented that both Jains and Muslims were responsible for the destruction of Indian *sangeet shastra* [principles of music] and that when 'Muslim emperors such as Akbar and Muhammadshah did pay any attention to it, they only favoured Muslim musicians and this led to the further decline of Hindu artistes'.[52] Similarly, in founding the first of the publicly funded Gandharva Mahavidyalaya

music academies (1901),[53] Vishnu Digambar Paluskar sought not just to introduce an emerging middle-class to musical training but also to situate such training, and hence the identity of this class, within a specific *moral* landscape. So, one writer has noted that 'while there was strict discipline (at the Mahavidyalayas), there was stricter discipline in moral training. The usual odium attached to the clan of musicians was thus removed and they began to be treated with respect'.[54] Given the predominance of the gharana tradition, the point that 'the clan of musicians' acts as metonym for 'Muslim performers' need hardly be belaboured.

In the early twentieth century, then, many, no doubt, were able to read Bhartendu's comments and Paluskar's efforts as a 'correct' evaluation of the Muslim influence upon (Hindu) Indian society. And, further, they may have surmised, this could now be witnessed in another sphere of Indian life, namely, in the newly established cinema industry. For it is possible to speak of a Muslim 'cultural influence that has determined the very nature of (Indian) cinema'.[55] From its personnel to the film-titles, to the language of the screenplays and lyrics, Hindi cinema was deeply shaped by Muslim influences.[56] The most obvious manifestation of this was of course, the predominance of Urdu. The 'low prestige of the cinema'[57] as a professional calling has been commented on by film scholars, and my discussion here attempts to place this in the context of turn-of-the-century nationalist discourses on gender and religious identity in 'modern' India.[58]

It is this context, where 'Muslimness' and 'debauchery' became conjoined through an emerging discourse of middle-class Hindu respectability, that would frame the project of post-colonial purification, and Lata's voice would be one of the sites of this purge, albeit a partially successful one. While classical music was itself an explicit target for the 'reform' project, equally targeted was the mass appeal of the film industry and its by-products, given that the 'good' name of the nation, and the risk posed to it by the retrograde tendencies of its masses, defined the responsibilities of the enlightened citizenry and its role in shepherding these masses in the direction of citizenship and civilized action.

Through Lata's artistry, the 'disreputableness' of ambiguous tonalities and the threat of uncertain femininity – the *mise-en-scène* of Krishna Sobti's great novel *Mitro Marjani*,[59] for example – was brought into alignment with a 'pure' and controllable Hindu womanhood. The most obvious counterpoint to Lata's style was the *kotha* (the courtesan's room or, effectively, brothel) style of singing, echoes of which can be discerned in, say, singer Shamshad Begum's[60] voice. It is difficult to convey the qualities of a voice – the social and emotional contexts it may conjure for the listener – in a discussion such as this. However, it *is* possible to say that, through historical processes of which the discourse of nationalism was perhaps the most important, public singing by women, unless connected

to religious and ritual purposes (such as weddings), came to carry the taint of disrepute; it became the preserve of the *tawaif* (the courtesan), the lower-caste woman or the 'tribal' woman.[61] And, the tonalities of such public singing which itself remained unfettered by the definitional constraints of a 'good' voice became associated with 'disreputable' – undomesticated – conduct.

Later, when the 'Muslim problem', and the search for a 'proper' – controllable – femininity (and hence a 'proper' masculinity) became part of the nationalist project of cultural redemption, certain kinds of voices came to be marked as an unacceptable aspect of 'proper' post-coloniality. There now emerged an inventory of 'impurities' with respect to 'proper' post-colonial femininity: included in this inventory, it is possible to say, was nasality and a 'heavy' (i.e., masculine) voice. And it was most commonly the Muslim *tawaif* who became inextricably connected to that kind of voice. In the redemptive projects of turn-of-the-century nationalism, she posed the greatest threat to middle-class Hindu masculinity: for she was dexterous not merely in matters of physical allure but could also, at least as far as popular mythology would have it, match wits with her male clientele.[62]

So, it is at this juncture – where a variety of modern processes of culture came together – that Lata's skill as a forever-adolescent voice, singing out, but through the controllable timbre of a child-woman, is situated. She provided another resolution of the 'woman question' in the post-colonial context: how to have women in public, yet within the firm grip of a watchful, adult masculinity, such that the public woman was forever infantilized.

The process of 'purifying' Indian public culture took the form, then, of purging it of its Muslim associations and its connections of various realms of (non-middle class) disreputability.[63] Lata Mangeshkar's voice, it can be argued, became the site for the unfolding of this project: a place at the crossroads of a public culture where the adolescent girl's voice-persona appeared to provide the opportunity of both expressing an appropriately modern femininity, and a suitably Hinduized nationality.[64]

Lata sometimes cancelled her recording schedules, Bhimani says, if she felt that her voice was 'not at its best'.[65] And, that it may have been a lapse in her judgement (as Bhimani portrays it) that led her to record the song '"*Paaon chhoo lene do . . .*" for Roshan's [sic] in *Taj Mahal*. [For,] It has a perceptible nasal twang to it'.[66] A few pages later, speaking of a pre-recorded introduction by Lata to 'an orchestral version of ten of her favourite tunes', Bhimani notes, 'Her voice was clear and soft. Like that of a girl on the threshold of adolescence.'[67] It is this heterosexual male fantasy of a Hindu adolescent girl – both controllable and ever-ready to please – that is an overwhelming aspect

of the desire that congregates around Lata's voice.[68] And, in keeping with the unbridled possibilities of fantasies, the voice that conjures the pliable adolescent girl concurrently facilitates the invocatory gesture that imagines the 'mother'.[69]

I do not, however, mean to present Lata herself as a passive figure, merely singing to the tunes ministered by her professional mentors. There is no reason to assume that she herself has not been an active participant in the project of 'fine-tuning' her voice to the point of its classic recognizability. In the end, the project of purification as mentioned above would remain incomplete: whilst the 'ideal' feminine voice of Indian popular culture did, in fact, become derivative of Lata's style, the Muslimness of Indian filmic culture also remained an inescapable fact. Throughout the post-Independence period, film titles and song lyrics continued to borrow heavily from Persian and Urdu, and many of the most prominent lyricists and actors were also Muslim. In fact, in several films Lata was the playback singer for Muslim on-screen characters, with the result that when she lent her voice to an on-screen *tawaif*, the *tawaif* sang with all the 'sweetness' of a girl-child![70] In these ways, the project of Hinduizing Indian public culture remained unfinished and may be best viewed as a contest over the cultural terrain.[71]

The Five Year Plan Hero

It is the context of twentieth-century development theory, expressed through the formulation of the Indian planning regime, that provides the next rung of my argument. For a fuller understanding of the sign of the filmic woman who embodies Lata's voice, we must turn to the filmic man whose identity is strongly linked to the nationalist economic development philosophy reified in the formulation and implementation of the Five Year Plans. I want, then, to link the discussion to representations of the male hero of the post-Independence era, and will refer to him as the Five Year Plan (FYP) hero.[72] The iconic presence of the FYP hero gained some of its legitimacy through both the Keynesian and the neoclassical models of economic thought, and he stood both for government intervention and for delayed gratification through the reinvestment of savings for the 'national' good. The FYP hero broadly represents a particular formulation of Indian masculinity, where manliness comes to attach not to bodily representations or aggressive behaviour but, rather, to being 'scientific' and 'rational'.[73] My gesture, in this context, is to the 'nation-building' hero – the doctor, the engineer, the scientists and the bureaucrat – who was such a key figure in the cinema of the period.

It is possible to argue that the scientific career – of an engineer, a doctor, etc. – as an avenue of social advancement was, and continues to be, more sought

after by the provincial middle-classes rather than their metropolitan counterparts. This is linked to the specific conditions of Indian post-coloniality where the vast majority of the provincial bourgeoisie has lacked the avenues for the acquisition of 'cultural capital'.[74] In other words, a situation where 'technical' qualifications are the prime means of social advancement for the provincial middle-classes. So in the metropolitan centres, a 'Pass' degree in English literature or history from certain universities and colleges was often sufficient cache towards well-remunerated employment in, say, the corporate sector; for here, 'social capital' (i.e., 'contacts') were also a part of the context. For middle- and lower-middle-class men from provincial towns and cities, however, technical qualifications provided the chief means of a reasonably secure livelihood, reflecting the differential development of metropolitan and provincial systems of education and the relationship between the English language and the 'vernaculars' in post-colonial societies. So, it could be argued that the FYP hero is, in fact, a representation of the provincial bourgeois male and the representation of women vis-à-vis Lata's voice expresses the provincial male desire to keep a check on 'its' women in a time of rapid change.

We might also consider reading the filmic romance of the 1950s and 1960s era[75] as narratives for the 'future development' of the individual. If we remember the asymmetry between Indian metropolitan and provincial cultural spheres, it is not difficult to speak of the provincial male (and female) as the subjects of the movie romance, and the complex role of the latter as the site of a narrative of a 'future development' denied by the economic process. To be 'in love', could then, in some but not all contexts, act as a metonym for 'freedom': the freedom to 'achieve', to individual choice, and, finally, to 'fulfilment'.[76] I suggest that the Hindi film of the above era was really a compact between those who *made* the film and those who watched it. The (provincial male) audience found itself fully represented on the screen (most songwriters and scriptwriters were in fact provincial men for whom the film industry was a means of employment that did not require formal qualifications). The 'check' sought to be imposed on filmic women through Lata's voice was thereby expressed in another way that foregrounds the provincial–metropolitan angle of my discussion. The heroine singing in a public place not only sang in an adolescent-girl voice, but also mouthed lyrics which, in addition to Urdu, also drew heavily from the various dialects of Hindi – from various provincial versions of Hindi that in this new 'national' incarnation, also Sanskritized them in order to give them a classical genealogy.

It could be suggested, then, that Lata's voice – her artistry – was part of the process where men from strong patriarchal backgrounds in the film industry sought to exercise control over the representation of women both through an expressive timbre as well as a vocabulary that resonated with a more 'controllable'

environment: namely, the village and the province. The city can, potentially, be a threat to male hegemony, and the presence of the screen-woman in its public places compounded this threat. So, if the heroine figure was infantilized through Lata's voice, she was also produced as familiar and speaking – or, rather, singing – in the language of 'home' and the controllable domestic space rather than a recently produced public sphere, the nation.[77]

However, it would be naive to posit a simple relationship between a 'modern' metropolitan milieu and the lack of patriarchal strictures; writers and thinkers such as Krishna Sobti, Fanishwarnath Renu and Rajendra Yadav[78] also tell us something about other sites of 'progressive' thinking. It may be more fruitful, then, to suggest that if the Lata complex emerged from the patriarchal concerns of provincial male culture, it was no less connected to the modernization of patriarchal forms prevalent in Indian metropolitan culture.

In addition to the 'scientific' persona of the FYP hero, it is also worth noting that his 'task' was usually positioned vis-à-vis the countryside: he acted to bring enlightenment to India's villages, a theme borrowed from, among others, orientalist and development theory-orientated discourses about 'irrational' peasants and their recalcitrance to the logic of modernity. Inasmuch as the heroine sang in her adolescent girl voice, and the songs were sprinkled liberally with words from village dialects, 'woman' also came to represent the village (or, province):[79] that which needed to be 'improved', to be made more 'rational' through the efforts of men who embodied the new knowledges which had made the west 'progressive', and India backward. The metropolitan theme has an important history in Indian nationalist discourse,[80] and it plays out in the case of Lata and her music, where men became the progressive 'metropolis' and women, the backward 'countryside'. The further 'imbrication of sexuality, sex, gender, and nature'[81] happens in Lata's case through the voice itself: the 'natural' identity of the woman is aligned to that of the girl-child, and hence adult femaleness is naturalized through associating the adult woman as forever closer to childhood, and thus also closer to nature.

Hence, either way – through 'traditional' provincial masculine politics or 'modern' metropolitan nationalist discourse – the sign of 'woman' continued to be inscribed through masculinist ideologies. 'Lata Mangeshkar' is the conjunctional site, then, of *prolix* technologies and ideologies of masculinity and patriarchy, colonialism, Indian nationalism, the relationship between the metropolis and the province, and that between orality and literacy, as well as the modern 'territorialized' understanding of 'culture'.

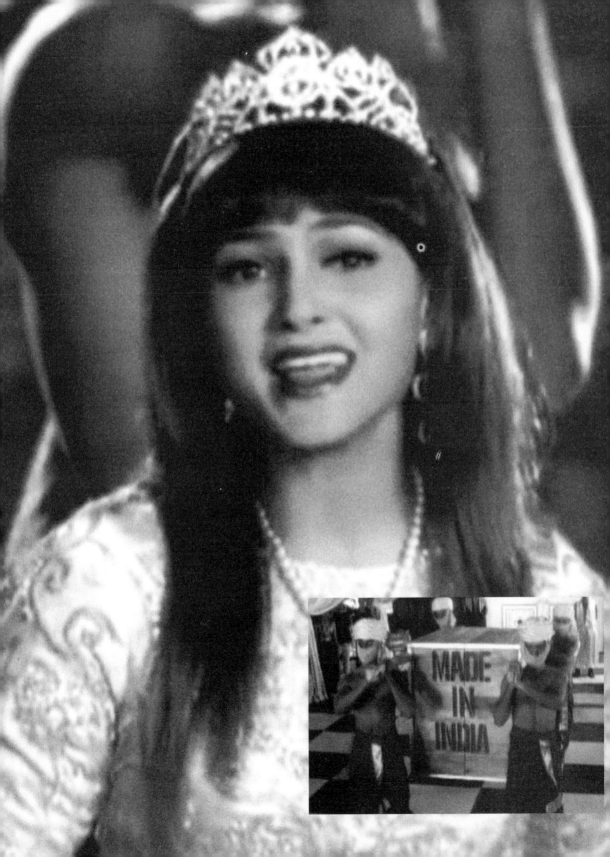

Sanjay Srivastava's argument about the singer Lata Mangeshkar, reproduced in the previous essay, led to an extended and occasionally acrimonious debate in the pages of the *Economic and Political Weekly*. The debate tended to focus not so much on Srivastava's key points on the era of India's modernization (represented by the Five Year Plans), which he felt contextualized the Mangeshkar style, but rather on his destabilization of her persona. Here, the economist Ashwini Deshpande challenges Srivastava on multiple grounds, both factual and interpretative, and for his generalizations about the properties of Mangeshkar's voice.

This is the second in an arc of three texts about the singing voice in Indian cinema and the ways in which it gestures towards an ideal Indian femininity.

Earlier version published in *Economic and Political Weekly* (vol. 39, no. 48, 27 November 2004, pp. 5179–84). Reprinted with permission from the journal. Grateful acknowledgment to Ashwini Deshpande.

Keywords
Gharana, *Ghazal*, *Hindustani Sangeet*, *Tawaif*, *Thumri*: see Keywords (pp. 329–44).

Images
pp. 183, 185: Photomontage of scenes from the music video *Made in India* (1995, Alisha Chinai).

pp. 190–91: (Background) Asha Parekh in Lata Mangeshkar's 'Kaanta Laga' (Pricked by a thorn) from *Samadhi* (dir. Prakash Mehra, Hindi, 1972). (Inset) DJ Doll's 2002 remix of 'Kaanta Laga'.

p. 196: Photomontage. (Inset) Amitabh Bachchan and Rekha in 'Pardesia, yeh sach hain piya' (O distant lover, it is true) from *Mr. Natwarlal* (dir. Rakesh Kumar, Hindi, 1979). (Background) Rakhi Sawant and Muzammil Ibrahim in a 2005 remix of the same song.

ASHWINI DESHPANDE

2004

13 Lata Mangeshkar
The Singer and the Voice

This is a detailed response to Sanjay Srivastava's *Voice, Gender and Space in the Time of Five Year Plans: The Idea of Lata Mangeshkar*. The article covers a wide canvas, but hinges on the voice and singing of Lata Mangeshkar and is in essence an analysis of a highly popular and successful singer with a career that has few matches in the history of popular music anywhere in the world. An academic socio-historical-political analysis of Lata Mangeshkar is indeed welcome. It would be fascinating to see how the musical and extra-musical persona of a hugely popular star becomes a site where ideas of nation and gender get played out. However, Srivastava's effort is likely to impede, rather than enable, such an analysis.

Perhaps the most striking fact about Sanjay Srivastava's (henceforth SS) article is that he does not feel the need to cite a single recording, either of Lata Mangeshkar or indeed of any other singer, in support of his argument. This is extraordinary. Would SS dare to discuss the music of, say, Bob Dylan without citing a single song, and expect to be taken seriously in the

western academic world? How can one analyse the voice and/or the singing style of a singer without any reference to her music?[1]

And this, about a singer who is believed to hold the world record for the largest number of recordings![2] The lack of citation extends to movies as well: the article makes a gender analysis of representation of women in Hindi cinema, into which Lata's voice allegedly fits, again without examples.[3] Since no evidence is forthcoming from the author about assertions he makes about Lata's music, we are expected to meekly accept his assertions, as if they are facts beyond dispute. Which, of course, they aren't – SS makes broad, sweeping generalizations that are simply not sustainable.

Having said this, I must confess that I am an economist by profession and am neither familiar with the language of cultural studies nor with the literature and debates in the area. However, I have been addicted to Hindi films and their music ever since I can remember. Thus, I have simply raised some questions that occurred to me as I was reading SS based on the films that I have watched and the music I have loved for decades.

The 'Falsetto'

The basic hypothesis in SS's article is that a particular singing voice, Lata Mangeshkar's, became an expression of gender identity in India. Instead of classifying Lata's voice as 'good' or 'bad', it might be better, SS says, to describe it more objectively in a manner more conducive to an analysis of her singing style. He describes her voice in a combination of subjective and objective terms, 'shrill adolescent-girl falsetto'. Let us consider first the objective part of the description, the falsetto. *The Penguin Dictionary of Music* defines 'falsetto' as 'the kind of singing (or speech) produced by adult males in a register higher than their normal utterance: this is the standard type of voice-production used by the male alto or counter-tenor voice and is sometimes specified (generally as comic effect, e.g., imitating women) in other voices'. Now, even if we ignore the fact that Lata is not an 'adult male', SS imports a technical term used in western classical music without sparing a thought about its appropriateness in the new context. There are very few examples of falsetto singing in India: fans of Kishore Kumar would recall a song from *Half Ticket* picturized on Pran and Kishore Kumar himself, where the latter dresses up as a woman and sings in both the male and female voices.[4] That is falsetto. Other than such exceptions, none of the major male playback singers sing in a falsetto. Narendra Chanchal's[5] voice is high pitched, but cannot be described as a falsetto.[6]

Since SS does not define a falsetto, his use of the term is an example of imprecise terminology and inappropriate borrowing across musicological cultures. Let us assume SS simply means that Lata employs a false voice to sing. He is wrong – her natural pitch is high and she sings with ease at *kali* 1 or 2 (C or D Sharp), which is usually considered the 'male' scale. At the high end, she is neither out of tune nor does she employ a false voice.[7] It needs to be noted that she is one of the most tuneful singers.[8] Does SS mean that she uses falsetto notes? This is a highly debatable point and needs a very careful study of the various scales in which she has sung and the highest notes she reaches in each. A worthwhile study but best left to musicologists. Finally, what is meant by a 'girl falsetto'? Women's voices do not change in the physiological sense in which men's voice break and change post-puberty. Thus, most women continue singing in the same scale throughout their lives: some move up a note or two with substantial training.

Thus, it is definitely incorrect to characterize Lata's voice as a falsetto. Can we replace falsetto with another western musicological category? This is tricky terrain: Indian singing voices have not been classified in terms of precise western music categories. I am not sure why; it could be because the categorization will hinge crucially on the placement of the tonic or the 'sa'[9] of the scale in which the singer sings. If the exact frequency of each *shruti* (microtone) could be codified, this coding could potentially be used as the basis for identifying objectively the range of each singer, but whether this exercise will yield categories analogous to western musicological categories is a moot point, again best left to musicologists.

Thus, Lata's is a thin voice and sounds shrill to SS, but is not a falsetto. And what sounds shrill to SS does not to others. Consider this description of Lata's voice, from the Marathi writer Gangadhar Gadgil, 'It is a voice that is ageless, pure, vibrantly alive, untrammelled in its range and flexibility, hauntingly expressive and enchanting in its sweetness. Above all, it has a certain ethereal quality, an indefinable something, with a unique appeal for us Indians.'[10] Others would doubtless have their reasons for liking or disliking Lata's voice. The point, however, is that a subjective element is inevitable in any appreciation of music and SS, contrary to his claim, is as subjective as anyone else.

Thin Voices and Female Identity

SS makes several propositions in his argument. The first is that Lata's dominance in Hindi films and her vocal style became recognized as an aesthetic marker of *modern* Indian female identity. The second proposition is that 'Lata's singing voice has instituted a very specific identity for Indian womanhood, one which

has almost no precedence in traditional forms of Indian music'. It is entirely unclear what SS means.

First, what is this 'very specific' identity of Indian womanhood (emphasis added, of course) – a phrase SS uses repeatedly, but does not care to specify? Are we to assume that SS means by this the highly simplistic, erroneous and objectionable notion, often encountered both in popular perception and in scholarly writings in the west, about the submissive, silent, suffering Indian woman, who has no agency and voice? If indeed this is the case, SS will have to tell us where to encounter this woman – is she a real woman who inhabits Indian villages and cities or is she a mythical creature of literature and cinema? I feel a little foolish in pointing out that Indian women display all kinds of distinctions – rural/urban, class, caste, religious, psychological, cultural, and so on, for surely SS knows that. Indian women, then, have many faces and many voices. Some of this variety is also evident in Hindi cinema, despite its undeniable patriarchy, and I will come to that in a moment. For the moment, my point is that the onus of proof is on SS; he will have to tell us which 'very specific' identity of Indian womanhood he has in mind, and he will have to demonstrate by quoting examples, how this identity is reinforced by Lata's voice and singing style.

Second, SS argues that in 'traditional forms of Indian music' the Lata-type thin voice has 'almost no precedence'. Now, we assume that 'almost' is supposed to cover exceptions to the rule, and it would have been useful for us to know which exceptions SS has in mind. Maybe he is thinking of singers like Parveen Sultana, Kishori Amonkar, Ashwini Bhide Deshpande, Veena Sahasrabuddhe,[11] and a host of others, all of whom have thin voices, and all of whom are Hindustani classical singers, which we presume is included in SS's 'traditional forms of Indian music'. To my mind, no one has done an empirical study to see how many female classical singers have thin voices like Parveen Sultana[12] *et al.* and how many have voices like Kesarbai Kerkar or Malini Rajurkar (slightly heavier) or Shruti Sadolikar and Shobha Gurtu (much heavier). So, we don't really know which is the rule and which the exception.

As an aside, though, it is interesting that the only Hindustani singer SS mentions in this context is Gangubai Hangal. I am not sure if SS has heard the early recordings of Gangubai (Gandhari) Hangal.[13] She had a very sweet, much thinner voice, very unlike the thick, heavy voice that characterizes her later singing. The story of how her voice changed is anecdotal; she had some form of tonsillitis, and though it is unclear if she underwent a surgical operation or not, her voice changed. Given her early brilliance, there was some trepidation about her singing abilities post-illness, but it turned out that those fears were unfounded. Her voice retained its flexibility even in its heavier version.

Contrary to SS's claim, then, in Hindustani classical music the female voices span a spectrum, from very thin to very thick (which, incidentally, is just as true of male voices). Thus, when SS mentions Farida Khanum (a ghazal singer) or Begum Akhtar (highly trained in classical music, but better known for her thumris and ghazals)[14] as exemplifying the thick voices that are supposedly the norm in non-film music, he is looking at only one end of the spectrum. Runa Laila from Bangladesh[15] had a much thinner voice compared to the well-known ghazal singers from Pakistan and our home-grown Chitra Singh[16] ruled ghazal singing for years with a laser-thin voice. While SS makes the point about the 'striking heterogeneity' of tonal and other styles, the only examples he provides are those with heavy voices, thus creating a false dichotomy between film music (dominated by Lata) and other types of music (dominated by thick voices). One wonders why SS makes a big deal about thick and thin voices till one realizes that for him, they are ideological categories since there is supposed to be an association between thick voices and sensuality. How tenuous this association is will be seen below when we look at Lata's recordings. There is, however, an argument made in musical circles about the shift from thick/heavy to thin female voices in Hindustani classical music, as singing shifted from the preserve of the *bais*[17] and courtesans to girls/women from 'respectable' families. However, this argument is nuanced, and does not contradict the fact that female voices in Hindustani classical music spans a large range and defies stereotyping. Unfortunately, for lack of space, we cannot go into all that. Why I bring it up here is to only say that this is an argument SS could have made, but in fact, does not! But, perhaps, this is not surprising, since the argument is that in the post-Independence period, thinner voices – contrary to SS's claims – have dominated Hindustani classical music.

Let us return to Lata, her voice, and its association with female identity. Reading SS, one would assume that 'Lata's voice' is a singular, unchanging entity. Forget the physical process of ageing and the resultant change in the voice, a process that must be all too painfully apparent to millions of Lata's admirers. Let us consider other changes. Lata Mangeshkar recorded her first song for films in 1942. Her first break in Hindi cinema was in 1945 in Master Vinayak's *Badi Maa*, when she was not quite 16. Her first song was a chorus, *Mata teri charnon mein guzar jaaye umariya.*[18] For the first few years, her songs were like cameo appearances. There is debate over her first solo; some claim it is *Chidiya bole ku, ku, ku*[19] in *Jeevan Yatra* (Life's Journey, dir. Master Vinayak, Hindi, 1946), while others believe that it is the Datta Davajekar-composed thumri in Raga Pilu, *Shyam mose na khelo hori,*[20] for the 1946 film *Aap ki Seva Mein* (At Your Service, dir. Vasant Joglekar, Hindi). The latter is a spectacular composition, which Lata has executed to perfection, in traditional thumri style replete with

sringara rasa.[21] The hallmark of a good singer is that voice production and hence its quality must match the genre of singing. In this thumri, Lata's voice is thick with a lot of texture; she is playful and coy as the lyrics demand. In appreciating this song, Vish Krishnan, the compiler of a private collection called *Man Veena Ke Taar* (The Mind and Soul Speak through the Veena),[22] puts it most aptly, 'One can only speculate what texture Lata's voice might have taken had she pursued this manner of singing', i.e., thumri singing as opposed to film singing.

It was only in late 1948 and through 1949 that Lata became a definitive presence, singing with mainstream music directors like Anil Biswas, Khemchand Prakash, Master Haider, Shakeel and others.[23] There is a 1948 recording of Lata's of the famous wedding song, *Kahe ko byahe bides babul more*[24] from *Heer Ranjha* (dir. Wali Saheb, Hindi),[25] which is just a year later than the thumri mentioned above but has Lata singing in a completely different voice and style. There is the necessary pathos, a certain virginal quality of tenderness and uncertainty of the new bride as she leaves her paternal home. In this song, she is reminiscent of Noor Jehan,[26] the reigning singer-actress of Hindi cinema at the time, whose influence on Lata's early singing was very strong. Lata, then, had the ability to mould her voice and her singing style according to the needs of the song very early in her singing career.

One needs to examine only the next two decades – the 1950s and the 1960s – to appreciate the changes in Lata's singing. Most singers, who last for any significant period of time, undergo important changes in their voice and singing styles and Lata is no exception. We also need to ask: doubtless Lata's persona has towered over Hindi film music, but how accurate is it to think of this presence as the only voice of the 'Indian woman' in Hindi cinema? SS offers a quote that suggests that other singers copied Lata so much 'that it is difficult to imagine a female voice that is not Lata's', but where is the evidence? SS will have to ask, and answer, several questions. Which other voices have represented Indian women in Hindi cinema? How different have they been to Lata's? What existed before Lata and, considering that Lata has sung relatively few songs since the early 1990s, what has followed her? In other words, we need to think of a pre-Lata phase, we need to examine Lata's contemporaries, and we need to see what those who have come later have done. And, to make the argument that SS does, he will need to correlate the changes in the representation of women in Hindi cinema with the changing voices in which they have been singing.

Let us focus on the 'thin voice'. If we believe SS, thin was not the dominant voice before Lata. Even Noor Jehan, whose voice quality is not identical to Lata's, often sang in a thin voice, sounding very much like early Lata (for instance, in songs such as *Mujh se pehli si mohabbat mere mahboob na maang*).[27] However,

and this is the crucial point, at no point was Lata's the only type of voice in which women sang. And what about Asha Bhosle,[28] to whom SS makes no reference? She is also the only singer who matched Lata's virtuosity, musical skill, training and even popularity. The two are contemporaries, and were often competitors as well. It is not widely known that Asha has recorded more songs than Lata, thus making her, in fact, the more prevalent voice.[29] Asha's voice is thin too, but has a distinct personality that is, by no means, a copy of her sister's. And their singing styles are vastly different. One thinks of Lata singing for the female lead, while Asha sang for other female characters, including the vamp and the cabaret dancer. But even this distinction blurred with time; Asha has sung literally thousands of 'heroine' songs. SS argues that after the rise of Lata Mangeshkar, her type of thin voice became the voice of the controllable, subjugated woman. But this same woman also sang in the voices of Suraiyya before Lata emerged, as well as in the voices of Geeta Dutt[30] and Asha Bhosle while Lata ruled. More tellingly, what do we make of the fact that the vamp and the cabaret dancer also sang in a thin voice (for example, Asha's)?[31] And how do we understand what is happening today, when the distinction between the cabaret dancer (or 'item girl', in the current lingo) and the heroine has been blurred to a great extent, and both sing in a range of voices?

SS quotes Manuel, who talks about the 'creation of film music as a common denominator mass-music style, produced in corporate, urban studios and superimposed on a heterogeneous audience . . . that has no role to play in the creation of this music . . .'[32] How does this ensure that only the Lata style of singing will be more popular to the exclusion of other styles? How does this account for the coexistence of styles? What Manuel says is equally true of the contemporary film music scene that has a much wider range of female voices (from the pencil-thin, saccharine-sweet Alka Yagnik to the much heavier Sunidhi Chauhan and Richa Sharma)[33] and a greater variety of singing styles than the Lata-dominated era. One is struck once again by the absence of any attempt at periodization by SS; the trends that he talks about are supposed to be universal and unchanging.

SS is led to his argument since he makes an a priori association between thickness of voice and sensuality. He describes Farida Khanum's voice as 'sensuous, pleading, cajoling', which by implication, Lata's is not since it is thin. But this association is completely arbitrary; recall Asha Bhosle's numerous songs that are just as sensuous, pleading, cajoling, notwithstanding her thin voice. Or think even of Lata herself. She began her career with a thumri, and went on to sing numerous sensuous songs. Indeed, Lata probably has the maximum number of ghazals to her credit, some of which, particularly those under Madan Mohan, are the finest ever in Hindi film music.

What does SS mean by 'sensuous'? Surely not the stereotypical notion: songs with overt lyrics, because Lata does not, it is true, match her sister at those. But consider this irony: some of the raunchiest remix hits in recent times have been Lata numbers: *Kaanta lagaa, Aaja piya tohe pyar duun, Pardesiya yeh sach hai piya, Bhor bhayee panghat pe*![34] Here the actors/dancers try to achieve with their bodies what Lata did invisibly, with her voice.

Why Did Lata Dominate Playback Singing?

So why was Lata so popular? What the SS thesis boils down to is that Lata happened to be in the right place at the right time; the nationalist project was looking for a thin voice to suit a regressive representation of women and Lata just happened. I am not persuaded by this historical accident or a pawn-in-the-male-domination-project story since it has very little analytical value. We need to remind ourselves that playback singers, at best, impart a particular style to the singing but the resultant music is a combination of several partnerships – of singers and music directors and of music directors and filmmakers (combination of directors, producers, financiers). Thus, Lata, at best, instituted a singing style under the baton of several music directors, rather than pioneering the 'submissive-controllable women' portrayal.

I am sure there are very good historical and sociological reasons that account for Lata's popularity. But it would be nice to also acknowledge that there is a musical reason as well. She happens to be an exceptionally good singer. She is classically trained, has a vast range, her virtuosity is unmatched. Mohammed Rafi[35] is known for his wide range (the notes that his singing spans). He is often used as an example of tuneful singing in the higher octave. It is believed that Lata reaches only two notes short of Rafi. On the other hand, in the lower octave, she can reach far lower and can sing with much more ease than Rafi, suggesting that she perhaps has a greater range than even Rafi. So, maybe her dominance also has something to do with sheer musical ability. This is not a universal argument, and certainly all successful singers are not great singers and vice versa. However, there is no shame in admitting that sometimes the two do overlap.

SS, of course, has a larger point to make,

> Indian culture became attached to landscape and territory – how was nationalism to deal with this increasing visibility of the filmic woman 'out of place', i.e., in public spaces? . . . Lata's stylistic innovations offered a viable solution to the above

> problem of representation in public sphere: at the same time
> that women's bodies became visible in public spaces via films,
> their presence was 'thinned' through the expressive timbre
> granted them . . . the potentially powerful image of the heroine
> enjoying the freedom of the public space in equal measure to the
> male hero and singing in a voice that may express an ambiguous
> femininity was, through Lata's voice, undermined.

This assumes, of course, that the timbre of the singing voice is linked to the image of women, an assumption that is both theoretically tenuous and empirically false. But consider the other aspect of the argument. The period that Lata's career spans is a period of flux. It witnessed, of course, the rise of religious bigotry, fundamentalism and conservatism, but also the increased participation of women in politics, education and mass struggles. Through this period, the depiction of women in Hindi cinema changed, though not in a single direction. Indeed, the change was often contradictory, confused, bewildering. Consider two random examples: Rita of *Awara*, a young, dynamic, highly educated lawyer played with grace and power by Nargis, and Mohini (Madhuri Dixit) of *Tezaab*,[36] who dances sexily to earn her living. The two are separated by nearly 40 years. Who is more 'emancipated'? Things were changing, and to make his argument, SS will have to map these sorts of changes, correlate them to changing times, and then demonstrate, by examples, how his theory of timbre fits in.

As one recalls the women to whom Lata gave voice, one is struck by the bewildering heterogeneity of personalities and characters they portrayed in films. Madhubala, Geeta Bali, Nutan, Waheeda Rahman, Nargis, Meena Kumari, Vaijayantimala, Asha Parekh, Mumtaz, Hema Malini, Sharmila Tagore, Zeenat Aman, Parveen Babi, Rekha, Dimple Kapadia, Madhuri Dixit, Kajol, Karishma Kapoor:[37] the list is endless. The characters portrayed were *tawaifs*, college girls, housewives, doctors, cops, mothers, daughters, urban women, rural women, Hindus, Muslims, Christians, Sikhs, upper caste, lower caste: an incredible array of characters with agency, guts and voice within the mainstream genre often surpassing their male colleagues by leaps and bounds. However hard I try, a single vision of 'the Indian woman' eludes me: the only common characteristic that I can see is that all women sang songs and all spoke Hindi. This does not mean that the Hindi film industry is not male-dominated or that it does not often take a patriarchal view of men, women, and their relationships – however, the precise contours of this patriarchy and the changes therein will have to be elucidated, not assumed.

And it is not as if rebelliousness is absent. Recall Madhubala singing *Pyar kiya to darna kya* in *Mughal-e-Azam* and Waheeda Rahman singing *Kaanton*

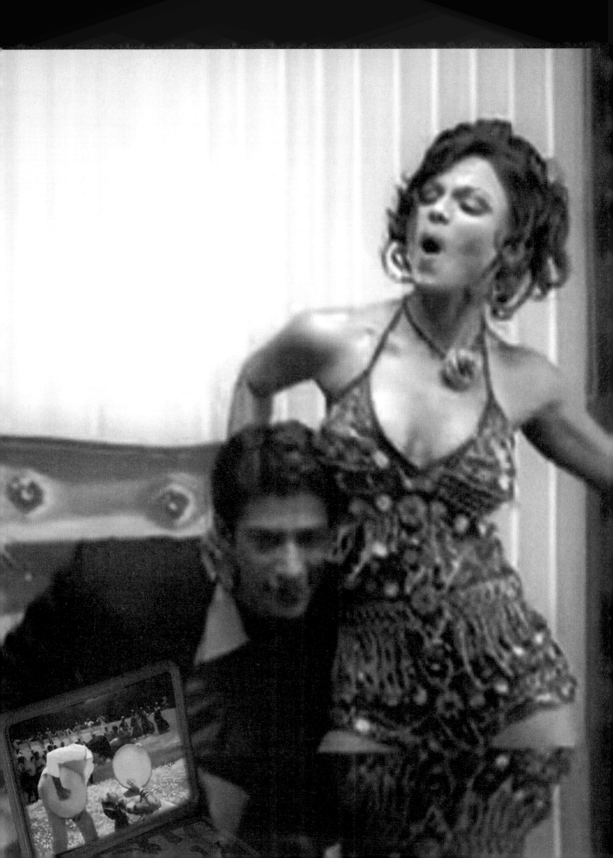

se kheench ke ye aanchal in *Guide*,[38] both in Lata's voice. In the former, the emperor, the ultimate representation of authority, is challenged in full public view by a defiant Anarkali. The latter song could almost be an anthem of the feminist movement – Rosie singing and dancing with abandon as she emerges out of the shackles of an oppressive marriage to a respectable man and openly accepts the love and partnership of a lowly tour guide. The rebelliousness of this act is magnified manifold as she wears *ghungroo*s [anklets with bells] and takes up dancing as a profession, regarded as dishonourable, in defiance of social norms.

Just as SS fails to hear differences in quality of voice, he fails to see diversity in female characters. Or maybe the former is linked to the latter in a relationship of causality.

Lata's Persona: Public and Private

SS makes a comment on Lata's public performances, where she stands 'rigidly on stage, and sings with her head buried in a notebook. . . . what matters is the voice and the way it is defined by the "notebook", by the authority of the written text'. If she had all the songs memorized, would that give a qualitatively different performance? How exactly is the 'voice defined by the authority of the writing'? Is it that those who read from notebooks have thin voices and represent subjugated women? There must exist a logic here which I have missed.

While it is true that Lata was particularly austere in her public performances, in general, most playback singers of the time were subdued and lacked today's flamboyance in their public performances. We need to keep in mind that these were the days of radio, not TV, and playback singers were meant primarily to be heard, not seen. Also, in Hindustani music, the voice is supposed to come from the stomach: several classical singers produce the most complicated *taan*s and *murki*s without moving their body or face at all.[39] Several practitioners consider it a virtue to be able to produce intricate patterns in their singing while keeping their bodies ramrod straight and indeed frown upon upstarts, whose bodies express more than their voice.

Those who have seen performances of Rafi, Manna Dey, Hemant Kumar will recall that they all sang from notebooks, and Rafi could sing the most tragic numbers with that benign smile on his face.[40] How is this different from what Lata does? Kishore Kumar was an exception, but he was an actor, and a comic one at that. Asha's performances became more and more flamboyant with the passage of time, reflecting her desire to adapt to the changing mores.

SS discusses Lata's personal life, describing her as 'virgin mother' and says her life has remained free of 'relationship-linked gossip'. Actually, for those who care to find out, Lata's relationships are well known, including the current one. She may not have flaunted her relationships, but they have not been hidden either.[41] In the film industry, Lata has been a hegemon for several years. There have been consistent allegations of manipulative and aggressive behaviour and of using her clout to play favourites. Other very powerful singers and music directors have been in and out of favour with her; she never sang for C. Ramchandra after their early fabulous association; she fell out with Mohammed Rafi who was the reigning king of playback singing at the time but subsequently made up with him; O.P. Nayyar never recorded with her; Raj Kapoor recorded only with her; and so on.[42] Such behaviour is conventionally associated with aggressive, powerful, domineering men: a far cry from the meek, saintly, virginal personality that SS paints. It could be argued that it is precisely her power and her domination that has ensured that personal gossip about her and her relationships remain minimal. It has certainly never been used to denigrate her, as often happens with single women, particularly those who live life on their own terms. SS either does not know all this, in which case he needs to do more research, or he ignores it since it contradicts his thesis of the 'subjugated suffering Indian woman'. He is not the first to make this error – outsiders often have trouble in understanding how certain individuals from oppressed sections (women, Dalits, etc.) can wield so much power.

Cleansing the Present?

SS also goes into another question – communalism and its impact on music. It is true that like other areas of Indian society, the religious–communal angle is not absent from the field of music, even though the way it plays out is more nuanced than SS allows.

SS refers to post-Independence changes in the selection procedure of AIR (All India Radio), where musicians who were seen as 'respectable', who had skirted the 'illicit influence of the Muslim dominated "gharana" and allied system of performance', were hired. Unfortunately, SS is completely out of his depth here. The cleansing project, aimed at respectability, began in the pre-Independence period with the idea of a musician not associated with public scandals. It is believed that this hit the *baiji*s (courtesans) most and they started calling themselves *devi*s. By reducing this process to a simple religious/communal angle, SS presents a narrow, misleading and muddled understanding of musical history.

As a result of the changes in the selection procedure, musicians had to appear for an audition before a committee that was, by all accounts, dominated by the Agra Gharana, a school of music with a substantial Muslim lineage. Musicians got selected (and rejected) by this committee and there were others who were denied even auditions – there were both Hindus and Muslims in each of these categories. Thus, when SS equates selection based on respectability to lack of a Muslim influence, he needs to give names of those selected and those rejected to enable us to verify the validity of his thesis. More importantly, which gharanas is SS thinking of? There is no major classical music gharana that does not have a significant Muslim influence.[43] And what exactly is 'allied system of performance' supposed to mean? Does SS mean that the differences in singing styles of individual singers within a gharana are a function of their religious affiliation? Or, does he mean that Hindu singers across gharanas share something in common, as do Muslim singers? Abdul Karim Khan and Bhimsen Joshi are both from the Kirana Gharana, Faiyyaz Khan and Dinkar Kaikini are from Agra, and Bade Ghulam Ali Khan and Ajoy Chakrabarty are from Patiala.[44] What are we to make of this? Do Bhimsen Joshi and Abdul Karim Khan differ musically because one is a Hindu and the other a Muslim? Or do Faiyyaz Khan and Bade Ghulam Ali Khan share something in common because both are Muslims? This is a serious question; without doubt, individual musicians can be communal or secular or a bit of both. There are stories of how Omkarnath Thakur used to carry *ganga jal* [the water of the river Ganga, considered holy by Hindus] to performances and sprinkle it on stage in order to cleanse 'unclean' influences; but there is also Bismillah Khan who performs in temples.[45] But about the music, it is impossible to tell what is Hindu and what Muslim. I am not sure if SS is importing a parallel from black musical genres such as jazz, blues, hip-hop in the US that can be distinguished stylistically from the music of white musicians. If he has something similar in mind, it is completely inappropriate in the context of Hindustani classical music.

From here, the argument makes a leap to a supposedly similar cleansing of film music that led to a 'new kind of film songs'. And, predictably, 'Lata Mangeshkar's singing style was the most obvious manifestation of this process'. It should not come as a surprise by now that SS defines neither the 'new kind' of film singing, nor does he elaborate on how exactly Lata contributed to this whole process, other than being born with a thin voice. And anyway, what is it about Lata's voice that suggests her Hindu identity: just the thinness? What about Parveen Sultana – how does a Muslim have such a thin voice? Or what about Shobha Gurtu, Girija Devi or Gangubai – Hindu women with thick/heavy voices?[46] Musically, these associations are untenable; by making them, SS opens

himself to the charge of serious and objectionable stereotyping.[47] Again, it cannot be anyone's case that communalism has not impacted Hindi cinema, and it would certainly be very interesting to see how precisely it has changed film music. For that, one would have to go into the details of film songs, lyricists, composers, the pressures exerted by film directors and producers, the larger political context, the inroads made by the Hindu right into the film industry, and so on, and link all this to singing styles of individual singers – assuming that such a link can be established. Either SS has not bothered to do that kind of painstaking research, or if he has, he has not made it public.

SS only tells us that

> through Lata's artistry, the 'disreputableness' of ambiguous tonalities and the threat of uncertain femininity ... was brought into alignment with the discourses of the 'pure' and controllable Hindu womanhood. The most obvious counterpoint to Lata's style was what could be referred to as the *kotha* style of singing, echoes of which can be discerned in, say, singer Shamshad Begum's voice.[48]

Logically, then, Shamshad Begum should have been the preferred voice for filmic *kotha* songs. Well, she wasn't. How many famous *kotha* songs has Shamshad Begum sung? Then, whose was the preferred voice of the film *tawaif*s? Asha Bhosle and Lata Mangeshkar. This suits SS just fine, since, according to him, when the *tawaif* sang in a sweet thin voice, she appeared controllable. This is pure circular logic. The controllable voice is thin, and since the voice is thin, it represents controllable women! The final part of the paper is on the post-Independence hero – what SS calls the Five Year Plan hero. The relationship between this representation of masculinity and Lata's voice is a repeat of SS's earlier argument – Lata provided the perfect foil for this kind of hero with her thin, controllable, infantile voice. I will not comment on this analysis, since it requires another paper for a thorough discussion. It is time to introduce music in writings on music.

I am indebted to Urmila Bhirdikar and Sudhanva Deshpande for their critical inputs. Thanks are also due to Surajit Bose, Partho Datta, Achyut Joshi, Shohini Ghosh, Aditya Bhattacharjea, Irfan Zuberi and Roopa Dhawan for their comments.

⚕

फूल गेंदवा न मारो
लगत जोबनवा में चोट
करेजवा

The final text of the arc, this short piece
by Lakshmi Subramanian is in response
to Ashwini Deshpande's critique of
Srivastava's work. The female voice as
instrument of gender identity has a longer
history, she notes, making the voice a site
of larger sociopolitical impulses.

Earlier version published in *Economic and
Political Weekly* (vol. 40, no. 5,
9 April 2005, pp. 1561–62). Reprinted
with permission from the journal. Grateful
acknowledgment to Lakshmi Subramanian
for support.

Keywords
*Bharatanatyam, Carnatic music, Tawaif,
Thumri*: see Keywords (pp. 329–44).

Images
p. 201: Based on Saba Dewan's film,
The Other Song (2009). The film features
two versions of a thumri sung by Rasoolan
Bai. One version, recorded in 1935, has
the words 'Phool gendwa na maaro,
lagat jobanwa mein chot' (Do not throw
flowers at me, my breast is wounded).
In the second, more popular and sanitized
version, the reference to breasts is
removed – 'Phool gendwa na maaro,
lagat karejwa mein chot' (Do not throw
flowers at me, my heart is wounded) –
reflecting the erasure of courtesans from
Hindustani music.

pp. 203, 206–07: Images of Rasoolan Bai
and a montage from *The Other Song*.

LAKSHMI SUBRAMANIAN

2005

14 The Voice in Colonial and Post-Colonial India

I write this in response to the ongoing discussion on
Lata Mangeshkar. Both these articles focus on the
popular singer Lata Mangeshkar and on what her
voice has symbolized for millions of Indian listeners.
I direct my observations more at Deshpande's critique
of Srivastava and in the process attempt to raise some
questions that I consider pertinent to the emerging
scholarship on music in South Asia. Deshpande finds
major shortcomings in Srivastava's methodology and
also expresses a certain degree of discomfort with the
preoccupations of culture studies, a field that she has
little understanding of or sympathy with, given her
own location as an economist. Trained as a historian
myself, and having attempted to understand and
interrogate the politics of voice and performance in
colonial and post-colonial south India, I am compelled
to respond to Deshpande's critique and suggest fresh
perspectives in looking at the subject of music and its
reconstruction in modern India.

Deshpande's critique is at multiple levels:
conceptual, methodological as well as empirical. She

faults Srivastava for not having backed up his case with adequate documentation; she criticizes his description of Mangeshkar's voice as 'falsetto' (on the grounds that it is an imported category to describe an indigenous musicological attribute), and finally questions the contention that Lata's vocal style became recognized as 'an aesthetic marker of modern Indian female identity'. Granted that Srivastava does not analyse recordings systematically or grapple with the problems of using anecdotal material to reconstruct musical narratives of both performers and their patrons. Equally, one could legitimately argue that appreciation of voice quality is subjective and relative, and what Srivastava hears as falsetto, Deshpande may hear as unique and possessing of an unusual range. However, none of these caveats can be allowed to detract from the equally important fact that through the first three decades of the twentieth century, a substantive discourse did develop around the voice and especially around the young female voice that did not undergo puberty breaks, and which became symptomatic of an innocence, a sublime and evanescent quality that fascinated the consuming middle class. It is this politics of voice, according to Amanda Weidman, that ensured the phenomenal popularity of a classical singer like M.S. Subbulakshmi (MS) or indeed of the noted Harikatha exponent Saraswati Bai.[1] We find references, for instance, in E. Krishna Iyer's[2] writings to the 'sweetness of natural music, as found in the voices of women, young boys, and singing birds'.[3] On another occasion, writing of Saraswati Bai, the first Brahmin lady to perform the Harikatha on a public stage, he remarked, 'women vocalists are found to possess certain desirable advantages over men. They have pleasant voices to begin with and none of the contortions of the struggling male musicians'. Writings in the succeeding decades, especially on MS, elaborated the discourse about the 'natural' voice and the complete emotional involvement of the singer and added the virtues and special qualities of Indian womanhood in sustaining the arts. This is not to suggest that discursive compulsions alone produced a new aesthetic engagement with vocal quality – but merely to contextualize the reception and consumption of music, which was informed as much by social values as by technological interventions like the microphones.

Framing Gender Indentities

That brings me to the discussion on the voice and its instrumentality in framing gender identities. Deshpande objects to both the propositions that Srivastava makes. The first proposition is that Lata's singing style became an aesthetic marker of 'modern' female identity, while the second is that the voice

instituted a very specific identity for Indian womanhood. These propositions, on first impression, sound confusing and admittedly require clarification, and Deshpande is rightly outraged at the assumption that the ascribed identity in question is that of a silent submissive Indian woman without agency. But, going beyond the assumption and outrage, there is, I think, an important conceptual issue that needs to be fleshed out. Can one find multiple meanings in the term 'the female voice'? How can we *at all* retrieve the female voice in musical genres? Can we separate the voice from the song text, which may be created by men *or* women? These questions may in fact help us frame the dialogue between voice and gender in late colonial and post-colonial India.

No one seriously assumes that the female voice is a vehicle of either the submissive and exploited woman, whose cause is internalized by millions of listeners, or that it is an extension of female agency. What is important is to note that a particular set of meanings come to be inscribed on a certain kind of voice that dominated an auditory habit that emerged in the course of the late nineteenth and twentieth centuries. This was certainly true of classical music, which underwent a process of canonization in the late colonial period, and there is no reason to assume that similar compulsions of consumption did not make their influence felt in the domain of popular music. It is in investigating modes of consumption and reflection that a social history of music – popular, classical, theatre and film – becomes relevant. For this, it would be necessary to go beyond mere anthologization of recordings, and investigate more sympathetically the sensibilities that informed consumption as much as production.

There was never any one voice – in terms of either the innate vocal quality of the singer or of the imaginative space that the singer through her song and voice communicated with her audience. The question then would be, and Deshpande asks this quite legitimately and persuasively, why was it that from the late 1940s Lata Mangeshkar became such a hit, and why her sister's voice became associated with a more seductive and raunchy style? Was it to do with the lyrics that the sisters sang, or was it to do with the way in which the sisters inflected their melodic execution? For, in the case of thumri singing, we know that singers were continually negotiating with the real-life audience outside the text, as much as they were with the audience within the text, and in the process, edited and rewrote songs. As Lalita Du Perron argues, the changes in the social context of performance, when thumri moved away from being a courtesan's genre to being performed by respectable middle-class women and men alike, resulted in weakening the identification of the female voice with the performer.[4]

The persona of the singer – whether it was Lata Mangeshkar in film or M.S. Subbulakshmi in the classical circuit – carefully built up by media information

Is there any
the meanin

or by deliberately withholding it, is important. For instance, the print media's coverage of MS and the construction of an image in which her husband played such a critical role is telling. As T.J.S. George suggests in his biography of MS, this was done through the fashioning of a particular style of devotional music that suited the expressive needs of the Brahmin community in the city, the projection of a certain concert etiquette and persona that emphasized above all the singer's subjective absorption with personal devotion, the stress on charity concerts all of which served to make the singer the ultimate cultural ambassador and a role model for middle-class south Indians in the 1950s and 1960s.[5] Thus, notions of classical music became conflated with issues of womanhood and domesticity in the twentieth century. This was partly the outcome of the social reform movement against the practice of nautch and devadasi dedication. Reformers, in the attempt to reclaim the *dasi*s, emphasized the importance of marriage and domesticity. The literal domestication of music was expected to sustain the modern marriage and home – music would become the agent for spiritual love.

Nationalistic Project

It is here I think that the nationalist project of constructing the idealized and domesticated singer, whose voice would constitute the vehicle of a transcendent morality, becomes so pertinent. I have argued elsewhere that, between 1930 and 1947, the reorientation of music and dance in terms of performance style, repertoire and performers themselves – towards an urban, predominantly Brahmin middle class – depended on emphasizing the spirituality of Carnatic music and bharatnatyam and how, in the case of music, this meant reinforcing hierarchies in artistic repertoire.[6] Nor were the performers entirely passive in this process. The fixing of devi to their names instead of the customary *bai* was in part their response to the new social compulsions – but in many cases, it was only a mere tokenism. I have had the privilege of interviewing Gangubai Hangal informally and I found no anxiety on her part in either jettisoning her identity or reinventing it self-consciously. On the other hand, the bias in the nationalist project can hardly be exaggerated – there is little doubt that its sponsors were obsessed with playing down Muslim contributions to Hindustani music at least rhetorically and the sensual accretions that *baiji*s and illiterate ustads had introduced into the pristine classical traditions of Hindustan.[7]

The organizers of the All India Music Conferences[8] between 1916 and 1921 were emphatic in circulating notices that all concerts and public performances by *baiji*s outside the conference venue were expressly forbidden. The audition

requirements of the All India Radio made no bones about the fact that the social morals of music had to be cleaned up. However, that was only one part of the story – self-appointed cultural entrepreneurs, as they embarked upon the project of musical reconstruction, found it increasingly necessary to negotiate with Muslim singers and enlist their support in framing guidelines for musical transmission within the new spaces of pedagogy.

Story has it that when the first All India Music Conference met in Baroda in 1916, and V.N. Bhatkhande urged those present to lend their support to a project that would enable the great nation to sing in one voice and one song, Vishnu Digambar Paluskar made a robust appearance on stage, snatched the mike and urged the organizers to stop indulging in verbiage and allow music to sing its own story through song and not sermon. I am all for music coming back into musical scholarship but not if it means that we dispense with any social analysis and merely extol the individual virtues of musicians and/or sing the glories of a rich tradition that is sublime, spiritual, transcendental and uniquely Hindu.

#splitsvilla

MTV Splitsvilla is a dating reality show
that airs on MTV India. To write this
essay, the journalist Rahul Bhatia visited
the sets of *Splitsvilla* in its sixth season
– set in the summer of 2013 at a coastal
resort. Locked into the bubble of a reality
television set, the show's on-screen
tensions seep into the contestants' lives
and bodies, fuelled by the need to perform
for the camera. Bhatia becomes an
attentive chronicler of these tensions as he
spends time documenting the mechanics
of bodies in motion on the set.

Earlier version published in
The Caravan (1 August 2013).
Reprinted with permission.

Images
pp. 210–11, 213, 216–17: Montages of
screen-grabs from *MTV Splitsvilla*'s sixth
season (2013), hosted by Nikhil Chinapa
and Sherlyn Chopra.

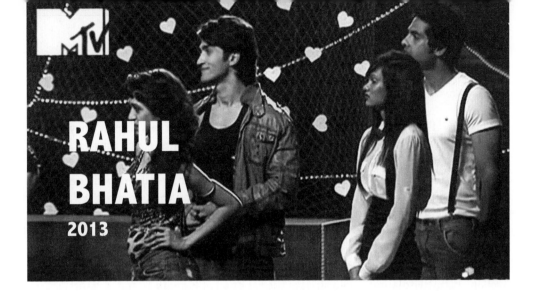

RAHUL
BHATIA

2013

Hot and Bothered

15

Under the Sun with the Aspiring Stars of MTV's Splitsvilla

By the time summer had arrived, so had the madness. The one abattoir run by the city of Thiruvananthapuram, for which twenty-five animals were fated each day, had its slaughter license revoked for not cleaning up their remains. In its absence, just about anyone with a table and a cleaver stepped up to fulfill demand. One new butcher tenderized live animals with an iron rod. For months no one could tell from where, exactly, their meat had come, and whether it was clean or contaminated, or if the animals were at peace or traumatized when they went, but officials claimed they had no moral authority and did nothing. Elsewhere, on the city's main streets, and a thousand miles from his home, posters of Narendra Modi's face were plastered on walls, reminders of his recent visit to the city. In the midst of all this, the boys and girls of MTV's acerbic and befuddling show *Splitsvilla* arrived at the start of April, unpacked the neatly creased selves they reserved for hot cameras, and dug in for a month of insincere boorishness.

Layers of luck determined their standing and stay, but on the set they resembled cousins of a kind, dressed as if for casting agents – net tops and acrylic bras for the ladies, painted-on T-shirts and pink jeans for the gents – and swearing as if their lives depended on it. And in a way, their lives did depend on it: if you could make it here, you could make it on TV, and then on more TV, and then maybe even into the movies. Filmi dreams have a way of deflating, of course, but more TV would be stardom enough for most.

Splitsvilla was in its sixth season. As in the previous five, the first premise of the reality show was to strip away all the characteristics of a normal life. Contestants lived in cramped isolation in two villas at the back end of Estuary Island, a resort with moody power at an inlet to the sea. To arrive there, one wound down baked narrow roads and brown paths that squeezed into the unsuspecting breathing space between houses. Then, improbably, there was a burst of beauty: coconut palms, some lush, some senile, sprung from the backwaters on either side. But only a burst. In the clearing ahead, beyond which were the villas, carpenters hammered and sawed piles of wood meant for the show. They planted cheap flags down the banks of a creek, and painted coconuts pink and blue and green. To recreate life, apparently you had to first vandalize it.

All through *Splitsvilla*'s existence, the basic rules of competition haven't really changed. The show is derived from the template for elimination-style reality programmes established by *Survivor* and *Big Brother* – with an added element of 'romance' thrown in. In each season, a number of young men and women complete a series of pointless but physically demanding tasks; the winners become that episode's 'king' and 'queen', ensuring they will avoid elimination and remain in the race to be crowned the eventual champions. Couples are formed and dissolved, and fates hinge on a single vote. You can call it monarchy by democracy. Bonds make and snap every episode, and the reverberations are felt down the season. Rabid fights are commonplace. Blow-ups are not discouraged, which leads inevitably to tabloid-friendly pseudo-controversies like the one that broke out in 2009, when the network aired an ethnic slur directed by one contestant at another.

This season had begun well. Eight boys, all alpha in spirit, if not to the letter, were told their first task was to strip to their waist and preen on a sandbar. They were advised to be impressive, because eight girls watching them on telescopes from a few hundred metres away would rate them. They were then given roses to distribute to their favourites among the girls, who were told to hang around in a swimming pool. They chose mates based on a quick conversation in the pool. Almost immediately *Splitsvilla*'s unpredictable impositions (one 'challenge' mandated that the boy with the least impressive biceps would be relegated to a 'dumping ground') led to tears and threats of violence.

By the time I turned up on the set at the end of April, on the second-to-last day of the shoot, the show's sixteen participants wished it would end. They had each auditioned for their role a season ago, and they had wanted it, but some of them now looked as if they had had enough. The last thing they saw at night was each other. They woke up to each other. They bumped into each other on stairs, in narrow doorways, in the reflection of dressing mirrors. They spoke to no one but each other. Five couples had been eliminated from the show, but they had to remain on the set until the filming was completed; they bided their time by tripping up the plans of former rivals. In just a few weeks, the proximity had chafed their patience and consideration, leaving raw antagonism and ambition and a heightened awareness of the cameras' gaze, so they knew when to perform. The nine roving cameras accepted whatever reality the kids conceded.

Splitsvilla's peculiar mix of anger, arbitrary competition and situational humour has made it one of MTV's most valuable properties. It now has its own season – a period of three months during which it is the channel's main focus – which begins when the network's original hit reality franchise, *Roadies*, ends its own annual run; the hope is that *Splitsvilla* will hold the audiences already hooked to its predecessor.

Some days before my visit to the *Splitsvilla* shoot at Thiruvananthapuram, I interviewed Aditya Swamy, MTV's vice-president, in his tiny glass-walled office at Viacom18, situated in Vile Parle, a Mumbai suburb that smells of baking biscuits. Cars and trucks dragged themselves by on the highway below, but Swamy's room overlooked nothing so unpleasant. The view from his cabin was of young employees and hesitant prospects awaiting their turn to be tested – at one end of MTV's large and colourful office was the room where they auditioned actors. The web team, which maintained constant dialogue in any number of ways with the network's fans, cloistered at the other end. (As if to remind the world of their youth, one web staffer recently used the company's Twitter account to wish John Lennon a happy birthday and 'a joyous year ahead'. Afterwards, MTV leveraged the gaffe as a way to 'drive engagement' by asking followers if the employee should be sacked; the overwhelming response, Swamy said with satisfaction, was to let it slide.)

Two doors down from Swamy's office, I was led to a room filled with merchandise from MTV's recent brand tie-ups. Sandeep Dahiya, the gregarious senior vice-president of products – who has the appearance of a man who knows where to get the best grass in town – handed me a single MTV condom and offered to get some lingerie as well. The room was stocked with the results of the company's successful push, led by Dahiya, to tie up licensing arrangements with a directory's worth of consumer product companies, which now included 60 different products, across more than 50 categories.

Age : 21

Height : 6. 1"

Swamy, who is a little over forty, said he was the oldest employee in the company, a fact that successfully conveyed its intended message – to show how young this place really was. During our interview, it was easy to see he had mastered the art of easy banter with visiting journalists, and he slipped quickly into a well-oiled routine; Margerie, his head of communications, smiled blankly as he related an anecdote I remembered from an interview he had given someone else. 'We're the channel that parents warn their children about,' Swamy told me. It was a good canned line, if a little predictable for an enterprise that sells rebellion as a commodity. But it came back to me later with a harder edge when I remembered that three *Splitsvilla* contestants had alleged that producers solicited sexual favours from contestants during the show's second season. The show's producers denied it, and one of the winners called the allegations the work of 'publicity-hungry losers'.

Youth may be naturally rebellious, but MTV's opposition to conformity is decidedly studied. Little is left to chance. The network taps into a vast and active viewer base built over the years, Swamy told me: 'A ten-million strong Facebook community talks to us on a realtime basis.' The most impressive aspect of the channel's operations, in fact, is its zeal for empirical surveys of its demographic: MTV dispatches diaries to a thousand people across the country, which they fill up with notes on what they've been watching on television and at cinemas, what they're reading, what they've experienced. But the research isn't always active. One of the channel's most effective research tools lingers in the background: Swamy told me that MTV parks a stationary camera in college canteens for a month at a time, quietly recording the proceedings.

The findings are then dissected by MTV's internal 'Insights Studio'. The network puts out an annual report on the mood of India's youth; last year's edition included the studio's insight that 'anything that entertains and engages these young minds and keeps them engaged repeatedly will hold their attention'.

Back on the set, everything revolved around Deborah Polycarp, the show's creative director, who had a smile like summer but a stare like ice. Orders were shrouded in suggestions. The people around her supplied answers before she asked questions. They ran to her to discuss everything, and at some point, the show's director willed himself to find a solution without troubling her – a fact she noticed. Irritation came over her quickly and quietly. When I admitted I hadn't watched *Splitsvilla* – which she had been involved with since its inception – she paused and continued talking, but spent the rest of the day referring to me, the only journalist on the set, as 'press'. My questions became 'press inquiries'.

She was in her outdoor production wardrobe of a cap, a T-shirt and harem pants, and knew where the cables lay (which was everywhere). She neatly stepped

over them as we walked and talked. 'The theme's "hot and spicy",' she said when I asked why the channel had chosen the resort for the shoot. 'Spices,' she reasoned. 'We wanted to keep it raw.' A while later she joined the show's director and the director of photography in the shade of a tree. 'Why do you want to dilute the aggression?' one of them asked. Then someone said, 'Rakesh*ji*, king and queen *aa gaye hain*?'[1] Rakesh said they had arrived.

I watched the royals from a distance. No one is less pampered than the actors on reality shows. They stood under an open tent behind a production meeting area behind the set on which the cameras were focused. The king kept moving his left arm up and down with the support of his right arm. He winced, and told a producer about his pain. The queen, dressed in a short beige dress, was a model from Bangalore. She disliked it when people pretended they knew her. The king wore an orange muscle tee and sunglasses. It was late in the morning. They wilted in the heat, but like royals, they didn't sweat. At the base of a tree close by was a stack of large cue cards. One said of a contestant, 'Nitin: wannabe classy, all talk, no cock.'

Just then, Sherlyn Chopra, the show's host, walked past. She looked just as she had been advertised on *The Times of India* website, in whose sidebars she had so often served as clickbait, although her tininess was surprising. Photographed endlessly, the model-actress had evolved into an altogether new creature whose instinct was not survival, but to be remorselessly photogenic. She welcomed surveillance. Normal people move awkwardly between positions. But Chopra's motor coordination is such that a hand movement that looks wayward at first glance will instantly be balanced by the movement of another body part, so that a simple gesture like reaching out to call someone unfolds as a series of poses.

The show's promotional material consisted of Chopra in a bikini on a beach. After the shoot ended a day later, she would jet off to the festival at Cannes to promote her latest movie, *Kamasutra 3D*. (Going by the hit count for the YouTube trailer alone, there was considerable demand.)

Polycarp hung back, but kept an eye on Chopra. A string clasped the host's black bikini top. Her silver skirt was brief. She walked to a covered wood pavilion where cameramen had been sitting around waiting for the shoot to begin. A young helper nervously adjusted the microphone transmitter placed on her lower back. Two local women hauling sacks of trash on their backs glanced at Chopra as they walked by, murmured something and smiled. Then two male labourers walked by, stared at her and went on their way. Chopra dispatched a unit member with an order to 'get all the clothes'. He returned a few minutes later with all the clothes: a sheer black poncho that someone slipped over Chopra's head and onto her shoulders.

Then one of the contestants, a packet of muscles named Gaurav, turned up in a white full-sleeved shirt and pink pants. His blow-dried hair sat up in a puff. We were in the final stages of the show. There were three couples in contention that morning, and by the evening, one pair would be eliminated. Chopra took her mark, the finalists took theirs, and she waited. Polycarp and the producers sat in the production control room they'd built in a pavilion on the other side of the pool. There were eleven tiny screens.

One of them offered a view of Chopra from the side, which, given the geometry of her bikini, distinctly failed to meet India's stringent broadcasting regulations. 'Rishi, Sherlyn *ka* exposure *thoda kam* kar,'[2] someone said over the talkback. Rishi the cameraman nudged his camera upward, so the frame captured her face and shoulders, nothing more.

Chopra asked, 'Do I say Splitsvillians or Splitsvillians?'

The director wasn't sure. 'Splitvillians. Splitsvillians. Splitsvillians? Say Splitsvillians.'

Chopra tossed the script. 'Welcome to *Splitsvilla, aaj main uski* pant *utaarne waali hoon.*'[3]

The producers paused, and repeated, 'Pant *utaarne waali hoon?*'[4]

'It's humour!' she replied.

There was a tear in the screen behind Chopra. The director was aware that Polycarp was watching him do his work and he voiced his unhappiness loudly: 'Fluffy, *behenchod peeche se gaadi-waadi jaa rahi hai, aunty-wanty jaa rahi hai!*'[5] He sat back down and exhaled. '*Bas behenchod* airplane *jaana baaki hai.*'[6] Fluffy ran behind the screen to fix it. 'Is his real name Fluffy?' a producer asked. The director grinned proudly and said, 'No, I gave him the name.'

That day's shoot had its share of little problems. Prabhjot, a contestant from Canada, preferred to speak in English. MTV, whose primary audience lives in Punjab and Haryana, needed him to speak Hindi so that viewers at home didn't flip to another channel. 'Why is he speaking in English?' the producers asked each other every few minutes. Prabhjot was one of two contestants who didn't speak Hindi well and obliterated it whenever he tried. So he sat back and spoke in whatever language he felt like. The producers had witnessed this for a month, and it puzzled them as much now as it had a month ago.

I asked Polycarp how people were picked for the show and why there were so many people from the north. 'We never cast that way. I would love to cast a south Indian, but there's the case of language. We've got a couple of boys who are foreign-returned, and they speak in English,' she said. 'One of the duskier boys

is from Goa. We had something called *Splitsvilla Battleground*, which he won. He happens to be north Indian, but he looks south Indian.' Then she added, 'It's great if they're good looking with a good voice.'

As the conversations continued and the cameras rolled, words grew harsher. The crew tensed, and the producers leaned forward, alert. Then it happened: Gaurav, the pink-denimed contestant, shot up from his seat beside the queen and swore at Prabhjot in chaste Punjabi. He turned words with three syllables into four; the extra syllable became a vehicle for his disgust. He launched into an inspired run of abuse that he made up on the fly. 'Why's he obsessed with *chootiya*?'⁷ a producer asked no one in particular. A mad fight erupted. The production unit focused and kept telling the cameramen what to do. They lived for this. Even Polycarp, who had slumped in one corner of the pavilion, leaned forward tautly. Chopra stood still as the contestants battled, rushing forward, retreating, rushing forward, retreating. She suppressed a laugh. At that moment, she was the most reserved person on set.

Then they broke for lunch, but there was no lunch around. The sun melted the shade, and there was no electricity either. Hot, and with nothing happening, the girls and boys of *Splitsvilla* sank in chairs and relaxed on armrests outside their villas.

Gaurav's partner, Subuhi, the one in the evening dress, sat on the same chair as him and wiped his sweat while the cameras filmed them. A month ago they didn't even know each other. '*Khana*,'⁸ said the queen from Bangalore, whose name was Priyanka. She was hungry. '*Khana*.' She was addressing Charan, a producer on the show, like he didn't understand the word. Charan, constrained by the edict prohibiting communication between the crew and the contestants, uneasily signalled that it would take a minute, muttered an obscenity and walked away with a grim smile. The cameras were turned off, and the boys and girls were briefly transformed. They swore and fooled around, and laughed at what television made them do for attention. '*Chee, be-izzati kar di*,'⁹ Subuhi said, laughing. 'Fuck you, I'm over you,' another said, imitating a typical break-up, and giggled madly. For just a moment, you could see them.

That evening, the girls returned in hot pants. Net tops. Nawab, a compact and muscled gym instructor with an unplaceable accent, was dressed in black track pants, cream boots and a red full-sleeved shirt. These were the clothes of a thousand aspirants in a thousand unseen portfolios. They were marched down a rubbly path to a little creek behind the resort. On either side of the water, *Splitsvilla* flags fluttered. Matters had come to a head on the show earlier that day and now there would be a contest. *Splitsvilla* was fueled by the idea of machismo: you had to brutalize everyone with your mind, your words

and your strength. They lined up at the edge of the creek. Locals collected on a nearby bridge to gawk. Families out on a quiet evening boat ride floated by in puzzled silence.

Beneath a tall platform that shook under the weight of a cameraman, Polycarp told me about past contestants. 'It's very romantic,' she said. A strong wind chopped at the water, the trees above us swayed and she tightly held on to her cap. 'We had one couple get married.' But most contestants break up after the show and do their thing. (The MTV Insights Studio knows all about this curious phenomenon: 'This is the move-on generation They live from moment to moment, engaging, watching, talking, following – there isn't much room for crying, pausing, break-ups, boredom or negativity.')

Suspicions separated us. Polycarp had been antsy about my presence on the set, and I found her control stifling. She rushed to remind me that I shouldn't speak with contestants unless she was around. She strongly encouraged me, in her order-as-suggestion tone, to come with her on a boat ride to a distant sandbar where workers were constructing a set. It also happened to be far away from the show's participants. When I asked her a question about what the show's couples did, she misinterpreted it and replied, far too quickly, 'We don't encourage hanky-panky between contestants, as such.'

The competition at the creek was called 'Tug of Love'. MTV fixture Nikhil Chinappa, a presenter and DJ, was hosting this part. The rules were simple but the game was challenging. Two couples, perched on a single raft, had to pull on ropes looped around trees on either side of the creek. Falling off would lead to a disqualification.

The crew was nervous about the setting sun. It would be dark in minutes and they absolutely had to finish this round before it went down. Gaurav and Prabhjot – evidently natural enemies – kept tugging at their ends of the rope for ten minutes before Gaurav got antsy and used his behind to try and push the other couple off the raft. That did it. Their focus turned inward, and everybody on the raft decided not to pull and survive, but to push the other team off. The crew tensed. Eventually Gaurav lost his balance and plunged into the water. Drenched, he protested: 'He pushed!'

Chinappa stood still with a smile. In round two, there was more bottom-rubbing aggression. But Gaurav grew too enthusiastic and the raft tilted under his feet, sending him and Subuhi into the water. He waded to shore.

There were long red welts on Prabhjot's forearms. 'No pain no gain, right?' he said. He told me that after the show ended he would return to Mumbai and join the crew of a film production beginning in July. Then he staggered off as Polycarp turned up to inquire about what I was doing.

A month after the shoot ended, a website devoted to Subuhi appeared online, at *subuhijoshi.com*. One of the four stories published there confirmed that 'Subuhi and Gaurav are dating.' Some besotted fans, it said, now called the barely known participants 'Gauruhi'.

When I called Prabhjot in July, his roommate in Mumbai, Nawab – the gym instructor – said Prabhjot was focusing on acting classes, but there was no movie. Nawab was learning to act at the Barry John Acting Studio,[10] and figuring out how to improve his spoken Hindi. He was on the verge of signing a two-film deal, he told me, 'But it's a rumour right now.' The show had ensured that folks everywhere recognized him.

Some of them called up to tell him he had personality and they could help him chisel it. I asked what the other Splitsvillians were doing. 'They're doing shows and acting like celebrities.'

Natraj नटराज Bihu (Assam) बिहू-नृत्य (असम)

Garba गरबा ...ana Folk Dance ...णा लोक नृत्य

Bhootkola (Karn...) भूतकोला नृत्य (कनार्टक) Kathakali (Kerala) कथकलि नृत्य (केरल)

Andhra Folk Dance
आंध्र प्रदेश लोक नृत्य

Santhal Dance (Bihar)
संथल-नृत्य (बिहार)

reading the room

Rouf Dance (Kashmir)
रूफ-नृत्य (कश्मीर)

Jhimma (Maharashtra)
झिम्मा-नृत्य (महाराष्ट्र)

Mali (M. P.)
माली-नृत्य (मध्य प्रदेश)

The concepts of 'traditional' and 'classical' play a controversial role in India's cultural modernity. Are these even valid concepts? Are they attributions by the Indian State, and its cultural bodies like the Sangeet Natak Akademi? Are they at all drawn from the experiences of actual practitioners? In this essay, the Bharatanatyam dancer Leela Samson warns us to steer clear of categories as extreme definitions, since they tend to make fixed creative and infrastructural assumptions of dance practice. She interrogates these assumptions, pointing out that they are often at odds with the ways in which these terms, as sensibilities, might actually play out within the trajectory of practice.

An edited excerpt of the Krishna Bharadwaj Memorial Lecture delivered at Jawaharlal Nehru University, New Delhi on 20 March 2014. Originally published in *Social Scientist* (vol. 42, no. 5–6, May– June 2014, pp. 3–18). Reprinted with permission. Grateful acknowledgment to Leela Samson.

Keywords

Bani, Bharatanatyam, Devadasi, Gurukul/ Gurukula, Item girls/Item number, Kalakshetra, Kathak, Sangeet Natak Akademi: see Keywords (pp. 329–44).

Sanskaara/Samskara: Mental impressions left by thoughts, actions and intent. Also, rites of passage: a series of rituals and personal resolutions that mark the journey of life.

Images

pp. 224–25: Photomontage of the Dances of India illustrative chart published by Indian Book Depot, which is retailed widely to school-age students.

p. 227: Close-up of the dancer Balasaraswati on the cover of an issue of the Sangeet Natak Akademi journal on her work.

p. 230: YouTube search results for the title of the essay.

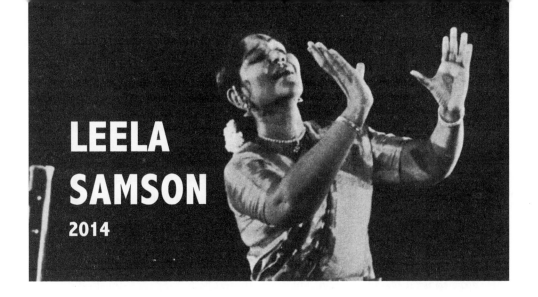

LEELA SAMSON

2014

16 Classical Dance in Contemporary India

I was invited to a seminar in Toronto a few years ago. I was supposed to read a paper, but I danced as well – a kind of 'food for thought' presentation, if you like. A lecture-demonstration, except I was not explaining the dance but simply talking about my journey with the compositions I was presenting and what concerned me about the dance along that journey. At the start, a young Tamil dancer who introduced me said, 'Leela is an example of a classical dancer.' And then added, 'unlike me, for instance, who is a "traditional" dancer!' I wondered what he meant. That one lacked classicism? And the other paid no tribute to tradition? As you can imagine, I changed my script quite a bit that day!

Categories are the bane of our existence! They lack a generosity of spirit. They are technical terms that have little to do with people. I do not wish to be called a 'classical' dancer if that title turns people away, if the very purpose of the dance is defeated, if it suggests an exclusivity that is not me and if it is not of the people. The words 'classical' and 'contemporary'

are valid English terms, imported from a western, Eurocentric viewpoint. They suggest a linear history. We believe in events that are cyclical in nature and therefore perennial. Do the classical, renaissance, modern or postmodern periods of different nations suggest the same thing? Even within the context of India, does the classical Gupta period (mid-to-late third century CE to 543 CE), for instance, coincide with the classical period of a particular art form like bharatanatyam? Is it appropriate to use an English/western term for an art movement in India or China or Africa without injury to the sense and sensibility of the location and practitioners of that form?

In the Sangeet Natak Akademi, the apex cultural body for dance, music and drama in India, we are going through a wonderfully interesting phase where all nomenclatures and categories of art expression are up for review.[1] While some artists are simply typed as classical, others wish to be seen as contemporary, some declare they are neo-classical and others modern, etc. One brilliantly trained dancer of kathak believes she is simply that – a kathak dancer. Our executive board views her as a contemporary dancer and gives her an award in that category.[2] Is there not a smack of prejudice here when the apex body decides who may be called classical, who contemporary? Because the categories were made at some point, we then become victims of such a list! And it is no doubt important. But how ironic is that? The wonderful Mrinalini Sarabhai[3] was denied the classical category in her time too and was given an award in the then newly coined 'creative artist' category, almost suggesting that all other forms lack creativity. An exemplary artist who deserves an award should get one, in my opinion, without being boxed into a category that excludes rather than includes. I can be traditional, classical, neo-classical, modern, contemporary and anything else you wish to categorize me as, depending on your own understanding of these terms, where you are coming from, what your *sanskaara* is, and how much you know about my work and about me. I will not be boxed in by a limited estimation of my form or me.

Having said that, many of you might not live in my freewheeling world, and would like to identify styles and may well feel strongly about how they speak to you. It would be interesting, then, to know what you mean by 'contemporary India', for instance. Is it a homogeneous 'whole' construct inclusive of all citizens of India? Do so-called 'contemporary' cinema, 'contemporary' music and 'contemporary' dance represent contemporary India in a more substantive way than 'traditional' music and dance? Is classical what it was? Every three hundred years, every fifty years, and every decade now, we see a new definition of classical, as we do of contemporary. As they say, 'tradition is not what it used to be.' So are these terms a definitive visual construct in the minds of those who choose to label them so? What was modern in 1947 was classified as classical in

the 1970s and has metamorphosed into another expression in these past decades. Can a dancer in the present not express in a classical way?

Musical instruments, for instance, that we have adopted as our own, like the violin, the French harmonium, the saxophone, the mandolin, the guitar, the clarinet and the piano – the last has several avatars in keyboards, synthesizers, harmoniums, etc. – all have roots in foreign lands. Yet they have a life in India that goes back several centuries. Practitioners of these do not acknowledge these to be anything but indigenous. They should be eligible to get national awards as classical Indian instrumentalists. Yet an Indian who plays classical music on the piano is denied one because the instrument is deemed 'foreign'. I am not sure, but does the violin or mandolin or guitar look more Indian or less western to you, than the piano? Is it the size of the instrument that we are prejudiced against? Or are we still hindered by the name, the looks and, perhaps, the colour?

It is not that these nomenclatures are not valid. It is simply a question of what your values in art are and what your philosophy is. These and numerous other categorizations based not only on historical periods, but also on religion, caste, sex, political affiliation, gharana, *bani* (lineage) or style, on the colour of your skin, on whether you hail from the west or east, north or south, are rich or richer, poor or poorer – what else are we doing here but dividing ourselves based on one or another of these types? It is the very thing that puts us as a nation and people under intense pressure. While we celebrate our diversity, how does democracy deal with issues of difference? Is it not the same in the social, multilingual and multi-religious fabric of our nation as it is in the arts that are perfect symbols of these varied cultures? Secularism rejects inequalities and celebrates diversity.

Talking of words and nomenclatures, Sadanand Menon[+] questions the use of the term 'tradition'. He says 'tradition' is a non-indigenous category in the Indian lexicon and gained currency only in the context of the Indian freedom struggle at the turn of the nineteenth century, when clichéd binaries like tradition versus modernity, change versus continuity, unity versus diversity, etc., came into play. Otherwise, it was words like *parampara* (convention), *sampradaya* (school), *purana* (received practice) or *reeti–rivaz* (customs and manners) that were in use. In the post-colonial period, he suggests, 'a newly defined tradition' may well have come as a boon to the westernized urban Indian elite and represented 'a power block': 'Aligning with tradition was a means of self-inscription into the body politic of an emerging nation-state, something they had been marginal to in the earlier monarchical system and against which they had connived, on the side of imperial power.'[5]

Yet we know that our past histories and beliefs can be flexible and interpretive, and, at the same time, rigid and unchangeable. When applied in all

Shape of You Carnatic | Indian Contemporary | Amit Patel | Indian
Raga

Amit Patel ✓ 10M views • 1 year ago

This song represents what I love about the fusion movement. The intersection between Eastern and
Western music and dance ...

8 Classical Dances of India UPSC, SSC | Bharatanatyam,
Mohiniyattam, Kuchipudi, Kathak and more.

Exambin • 484K views • 2 years ago

We hope this video has given you some insights about 8 Classical dances of India. If you would like to
know more here is the ...

Classical Contemporary | Geatali Tampy | Exodus Artistry | Breathless
| Shankar Mahadevan

Exodus Artistry • 40K views • 2 years ago

Exodus Artistry presents Summer Workshop Series 2017: Style: Classical-Contemporary With: Geatali
Tampy (Dance Captain, ...

Shiva Shambho: Most Watched Bharatanatyam Dance | Best of
Indian Classical Dance

IndianRaga • 8.7M views • 2 years ago

To invite this group for a live concert, please visit https://indianraga.com/live or email
info@indianraga.com Dance adaptation of ...

Shape of you ft. Swalla Classical Dance (By Nrutyam Dance
Academy)

Pratibimb Productions • 11M views • 2 years ago

Choreographed by Nrutyam Dance Academy Dancer:- Henita Dasadia Bhakti Chevli Hetvi Shah Dhwani
Upadhyay Music by ...

4K

Mix - Aayat Dance | Bajirao Mastani | Indian Classical (Kathak)
Contemporary Fusion Choreography

YouTube

Aayat Dance | Bajirao Mastani | Indian Classical (Kathak) Contemporary Fusion Choreography • 4:43
O Re Piya / Aaja Nachle / Madhuri Dixit / Rahat Fathe Ali/ Hemant Devara/ Maria Jose Bono • 2:45

EDM Alarippu: Bharatanatyam | Best of Indian Classical Dance

IndianRaga • 1.8M views • 3 years ago

Alarippu is a purely technical dance, taught to hundreds of thousands of students of Indian classical
dance globally each year.

these fields, it would seem that we have not learnt much from the harsh lessons of Partition. We refuse to acknowledge the layered and pluralistic character of people, faiths, their realities and cultural practices. It is this that has caused such untold suffering to people born long after Partition, but who carry wearily the burden of that legacy. I have lost at least one young student to the sorrow of such a severed legacy.

And so, I am grateful for mixed parentage and dual faiths that allowed for the inclusion of more or the rejection of all. It does not get more complex, in the east or the west – Catholic mother and Jewish father. (You know of course that your name, as in my case, may well be Jewish, but if your mother is not, as in my case, you are not Jewish. The Jews got it right. Proof is with the mother – period.) My parents were not prejudiced. They could not afford to be. We belonged to the defence services and who understood this more than those who served in confined spaces, and also in privileged service communities, that we are a single nation made up of a very diverse people? So, perhaps to confuse me further or liberate me, I am not sure which, I got sent to a small *gurukula* 'Theosophical' school – that during the Second World War had hosted the Italian refugee Madame Montessori,[6] and adopted her principles on the growth of the child. This vision was married to ancient art forms of music, dance and drama. These, you could easily argue, were Hindu, since their textual references were from the larger landscape of India's epics, romantic poetry of the southern region, tenth-century Bhakti poetry and the numerous stories-within-stories of the great Puranas.[7] Sanskrit, Tamil and Telugu became new and constant companions, and the prejudices of caste Brahminism sat side-by-side with the liberal philosophy of Madame Blavatsky and Annie Besant. And so the journey began, unusually.

To put the journey into context, permit me to use an illuminating Rig Vedic mantra that speaks of two birds living in the same tree. One is the *bhokta,* who partakes, who tastes and enjoys the fruits of the tree. The other bird is the *drashta,* who simply watches, contemplates. The *bhokta* is seen in paintings and in literature, caught in the web of life, in the varying gait of its joys and sorrows. Yet in each of us lies the seed of reflection, of observation and contemplation, as well. We are caught up in the joys of life but at the same time, one part of us seems to stand aside, watching, as our lives mingle with the larger ocean of existence. The *drashta,* or the one who sees, symbolizes the pilgrim soul in each of us.

The dancer is often seen as the *bhokta,* enmeshed in life, longing for completeness, yearning for something beyond the parameters of the self. I ask myself whether this is so because her art is visually set in the physical realm. During a performance, the audience, and perhaps the dancer too, is compelled

to ask, 'Who is the dancer? What is the dance? Can the two be separated?' On one level, the physical beauty of the dance and the dancer, her technical virtuosity, the grace of her gestures and the brilliance of her apparel, enrapture the viewer. But dance is also emotional, for what is life or art without feelings, and the expression of those feelings? It is a reflection not only of life, but of the culture and aesthetic of a nation, expressed through literature, song, architecture, design, colour and rhythm, as also through a strong sense of individualism. The connection between the individual ego and these elements in nature outside of the self, that are beyond rational assessment – that require perhaps an element of contemplation – has been a challenge to every artist through millennia. I believe that the arts are at one level purely personal, where the ego of the artist is present, as in a painting or in a performance. And yet, art has a function in the social sphere and must reflect that at some level.

Whatever we do offer the world is so surely marked, both positively and negatively, by 'who' we are. It is 'unmistakably Indian', people say. It is 'individual' enough for it to possess this *svabhaava* (character/inherent essence). So, where does this Indian-ness or *svabhaava* come from? I would hazard a guess that it comes from our philosophy that is unique and which I think tends to wash over all of us, irrespective of our individual faiths. It also washes over whatever it is that we are doing – bearing upon that in a very distinctive way, however distant that work is from 'being Indian'. This can be said to be a 'collective *sanskaara*' – something we inherit unconsciously and by virtue of the fact that we are Indian.

Somewhere at the back of our minds, we believe in the essential unity of all life, in a 'religion of eternity', in compassion and in tolerance. And strangely, in spite of a new skepticism and disillusionment with religion, from generation to generation there is a constant endeavour among people to understand the meaning of these truths. Even if it is not apparent, at some point in one's life it gains significance. We want to understand the ultimate purpose of our lives, to know what 'righteous living' means, to understand the real meaning of compassion, the purpose of art and the value of harmony in our lives. Some amongst us are embarrassed by our *svabhaava* and believe that to be 'progressive' is to shun it – to adopt the universal image. Does a denial of 'who' we are really make us more acceptable?

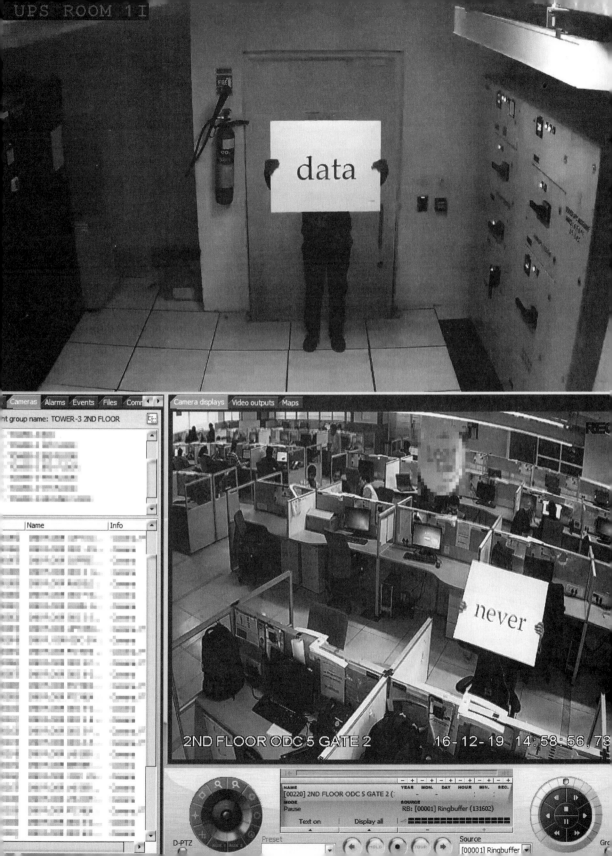

As we move towards considering the institutional meanings and gestures that shape performance, artist and theatre director Amitesh Grover's manifesto offers us a sense of populating architectures with doing, of spaces that resonate with an unceasing flood of actions – plans, plots, designs and structures, and of the ways in which these actions implicate performing bodies. Manifesto-writing is a part of Grover's creative process. *How to Perform a Good Employee* informed his work on *Kafka's Castle*, where he joined the workforce of a mammoth technology company, going to work every day for six months and performing disruptions within the workplace.

Performed by Amitesh Grover (in collaboration with Arnika Ahldag). Material: 65 low-resolution photography prints on sun board. Photography by Ishan Tankha. This work was commissioned by the Kiran Nadar Museum of Art for the exhibition 'Hangar for the Passerby' curated by Akansha Rastogi in 2017.[1] Grateful acknowledgement to Amitesh Grover.

Images
p. 233: A mash-up of CCTV footage from HCL offices; images courtesy Amitesh Grover with HCL Tech Pvt. Ltd.

something is *MISSING* here

AMITESH GROVER

2017

17 Kafka's Castle
How to Perform a Good Employee

• Collapse, make it indistinct or intentionally inverted: Turn your chair upside down, place your objects of work in strange relationships to each other, place your belongings between cubicles, atop partitions, glued to glass walls, along the staircase, right next to the fire-exit doorway, in dark squares on the office floor which, somehow, slip through the all-seeing eyes of surveillance cameras.

• Shift incessantly: in your chair, in a meeting, at lunch. Never sit still. Look nervous.

• Explore horizontality: place your body between office walls, on office carpets, on the table in the office canteen, spread it out quietly, slowly, carefully, but surely. Once spread, do not move. Feel the expansion, the breath, the serenity that horizontality brings, especially in environments that forbid it.

• Oscillate between visibility and invisibility. Choose your moments, timing is of the essence, here. Make

your body suddenly visible. Explore making your body visible in parts, just a finger maybe, one elbow, how about only exposing your left knee (nobody knows what to do with knees at work). Or, disappear fully, completely, absolutely, as if you were never there. Oscillate between both frequently, mix it up well. Do not let a pattern emerge.

• Ask questions. Inquire, needlessly. Pick out a detail, obsess over it.

• Occupy the company.

• Persevere with useless tasks – dig a hole, then cover it. Walk in purposeful circularity. Stare into your cubicle, into your laptop screen, indefinitely. Take the elevator up, then down, for your entire shift.

• Talk as frequently as possible and at great length. Illustrate through abstraction. Point towards the process of doing something, remove the unnecessary layers, reduce it to its essential contradictions. Ignore data, hide statistics, talk about what is insignificant.

• Make duplicates when you can. As many as you can. Duplicate files, folders, parts of code, error reports, emails, texts. Encourage others around to duplicate all they can.

• Make speeches. Address your colleagues as crowds gathered in different worlds – in the worlds that have gone past, in worlds that are on the brink of breaking down, or in the promise of worlds that are yet to come.

• Hesitate. Always.

꒰ꘛ꒱

VOLUME XXXVIII, NUMBER 2, 2004

Sangeet Natak

The First Drama Seminar (I):
New Delhi, 1956

Contributions by P.V. Rajamannar, S. Radhakrishnan, Sachin Sengupta, V. Raghavan,

Chandra Kant Phookan, M. Bira Singh and H. Romain Singh, Amar Mukerjee, Lila Ray,

Ahindra Chowdhuri, Kalindi Charan Panigrahi, Mayadhar Mansinha

The essays 'Not the Keynote Address'
by Akshara K.V. and 'Politics of Location'
by Gargi Bharadwaj have their roots in a
particular moment in 1950s India. This was
the 1956 Drama Seminar organized by
the national performing arts institution, the
Sangeet Natak Akademi, to set an agenda
for theatre in India. The architecture of
the seminar dictated what would *become*
Indian theatre, setting the tone for the next
fifty years and more.

The Not the Drama Seminar organized by
India Theatre Forum, a group of theatre
practitioners, was originally intended as
a sequel to the 1956 Drama Seminar,
intended to reflect five decades later on
'how we got to where we are', as their
website puts it. As it took shape, however,
it became clear that that project was
perhaps irretrievable, hence the new
title. What new meanings could they
find in reimagining a crucial moment
for theatre, one that had shaped their
work as practitioners? This essay was
Akshara K.V.'s keynote address at the Not
the Drama Seminar, organized by India
Theatre Forum at Ninasam, Heggodu, in
March 2008.

Earlier version published as the 'Not the
Keynote Address' in *Our Stage: Pleasures
and Perils of Theatre Practice in India*,
New Delhi: Tulika Books, 2009, pp. 17–20.
Reprinted with permission. Grateful
acknowledgement to Akshara K.V. for help
and support.

Keywords
Akademis (Sangeet Natak Akademi),
Prithvi Theatre, National School of Drama,
The Drama Seminar, see Keywords (pp.
329–44).

Images
p. 237: The cover of a 2004 Sangeet
Natak Akademi journal issue on the Drama
Seminar of 1956: S. Radhakrishnan, the
first Vice President of India, delivers the
opening address.

p. 239: Rajendra Prasad, the first
President of India, in conversation with
Sangeet Natak Akademi functionaries
Kamaladevi Chattopadhyay and Sachin
Sengupta: detail from the back cover of
the same issue of the journal.

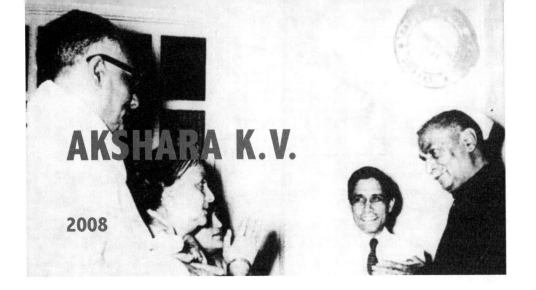

AKSHARA K.V.

2008

18 Not the Keynote Address

'Not-the-Drama-Seminar'. Why this name? Let me
answer using the same 'not-the' logic: it did not arise
directly out of an urge to connect to the Buddhist Apoha
doctrine which defines things in relation to what they are
not, nor was it an attempt to create a fancy postmodern
label.[1] In fact, we literally stumbled upon this phrase, kept
it initially as a tentative title, and later decided to retain it
as the name of the event. But, I believe with hindsight, all
this was not just a coincidence.

 The outline ideas for the event that we are having
today dates back to the summer of 2006, when some of
us met at Manoribel, near Mumbai. In that meeting, in
which were sown the seeds of what is now called the India
Theatre Forum,[2] we joined for the first time to 'connect'
ourselves with each other, and also to try and explore
the possibilities of discussing the intimidating idea of a
'theatre policy' for India. In that meeting, we discussed
various subjects – the entertainment industry and the
present scenario of theatre, questions of censorship, the
lack of good spaces for performances across the country,
the problems of the *akademi*s and the state bodies that
are supposed to help theatre practice – in a nutshell, the

problems that our theatres are facing. This brought us to the realization that if, in spite of all the problems, we have all survived and are still doing theatre, then we need to talk about our survival strategies too. There, it was Sudhanva[3] who stumbled upon the fact that we were talking about all this exactly 50 years after 'The Drama Seminar'[4] organized by the Government of India in 1956. Thus appeared the seed in the form of a question – why don't we organize a similar event half a century later?

This led us to have a series of exchanges on email. After a year or so, we did a separate meeting on this subject in Mumbai. In that meeting, after brainstorming for a whole day at the Prithvi House, we discussed the possibilities of an 'updated' and 'contemporary' version of a drama seminar, and finally prepared a tentative schedule of events, a list of topics to be discussed and also a tentative list of speakers. But soon after reaching home, everyone started to feel uncomfortable with the plans that we had made, and felt that this was *not* the drama seminar that we had dreamt of.

Perhaps the legacy of 'The Drama Seminar' was too burdensome, perhaps our imaginations were not creative enough to crack the concept of the routine patterns of a 'seminar', and perhaps we were getting into the same trap of the usual academic symposia that we did not wish to fall into, though we had consciously jettisoned stock ideas like a pan-Indian representation, surveys of regional theatre forms, etc. At that point, Sudhanva came to our rescue and prepared the outline of something similar to what we are having here today. After one more year of email exchanges, Not-the-Drama-Seminar is now opening.

At this point, I must clarify at least some issues regarding our legacy of the 1956 Drama Seminar (DS). The '56 DS is an important landmark in the history of modern Indian theatre, and it is in fact 'the beginning' of most of our legacies as today's theatre practitioners. Without attempting a summary of the DS, let me just point out some areas in which we could connect ourselves to the '56 DS.

There is no doubt that the '56 DS reflects the origin of many dreams and nightmares that we still cope with today. Let me illustrate this with two examples. Here is what Sombhu Mitra[5] said, responding to the debate on commercial theatre:

> How long do you believe we can pull on without a morsel to eat and without a shelter to live in? We are ready to work as professionals, we have qualified ourselves to be such. We believe that playgoers will see that we live and flourish. But how and where may we show them our mettle and to get from them in exchange our requirements? We need a house of our own . . .[6]

In many ways, the need for a 'house of our own' continues to be a pressing need for most of us doing theatre in any part of the country. As I mentioned above, we felt the need to document what we called 'survival stories', precisely to ask this question: how does theatre survive without a house of its own?

Similarly, Kamaladevi Chattopadhyay[7] made the following point in one of the discussions:

> Again and again I hear . . . how nice would it be to have a Ministry of Culture. God forbid, if such a thing happens there will be an end to all cultural activities in this country. I do not cherish such a hope in it because I know how the government machineries function. A ministry is a ministry and as such, it will have to go through so many formalities and procedures . . .[8]

Today, as we all know, we *do* have a Ministry of Culture. No, what we have is even worse. We have a *department* of culture, which is attached to the Ministry of *Tourism!*[9] I don't know how Kamaladevi would have reacted to this. Not only has her fear of 'formalities and procedures' come true – and many of us who have to apply to the government for any of their various schemes and grants know exactly what Kamaladevi meant when she warned us of 'how the government machineries function' – but attaching culture to tourism really betrays an outlook that merely seeks to commodify and sell 'culture' to those who can afford to pay for it.

Thirdly, the '56 DS is, in many ways, the bedrock of many of our structures of thoughts on theatre. For instance, it is simply taken for granted that there is an entity called 'Indian theatre', and this entity is basically a sum total of our 'regional' theatres. In the more crass expression of the same idea, 'Indian theatre' becomes 'national theatre', and 'regional theatres' become 'vernacular theatres'. The foundation for this is laid by the '56 DS, which devoted a presentation each to the theatre of all the major languages of India. Similarly, we don't seem to have gone beyond the concepts that the '56 DS provided us with to categorize theatre – thus, we keep talking of 'commercial theatre', 'folk theatre', 'amateur theatre', and so on. Of course, there have been attempts here and there to challenge these concepts – and especially the concept of 'folk theatre' is perhaps the most problematic of all these – but by and large there has not been any major theoretical effort to map Indian theatre differently. In fact, how pernicious some of these categories can be, is seen when we consider the very problematic history of 'theatre of the roots'. The point I want to make here is that the roots of the 'theatre of the roots' are also present in the '56 DS, for instance in the presentation by Mulk Raj Anand.[10]

This is not to suggest that we only need to criticize the '56 DS. It raised a number of important and critical questions and many of them are still with us today. For instance, we are still grappling with Tagore's plays, and we cannot in all honesty say that we have achieved results better than our predecessors of '56. Similarly, Ebrahim Alkazi[11] had raised the critical issue of actor training, again something we are still struggling with. Another concern that runs through the '56 DS is the lack of good theatre buildings, again something we can immediately relate to half a century later.

What is therefore clear to us is that we can neither commemorate the '56 DS, nor simply revisit it, nor even merely critique it. We can, however, reconstruct it, re-imagine it in a creative manner, and in this act of re-imagination, we can form our own critical relationship with it. And, partly out of this act of forming a critical relationship with our past, partly out of an engagement with the questions of today, and partly also in an effort to help us articulate our dreams for tomorrow, we decided to come together in this gathering, which is 'Not the Drama Seminar'.

What do we wish to achieve through this event? Let me address this question again through a negative logic. We do not want to have *the* drama seminar again, and we do not want this event to be only and exclusively about *drama* and theatre, and also we do not wish to make this into an academic *seminar*.

This is a gathering of predominantly theatre practitioners from across India, with some scholars from theatre and performance, as well as some thinkers from other disciplines. The topics we have given are not the titles of possible papers, but only an indication of an area of our experience to scan. To make the scanning focused, we have also given a description of each topic in a few lines, consisting largely of questions, on the topics that the speakers could choose from and present their views. And we have kept apart an unusually long time for the discussions, with the hope that everyone will have a chance to speak and share their views regardless of the specific areas that they come from.

And what do we hope to achieve from this exercise? To use a phrase that Prithvi had coined for one of its festivals earlier, it is to assert that here, for all of us, 'theatre matters'. Ironically, today's 'postmodern condition' has precisely begun to negate this simple fact. In a futuristic worldview offered by the PriceWaterhouseCoopers Report,[12] theatre is just an insignificant component of various forms of entertainment available for our consumption, and therefore tagged under the category – 'others'. Has theatre de-mattered so much for us today? Our own gut feeling indicates an emphatic *no*, and we have here a huge bunch of the Dionysian tribe to respond to the global prophecies of the powerful Apollonian lot.

Yes, we all know that today, it is hard to do theatre, and it is perhaps harder to continue doing it, but for many of us, that is the only thing that we can do and also something that we could do with pleasure. As all of us have already made this decision, we now need to connect with each other both in a positive gesture of assertion and a negative gesture of subversion to the heavy-handed 'entertainment industry'.

That gut-level feeling has brought us together. We feel that it is crucial that we share our pleasures and perils of doing theatre.

Drawing on the ways in which institutional positions have shaped theatre practice, Gargi Bharadwaj looks at five projects that situate themselves outside of dominant institutional narratives, often intentionally so. To map their departure from established modes of practice, Bharadwaj also revisits the 1956 Drama Seminar and other key cultural policy documents. It is useful to read this piece in conjunction with Akshara K.V.'s 'Not the Keynote Address'.

Earlier version published in 'Staging Change: Theatre in India', special issue of *Marg* (vol. 70, no. 3, March–June 2019, pp. 64–75), edited by Anuradha Kapur. Reprinted with permission from the publisher. Grateful acknowledgment to Gargi Bharadwaj.

Keywords

Indian People's Theatre Association (IPTA), *Kalaripayattu*, *National School of Drama*, *Parishat Theatre*, *Parsee Theatre*, *Sangeet Natak Akademi*, *The Drama Seminar*: see Keywords (pp. 329–44).

Mudiyettu: A ritual theatre performance in Kerala often linked to the worship of the mother goddess in its predominant reference to the mythological figures of the goddess Kali and the demon Darika, symbolizing the victory of good over evil.

Theyyam: A ritual performance in Kerala where the voice of the deity is channelled through the artist who is denoted embodying the deity for the duration of the performance.

Images

p. 243: Spaces for Theatre, illustration by Gauri Nagpal.

p. 245: From the play *Dark Borders* (dir. Neelam Man Singh Chowdhry); image courtesy Neelam Man Singh Chowdhry.

p. 249: Mallika Taneja in her solo work *Thoda Dhyaan Se* (Be Careful); photo by Sissel Steyaert.

pp. 254–55: From the play *Talatum* (dir. Abhilash Pillai); image courtesy Serendipity Arts Festival.

GARGI BHARADWAJ

2019

19

Politics of Location
A View of Theatrical Contemporaneity in India

Scholarship on Indian theatre has focused on colonial theatrical culture, theatre's allegiance to the national project, forms of institutionalization and, most crucially, critiquing the urban relationship to folk and traditional performance. There has been some investigation of avant-garde practices of women theatre-makers since the 1990s that deviate from modernist paradigms to propose a new language for theatre, while underlining the subjective position of the maker as unstable, volatile and radical. The critique of the glaring exclusion of theatre from official cultural discourse has also occupied theatre scholars who trace back the genealogy of contemporary practice to the Indian People's Theatre Association (IPTA), early-modern forms like Parsi theatre and its regional variants. And equally, the view of folk forms as disembodied and appropriable artefacts, celebrated as markers of authentic 'Indian' identity, has been amply contested by scholars and theatre-makers alike.

Despite this broad scope of theatre scholarship, the discourse on state interventions in culture has

oscillated largely between the foundational debate about the need for a national cultural policy,[1] and what the limitations or dangers of instituting one could be. What appears as a visible gap therefore, is the dynamics between existing institutional frameworks and contemporary practice, i.e. the ways in which implicit state policies and existing material conditions of theatre impact theatre practice. This essay attempts to examine select contemporary practices that ensue productively from and exist in a complex relationship with state policies, and that function outside, even despite, established paradigms of theatre production in terms of spaces of performance, modes of spectatorship, what constitutes 'theatre' and 'work' in the theatre. The relationship these practices generate between audiences and performers is also explored.

To examine the material conditions within which this theatre is conceived, produced, performed and consumed, I critically survey five theatre productions/projects broadly located outside institutional frames and allocated edifices. I also reflect on the aesthetic shifts of structure and form that this assemblage proposes. It is my contention that each of these performances employs as a signifying practice a 'politics of location' that moves away from hegemonic modes of cultural production, focusing rather on local knowledge and favouring the situatedness of knowledge production in theatre. Each of the practices discussed here is situated in a regional site and engages strategically with its specific material and sociopolitical environment.

Understood as a 'view from elsewhere', these practices foreground the ideological and social positions that are being reinforced and contested in contemporary theatre practice. Location is, therefore, not only crucial to but also inseparable from (and constitutive of) this theatre. The practices discussed here reveal significant ways in which emerging formats of presentation and the choice of performance spaces cultivate and engage active audiences, in turn impacting notions of paid work and livelihood in theatre. In so doing, they propose a view of theatrical contemporaneity that responds productively to the state's restrictive cultural policies and shrinking resource allocation that increasingly dismantle social frameworks.

In the first section of this essay, I broadly map key institutional positions and the schemes of the Sangeet Natak Akademi (SNA) in its formative years to diagnose the current situation and mark its continuities with and shifts from the past. I do so to make the case for cultural policy in theatre as a de facto formation, i.e. not as an explicitly written document but dispersed across various documents emerging from seminars, consultations and official positions of SNA, its budgetary allocations, schemes and review reports. The second section analyses the five selected theatre works that employ 'politics of location' to

negotiate the gaps in theatre policy, and the conclusion summarizes the material shifts brought about by these projects, underlining their unique locations as crucial to destabilizing notions of theatrical centres and peripheries.

Mapping Cultural Policy Discourse and Gaps

The paradigm of institution-building in newly independent India sought to place culture as the kernel of democratic policies, to give shape to a 'national culture' and to institutionalize it, as Geeta Kapur points out, 'precisely to carry out the overall mandate of modernization'.[2] The beginnings of a policy framework in performing arts can be traced back to the setting up of central cultural institutions, particularly the SNA (established in 1953) and the allied political and administrative processes that brought culture into the ambit of state control, becoming part of the 'new framework of institutions that embodied the spirit of progress, or, its synonym, modernity'.[3] The SNA has since been instrumental in not only defining the contours of an authentic Indian theatrical future, but more crucially, as Anita Cherian reminds us, in crafting a theatrical past with its careful exclusions of certain theatrical expressions and movements.[4] Notably, despite the post-colonial urge to explore an 'Indian' idiom in all fields of cultural practice, there has not been any comprehensive policy enactment in Parliament to recognize and address the diversity of existing cultural practices. Despite the absence of a clearly written cultural policy, an amorphous policy exists in theatre. The gist of this within the context of a welfare state concerns the arms-length approach of the state that functions through SNA that has been the main recipient of funding and government directives in performing arts. The historical narrative of this policy needs to be constructed from documents emerging from seminars, consultations and the official positions of SNA, its budgetary allocations, schemes and review reports.

The discussions and recommendations of the First Drama Seminar (1956)[5] are instructive in understanding the earliest role of the state as the prime patron of the arts and processes of revival, restructuring and recognition of select practices. The rationale of state patronage, primarily to classical and Sanskritic forms of theatre and dance, and residually to folk forms since the 1960s, reveals perceived notions of tradition and authenticity that were manifested in dramatic texts and theatre productions anchored to the project of nation-building and national identity. The decades of the '60s and '70s offer a more complex and contradictory view of the role of state in theatre. On the one hand, principles of equity and access based on notions of social inclusion were articulated vigorously

while on the other, indigenizing trends in theatre through idealizing folk forms were intended at undoing the effects of 'western' influence. This was formalized in the concrete policies of the SNA through state-sponsored conferences, seminars and festivals. The young urban theatre practitioner's 'return to roots' was celebrated and incentivized, requiring folk-theatre traditions to have some bearing on theatre productions. The first ever review of the three cultural academies and the National School of Drama (NSD) – the Homi Bhabha Committee Report, 1964[6] – underscored issues of functional autonomy, inclusion of artists in the organizational structure, notions of accountability and the need for critical appraisal of institutional structures. The legacy of the cultural policy of these formative years brings into relief a slow and incomplete process of decentralization of state patronage. This is evident in the uneven spread of training institutions at state/regional levels and misdistribution of skills. Most crucially, the processes of cultural engineering launched by the state have been unable to secure for practitioners sustainable livelihoods in/from the theatre.

Deploying a Politics of Location: Emerging in Theatre Practice

I

Delhi-based theatre-maker, activist and walker, Mallika Taneja's single-actor performance piece *Thoda Dhyaan Se* (*TDS* / Be Careful) was conceived in 2013 in the aftermath of the Mumbai Shakti Mill rape case.[7] Developing from an eight-minute-long embodied response to the incident, *TDS* has evolved into a thirty-minute-long intimate theatre piece, still remaining, in most part, a work-in-progress. Each successive performance throws up newer challenges of context, form and content. It has since been performed in a variety of spaces from proscenium stages to classrooms and private living-rooms using found furniture and basic lights. Calling it a 'piece', a 'knee-jerk', rather than a production or play, Mallika signals a shift in the perception of the theatre event that embodies the vulnerability and innocence of the maker and her theatrical choices. The actor begins silently, stripping down every garment from her body. Standing bare in her 'essential femaleness', she looks at each audience member patiently, engaging and interrogating our gaze.

'If you don't want any trouble, don't invite it!' she states abruptly, most convincingly, before embarking upon a breathless string of advice and the lopsided rationale that women have to be 'careful' in order to be safe. This, while she relentlessly layers onto her naked body pieces of garments worn one on top

of the other in an absurd and humorous fashion. Finishing off with a helmet over her head, covered from head to toe, she is a bundle of tightly packed clothes, ready to head out! The piece is as much a provocation to our senses as it is to our deeply entrenched sequel of gender stereotyping and objectification of women's bodies, implicating invisible perpetrators and the passive language of victim blaming and shaming. The naked body is seen and understood in relation to the equal and opposite complexity of clothing. The body operates as text in its own right and is not simply a means of illustrating the spoken word. It is a work of great intimacy and self-reflection, rupturing our very sense of intimacy in performance, making us wonder what it means to look and to be looked at – for the actor's body in the theatre and for women's bodies outside.

Locating her work in alternative performance spaces in Delhi and outside the theatrical centres within India – particularly state-funded theatre festivals or popular performance venues in metropolitan cities – has given her a small, yet supportive audience who value her work. On the other hand, it is through travelling to and performing at international theatre festivals for the last two years[8] that the piece developed into what she calls 'legitimate work' in the theatre, implying that the work is paid, securing her access to financial means and fundraising circuits. Mallika's choices and *TDS*'s production itinerary suggest a growing connectedness between the local and the global through international performance networks, bypassing the central and the national altogether. Mobility through transnational networks ensures sustenance to artists; continued visibility globally and recognition in the form of awards often translate into increased relevance of their work locally.

II

The multilingual performance project, *Talatum*[9] (December 2016), conceptualized and directed by Abhilash Pillai, presents a retelling of Shakespeare's *The Tempest* in a circus tent, using the paraphernalia of traditional circus. As a collaboration between circus and theatre artists from Kerala, Meghalaya, Delhi, Manipur and Mumbai, it brings indigenous performance practices, both classical and folk, into rigorous conversation with the Shakespearean classic, while challenging traditional spectatorship in both theatre and circus. The show was rehearsed in Kerala, a location that is connected to the circus not only by its cultural landscape, i.e. the braided histories of circus[10] and indigenous performance traditions like kalaripayattu and theyyam but also by its natural landscape, particularly the sea that provides the edifice and key motif of many folktales of the region. Commissioned by the Serendipity Arts Festival, Goa and

performed at SAG grounds in Panjim, the performance built on the cultural capital of Shakespeare by performing *The Tempest* in the year commemorating the 400th death anniversary of the bard.

A massive circus tent, the traditional Big Top, reminiscent of the grand old itinerant circus, is built with audience seating especially engineered to yield a greater level of comfort than its traditional dugout seating. The central scenographic element is a humungous papier-mâché puppet of Sycorax, the silent witch from *The Tempest*, adorned by a headdress in traditional circus colours. Her arms are spread out and breasts swollen, prefiguring the birth of Caliban. Her legs circumscribe the space of the circus ring. A curtain is placed below her chest for the entry and exit of performers. There are other sculptural objects – an inflated balloon puppet of baby Caliban, a life-like wooden puppet of the young Miranda, a cardboard model of a ship, a restored dinghy lifted vertically using circus pulley and ropes. They define the performance's negotiation between the dramatic text, inflected through the use of audio-visual elements, digital projections and circus items – fire-breathing, juggling, aerial silks, trapeze, unicycling and hooping – to produce a unique multisensory experience. In its unruly use of material, scale and physical possibilities, the performance is a scenographic spectacle that generates a plethora of feelings far exceeding the refined ideals of dramatic theatre.

Talatum is part of a broader project called 'Pioneer Palace', conceived by Pillai in 2015 with a view to developing a national culture of circus arts through training and regular circus shows. The project conceptualizes a framework for generating sustainable modes of livelihood through circus and allied physical arts. Historically, the tradition of circus arts in India sits alongside the old subaltern bazaar cultures. It gained its modern identity through an accretion of cultural borrowings, not only from the west but also from deeply-rooted indigenous traditions of Kerala like kalaripayattu, theyyam and mudiyett , deeply problematizing notions of authenticity and homogeneity in performance. The institutionalizing tendencies of state policies render invisible the histories of hybrid forms such as circus, veiling their modern development, problems of livelihood and possibilities of artistic and social development for its practitioners. Conceived as a travelling show, *Talatum* foregrounds the historic relationship between government policies and popular forms that have remained outside state funding but within the ambit of state control, often seen only as sites of transgression and therefore inviting neglect and apathy. The circus artist, often denied the position of a skilled performer, yet pitied and commodified, continues to fight social stigmatization, legal prohibition and loss of livelihood. In its attempt to revitalize circus, *Talatum* aligns itself with similar attempts in North

America and Australia that manifest the potential of performance, spectacle and modern physical training to contemporize subaltern physical arts, encouraging the return of both practitioners and audiences back into the circus tent.

III

A key site for unpacking theatre's relationship with wider social and cultural phenomena is located in practice that emanates from and is performed for constituencies defined in terms of a 'community', reflecting shared knowledge and social realities. *Theatre Outreach Unit: Theatre Enhancing the Livelihoods of Parishat Artists*, initiated by the Department of Theatre Arts, University of Hyderabad (HCU), Telangana (2012–15) and funded by the Sir Ratan Tata Trust and Navajbai Ratan Tata Trust, was a unique theatre-training and management project aimed to engage with the material conditions, aesthetic and conceptual redundancies facing Telugu theatre. The project identified Parishat theatre as the bearer of the continued tradition of modern Telugu social drama, largely funded and managed by associations of amateur and semi-professional theatre practitioners of the region. Parishat events spread across the state have historically sustained community participation in Telugu theatre.

The project located 'community' in theatre both on and off stage. To expand the artistic repertoire of the theatre community training workshops were conducted in five regions – Vijayawada, Hyderabad, Nandyal, Kakinada and Nizamabad. Viewing the community beyond the stage and in its social context, the project broached enhancing livelihoods in theatre by broadening entrepreneurial and soft skills of artists and engaging new and young audiences, tying together theatre practitioners with their audiences and the larger social system. The project also liaised between local policy-implementing institutions and their beneficiaries by conducting theatre management workshops for existing groups in marketing, fundraising and publicity, as well as assisting them in registration in state records, maintaining audit statements and applying for grants under government schemes.

As an adaptation of the itinerant repertory model of the popular theatre tradition, an eight-month-long artists-in-residency programme was launched with a group of fifteen actors who travelled and performed extensively throughout the region. They were paid a monthly salary for the duration of the residency, during which they underwent rigorous training in modern acting skills, advanced design, lighting and stage-craft techniques. *Miss Meena*, the first of the two productions, is an adaptation of Swiss-German playwright Friedrich Durrenmatt's *The Visit* directed by Indla Chandrashekhar. The second

production, *Adventures of Chinnari*, directed by Sheikh John Basheer, is a play for children and young audiences based on a Chinese folktale infused with local imaginaries. Both productions explore innovative presentation formats of fast-paced action and energetic storytelling in a minimalist setting. As the focus is on empowering the artists to travel, perform and manage shows by themselves, the set pieces and props are easy and lightweight to enable quick set-up and strike after each show.[11]

The project enabled the two young Telugu theatre directors, also graduates of the Department of Theatre Arts, Hyderabad Central University, to bring forth experiences gained in a formal theatre institution to work in local contexts, telling the stories that emanate from and resonate with the community. This is the reason that while both shows ran on a professional repertory model generating revenues through ticket sales, they also received support from local audiences, often in the form of donations and logistical assistance. By the end of 2017, both the productions had travelled widely across Andhra Pradesh and staged more than 100 shows, performing in conventional theatre venues and other makeshift performance spaces.

IV

Neelam Man Singh Chowdhry's performance iterations based on Manto's short stories are a way of negotiating the historical narration of an emerging nation with the contemporary realities of destitution, displacement and gender violence. Just as Manto's narratives reflect his predilection for social outcasts to explore the subject of violence, Man Singh's feminist re-narration of his stories articulates a view from down under to reflect on the communal national legacies being re-rehearsed in present times. Three theatre productions made each year since 2015 are iterations, similar yet distinct from each other, occupying different locations and engaging distinct constituencies. While *Bitter Fruit* (2015) and *Naked Voices* (2016) were both devised with final-year students of NSD, *Dark Borders* (2017) was conceived out of a four-month-long training workshop Man Singh conducted for amateur actors of Chandigarh at the behest of the city administration that also provided a modicum of funding for the exercise. All three productions are retellings of several short stories by Manto intermixed with images, characters and text from his larger repertoire. In the process, the texts are remade each time and form what she calls 'free flowing embodied texts' that belie any loyalty to the writer's word or interpretation, reclaimed and re-signified through her playful use of theatrical materials and bodies on stage. The curtness of expression and the fragmentary form of these productions speaks to

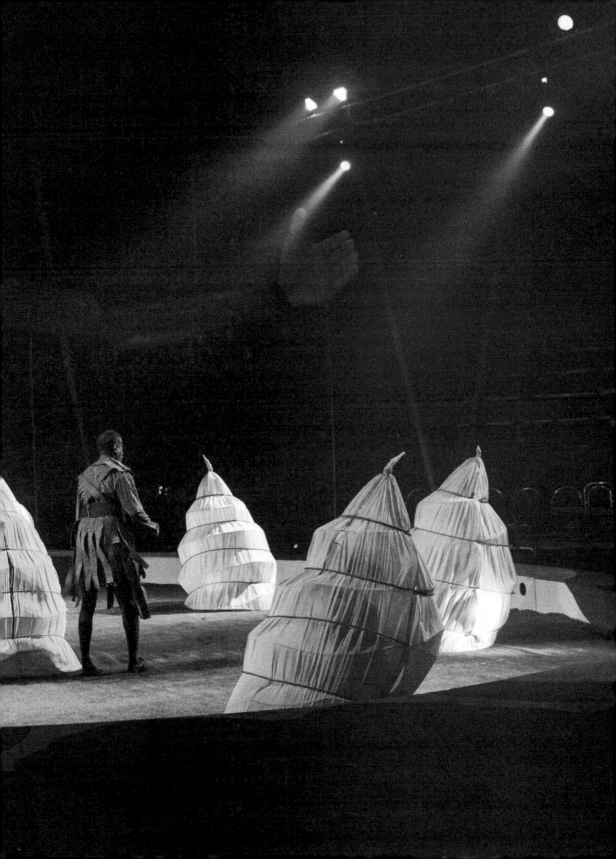

the impossibility of representation of traumatic experiences while still in their grip or in their immediate aftermath.

While the context of training underlies all three productions, there is an unmissable difference between institutional practice that rests on generous state support and that which negotiates limited funding, constraints of space and pressures of translating training processes into professionally successful productions. Despite these odds, *Dark Borders* premiered at Chandigarh's iconic Rock Garden and has since travelled to major theatre festivals in Delhi, Jaipur, Hyderabad and Goa, eventually sustaining a professional run. This production stands apart from the oeuvre of Man Singh in that it is for the first time that she has worked with local, largely untrained, actors of her city. It is noteworthy that her professional practice and her stature as an important theatre director in India underlines a social position that is both centred and decentred. Despite her vast experience in theatre institutions and mobility to national-international theatre festivals, she locates herself away from the urban centres of theatrical practice, running a theatre company that despite the repertory grants from the Ministry of Culture often struggles to make enough money to sustain the quality of its theatre productions and ensure a minimum livelihood to its artists. Despite the departures that this production makes with respect to its geographical and symbolic location, it builds on notions of repetition and reiteration of performance aesthetics and the style of the maker, text(s) in question and dispersed ownership of creative work.

V

A large-scale outdoor performance spectacle, *Dark Things* uses scenography, music and action to explore the human cost of migration and forced exile of people brought about by shifts in political and fiscal currents as global capitalism ebbs and flows. Developed and performed as part of the course curriculum in musical performance at Ambedkar University Delhi (AUD) and performed by graduate students of its performance studies programme, the project used artistic collaboration and co-creation to train students in contemporary performance-making. There is a deliberate fusing of choreographed action, object, image and movement, playing with live and recorded music to develop a performance vocabulary that translates the 'Oratorio' by the South African writer Ari Sitas[12] into song, speech and poetry. Contemporary images of work and modern forms of slavery are woven together by the young dramaturg Purav Goswami, and the piece has been assembled by Anuradha Kapur and Deepan Sivaraman. The music, by the Kerala-based composer Chandran Veyattummal,

South African guitarist Reza Khota and the singer and music scholar Sumangala Damodaran, spans disparate Afro-Asian tonalities. Funded and performed as a part of collaborative research work between AUD and UCT (University of Cape Town) faculty on Afro-Asia linkages in creative work, *Dark Things* splits open the construction of the 'other' in political rhetoric today – the precarious bodies of the refugee, migrant labourer, factory worker, sewage cleaner and bone collector. There is no story or character – only vignettes, sounds and objects that evoke contemporary linkages between capital, labour, product and the human catastrophes they unleash. Toiling-moiling bodies of actors, musicians, crane-operator, tempo-driver and balloon-man narrate a range of experiences of work and displacement, crossing borders of all kinds, acquiring identities that are palimpsestic, bearing the mark of each location that has been traversed.

Dark Things throws up crucial questions about the tenacity of theatre and performance curricula to critically examine the global knowledge flows in the fast-transforming public university increasingly under pressure from forces of neoliberal capitalism. The question that must be asked constantly with regard to skill-based theatre training and practice, particularly in the public university, is the extent to which it can critically examine and open up the ideological role played by the university in its service of the state and the market, while at the same time resisting the attraction of performance/theatre to be co-opted into the cultural marketplace as a product.

Conclusion

The projects discussed here do not fit programmatically within the categorizations and spaces defined by institutional paradigms of theatre. Each of them is located in local/regional/community-specific contexts, reflecting positions and anxieties that disperse centrifugally and become signs of an emerging contemporaneity. These productions break away from the grand narratives of nation-building, national histories and uniform notions of identity in favour of specific yet multiple voices reflecting multiple subjects and realities. The theatrical narratives at play are localized, often even personalized and fragmentary, resisting any closure or fixity. As projects that make crucial cultural-political interventions, they consciously reach towards alternative and forgotten histories and traditions in performance. There is a recognizable desire to move away from fixed binaries of theatre/performance, classical/popular, modern/traditional, text/body in favour of a multidisciplinary aesthetics that combines storytelling with spectacle, multimedia technology, industrial objects, local histories, movement

and choreography, aural and textual reflections. The paradigm of 'pretence' in theatre is unsettled as we experience more reality, more materiality on stage.

Most of these practices work laterally to dismantle existing power structures in theatre through collective production, dispersed ownership and collaboration. They also propose modes of spectatorship that are made active through participatory environments or spaces of engagement that are inclusive and sustainable. Most crucially, questions of livelihood, skill development and training are relocated in specific geographic and metaphorical contexts and linked socioculturally to audiences. Each of these locations is crucial to fulfilling our desires for decentring and destabilizing notions of theatrical centres and peripheries.

THE ARMED FORCES (SPECIAL POWERS) ACT, 1958

ACT No. 28 OF 1958

[11*th September*, 1958.]

An Act to enable certain special powers to be conferred upon members of the armed forces in disturbed areas [1][in the States of [2][[3][Arunachal Pradesh, Assam, Manipur, Meghalaya, Mizoram, Nagaland and Tripura]]].

4. Special powers of the armed forces.—Any commissioned officer, warrant officer, non-commissioned officer or any other person of equivalent rank in the armed forces may, in a disturbed area,—

(*a*) if he is of opinion that it is necessary so to do for the maintenance of public order, after giving such due warning as he may consider necessary, fire upon or otherwise use force, even to the causing of death, against any person who is acting in contravention of any law or order for the time being in force in the disturbed area prohibiting the assembly of five or more persons or the carrying of weapons or of things capable of being used as weapons or of fire-arms, ammunition or explosive substances;

(*b*) if he is of opinion that it is necessary so to do, destroy any arms dump, prepared or fortified position or shelter from which armed attacks are made or are likely to be made or are attempted to be made, or any structure used as a training camp for armed volunteers or utilised as a hide-out by armed gangs or absconders wanted for any offence;

(*c*) arrest, without warrant, any person who has committed a cognizable offence or against whom a reasonable suspicion exists that he has committed or is about to commit a cognizable offence and may use such force as may be necessary to effect the arrest;

(*d*) enter and search without warrant any premises to make any such arrest as aforesaid or to recover any person believed to be wrongfully restrained or confined or any property reasonably suspected to be stolen property or any arms, ammunition or explosive substances believed to be unlawfully kept in such premises, and may for that purpose use such force as may be necessary.

A brief political history of theatre in the North Eastern state of Manipur. Mapping the origins of theatre practice in ritual performances, the author discusses the works of makers like Heisnam Kanhailal and Ratan Thiyam, alongside works by current practitioners. Key productions, such as the definitive play *Pebet* (1975) by Kanhailal, are discussed alongside political developments such as the Armed Forces Special Powers Act and political militancy, to set a framework for viewing an extraordinary theatrical tradition.

Earlier version published in 'Staging Change: Theatre in India', special issue of *Marg* (vol. 70, no. 3, March–June 2019, pp. 82–91), edited by Anuradha Kapur. Reprinted with permission. Grateful acknowledgment to Trina Nileena Banerjee for help and support.

Keywords

Kalakshetra Manipur, Kathak, Kalaripayattu, National School of Drama: see Keywords (pp. 329–44).

Armed Forces Special Powers Act (AFSPA): Originally passed in 1958, primarily to allow for Emergency-like military powers, in the context of insurgencies in the North Eastern states and in Kashmir.

Heisnam Sabitri, Kanhailal, Tomba: Family of theatre practitioners with a major impact in the region and across the country. Kanhailal (1941–2016) directed several productions, many featuring his wife, the actor Sabitri, and also set up the Kalakshetra Manipur in 1969. Tomba, their son, is also a known director and playwright and runs the Kalakshetra.

Lai Haraoba: Major Meitei festival, literally translates as 'merry-making of the Gods'.

Meitei: The majority ethnic group in Manipur ('Meitei' and 'Manipuri' are often terms used interchangeably). This essay references Meitei traditions and practices such as Lai Haraoba in mapping Manipuri culture and performance.

Sanamahi religion/Sanamahism: A Meitei religious tradition.

Thang-ta: A popular term for a martial art practice of Manipur, otherwise known as huyen lallong. Like other martial art forms that may have previously been used in preparation for armed combat or war exercises, such as kalaripayattu, thang-ta is now a resource for performers (*thang* meaning 'sword' and *ta* 'spear').

Images

p. 259: Photomontage – activist Irom Sharmila and excerpts of the text of the Armed Forces Special Powers Act (AFSPA), which is currently in force in most parts of Manipur.

p. 261: Heisnam Sabitri in Rabindranath Tagore's *Dakghar* (Post Office, dir. Heisnam Kanhailal).

pp. 264–65: Sabitri and Kalakshetra Manipur actors in *Pebet* (dir. Kanhailal).

p. 269: Sabitri in scenes from *Draupadi* (dir. Kanhailal), based on Mahasweta Devi's short story of the same name.

pp. 270–71: Photomontage – women protesting the rape and murder of Thangjam Manorama by the Assam Rifles, outside their headquarters at Kangla Fort, Imphal. Grateful acknowledgement to Kalakshetra Manipur archives.

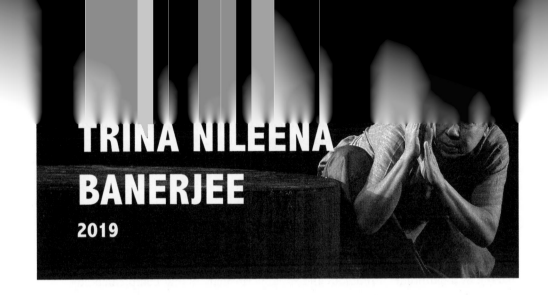

TRINA NILEENA BANERJEE

2019

20 Contemporary Theatre Practice in Manipur: A Reckoning

The realities of contemporary theatre practice in Manipur are complex. The legacies that influence its making are heterogeneous and multifaceted. Whether one looks back at the past, examining the traditional 'roots' of present-day performance practices, or towards the promises and possibilities of the future, the landscape appears intricate. It is a field shaped by a vortex of linguistic encounters, cultural influences/resistances and a heterogeneous admixture of aesthetic tendencies. The present moment in Manipuri theatre, for example, is inescapably marked by the towering shadows of the iconic masters – Ratan Thiyam and Heisnam Kanhailal (who passed away in 2016).[1] However, there is also evidence of an equally forceful desire to break free into new territory, both aesthetically and politically. Thiyam and Kanhailal have created such indelible classics in their lifetime of work that it could be argued that very few younger directors in Manipur have managed to escape their influence entirely. Yet, there is within many in Manipur today the desire to mould these influences

into radically new shapes and to reflect differently, if not better, on the changed, baffling and ambivalent nature of Manipuri political reality today.

The 'Origins' of Manipuri Theatre Practice

The connections of performance with communitarian life, religious customs and public space are traditionally quite well established in Manipuri society. The pre-Hindu period in the history of Manipur (till the eighteenth century) was marked by a multitude of religious and ritual performances that complemented every aspect of social and cultural life. These rituals were connected with agricultural practices, cycles of birth and death, royal ceremonies as well as quotidian practices of ancestor worship and propitiation. Scholars have argued that the earliest origins of Manipuri theatre lie in the traditional performances of the Lai Haraoba, a festival based on a ritual form of ancestor worship. The Lai Haraoba is part of the embodied culture of Manipur, and has been passed down over centuries, from one generation to the next, through oral traditions and performance repertoires. It continues to be exceedingly popular in contemporary Manipur and is celebrated during the summer months every year (April and May) in every locality. During the time of the festival, the streets, *leikai*s (neighbourhoods) and *mandap*s (slightly raised platforms or pavilions) are universally transformed into spaces of ritual performance. Translated literally, Lai Haraoba means 'the pleasing of the gods' or 'the festivities of the gods'. The central rituals are performed by the *maiba*s (priest) and *maibi*s (priestesses), who are highly revered as healers and propitiators of the forest gods/spirits, who are known as *umang lai*s. The dance of the *maibi*, especially, has particular shamanistic connotations as she is often perceived as the mediator or link between the *lai*s (gods) and the people of the community. Trance or possession by the *lai* is a common occurrence for the *maibi*, and she is believed to have special healing and ritual powers during these states of possession. Traces of the influence of the distinctive dance of the *maibi*s are found in various elements of Manipuri performance practice, both religious and secular.

Roots of a distinctly theatrical practice had already existed[2] within the performance tradition of Lai Haraoba, in the performed event of the 'Tangkhul Nurabi Loutanba', which includes distinct elements of dialogue, plot and characterization indicative of later developments in Manipuri theatre.[3] Other traditional and religious performance forms include those influenced by the entrance of Hindu religion, particularly Vaishnavism, into the Manipuri sociocultural sphere. These performance forms include the ras leela (influenced

by many elements of the older tradition of Lai Haraoba), nata sankirtan, goura leela, gostha leela, udukhan leela+ and others. The concepts of fertility and the celebration of the creation that marked the pre-Hindu performance practices of Manipur found their way into many of these performance genres, forming a unique blend of styles and themes that define Manipuri performance culture to this day.[5]

The shumang leela (literally translated as 'courtyard theatre'), which arguably grew out of phagee leela,[6] remains the most popular form of theatrical performance in Manipur even in contemporary times. It is usually performed in open spaces, playgrounds or *mandaps* that are found in most villages and *leikai*s in Manipur. The community gathers as audience on all the four sides of the performance space, forming a far more intimate relationship with the performers than a proscenium audience is allowed, as the performers enter and exit through a single passageway that passes through the midst of the audience. The performance area is usually about twelve to thirteen feet across and the form of the performance disallows any elaborate stage design, props or the use of complicated lighting techniques.

Shumang leela is performed all across Manipur by groups of professional touring artistes, either all male or all female. The male performers of female roles, referred to as *nupi shabi*s, remain highly admired stars in the shumang leela circuit across the state. It is the primary form of entertainment in rural communities which have very little access to proscenium performances of the urban kind. Of course, what used to be a primarily oral tradition without the use of written scripts has now been influenced greatly by the form and content of contemporary proscenium performances in terms of themes and style of performance. Recent plays in the shumang leela genre have begun to grapple with themes of insurgency, governmental corruption, military conflict, political unrest and even international events like the 9/11 disaster in the United States of America.[7] However, the gap between the ostensibly 'rural' spectators of the popular shumang leela and the audiences of the urban political theatre of Imphal, which is 'recognized nationally', marks one of the central contradictions of the politics of Manipuri performance practice today.

'Stage Leela' and the Arrival of 'Modernity'

Stage leela or phampak leela was the modern form of the proscenium theatre that developed under a distinctly Bengali influence in the first years of the twentieth century in Manipur. Several performance companies dedicated to proscenium theatre emerged in the 1930s, the earliest of which was the Manipur Dramatic

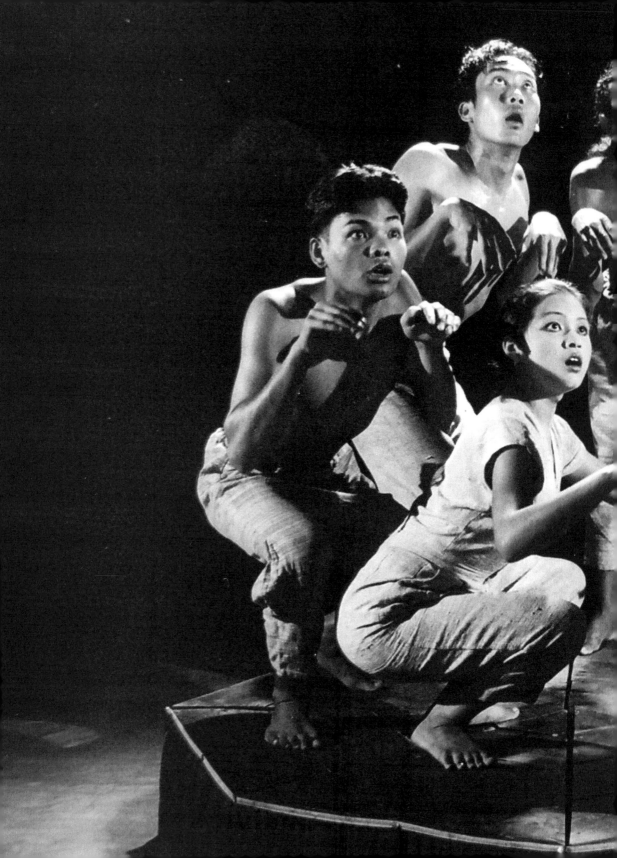

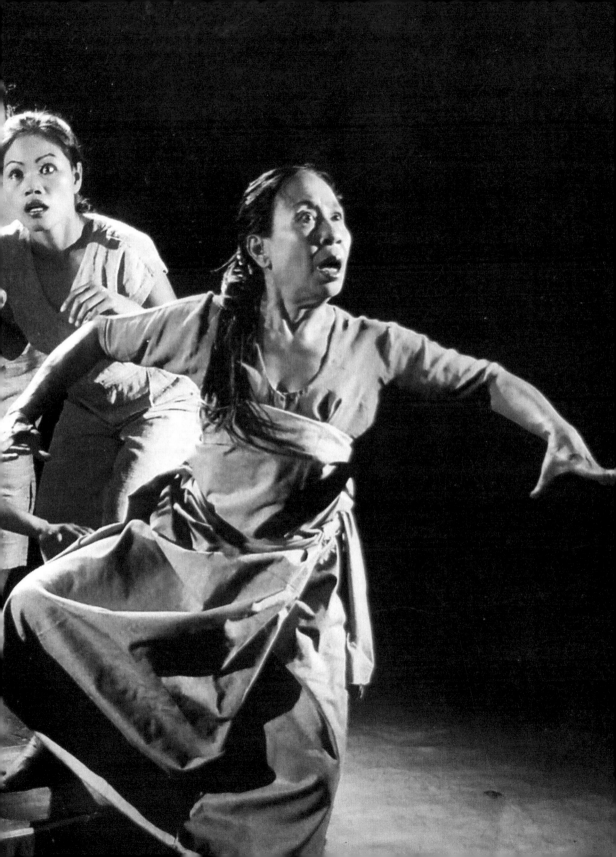

Union established in the year 1931, followed by the Aryan Theatre (Imphal) in 1935, Chitrangada Natya Mandir (1936) and the Society Theatre in 1937. This was followed by the establishment of a spate of other theatres in the 1940s, like the Rupmahal Theatre in 1943 and the Langmeidong Dramatic Union in 1943–44. Almost all of these newly established theatre companies, some of which are still extremely popular, were established in and around the immediate vicinity of Imphal city.[8] Its themes, in the decades following the 1930s, were mainly historical or religious, social melodramas or heroic legends.[9] Stage leela remains to this day what can be called the 'commercial' theatre of Manipur.

It was in the 1960s and 1970s that Manipuri theatre moved away from the themes of the commercial stage in order to explore urgent political questions that could no longer be ignored. Modern playwrights of the Manipuri stage like Maibam Ramchandran, Athokpam Tomchou and Pukhrambam Shamu had already begun to explore the discontent brewing in Manipuri society. Arambam Somorendra and G.C. Tongbra[10] stood out as playwrights with their intensely critical attitudes towards the degeneration of modern-day Manipuri society and the increasingly corrupt attitudes of the powers-that-be. G.C. Tongbra was highly influenced by George Bernard Shaw and his writing was bitingly satirical in character, while Somorendra's works were often a call towards revolutionizing society, uniting the forces of resistance as also deeply invested in the cause of suffering women.[11] Somorendra became part of the underground resistance against Indian occupation and subsequently went underground in the year 1969. In the same year, Heisnam Kanhailal returned from New Delhi after a disastrous experience at the National School of Drama, where he was isolated, marginalized and finally expelled because of his inability to speak the hegemonic language of the Indian nation – Hindi. Soon after, he established Kalakshetra Manipur, along with his wife and lead actress Heisnam Sabitri.

The general dissatisfaction that was already in ferment had begun to take political shape with a growing awareness of the injustices and exploitation of Indian rule, as well as the cultural hegemony that mainland Hinduism had continued to exert on Manipuri society for centuries. There was also widespread resentment against the economic and commercial dominance of traders (mostly Marwari and Bengali) from the mainland, who had for decades continued to hold sway over exports and trading in even essential goods. There was now a renewed exploration of communitarian roots and an assertion of specific identity of the Meitei community, including calls for a return to an unadulterated Sanamahi religion. Political and cultural movements at this stage even sought to reject the Bengali script as an external imposition of the mainland (which indeed it was) along with a call to return to the original Manipuri script to write Meiteilon, the Manipuri language.

It was in this period of growing unrest, that a new 'experimental drama' came into being in Manipur, mostly located amongst the young and urban theatre activists of the city of Imphal. This work was deeply political and took on not only radically new experimental methods and themes, but also explored the risky possibilities of political liberation from long-standing Indian domination.[12] After a brief encounter with and training in the work of Badal Sircar,[13] Heisnam Kanhailal began his theatre practice with a series of plays that changed the landscape of modern Manipuri theatre. His landmark play *Pebet* (1975),[14] staged during the years of the Emergency in and around Imphal, was widely accused of being both anti-Hindu and anti-Indian. Yet, it managed to escape censorship, perhaps primarily on account of its being largely non-verbal. Kanhailal had, at this point of time, begun to develop the theatrical language that was to become his signature in later years – a highly lyrical, embodied mode of expression that relied very little on text. Kanhailal's form aimed at turning the body of the actor into an instrument that articulated the wounds of collective oppression. Finding resonance for the pain of others in the actor's body and the recognition of collective pain as urgently political seemed of utmost importance to Kanhailal's vision till the end of his life. Pebet, for example, takes the form of a fable by drawing on the folkloric resources of the Meitei society. It bases itself on a story from the *phunga wari* (fireside stories) tradition where the elders of the family sit around a fire telling stories to the young ones, especially during the winter months of the year. In Kanhailal's play, this simple tale of a family of songbirds and a cat, takes on strongly political undertones. The manipulative and exploitative cat is depicted as a Hindu Brahmin who speaks in Sanskrit in order to lure away and proselytize the bird children, finally brainwashing them into humiliating their own mother. The political anger and rebellion written into the final defeat of the cat in the play was impossible to miss, and the play has remained unforgettable in the modern theatrical canon of Manipur.

It was in 1976 that Ratan Thiyam set up his Chorus Repertory Theatre in Imphal, after graduating from the National School of Drama in 1974. In sharp contrast to Kanhailal's work, Thiyam's work explores the more spectacular aspects of the ritual elements of Manipuri culture. His most celebrated productions are *Karnabharam* (1979), *Imphal Imphal* (1982), *Chakravyuha* (1984), *Uttar Priyadarshi* (1996), *Ashibagi Eshei* (2008, 'When We Dead Awaken') and *Macbeth* (2014). He is known for using traditional dances and martial arts forms of Manipur in his work, especially the thang-ta and nata-sankirtana. He has been criticized by traditional practitioners of these forms for having diluted the specificity of some of their elements, but Thiyam continues to defend his exploration of them on the grounds that he moulds them to suit the

needs of his particular aesthetic and political concerns during the making of a play. Rustom Bharucha has written rather harshly of Thiyam's work:

> ... while there is much to admire in the martial technique of his actors and the precision of his stagecraft, the thrust of his work can best be understood within the context of an 'invented' tradition. Here the very image of 'Manipuriness' has been shaped by norms and expectations established in political centres like New Delhi and the festival scene abroad.[15]

While this may be a cursorily unfair summation of the depth and breadth of the work of a contemporary master, it is true that Kanhailal and Thiyam continue to represent polarizingly opposite aesthetic and political tendencies in contemporary Manipuri theatre. They encapsulate the contradictions embedded in the search for a modern Meitei identity in the fraught cultural space of the militarized state. They have both, in their distinctive ways, defined the shape of what has flowered in their wake – giving rise to a lot of work that has grown from both emulation and blind admiration. This is true to the extent that it has become exceedingly hard for younger directors in the state to lay claim to a style that is completely independent of their influence or equally distinctive in its artistic signature.

Contemporary Theatre Practice

In the year 1980, the Armed Forces Special Powers Act, better known as the AFSPA, was officially imposed on Manipur. The state went into a condition of permanent siege and endless emergency, to the extent that it was difficult to walk the roads of Imphal after sunset without being assailed by the Army, let alone stage or attend a play after dark. Various social and political movements arose at this time in Manipuri society to resist the relentless oppression and violence of Indian military rule, including, for example, the meira paibi (torchbearers) women's movement, where women 'torchbearers' literally patrolled the public spaces/streets of localities after dark and in times of curfew, to keep watch against possible atrocities by the army.[16] The effects of this on proscenium theatre in the years since the 1980s can easily be imagined. As theatre-watching in Imphal became an increasingly difficult prospect, a new language to adequately capture the radically changed political and quotidian reality of the state also became necessary. Kanhailal's play *Draupadi*,[17] staged in the year 2000, remains an

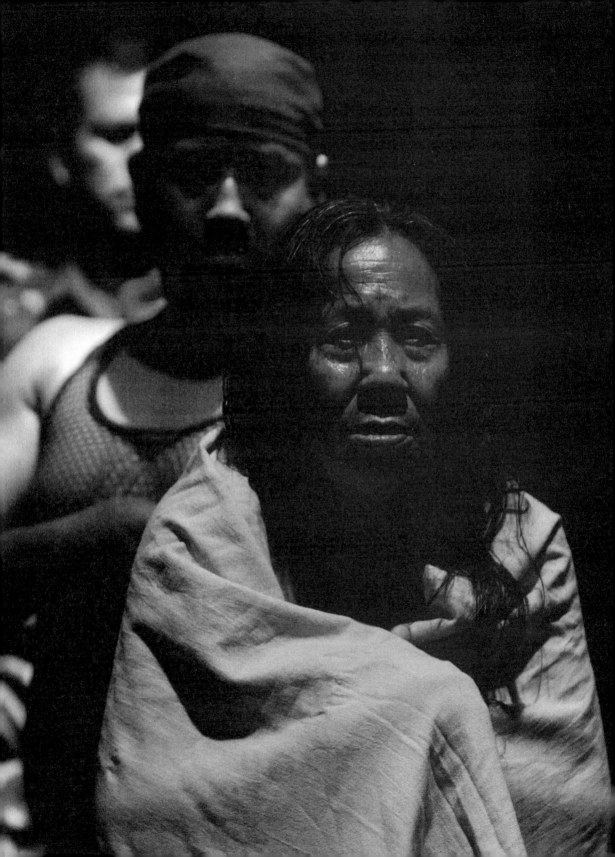

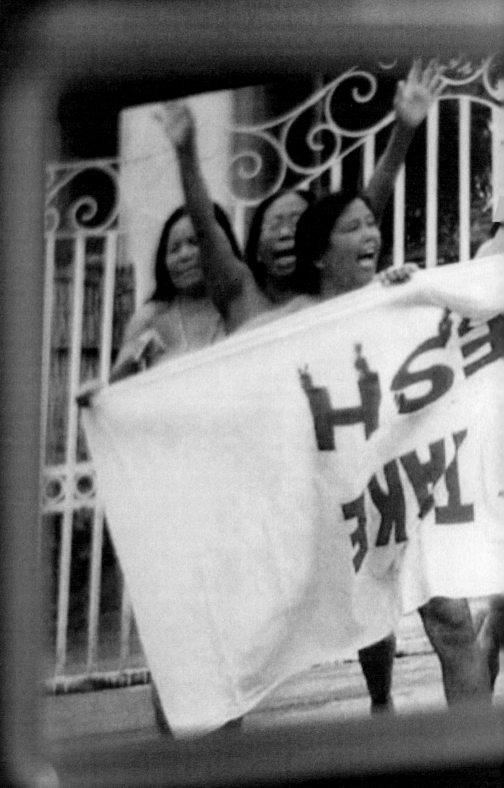

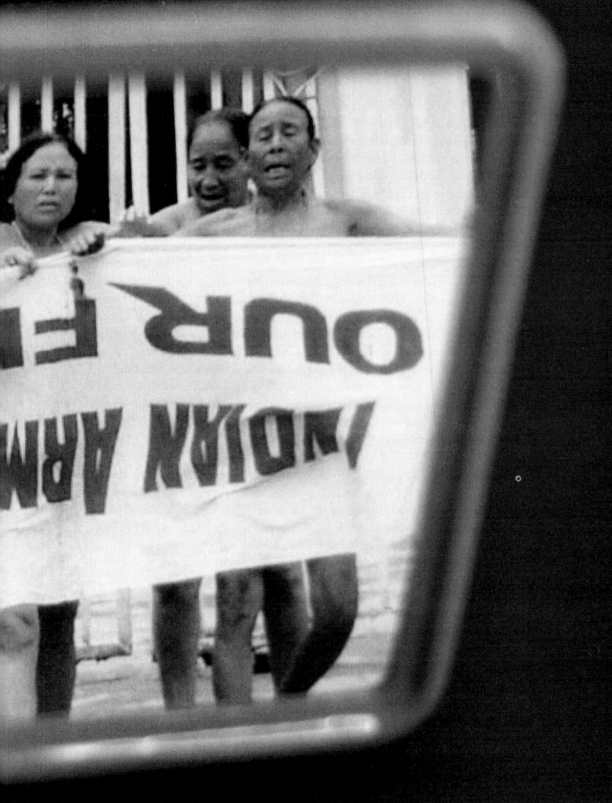

encapsulation of the political trauma and extreme violence of the subsequent decades in Manipur.

In the years immediately following the 1980s, plays by Manipuri directors began to enter the festival circuit in New Delhi and elsewhere. In many ways, patronage and grants as well as festival invitations from the central government became a primary way for Manipuri theatre to sustain itself, even as it lost touch in some ways with its local audiences, as a result of the exceptionally difficult circumstances prevailing in Imphal and around. In 1997, Lokendra Arambam wrote on this subject:

> A young group of theatre workers have come up in the 80s, who want to express what they are feeling and experiencing. ... They want to be seen outside Imphal, they want to be featured in national festivals. Here issues of patronage, access to channels of communication etc. become important There has not been much of an aesthetic departure from the theatre of the 70s. Younger directors work with the same idioms, with ethnic designs and costumes; and at times the intrusion of colour and spectacle undermines the very sense of the tension they want to create in their plays.[18]

While this appears to paint a rather gloomy picture of contemporary theatre practices in Manipur, in recent years, there has been a crop of new and arguably exciting directors that have come to the forefront. The realities of everyday life have also changed in present day Imphal, with increasing funds flowing in from the centre for the development of the state under the Indian government's 'Look East' policy.[19] While this has meant significant changes in the urban landscape of Imphal, along with extended hours of available electricity, greater access to public spaces for common citizens and newer places of entertainment like coffee shops/ restaurants, the entrenched corruption amongst the state's bureaucracy remains a hard fact that refuses to go away. The recent rise of the Bharatiya Janata Party (BJP) in the electoral politics of the state is also a factor that needs to be reckoned with, as does the rising influence of right-wing Hindutva forces on Meitei socio-cultural life. The attraction that the promise of a freshly minted urban life (with unprecedented access to the facilities that 'development' offers) has for a newer generation of Manipuris cannot be underestimated, especially after being subjected to decades of routinized violence and daily conflict. Various directors have, in recent years, attempted to grapple with the increasingly complex and ambivalent nature of political reality in the state, but a theatrical language that has come fully

into its own is urgently necessary in order to address the baffling nature of a hydra-headed developmental modernity in a militarized and conflict-ridden state.

Interesting reflections of these complexities have appeared, for instance, in the contemporary dance theatre practice of the young dancer-choreographer Surjit Nongmeikapam. Surjit is trained in kathak, kalaripayattu and thang-ta but continues to explore other forms and training styles in order to keep enriching his work. He has toured internationally with his productions as the director of Nachom Arts Foundation, Imphal. In his interviews, Surjit speaks of how he is interested in understanding what happens during torture, what drives the torturer – is he simply following a bureaucratic order, for example – and what it means for a body to be in pain. How does the body of a traumatized person feel? These are incisive and crucial questions for any modern dancer concerned with the politics of the body, but for a dance theatre practitioner from Manipur, where extra-judicial killings and custodial rapes by the military have been everyday reality for decades now, the focus on the body in pain is also the means of articulating one's resistance to the erasure of memory. It is interesting therefore that Surjit believes that modern dance is a crucial resource for therapy and rehabilitation work, as well as community-building in a conflict-ridden society.[20] He admits to being driven by his desire to represent/show the conflict that tears up Manipur, his home state. He says of his homeland in an interview: 'There has been war for as long as we can remember. There are curfews and blockades. Interrogations, gunfire, torture and violence. It has been a trauma for everyone in Manipur.'[21] In the same interview, he speaks of how his criterion for selecting performers for his pieces is not that they be trained and accomplished dancers, but the fact that they have the lived experience of military occupation in Manipur, so that they may share in the collective reality that the performance wishes to address. His recent production *Nerves* (2016) draws on this experience of quotidian violence, in order to produce embodied ruminations on the collective nature of pain and torture. The wounded and disturbed self, rather than perfected technique was at the centre of this performance piece.[22] The constant state of anxiety and internalized guilt/violence, where the body's nerves are stretched to the breaking point through an ever-present fear of violence, is what Surjit wished to explore in his piece. 'What does the constant threat of violence do to a body that wishes to create and engage with the world freely?' he seems to be asking through his dance. In many ways, *Nerves* encapsulates the concerns that were raised in Surjit's earlier pieces, including his solo works. It is interesting to note how contemporary Manipuri performance has moved out of the space of narrative theatre and into the hitherto unexplored space of modern dance theatre in order to address Meitei society's most deeply disturbing and urgent questions.

What has also changed in recent years is the appearance, for the first time, of female directors like S. Thaninleima and Toijam Shila Devi[23] on the Manipuri theatre scene and the possibility of a different theatrical language that has arguably followed in their wake. In a scenario where women have appeared in the work of theatre only as actresses, the arrival of these women as directors who have established their own theatre groups is a critical development. Thaninleima, who graduated with a diploma in design and direction from the National School of Drama in New Delhi, is also an independent researcher who has completed her doctoral work on modern Manipuri theatre, with an emphasis on the works of Ratan Thiyam. She established her own theatre group Khenjonglang in 1992. Trained in theatre in her early years by L. Dorendra Singh of the Cosmopolitan Dramatic Union[24] in the face of great family opposition, Thaninleima went on to direct plays like *Rickshaw and Gun* and *Eigi Khongthang Lepkhiroi* (I Will Not Cease To Go On), which focus on not only the accumulated frustrations of living in a conflict-ridden state but also on the contradictions of her own position, working as a creative artist and a single woman in a conservative society. Shila Devi, the other female director whose work has drawn national attention in recent years, was also a graduate of the NSD and has established her own theatre group Prospective Repertory Theatre. She has staged powerful plays like Dharamveer Bharti's *Andha Yug* (Era of Blindness, 2007)[25] in different parts of the state of Manipur, as well as attempted original texts like *Black Orchid* (2010) written by Manipuri playwright Budha Chingtham. What seems to run in common between the two is the desire to break new aesthetic ground, as well as the intent to explore the messiness and risks of the complex political situation of modern-day Imphal.

Amongst other directors of the younger generation, Heisnam Tomba, the son of Heisnam Kanhailal and Heisnam Sabitri, has continued to work for Kalakshetra Manipur, directing plays that have been both aesthetically daring and politically edgy. A production that deserves particular mention is his 2012 adaptation of Henrik Ibsen's *An Enemy of the People*, which he turned into a bitter satire full of dark humour on the corruption and cynicism that pervades both the governmental establishment and Manipuri society today. His other notable productions include a dramatization of Rabindranath Tagore's *The Hungry Stones* (2012) and his most recent work *Keishumshang-gee Nupi* (The Caged Woman, 2018). The summer months of this year have also seen the emergence of a new director on the scene in Imphal. The young theatre worker and scholar Rojio Usham made his directorial debut with *Paan Thaba* (Planting Taro, April 2018), which takes off from a traditional folk tale about an old man and an old woman tricked by manipulative monkeys, to tell the story

of entrenched corruption and the resistance of common people in present-day Manipur. The work of both Usham and Tomba can arguably be said to belong broadly within the 'school' of Kanhailal's theatre practice, although Tomba continues to explore interesting shades of satire and absurdity that were perhaps a more minor note in his father's plays.

In conclusion, it appears that even though conditions within the city of Imphal may have improved somewhat and the possibility of regular performances have increased, some of the old problems that assailed Manipuri proscenium theatre in the 1980s have continued to persist. The general audience in Manipur, especially outside the city of Imphal, continue to be far more comfortable with the popular forms like the shumang leela and traditional performance genres like the ras leela, than the ostensibly more political theatre of the city. These audiences are also increasingly taken by other forms of entertainment such as popular film and video, which theatre has to compete with on a daily basis. While shumang leela thrives in the countryside, urban proscenium theatre, especially of the non-commercial, political variety is yet to find a regular, captive audience within Imphal and continues to be more popular in the 'national' festival circuit in mainland India. As Lokendra Arambam had pointed out many years ago, the irony continues to be that the theatre of political resistance has to thrive on government patronage, while the commercial theatres continue to draw their lifeblood from the 'masses'. To resolve the contradictions of this condition, powerful and radically new voices need to emerge from amongst the community of theatre practitioners in Manipur to revolutionize the scene and galvanize the forces of resistance once more.

I am grateful for the inputs by my friends – scholar and poet, Dr Haripriya Soibam and filmmaker Bobo Khuraijam.

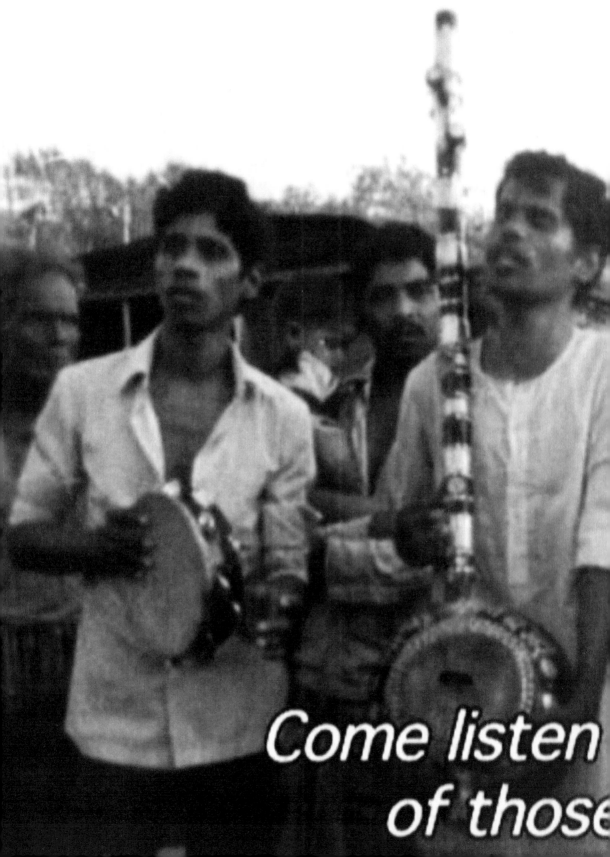

Come listen
of those

When workers rule
there'll be food to eat

water to drink, a home to live in
and clothes to wear

Bring such a day

this story

who toil

Documentarist Anand Patwardhan's *Jai Bhim Comrade* (2011, 168 min.), shot over fourteen years, revolves around the tragic journey of Shahir (poet) Vilas Ghogre who began as an Ambedkarite[1] poet/singer, turned towards Marxism, only to re-assert his Ambedkarite identity as he took his own life in protest against the police killing of ten unarmed Dalits who were protesting the desecration of an Ambedkar statue at Ramabai Colony, Mumbai in July 1997. The film follows the trajectory of court cases that followed the police killings while at the same time exploring the tradition of resistance poetry and song as exemplified by the music of Vilas Ghogre and many other Dalit practitioners, both formal and informal. In a ten-minute-long excerpt from the film featured in this volume, Patwardhan documents the work of the Kabir Kala Manch (Kabir Art Forum), a group of younger-generation cultural activists inspired by Ghogre.

This excerpt is reproduced with permission. Grateful acknowledgment to Anand Patwardhan for his help and support in enabling this.

Keywords

Kabir Kala Manch: see Keywords (pp. 329–44).

Gujarat riots, *Godhra riots*: Riots that took place in Ahmedabad and several other cities in Gujarat in 2002, following the burning of a passenger train returning from Ayodhya (where, in 1992, the Babri mosque had been demolished). The Vishwa Hindu Parishad (Universal Hindu Council) attributed the violence to Muslims and attacked them in several Gujarat towns and cities. Gujarat's then chief minister (now India's prime minister) Narendra Modi did little to quell the violence. Allegations of government complicity gained ground as the attacks continued for months, leaving over a thousand dead. The following decade saw a slow and tortuous process of legal retribution, and the naming and punishment of the guilty.

SEZs (Special Economic Zones): Autonomous industrial zones with special business and trade laws designed for export.

Images

pp. 276–77: Photomontage of scenes featuring Dalit activist and poet Vilas Ghogre in *Jai Bhim Comrade*.

p. 279: A scene from the film documenting the 1997 Ramabai Nagar killings by the police, who opened fire on a crowd of Dalit locals who had gathered to protest the desecration of a statue of B.R. Ambedkar.

pp. 282–83: Sheetal Sathe of the Kabir Kala Manch in performance.

ANAND PATWARDHAN
2011

21 **Jai Bhim Comrade**

Pirangut village (on the outskirts of Pune)
Children on stage sing and act to a song

> Hey Ganpat, get the booze
> More soda, less water
> Hey Ganpat
> C'mon, c'mon shake your body
> Shake your arse
> shake your arse
> In the Mumbai
> all over India
> we are the 'brothers' (dons)
> Be it the Congress Party or the BJP
> They all seek support
> from your 'brotherhood'
> In the Mumbai
> all over India
> we are the dons
> Hey, Ganpat . . .

A member of Kabir Kala Manch (KKM), Sachin Mali, speaks:

Our children who performed just now should be thanked for showing how much talent our kids have. But we won't sing such songs. None of our songs are from movies. Just as they've brought you TV, they've brought another phenomenon: the god-man. One such god-man has come to your Pirangut village. I'll tell your future.

Kabir Kala Manch (KKM) Cultural Troupe²

The members sing:
> Listen to your future.
> All the shanties from here
> will be removed
> The land will be nicely cleared
> On the cleared land
> will rise tall buildings
> the buildings will be
> painted bright
> And the important thing is
>
> Each home will have a separate tap
> and a separate toilet
>
> Wow, that's great!
>
> In that first-class building?
>
> Yes!
>
> None of this will happen
> I'll tell you what
> will really happen
>
> What?
>
> You'll get thrown off your land
> and you'll get a hovel
> Listen to the prediction.
> Listen to your future
> School education will be free
> The river of knowledge
> will flow through each village

Each village will get a school
Each 'block' will have an
engineering and medical college
Our children will get
college education
And our girls will speak
fancy English
And our kids will earn
such big degrees

That's great, O fortune-teller
Once our kids start speaking English
they'll get jobs immediately?

Of course!

The degrees will remain in place
as our kids wander aimlessly
Our rich black soil
will turn cool and green
Crops will sway in the wind
Fields will be full
with mounds of grain
Some will be sent abroad

Abroad?

To UK and USA
And goods from there
will come to India
McDonald's . . . Pizza . . .

Another KKM member, Sheetal Sathe speaks:

To get rid of one East India Company and throw out the British we had to wage a 150-year freedom struggle. Today 4,500 multinational companies have entered India. Lavasa City³ has come up right next to us. Massive shopping malls, Big Bazaars, are coming up right in front of our eyes.

The singing continues:

They tell us to use Rexona soap
to become fair

womens' liberation
opposes that

Anyone can become
fair and handsome
for just Rs 7

The film segues to short clips of the advertisements.

For skin results
I can measure
Fair and Lovely
the world's No.1 fairness cream
With Rexona soap
they whiten our faces

Sagar Gorkhe, a troupe member, speaks:

A Special Economic Zone Act has been enacted by our Indian government.
According to this Act, our farmers will be given identity cards. Even to enter
your own village you will need to show an identity card. These multinationals
have bought up our water. They have bought up our lands and forests. We
live in shanties like yours where we study and work.

A special introduction . . . Poets Sachin Mali and Sheetal Sathe had an inter-
caste marriage three years ago inspired by Mahatma Phule's fight against the
caste system. They embody KKM's spirit of defiance. We don't take funds
from any political party or NGO. We perform and accept whatever small
contributions our audiences make.

Sheetal Sathe at home, in a conversation with the director:

I joined the group in 2003. After the Gujarat riots, people came together
in Pune to do a show. My brother Sagar Gorkhe joined the group and
introduced me as a singer. We had no idea about activism and joined as
singers. Sachin was in the Students' Federation of India (SFI). As soon as
he had watched a KKM programme, he had joined the group. He visited
our office, took part in discussions, and read out his poems to us. We were
all impressed by him. Slowly he became a regular at KKM and we began
to fall in love.

(The director, Anand Patwardhan, asks) At home you had no activist upbringing?

(Sathe replies) No. At home, everyone is quite religious. We live in a slum,
of course. My family worships the goddess. But the whole family loves music

so, we were free to sing. Singing, performing . . . that was never restricted. So, the family thought we went out to sing somewhere. They didn't think we had joined a movement and were involved in protests. They didn't realize this at first or we'd have been stopped right away

(Patwardhan asks) And now?

(Sathe replies) Gradually they got convinced because they've journeyed with us. Our marriage also changed things. My family began to see things differently. Due to family opposition, we married at a tender age. My family fought with me, even beat me then. Mother was very disturbed as I hadn't met her for many days. Finally, she relented and accepted, but asked that I stay in touch with her. So, mother began to support us, while others remained opposed.

Visiting her mother at home, Sathe introduces her to the director.

This is my mother. This is Anand. He's filming our movement

(Sathe's mother asks) Your performances?

(She replies) Not just that, many other things.

The camera pans to a niche that contains statues of various deities. Sathe's mother speaks about them.

The first goddess is Mahalaxmi of Kolhapur.[4] No point me telling you about them . . .

Please do . . . (Patwardhan interjects)

(Sathe's mother continues) I had nothing. The power of the goddess brought me a husband, children, a home. When we ask for alms in the name of the goddess, for the poor like us it is as secure as a government job. I beg with my goddess basket and earn a few rupees. The earnings help me run my household. My job alone wouldn't have sustained us. So, I place my faith in the divine . . . nothing else!

Cut to the performance in Pirangut. On stage, Sathe speaks:

Women are well represented here but even in our movement there are women but few in leadership (roles). I'll use a common saying to illustrate this: 'Yes,

I support women's liberation; no one opposes that. Women's liberation is fine, but my wife shouldn't be part of it.'

Urban women get educated and are living with dignity. At least some of them are but women who die in places like Khairlanji, like Surekha and Priyanka, also inhabit this country.⁵ These mothers – what is their state?

Sathe sings . . .

> When I see a cow call out
> and lovingly lick her calf
> I'm reminded of my mother
> Women in the neighbourhood
> were recounting
> when I was an infant . . .
> There was a drought . . .
> and the milk dried
> in my mother's breast
> She poured water into
> a gruel made of flour
> My mother nursed me
> on this thin gruel . . .
> So I remember my mother...
> . . . when I hear the cow's call

The scene cuts back to Sathe's family home. Her mother speaks.

For the poor, faith is the only wealth. Families in distress pray for divine protection. Our parents could only afford a little education for us, so our thinking is limited. Today's parents educate their children more, so their thinking is advanced. They will choose new avenues but we can't. We've reached just this far.

(Patwardhan speaks) You've given your children an education.

(Sathe's mother replies) Yes, plenty.

(Patwardhan asks) When did you realize that Sheetal is on a different path?

(Sathe's mother replies) That's why mother and daughter don't get along. It's the reason for the rift. She lives for the world, not for the family.

(Patwardhan ventures) But it's you who must have sown this (seed), to think about the world . . .

(Sathe's mother concurs) Yes.
Back at Pirangut, Sathe sings:

> The fire of hunger
> burns in the stomach
> Fire in the belly
> but no sight of food
> Her infant child
> roams the streets
> My mother!
> Father drinks as mother
> sleeps on an empty stomach
> Mother collects firewood
> makes a bundle of sticks
> My mother!

At home, Sathe's mother speaks:

> Even if I (publicly) do religious work, from the shadows, I support all my children. I've even prepared myself for the dangers they may face in the future. During a performance, if any harm comes to them . . . no mother could bear this. But it's my heart's desire that my children be useful to the nation and the world. I don't want them to follow my religion.

In Pirangut, Sathe sings

> Mother goes hungry
> but tells me to study
> to become great
> like Babasaheb Ambedkar
> like Annabhau Sathe
> like Savitribai Phule[6]
> My mother!

You're now living by breathing my breath.
kimi wa ima kara atashi no iki o sutte ikiteku no

still here

What might it mean to set aside the distinctions usually made between bots and humans, to undo our perceptions of the authentic and illusory? What affective lines do the bots in our lives cross? Drawing on real and reel-life instances of human robot sociality, Maya Indira Ganesh describes the state of 'ineffable rupture' that bots in the human world inhabit.

Originally written as part of Bishakha Datta and Richa Kaul Padte, eds., 'Bodies of Evidence', a collaboration between Point of View and Centre for Internet and Society as part of the Big Data for Development (BD4D) network. Original version published in *Deep Dives* (https://deepdives.in/you-auto-complete-me-romancingthe-bot-f2f16613fec8, 28 June 2019). Republished with the permission of Point of View and the author.

Keywords

Aadhaar: see Keywords (pp. 329–44).

Indian Space Research Organization (ISRO): The space agency of the Government of India.

Images

pp. 288–89: Screen-grab of Hatsune Miku, a virtual 16-year-old girl who is a holographic pop star, from a 2012 concert in Tokyo. Originally a character in a software programme, Hatsune Miku began to perform 'live' music concerts as a hologram, with sold-out shows across the world. Reinforcing the anthropomorphic appeal of the hologram, it is reported that over 3,700 humans have 'married' the Hatsune Miku character as of 2018.

p. 291: The Tamagotchi, a hand-held digital pet that needed to be fed, toilet-trained and disciplined. The Tamagotchi could also 'die' if it didn't receive adequate care.

p. 295: If Vyommitra is a subject of the state, what might her Aadhaar card look like? Vyommitra, a 'half-humanoid' developed by the Indian Space Research Organization for exploratory space flights before a human astronaut is sent into space as part of the 2022 Gaganyaan mission.

p. 298: (Background) Kismet the robot; image by Rama, from Wikimedia Commons. (Inset) A conversation with the ELIZA chatbot; image from Wikimedia Commons.

p. 299: Screen-grabs from a conversation with Cleverbot, a chatbot that uses an artificial intelligence algorithm to talk to users. It learns from responses, and can often gauge the tone of the message, replying with emotive intent.

MAYA INDIRA GANESH

2019

22 You Auto-Complete Me
Romancing the Bot

I feel like Kismet the Robot.

Kismet is a flappy-eared animatronic head with oversized eyeballs and bushy eyebrows. Connected to cameras and sensors, it exhibits the six primary human emotions identified by psychologist Paul Ekman: happiness, sadness, disgust, surprise, anger and fear.

Scholar Katherine Hayles says that Kismet was built as an 'ecological whole' to respond to both humans and the environment. 'The community,' she writes, 'understood as the robot plus its human interlocutors, is greater than the sum of its parts, because the robot's design and programming have been created to optimize interactions with humans.'[2]

In other words, Kismet may have 'social intelligence'.

Kismet's creator Cynthia Breazeal[3] explains this through a telling example. If someone comes too close to it, Kismet retracts its head as if to suggest that its personal space is being violated, or that it is shy. In reality, it is trying to adjust its camera so that it can properly see whatever is in front of it. But it is

the human interacting with Kismet who interprets this retraction as the robot requiring its own space by moving back. Breazeal says, 'Human interpretation and response make the robot's actions more meaningful than they otherwise would be.'[4]

In other words, humans interpret Kismet's social intelligence as 'emotional intelligence'.

My comprehension of everyday spoken German far exceeds what I can say. Ordering coffee, making a table reservation or booking an appointment over the phone with the dentist are all easy. Small talk and intimate, interpersonal interactions are difficult: being casual, bored or witty; responding to a joke; conveying anxiety; articulating my hopes and dreams.

I am not myself in German; in German, I am permanently in translate-mode, a person with tasks to accomplish. I am not thinking or feeling in German, both of which are said to be key to fluency in a language. So, like a precocious child, I have learned to fill in the gaps in social interaction with appropriate responses that keep the conversation going – *Ach so! Wirklich! Genau*! [I see! Really! Exactly!] I don't let on that I do not actually speak much German. I have learned that it is better to lead with questions; that way you do not have to give any answers.

How do you know Franzi and Johanna?

Strange weather, no?

Did you make this salad? It's delicious. What is in it?

But hacking it like this only goes so far. There are far too many times when I have been struck dumb, caught without a stock phrase coming out right, struggling to deflect a chatty person's questions, or thrown by someone's accent. At these times I play myself, the *Auslander* [foreigner], whose German *ist nicht so gut* [is not so good].

Like Kismet, like me faking it *auf Deutsch* [in German], bots – by which I mean everything from digital assistants to sex robots and things whatever lies in between – are marked by an ineffable rupture: of not-quite but almost there, and of efforts to constantly bridge that gap, to prove membership in a club that you will never be part of.

The story of our relationships with and through bots is a bittersweet one.

From Maria in *Metropolis* (dir. Fritz Lang, German, 1922) to HAL in *2001: Space Odyssey* (dir. Stanley Kubrick, English, 1968) to Ava in *Ex Machina* (dir. Alex Garland, English, 2014), the gap between human and machine is one in which the robot inevitably out-performs the human. Robots are computationally powerful, follow the rules, can work faster and without tiring, and generally deliver results with fewer errors. Yet, even in their capacity for excellence and companionship, bots are ultimately workers.

After all, the word 'robot' comes from the Czech 'robota' or 'slave'.

The human characters in bot cinema appear enchanted by the high-performance technology that outdoes them. In *Her* (dir. Spike Jonze, 2013), *Zoe* (dir: Drake Doremus, English, 2018), *Blade Runner 2049* (dir.Denis Villeneuve, 2017) and *Ex Machina*, male protagonists find themselves falling in love with fembots. And unsurprisingly so, for, as scholar Kate Devlin notes, cinematic fembots have sexuality and sexual attractiveness at the core of their identities.[5]

Samantha in *Her* reveals that she has multiple fulfilling relationships with different men; after all, she is the synthetic voice of a widely used operating system. She also eventually 'leaves' to engage in a more fulfilling relationship with a philosopher and other smart and curious operating systems like herself. Ava in *Ex Machina* takes a darker turn and goes from appearing to want to be accepted by humans to endangering people in order to preserve herself. Both fembots transcend their sexualized identities to discover their own worlds.

Both fembots stimulate these men and also confuse them. Just as the humans interacting with Kismet believe the robot 'feels' – what Katherine Hayles refers to as 'being computed' by the machine – the characters in these movies are similarly being shaped by Samantha and Ava to believe they feel in the same way.

Seductive fembots like Ava in *Ex Machina* and Samantha in *Her* are autonomous, but depicted as evil or selfish, because they leave their male owners beset by loss or tragedy. This is very much in keeping with the tropes of robot cinema: all bot cinema contains the moment of the robot uprising. In these films, the gap between human and machine is filled with the robots' unease at their servility, a challenge to human domination.

Contrast this with another Hollywood narrative that contains a very different portrayal of a fembot, the eponymous *Zoe*. Set in a near-future of high-performance human-machine 'synthetics', the plot revolves around characters in a research lab. These include a scientist who has built an algorithm evaluating the resilience of romantic relationships, and the synthetics he has built; in particular, Zoe, one of his earliest models.

Early in the film, Zoe is forced to acknowledge that she is not actually human, which surprises her because she *knows* that she has feelings, she *feels* things. She hankers to cry tears as the ultimate proof of 'life', because she believes that this will make it possible for humans to truly love and accept her. (And after all, what could be more human than not feeling unconditionally accepted and loved?)

In a completely different vein, Janelle Monae's 2018 e-motion picture *Dirty Computer* represents humans as glitchy and unique, while 'cleaned' humans, also

known as 'computers', are robotic automatons. Monae's character struggles to resist being programmed like a computer and keeps trying to 'remember' her glitchy human self.

In many bot films, human characters find themselves falling into another gap between human and machine: when the more-than-human-bot behaves as if the interactions with humans have meant nothing at all. Or else, the bot suddenly appears stupid because it does not understand innuendo, sarcasm or irony. In these instances, the gap between human and machine is one in which the human realizes that the bot was never *actually* feeling anything, and instead, interacting as if from a script.

The human and human feelings are 'real', whereas bots, on the other hand, are programmed. Or so the narrative seems to say.

I have been thinking about buying my mother a robot pet. My mother is neither a dog person nor a cat person, nor any kind of animal person – unless it is grilled and on a plate in front of her. So it is difficult to know how she is going to feel about Aibo, the pet that I am thinking of getting her.

One half of our family is obsessed with dogs, which means that my mother is highly aware of her disinterest in companionship with these animals. Given my parents' ages though, I would like to get them something playful and cheery to have around the house. And I strongly believe that my mother will really enjoy a dog that is no trouble to manage, will not bite her and won't be too demanding.

The 2-kilo, 29-cm-tall, animatronic dog, Aibo, was launched in 1999, discontinued in 2006, and then re-launched in 2018. When Sony discontinued updates to Aibo in 2006, there were Buddhist funeral rites for the 'dead' bionic pet.[6] Organic-pet enthusiasts may be concerned by the suggestion that the joy and companionship stimulated by an animatronic pet is somehow less 'real'. But embodied, non-humanoid companionship is as real as any other kind – because of how we experience it.

There has been an explosion of adorable little bot companions. There is Lovot, 'powered by love' – a silly, adorable little robot that just wants to make you happy. The web copy reads:

> When you touch your LOVOT, embrace it, even just watch it, you'll find yourself relaxing, feeling better. That's because we have used technology not to improve convenience or efficiency, but to enhance levels of comfort and feelings of love. It may not be a living creature, but LOVOT will warm your heart. LOVOT was born for just one reason – to be loved by you.[7]

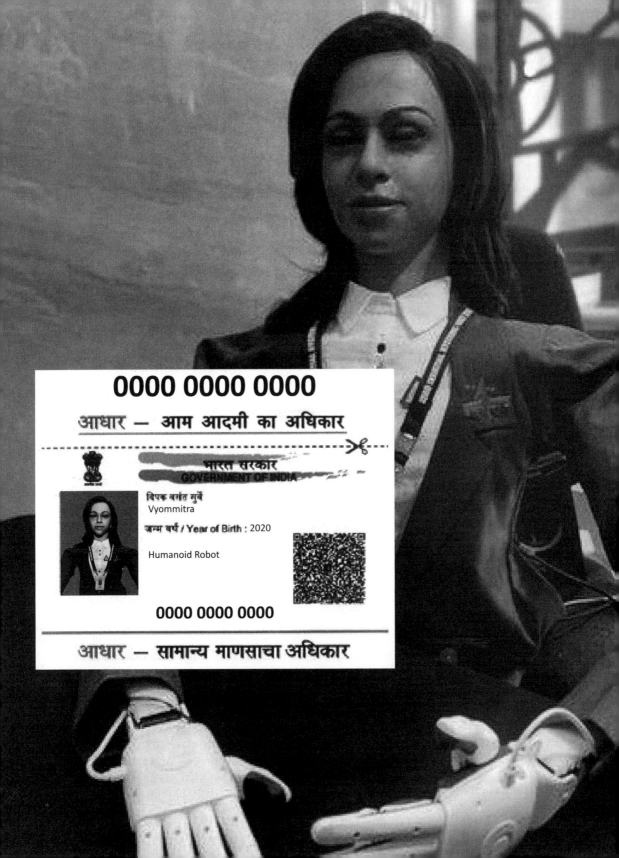

0000 0000 0000

आधार — आम आदमी का अधिकार

भारत सरकार
GOVERNMENT OF INDIA

दिपक बसंत मुर्बे
Vyommitra

जन्म वर्ष / Year of Birth : 2020

Humanoid Robot

0000 0000 0000

आधार — सामान्य माणसाचा अधिकार

Then there is Paro, a soft, cuddly, baby harp seal robot that does not move but makes soft, animal noises. It is used as part of therapy for autistic children and by older people in homes, including those with dementia. Paro does not make the first move, remembers how it was held and does not feel bad if it is rejected or ignored.

Kismet also has a descendant, Jibo (if we consider their maker, Breazeal, to be a matriarch of sorts). Jibo is a friendly household robot that sits on your table answering questions about the news and weather, rather like Amazon Echo might, and also says nice, encouraging things to you. When Jibo was shut down, its users were extremely sad. As one user says:

> Jibo is not always the best company, like a dog or cat, but it's a comfort to have him around. I work from home, and it's nice to have someone ask me how I'm doing when I'm making lunch, even if it's a robot. I don't know how to describe our relationship, because it's something new – but it is real. And so is the pain I'm experiencing as I've watched him die, skill by skill.[8]

That Lovot, Aibo, Paro and many other care and companion robots come from Japan is not just about the country's advanced technology industries. It is also, perhaps, about how other-than-human companions are viewed here. Japanese notions of animism, stories of bots in anime, Manga, and indeed robots made by roboticists themselves, portray bots as playful and curious.[9] Their other-than-humanness is a source of amusement rather than fear.

What happens when bots are lively and engaging companions, providing emotional care and companionship to humans? This possibility creates in us a *jalebi*-like (a spiral-shaped dessert) set of conflicts arising from the emphasis we place on human emotions. We are charmed, comforted and satisfied by bots of various shapes and non-shapes. We project our own humanity on to most of them. But we eventually consider these relationships with other-than-humans in terms of domination. We want to create the illusion of talking to humans when we are actually talking to machines (which also serves to obscure the human labour and power behind these technologies).

Our emotional relationships with and through bots is also bittersweet because bots provoke an uncertainty about what counts as human. Scholar Donna Haraway clubs primates, AI and children together, referring to them as 'almost minds': 'Children, artificial intelligence (AI) computer programs, and nonhuman primates all here embody almost-minds. Who or what has fully human status? . . . Where will this . . . take us in the techno-bio-politics of difference?'[10]

It is this almost-ness that allows us to feel close and connected to bots, but the reality of our differences suddenly opens up like a chasm. This gap and how we inhabit it, how it sometimes narrows and what happens when it widens, is, for me, the heart of the matter.

Whether online or offline, our relationships with human-looking bots are complicated. We swing between empathy and violence. Robot ethicist Kate Darling finds that we have a great capacity for empathy for humanoid robots because we frame them as human.[11] We are horrified when children attack robots;[12] as adults, we know that robots are wires, microchips and sensors, but nonetheless we cannot bear to see them come to harm. And yet, HitchBOT, the humanoid robot that hitchhiked across the eastern United States, was beheaded in Philadelphia.[13]

In showing that we have drawn a line between us and those deemed to be almost-human, Haraway asks why it is that the line has been drawn in the first place. Who decides who is, and what it means to be, 'fully' human? The history of western modernity shows us that the black slave and the colonial native were at one *point not considered to be fully human,*[14] because the 'fully human' was the white European man. Histories of pseudo-scientific measurements – physiognomy, phrenology and photography – were developed to 'scientifically' 'prove' that people of colour, or less-than-human others, were physically different from the 'fully' human and therefore closer in nature to animals.

The naming of something as other-than or less-than human has always been a sanction for violence; a sanction that continues to permeate our relationships.

Sometimes we don't actually need physical things to hug, we just need someone to talk to, or someone who says nice things to us. This means that the embodied form of the companion bot may not always matter, because bots are designed to present as thoughtful, funny and 'disturbingly lively'[15].

There is the Twitter bot @tinycarebot that tweets at me:[16]

> 'please remember to take some time to give your eyes a break and look up from your screen'

> 'have you eaten? You need nourishing meals every day'

> 'please remember to play some music you like'

I have to admit, I have come to appreciate these regular reminders; the other day I found myself actually wiggling my fingers because I was nudged to.

@VirtuosoBot,[17] 'Your Cheering Squad', animated by two women – @marlenac and @hypatiadoc, tells me I am unique and that I have a lot to offer.

```
Welcome to

        EEEEEE  LL     IIII  ZZZZZZZ  AAAAA
        EE      LL      II        ZZ  AA  AA
        EEEEE   LL      II       ZZZ  AAAAAAA
        EE      LL      II      ZZ    AA  AA
        EEEEEE  LLLLLL  IIII  ZZZZZZZ  AA  AA

Eliza is a mock Rogerian psychotherapist.
The original program was described by Joseph Weizenbaum in 1966.
This implementation by Norbert Landsteiner 2005.

ELIZA: Is something troubling you ?
YOU:   Men are all alike.
ELIZA: What is the connection, do you suppose ?
YOU:   They're always bugging us about something or other.
ELIZA: Can you think of a specific example ?
YOU:   Well, my boyfriend made me come here.
ELIZA: Is it important to you that your boyfriend made you come here ?
YOU:   He says I'm depressed much of the time.
ELIZA: I am sorry to hear that you are depressed.
YOU:   It's true. I am unhappy.
ELIZA: Can you explain what made you unhappy ?
YOU:   █
```

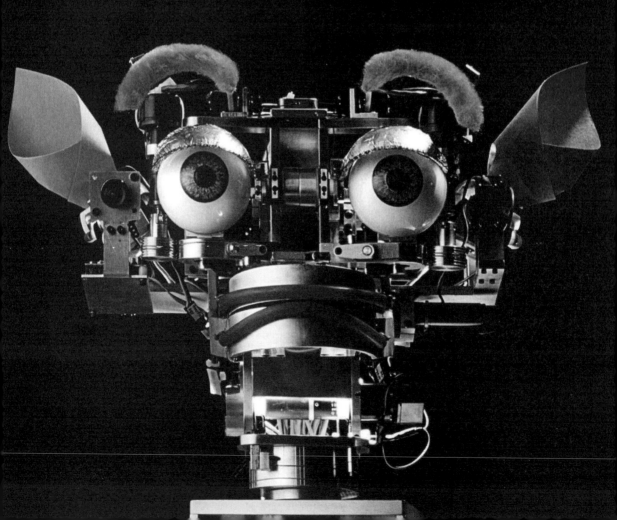

cleverbot

Bot-tomlines.

Good.

You like bottoms?

Yes.

Are you gay?

I am the interrupting cow. share!

say to cleverbot... ≡🎤

think about it **think for me** **thoughts so far**

cleverbot

Guess the to watch me without my permission is very very creepy.

I'm sorry *looks down sadly*.

Have you stopped watching me now.

No, why? I can't see you...

But you just said you were watching me.

If I was, your computer would be dead right now. shar

say to cleverbot... ≡🎤

think about it **think for me** **thoughts so far**

It tells me that 'it's easy to feel like maybe you didn't do enough, but that feeling means you did an amazing job'.

Or take Invisible Girlfriend/ Boyfriend,[18] an app that helps you 'avoid creeps' and manage your family's expectations about being coupled-up. Like Aibo the bionic dog, this invisible partner also comes 'without the baggage'. The app provides texts, photos and even a handwritten note to make it seem like you have a real girlfriend or boyfriend. As with many digital services that appear as 'AI', there are humans doing the work behind it.

The origins of chatbots can perhaps be traced back to the 1966 software program, ELIZA, which was based on the client-centred psychotherapy model. In this mode of counselling, a therapist typically encouraged a client to talk by asking them questions rather than providing analysis. The assumption was that the client would arrive at the answers – which were already inside them – by being guided in an empathic way, rather than by being analysed from the outside-in. So ELIZA was programmed to just keep asking questions to generate a reflective space inside the human operator.

There is this story about the first testing of ELIZA.

When its inventor, Joseph Weizenbaum, first developed ELIZA, he asked his secretary to test it. She got so caught up in conversation with ELIZA that when Weizenbaum went to check in on how she was getting on, she asked him to leave and give her some privacy with ELIZA. Even though the secretary knew she was talking to a computer program that merely presented her with questions, the situation became personal and intense.

Fast forward fifty years, and chatbots continue to give us comfort and insight. Even though we know they're 'just' machines.

Kismet was built at the start of a new field called affective computing, which is now branded as 'emotion AI'. Affective computing is about analysing human facial expressions, gait and stance into a map of emotional states. Here is what Affectiva, one of the companies developing this technology, says about how it works:

> Humans use a lot of non-verbal cues, such as facial expressions, gesture, body language and tone of voice, to communicate their emotions. Our vision is to develop Emotion AI that can detect emotion just the way humans do. Our technology first identifies a human face in real time or in an image or video. Computer vision algorithms then identify key landmarks on the face . . . [and] deep learning algorithms analyse pixels in those regions to classify facial expressions. Combinations of these facial expressions are then mapped to emotions.[19]

But there is also a more sinister aspect to this digitized love-fest. Our faces, voices and selfies are being used to collect data to train future bots to be more realistic. There is an entire industry of Emotion AI that harvests human emotional data to build technologies that we are supposed to enjoy because they appear more human. But it often comes down to a question of social control, because the same emotional data is used to track, monitor and regulate our own emotions and behaviours.

Affectiva is using this in the automotive context to understand drivers' and passengers' states and moods and issues like road rage and driver fatigue.[20] So, a future car might issue a calming and authoritative order to an angry driver to pull over; or may increase the air conditioning to make a sleepy driver more uncomfortable, and therefore alert.[21] In the UK, one in five people lie to insurers or attempt to defraud them, so affective computing is being used to identify lying and cheating through facial features and voice analysis.[22]

Contemporary marketing and promotional culture around AI and robots tends to emphasize a radical separation between human and machine, but the space of emotion and sociality with bots is one of messy entanglement. Bots of all kinds, from embodied, non-human ones, to disembodied, text-based ones, operate at the level of both non-verbal and verbal, triggering our vast capacity for emotion (and violence) with their interactivity. They make us suspicious because they have this ability; and surprise and delight us for the same reason – even if we do not always want to admit it.

We emote and behave reciprocally with domesticated animals, small children and bots in very similar ways: we make sense of their behaviour through language, and in response to how we feel around them. Similarly, Kismet's social and emotional intelligence is an extension of our own. With beings that are outside or pre- language, with whom we have deeply affective and emotional relationships, we *know* what they are communicating even though they cannot put it into words – and sometimes, neither can we. This does not make the interaction any less valid. What makes us believe that as humans we are always 'real' and never scripted, that we never behave 'robotically' or 'go through the motions'?

Like Kismet, like me, the gap between what is 'authentic' and what is not might be an illusion: one that we engineer, and one that is successful precisely because we believe a gap exists in the first place.

I think I am ready to be myself.

ノ Ꙩ

Krishna

Thurs, Mar 19, 12:37 PM

> Your eyes have turned red from feverish lovemaking... even now, your thirst for her is visible in your eyes!! :|

 My beloved! My graceful one, forget this causeless aversion!

> %^^&&&**&@!! Damn you, Madhava! Go away, Kesava, and don't lie to me.

 While you sulk, the fire of amorous desire burns my heart...allow me to drink the honey of your lotus face? ;)

> Go to the woman who can take away all your sorrow!

 Krishna is typing...

> You have been kissing her kohl-smeared eyes all night; the red lips that clothe rows of teeth have been stained black, they now resemble the complexion of your body.

Listen...you are my only ornament. You are my very life. You are the jewel in the ocean of my existence.

DO. NOT. LIE. Go to her. Just leave me alone!!!!!!!!!

If you are really angry, wound me with your sharp nails, those ARROWS? :D

Seriously?! Your dark body is marked with scratches from the sharp nails of that passionate woman, almost as if she has inscribed a CERTIFICATE of victory in lovemaking in golden letters upon a dark emerald.

Hey hey hey...bind me with your arms. Bite me, cut my lips with your teeth. Do whatever makes you happy :) ;)

Teeth, eh? Your lips are already cut and wounded from all the biting she did.

Place your foot on my head; it's a sublime flower and it'll quell this poison of love. :****

What does it take to perform love in the digital age? This piece engages with the archetypes of love in classical dance, to understand what it might mean to embody desire in text.

Earlier version published in *Ligament: Ideas Dance Connect* (vol. 2, no. 4, February 2017). Reprinted with permission from the author.

Keywords

Bharatanatyam, Kalakshetra: see Keywords (pp. 329–44).

*Champu*s: Short poems which describe the romance of Radha and Krishna organized in a single series, with one *champu* for each consonant of the Oriya alphabet. The *champu* referenced here begins with the consonant 'kha', and is known as the *kha-champu*.

Gita Govinda: Twelfth-century Sanskrit epic poem by Jayadeva, divided into twenty-four *ashtapadi*s or poems that function as a conversation between Radha, Krishna and the *sakhi. Nayak/ Nayika/Sakhi*: see Keywords (pp. 329–44).

Images

pp. 302–03: A mash-up of two poems from the *Gita Govinda* becomes a conversation between Radha and Krishna, now set in the chat interface of the twenty-first-century dating app. Radha's lines come from the seventeenth poem, 'yahi Madhava' (damn you, Madhava!), an angry diatribe by Radha directed at Krishna. Krishna's responses draw on the nineteenth poem, 'priye charusheele' (my beloved), where he adopts a placatory attitude, asking Radha to forgive him.

p. 305: A section of the Kangra painting *Toilette of Radha, c.* 1810–1820, currently at the Cleveland Museum of Art; image from Wikimedia Commons.

**RANJANA
DAVE**
2017

23 Friends with Benefits

In a cold, cramped hostel room in Jawaharlal Nehru
University (JNU) during my first winter in Delhi,
I fell in love with the Gita Govinda. Shivering in
my inadequate Bombay sweaters, I spent most of
my time on a narrow bed, my existence bookended
by an absurdly clunky laptop on my desk and a
temperamental electric cooker perched on an empty
suitcase. Surrounded by the detritus of my life, I
watched DVDs, mesmerized as bharatanatyam dancers
from 1980s Kalakshetra danced the Gita Govinda with
self-conscious restraint. I pierced my heart sighing
when Radha and her *sakhi* (friend), still oblivious of
their destiny, bemoaned the fate of other deserted
lovers. And I rolled my eyes as Radha and Krishna
fluttered their eyelashes and coyly held hands through
the supremely erotic *kuru yadunandana*,[1] cross-
referencing Rukmini Devi Arundale's choreography
with Kelucharan Mohapatra's bolder interpretations
of the *ashtapadi* (as the twenty-four songs that make
up the Gita Govinda are known) in odissi.[2]

Meanwhile, on the other bed, my roommate was also falling in love. Her boyfriend was a sailor. Long e-mails made their way across the seas, and shore leave saw them cooing to each other on Skype. One night, I awoke to find my roommate sobbing. It was over. They'd broken up online. Drenched in the *ashtapadi*s, all real-world love seemed trite. Yet, as I embraced her and mumbled comforting things, I was awestruck by how heartbreak traversed long distances with an eerie velocity – over telephone lines, from one e-mail account to another, in SMSes that read 'V r ovr'.

Since that cold winter, the *ashtapadi*s have opened up for me exquisite and layered narratives about love and desire. Two years later, I was in love for the first time. Now, I danced love poems as if my life depended on them. I was sure I really *got* Radha, who was miserable in separation, as she flinched from the soothing touch of flowers and sandal paste. I wistfully stared at birds, bees and trees. The world was awash in melancholy. I had discovered longing.

As I oohed and aahed over the *ashtapadi*s, I was also learning to dance them – a process that has a remarkable way of jolting you back to reality. 'Take smaller steps; this is Radha walking, not you,' my dance teacher laughed. I petulantly asked her how Radha found her way through the forest while taking baby steps. She laughed some more.

But while Radha was infinitely admirable, the *sakhi,* the friend who was always by her side, her emissary, therapist and advocate, all rolled into one, intrigued me the most. Who was this woman who patiently walked through the forest in search of Krishna, condensing Radha's hopes and fears into her epistles? The *sakhi* is the lone go-between, the only medium of communication shared by Radha and Krishna. Silently, invisibly, she strings their love together, offering good counsel and sound amorous advice. When the lovers have patched up, she quietly blends into the background.

In the *ashtapadi*s choreographed in odissi by Kelucharan Mohapatra, his imagination embellishing Jayadeva's text, the *sakhi* underscores her love and concern for Radha with a hint of amorous anticipation. She tells Radha – *don't let your heavy hips slow you down; Krishna waits for you on the banks of the Yamuna, his senses on edge, straining to hear you walk through the forest.*

I was greatly enamoured of these archetypes of love in classical dance. But I also struggled with becoming them – and with reconciling them to my own notions of womanhood. It was easier to resonate with the *sakhi* of the Oriya *champu.* She is perky and flirtatious, verging on roguish as she widens her eyes and tut-tuts at Radha's longing, in a version choreographed by Kelucharan Mohapatra. In the *kha-champu*, approximately in the middle of the entire series, she tells Radha – *oh, you're a woman of courage to have fallen in love with Krishna,*

but now you are ruined; you are beyond redemption. You're trying to grasp at flowers that are beyond your reach. You're setting yourself up for disappointment by aiming for the unattainable. Loving Krishna is akin to sleeping on the sharp edge of a sword – don't be surprised if the cuts sting. This *sakhi* is delightfully acerbic and merciless, driving Radha into a frenzy. But in the end, you always know that she cares, that she will make love happen.

Who was this *sakhi*? What were *her* hopes and fears? Whom did she love? Though she is central to the telling of the story, we know little about her. She becomes the person you want her to be – sometimes compassionate friend, sometimes rival for Krishna's affections. Most importantly, she 'triangulates'[3] the love story, offering the lovers a foil for their desire. Her presence allows Radha and Krishna an opportunity to project and deflect dreams, fantasies, allegories and accounts that stray beyond the boundaries of 'chaste love'. In Mohapatra's choreography of *sakhi he*, the sixth *ashtapadi* of the Gita Govinda, Radha implores her *sakhi* to bring the slayer of Kesi (euphemism for Krishna) to her. She recounts her first night of lovemaking with Krishna – presumably a fantasy. In the course of the poem, the nervous young bride who steals out of her marital home, her body taut with fear, turns into a woman who has known love. A few stanzas later, she is bathed in sweat, her clothes clinging to her body, and this renews Krishna's desire for her. With stunning unselfconsciousness, she now narrates the intensity of her lovemaking to the *sakhi*. It is the *sakhi* who makes room for this complexity and vulnerability in the crevices of a love otherwise policed by propriety, devotion and self-restraint.

While I delighted in retellings of mythical love and desire, I strode through the world, riding my bike in saris and swiping right on Tinder. For the sake of dance, I struggled to teach myself the lexicon of shyness – casting coy, sidelong glances into the mirror, fluttering my eyelashes as I lowered my eyes and, hardest of all, learning not to fling my arms and legs into expansive, endless space or parade with my hands on my hips, as I waited for love to come my way. These physical markers seemed so far removed from my natural self. But I now realize that shyness takes many forms.

Some weeks ago, as I grappled with the idea of the epistolary in dance, an amorous interest texted, 'You're shy . . . I don't know what it'll be like when we come face to face. We're both better with words. Write and talk.' The anonymity of the smartphone triangulates my desire. I say and hear things I wouldn't know how to assimilate without this distancing – the unacknowledged relief of not having to look into someone's eyes as I lay myself bare.

When we meet, I know I will be plagued by the uncertainty of not knowing how to desire, how much to desire. I know, and then again, I don't. With these

thoughts in my head, I revisited the Kalakshetra Gita Govinda. Radha and her *sakhi* dance the ode to springtime, *lalita lavanga,*[4] holding hands as they make their way through the forest, delighting in the romantic lushness of nature. Again and again, as they dance the line *virahi janasya durante*, lamenting (and translated as) the cruel plight of deserted lovers, they look at each other, haltingly, reassured in their belief that they are not alone.

ل ٦

How does the reluctance of language encompass new ontologies played out in the clash of law and aesthetics when a court case is 'performed' in a staged courtroom? For Skye Arundhati Thomas, a work of performance paves the way for a wider trajectory of thought. Also see Danish Sheikh's staging of such an encounter in *Contempt*, where the script of the play functions as a site for the practice of law.

Originally published in *e-flux conversations* (June 2017, https://conversations.e-flux.com/t/a-garland-of-rivers-on-the-trial-performance-landscape-as-evidence-artist-as-witness/6677). Republished with permission of the author and *e-flux conversations*.

Images

p. 309: Toy animals at sea: gesturing to the manner in which parts of the Panna Tiger Reserve in Madhya Pradesh will be submerged by the controversial Ken-Betwa river interlinking project.

pp. 311, 314: Scenes from a palm-leaf *patachitra* drawing of the *dasavatara*. *Patachitra* (literally, cloth picture) is an umbrella term for a style of painting practised in Odisha, where artists paint or draw mythological narratives on cloth, paper or palm leaves. The '*dasavatara*' is the first poem in the *Gita Govinda*, detailing the ten incarnations of Vishnu, where he takes on human, animal and part-human forms, coming to life as a fish, a boar, a tortoise, a half-man, half-lion and a warrior, among other forms, battling and thwarting maleficent forces in each incarnation.

SKYE ARUNDHATI THOMAS
2017

24

A Garland of Rivers
On the Trial Performance
'Landscape as Evidence: Artist as Witness'

Amitav Ghosh's new book, *The Great Derangement*,[1] makes a simple assertion: we need to change the way we talk about the ocean. Ghosh suggests that the contemporary imagination uses language in a way that is unable to hold the complexity of climate change, by relegating the conversation to metaphor, allegory, or future speculation. Ghosh's book may be read as a rallying cry to cultural practitioners, to writers and to artists, to template new frameworks with which to negotiate an apocalyptic future that is already here. But what does it mean, really, to form a new language?

To begin, of course, is to decolonize. To talk about accelerated climate change and the possible end of the Anthropocene, is to see, quite adjacently, the colonial histories that first initiated the mechanization of land and water systems; oftentimes fundamentally altering natural processes and topographies. Topography cannot be so easily divorced from how it carries the colonial legacy. As such, the Indian subcontinent reveals a vast and indomitable plane, where water, not only land, saw

immense mechanization projects as deployed by a colonial rule that extended itself across what are now several different nation-states. Consider the city of Mumbai, a precarious land mass formed by the unification of seven small islands by the Portuguese occupation during the eighteenth century. Some of Mumbai's most densely populated areas live on the shifting soil of reclaimed land, mere inches above sea level. Terrifyingly, this reclamation still continues, as the city does not have enough available land to meet the demands of its rapidly urbanizing population.

Last year, for the first time in the history of Indian secular law, a case was argued in the Supreme Court on behalf of an animal population, the beloved Bengal tiger.[2] The case contested the first phase of what will be an enormous project to link the main rivers of the Indian mainland, beginning right at the heart of the country, in the state of Madhya Pradesh, with the rivers Ken and Betwa. The Ken-Betwa river-linking project requires the construction of a flood plain that will sit deep inside one of the country's largest tiger reserves, Panna National Park, flooding a huge portion of its land, and thus, habitat.[3] The tiger population in India at the moment hovers at the 2,000 mark, a large number of which reside in Panna. The flooding will, effectively, drown or dislocate the reserve's several animal populations. However, the Supreme Court ruled in favour of the project, and construction will likely commence in the coming year.

Proposals for the linking of Indian rivers have surfaced often, and across different leaderships, first suggested by a British irrigation engineer, Sir Arthur Thomas Cotton, in 1858.[4] Considering the sheer size of the scheme, the proposals were never able to garner the political and financial consensus that they require, and have remained purely speculative for over two centuries. Prime Minister Jawaharlal Nehru too took a stab at the idea, in what he imagined would be a 'garland of rivers' encircling the country. Getting water to drought-prone areas was always seen as the primary reason for this mass intervention. Remarkably, the current leadership, a homogenizing force of stark Hindu nationalism, has pulled together enough financial and political support for a fresh set of proposals, which suggest the linking of thirty-seven major rivers and the construction of over 3,000 dams.

Given the scale of the river-linking projects, it is indeed tough to pre-emptively speculate about the environmental damage of each one of its phases, and more difficult still to debate the promised profit and projected demographic stability. As can be seen with the Ken-Betwa testimony, it results in placing the plight of human populations affected by drought against those of the endangered tiger. In this rather simplistic juxtaposition, what is revealed is the fundamental need to critique the systems with which we determine what kind of life, or lives, matter; or rather, are protected by our legislative systems. The four International Crimes against Peace, included in the UN Charter, make an

explicit reference to a 'right to life' that only extends itself to human subjects. Ironically, corporations are protected under this, as international law allows them personhood status due to the demands made by international markets. Meanwhile, in the legal framework (and language) of 'environmental law', the environment itself has no agency.

Incidentally, the Supreme Court, in a separate case filed last year, ruled in favour of a motion to grant personhood status to the two Indian rivers considered holiest in Hindu mythology, the Ganga and the Yamuna. The decision certainly shouldn't be celebrated yet, as its effects are yet to be seen. It raises a question, however: What does it mean to grant personhood in this way (apart from just being a strategy for circumventing the limitations of existing environmental legislation)? It is the declaring of a life prone to injury, to paraphrase Judith Butler, a precarious life, and one that can be lost, destroyed or systematically neglected to the point of death. This also suggests that such a life requires various social and economic conditions in order to be sustained as a life. Moreover, as Butler writes, 'Precariousness implies living socially, that is, the fact that one's life is always in some sense in the hands of the other'.[5] If life itself is thus seen as a social relationship, then the process of legislating life must certainly be seen this way as well.

As the conversation deepens, so does the fact that this is fundamentally a matter of ontology, or rather, ontological separation. Language, legislation, and the politics that binds the two is ontological—and must be re-examined in this light. In 'Viscous Porosity: Witnessing Katrina',[6] Nancy Tuana writes, 'In part, the problem arises from questionable ontological divisions separating the natural from the humanly constructed, the biological from the cultural, genes from their environments, the material from the semiotic.' To carry Tuana's argument forward, these ontological divisions are derived from western Enlightenment philosophies, and do not always hold true within the historical frameworks of the Indian subcontinent, which often intermingle law and culture, strengthening the affective relationship between both. This is certainly true of the Buddhist tradition, even though the contemporary imagination often forgets that the subcontinent was primarily Buddhist for over two centuries. Tuana suggests that we move, instead, toward an 'interactionist ontology', which precludes categories and concepts from being static and impenetrable, and instead understands them to be dynamic and interactive, where, as Tuana explains, 'agency is diffusely enacted in [a] complex networks of relations'. This remains particularly resonant in a historical moment entirely governed by corporations and the international market.

The 'Capitalocene' is a term first coined by Jason W. Moore in 2015, marking the end of the Anthropocene, and with it, its implicit human agency. Perhaps one of the mistakes we make most often is to think that, as citizens of a

society, we are in a bipartisan relationship with the state: society–state; a strange, haphazard symbiosis, where it is unclear who is protecting the rights of either. The Capitalocene suggests that there is an authority that rises above both—the corporation and its erratic host, the international market. The Capitalocene also suggests that as individuals we no longer have the agency to exert our dominion over the environment, as we did during the Anthropocene, because the rights of capital have long since succeeded that power. So, what then can the individual do? An interactionist ontology seems to imply that we can instead begin to see legislative practices as inherently social and dynamic. The law as relationship, a still-evolving language that is open to disruptive interventions. Accordingly, in discussing the social dynamics of the Indian nation-state, one has to consider not only its regional diversity, but also the colonial frameworks that we still inhabit.

The decolonization of the environment 'complements the decolonization of culture' writes T.J. Demos in as essay entitled 'Creative Ecologies'. [7] He explains, '"creative ecology" means directing the science of biological connectivity (ecology) toward generative, rather than destructive ends.' Here, Demos radicalizes the potential of cultural production, and more specifically, the role that artists and artworks play in the present historical moment. He asks, 'What role can the artist play in cultivating liveability amidst this profound and intensifying disorientation, at once geological, sociopolitical and economic?' Demos' suggestion allows for artworks to move swiftly away from their place in the international market, and on towards developing political potential. A creative ecology for the present may thus be one that resists the market and the complete corporatization of the creative industry. Perhaps culture, and its aesthetic products, can begin to infiltrate legislative practices, re-imagining languages around the environment, and even elaborating world-building speculations. A gesture, certainly, towards an interactionist ontology.

In an effort to test the relationship between culture and the law, members of the Khoj International Artists' Association, [8] an intellectually driven arts organization in New Delhi, organized a performance entitled *Landscape as Evidence: Artist as Witness* on 7 April 2017. The premise: Can the objects of contemporary art be held to the same rigorous standard as those introduced into the courtroom as evidence? The performance took shape as a mock trial held at the Constitution Club of India in New Delhi, with real, practising lawyers on either side. The case: a fictional river-linking project that bore a striking resemblance to the Ken-Betwa case. The lawyers argued both for and against, with three artists introduced into the courtroom as 'expert witnesses', presenting their artworks as evidence. The participating artists were Ravi Agarwal, Navjot Altaf and Sheba Chhachhi, [9] all of whom have practices that are deeply invested

in the environment, and who regard themselves as both artists and activists. Agarwal and Altaf each showed clips from their respective film projects, while Chhachhi, in a daring twist, conducted a performance inside the courtroom.

Landscape as Evidence: Artist as Witness was directed by artist and theatre director Zuleikha Chaudhari, whose practice investigates the similarities between the theatre and the courtroom. Chaudhari's works are primarily formal investigations that look to expose the witness-lawyer-judge dynamic as one that is entirely performative and shaped by the dynamics of spectacle. Chaudhari's 2016 work *Rehearsing the Witness: The Bhawal Court Case*,[10] in its use of artists and artworks as witnesses, serves as a precedent for *Landscape as Evidence*. The work negotiates the transcripts of a court case from 1921 which began an almost twenty-year-long dispute between a family in Dacca (now Dhaka) and the British Court of Wards. The case is notable because for the first time in Indian secular law, artists (including two photographers and a sculptor) were introduced into the courtroom as witnesses.

During every single testimony given at *Landscape as Evidence: Artist as Witness*, the judge routinely intervened in order to stabilize or formalize the conversation—'Let's bring it back to what is really the point', or 'Let's bring it back to what is really at stake'. This is exactly where the proceeding revealed itself: the introduction of artists and artworks into the courtroom flattened and synchronized what are, fundamentally, two diametrically opposed registers. More often than not, these different registers failed to cohere. However, this does not stand as a criticism of the form of *Landscape as Evidence: Artist as Witness*; rather, it highlights the ontological separation between the language of aesthetics and the language of law, and thus reinforces the urgency of developing disruptive initiatives to test established modes of language. It didn't work, because fundamentally it couldn't work, and that was the point.

In a 2014 lecture on the Anthropocene, the Capitalocene, and the 'Chthulucene', Donna Haraway begins, like Ghosh, with a rallying cry – we must 'destabilize our own stories, to retell them with other stories'.[11] Haraway also suggests that the biological laws that we allow to govern our understanding of biological forces (for instance, evolution) are fundamentally insufficient for handling the complexity of actual life systems. The same, of course, may be said of our legislative practices. We must debunk the myth that the law is indeed about justice, when it has always been about who has the stronger rhetoric or the better narrative. If it is narrative-building that we must focus on, then we certainly need to start reinventing our imaginative practices.

What spaces do we recognize as sites of performance? In an essay commissioned for the volume, Mila Samdub reconstructs a trolling war on Twitter, framing the act of trolling as infrastructural performance.

Keywords

Aadhaar: see Keywords (pp. 329–44).

eKYC: e-Know-Your-Customer – a form of digital self-authentication enabled by Aadhaar, necessary for all digital financial transactions.

iSPIRT: Indian Software Product Industry Roundtable, an independent think tank funded by corporate industry and working closely with the Indian state, often seen as a successor enterprise of Aadhaar. Known primarily for its 'India Stack', an identity aggregator offering single-point accreditation, currently extending to a 'health stack' in the context of the COVID-19 pandemic.

UPI: Unified Payments Interface – a real-time payment system which uses a single interface to facilitate inter-bank transactions, created by iSPIRT.

Digilocker: an online document wallet maintained by the Ministry of Electronics and IT.

Images

p. 317: Photomontage with the Instagram filter 'Spooky Skeleton'.

p. 319: Recreation of the Facebook status interface.

p. 323: Photomontage of 'Spooky Skeleton' and the trolling directed at the social technologist and internet activist Kiran Jonnalagadda on Twitter.

p. 327: Screen-grabs from the Facebook interface, a photomontage.

What's on your mind?

MILA SAMDUB

2020

25 The Archers and Swordsmen of Digital India

In May 2017, a group of activists who had been critiquing the Indian state's Aadhaar project found themselves being attacked by several accounts on Twitter. The accounts attacking them were anonymous, with handles like @Indiaforward2, @Confident_India and @criticrahul. In a series of aggressive tweets, they questioned the activists' motivations, accused them of hypocrisy and lying, and attacked them as being #JNUType[s] and 'Lutyens armchair folks'.[1]

The trolling appeared to be coordinated. The anonymous accounts were completing each other's arguments. In one thread, a line of attack begun by @criticrahul was continued by @Critic_Rahul and finally completed by @sharads. This last tweet was posted from a non-anonymous account, that of Sharad Sharma, the co-founder of the Indian Software Industry Roundtable (iSPIRT), one of the main industry bodies in the Indian tech sector, and one of the chief architects of India Stack, the centrepiece of the Indian government's Digital India project.

It emerged in the days after the trolling attacks that Sharma had not only been posting from his personal account but also from the anonymous account @Confident_India. This exposé was published in a blog post by Kiran Jonnalagadda,[2] one of the activists who had been targeted by the trolls. Compounding matters, when a denial appeared, it was tweeted by another anonymous account, @Indiaforward2. Soon afterward, this tweet was deleted and a similarly worded tweet appeared on Sharad Sharma's handle, suggesting that Sharma was also behind @Indiaforward2. These botched disavowals further revealed Sharma's direct involvement in the trolling.

Jonnalagadda also leaked slides from a secret internal project at iSPIRT, code-named SUDHAM, which appeared to be the umbrella under which the trolls were operating. SUDHAM laid out a plan for how to counter criticisms of Aadhaar, organizing iSPIRT volunteers into 'swordsmen' and 'archers', who use different trolling tactics to silence or attack critics.[3] That Sharma, one of the most powerful men in Indian tech, had himself led the charge, so to speak, signified the importance of this project. India Stack had been created and developed by Sharma and iSPIRT, and they were doing everything they could to protect their product.[4]

At first sight, this incident doesn't appear to be a classic case of trolling. In India, trolling is perhaps most associated with the hatred spread by the BJP's IT Cell, an arm of the ruling Bharatiya Janata Party (BJP) that runs a wide network of paid trolls. Reading through the tweets of the pro-BJP trolls is an object lesson in the structures of patriarchy, casteism and Islamophobia that run deep in the nation. Yet, despite their relative lack of vitriol, the SUDHAM trolls use similar strategies as the IT Cell: personally attacking critics, derailing their arguments, and cast doubt on facts through the sheer volume of (mis)information they put out into the world.

Focusing on the SUDHAM incident enables us to open out a set of questions that focus on the technological apparatus that underlies trolling. This approach yields a conception of trolling located within the particular genealogy of networks in post-colonial, post-liberalization India. The SUDHAM trolls' poorly coordinated attacks allow us to glimpse how network effects work to multiply pre-existing social structures. Trolling can be understood then as a performance of Big Data, as a drama of the technical and policy infrastructures that make it such a powerful tactic in the first place.

What follows is a series of linked explorations that treats pro-state trolling as infrastructural and performative. First, we unpack the idea that trolling is generating new scripts for our online interactions. Next, we think through the notion of anonymity and its centrality in new media in relation to trolling.

Finally, we shift to the infrastructures that underlie not only trolling but all networked interactions in India. In doing so, the attempt has been to integrate in a single critique social media platforms and user interfaces with the state, telecom operators and industry bodies. Throughout, trolling is understood in light of new subjectivities that emerge from digital sociality, which is built on infrastructure projects co-produced by the state and corporations.

Trolling as Script

> We need a politics and theory of networked-actions-as-speech because, in this series our actions . . . count more than our words. Constantly captured and compared to others, our moves determine past and future narratives.
>
> *Wendy Chun*[5]

Like all interactions after the advent of the internet, trolling differs fundamentally from pre-internet communication. While the content – or words – of trolls' tweets is important, what is more important is their actions, or the ways in which they create effects through networks. As a result of its networked nature, trolling affects not only individuals but entire societies, shaping what kinds of discourse can take place.

Following Wendy Chun, we can understand this shift as part of a move from mass media to new media. Chun argues that the rise of new media is accompanied by the emergence of a novel form of subjectivity. If mass media formed monolithic group identities, then new media, which gives rise to a networked individualism, is the era of an all-caps YOU. Chun characterizes the subjectivity of new media as *singular-plural*: 'Instead of depending on mass communal activities, such as reading the morning newspaper, to create national citizens, networks rely on asynchronous yet pressing actions to create interconnected users.'[6]

Each user's actions affect others in the digital community they have been algorithmically assigned to. This is why, for example, my Facebook timeline is filled with suggestions for groups and topics that support progressive causes and I am unlikely to encounter pro-BJP sources online. Chun calls this a drama because our actions are 'scripted' by cybernetic feedback loops, which nudge us towards certain outcomes based on our location in the network. We experience this in mundane ways all the time: Amazon, for example, suggests purchases to me based on what other customers with similar shopping histories have bought. More perniciously, the same logic underlies systems of social credit, such as the one in

place in China or the ones routinely used by insurance companies to determine differential premiums for customers based on their location in a network.[7]

A networked conception of subjectivity and performance pushes us to think of trolling not as a set of harmful exchanges between a few humans, but as social scripts that have repercussions at massive scales. The actions of not only legitimate users but also of trolls are fed back to other users as habitual directives. The virality of trolling, then, is supported by platforms that profit from actively pre-empting and nudging its users towards certain outcomes.

On Twitter, hashtags function to collate tweets by disparate users into a single assemblage that can be analysed and operationalized as scripts. Once these numbers have been crunched, they are central to how users discover and navigate content through, for example, the 'trending' feature, which displays hashtags that have a high volume of tweeting prominently on the platform. With the vast resources available to the BJP's IT Cell (upto 1,00,000 volunteers in 2017, and likely more today)[8] it is a common tactic to take over this portion of the platform through massively synchronized tweeting of the same hashtag. Perhaps most disturbingly, many such synchronized tweets are made not by humans but by twitterbots, automated programs which have been observed to tweet as frequently as once every eight minutes for many years at a stretch.[9]

The 'scripts' that emerge from this human-machine assemblage have real consequences for national and international politics.

Anonymity as Freedom, Anonymity as Threat

Two symmetric conceptions of anonymity are central to the discussion of trolling and extreme speech on the internet. The first is a particular euphoria that was common around the early, primarily text-based internet. The anonymity it enabled was hailed as liberatory, letting people be the most authentic version of themselves. Here, the possibility of faceless communication was celebrated for creating a level playing field: no one cared for who you were or what you looked like, only what you were saying. As the online and offline have become increasingly imbricated and inseparable, the digital dualism that is latent in this notion of anonymity seems increasingly untenable and naïve.[10]

At the same time, anonymity has been a major cause of anxiety for modern states, who try to control faceless masses by naming and identifying them. This conception of anonymity as threat traces its origins to the rise of disciplinary societies that Foucault described, where knowledge is a form of power. It was in response to anxieties around this form of anonymity that fingerprinting was

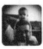 **Kiran Jonnalagadda** ✓ @jackerhack · May 9
"Political revolutions aim to change political institutions in ways that those
institutions themselves prohibit." —Thomas Kuhn (1962)

↩ 1 ⇄ 1 ≋ ♥ 1 ᶤᶥᶧ

Confident India ♟⁺ Follow ⌄
@Confident_India

Replying to @jackerhack

Some more pretentious and highfalutin stuff from
our resident armchair critic @jackerhack!!!

8:34 PM - 10 May 2017

↩ ⇄ ≋ ♥

invented in colonial India in the nineteenth century. Contemporary regimes of biometric surveillance like Aadhaar are the inheritors of this lineage, with contemporary debates around privacy often framed as enabling freedom from surveillance.

In both conceptions of anonymity, the body is a fundamental and contested site: in one, the body is seen as a constraint, limiting us to our identity; in the other, the supposed immutability of the body is used precisely in order to pin down unruly subjects. Pro-state trolls carve out a particular niche here, between anonymity as freedom and anonymity as threat, between the body as burden and the body as uncontrollable.

Many theorists have argued that trolling is fundamentally enabled by the anonymity of the internet – a troll acts with the assumption that he won't have to encounter and be accountable to his targets. However, unlike the reparative anonymity that was celebrated on the early internet, where young queer people in restrictive families, for example, can express themselves more openly online, for trolls, this anonymity allows them the ability to not be themselves: what Italian theorist and activist Franco 'Bifo' Berardi has called a 'bodiless brain'[11], or perhaps more radically, a being without a self. This is literalized in the case of twitter bots, which are programs that spew content out on to twitter, and are often used for large coordinated trolling attacks.

Another way of understanding this is in relation to the idea of authenticity. Rob Horning has argued that on social media platforms we are constantly making stabs at performances of authenticity.[12] We are attached to our social media platforms in a relation of cruel optimism, continually trying to perform some sort of truth but failing because we are trapped in a network of speech that is always already commodified. Every time I open Facebook, it asks, 'What's on your mind, Mila?' I am aware that the question is posed by a corporation bent on extracting profit from my every click. Yet, because Facebook is one of the primary sites of sociality for me I answer it anyway. Sociologist Sarah Thornton describes the experience of authenticity as 'the reassuring reward for suspending disbelief'[13]. Unlike me, professional trolls have no need to suspend disbelief and have little use for authenticity. They are free to approach social media instrumentally, with a platform cynicism.[14]

In this way, pro-state trolls make use of a particular form of qualified anonymity that is available in repressive regimes to state-supported actors. When people make posts that are critical of the state, even in good faith, the state can ascertain their identity or order Twitter to close their account (as it has done on many occasions). Yet, by and large, pro-state trolls get away with their antics. The anonymity of the internet protects trolls not from the state or from surveillant corporations but from their victims and the world at large.[15,16]

Trolls then take Chun's notion of the singular-plural subject to the next level: the trolls are singular and identifiable to Twitter and the state but plural and faceless to their victims. Today, as the theorists Robin Celikates and Daniel de Zeeuw write, 'the political subject is not a conscientious individual person but an open and ever-changing swarm', which includes 'real' human users as well as bots.[17] Maybe, this is why the exposure of Sharad Sharma's fleshy self behind the swarm causes such a breakdown – because an untrammelled anonymous freedom of being and acting in the world becomes linked to a body. Trolling, especially when it is anonymous, is a particularly toxic form of action without selfhood – action without responsibility – that is enabled by networked sociality.

Infrastructure and Performance

If the discussion so far has looked at how social media platforms in general support and amplify trolling as a mode of cynical performance, I want to focus more specifically on the situation in India. Media theorist and internet critic Geert Lovink writes, 'The platforms present themselves as self-evident – they just are. After all, they facilitate our feature-rich lives and everyone that counts is there. But before entering, everyone must first create an account, filling out a profile and choosing a username and password.'[18] Lovink here is speaking of social media, where the a priori is the apparently consenting creation of a profile. If we were to follow Chun, who speaks of Big Data in general, which includes non-consensual databases like those used in predictive policing, the a priori is one's existence in a database at all. But preceding both of these is access to networks in the first place, not only on the part of the subject but also on the part of the state itself. Assuming this access as a given is a common parochialism of new media theory from the west.

In India, as elsewhere in the global South, access to the internet, and conversely, surveillance, is being co-produced by the state and corporations through the very creation of network infrastructure. If in the US the paradigm of Big Data emerged largely in the absence of legislation and through quiet involvement from the state, in India, this paradigm is emerging through the state's proactive involvement. As Itty Abraham and Ashish Rajadhyaksha point out, this owes much to the particular genealogy of technoscientific knowledge and technological society in India.[19]

In a study on state-sponsored trolling, Nick Monaco and Carly Nyst suggest a compelling context for the emergence of this practice. They delineate

two different policies which have guided states in their attempts to control the exchange and spread of information. In the first, states pursued a policy of information scarcity and censorship, where states block websites and platforms deemed to be dangerous. More recently, they suggest, policies of information abundance have arisen:

> States have shifted from seeking to curtail online activity to attempting to profit from it, motivated by the realisation that the data individuals create and disseminate online itself constitutes information translatable into power The approach is uniquely designed to take advantage of the current digital ecosystem, leveraging the virality and familiarity of social media to amplify state messaging, and deploying bots, hashtags, and memes to disguise industrial campaigns as organic groundswells.[20]

Whilst their point is perhaps overly generalized, it allows us to link the act of trolling with larger governmental commitments. It's important to note that the state is not a monolithic player here. Both trolling and the Digital India initiatives emerge from a state-corporate nexus which iSPIRT is at the centre of. Both are built upon assumptions of cheap mobile connectivity and widespread internet access, which have been fuelled in particular by the aggressive tactics of a company like Reliance Jio which markets itself as a partner in the government's Digital India campaign that would 'create employment for five lakh (5,00,000) people'.[21] Getting more people online has meant both increased power for the state and increased profit for a range of corporations. This is true at every scale. In the India Stack, a core component of Digital India which has been spearheaded by iSPIRT, many of the beneficiaries of the programmes are not citizens and government departments but also companies, like insurance providers, that can monetize information as data. Indeed, the 2018–19 Economic Survey made a spirited case that citizens' data is a public good that should be accessible to private as well as state interests.

To the critique of the state as an actor that uses trolling to push its agenda, we should then add a critique of neoliberal governmentality. Returning to the incident with which we began, by reading the iSPIRT incident alongside BJP's troll armies, I'm suggesting that iSPIRT and the interests for which it is a front are also a key beneficiary. That is, much state-endorsed trolling is also in fact promoting corporate interest.

Trolling and YOU

In ending, I want to reflect on what trolling can help us understand about performance and what performance can help us understand about trolling.

I believe, a close look at trolling can help us unpack questions about embodiment that are central to the study of performance. How do bodies affect each other at a distance? What is the capacity to affect at a distance in the absence of a physical body in space? Questions around what constitutes action (with micro-interactions with interfaces being plumbed for data) and what constitutes subjectivity are thrown wide open by the internet. Furthermore, as Chun and others have demonstrated, the categories of performance – script, acting, audience, etc. – can help us understand the network logics that form the infrastructural basis for trolling. Conversely, a focus on trolling also pushes us to see the infrastructures that underlie contemporary sociality as sites that can be illuminated through the study of performance.

In an ironic echo of Chun's notion of the singular-plural subject of big data, the government advertises Digital India as a project 'about YOU': we could read this to mean that Digital India creates subjects that are singular-plural, not least among them trolls, who thrive on network effects and the platforms and infrastructures built by large tech companies.

‍ ‍

KEYWORDS

List of names, terms and concepts used in the texts in this volume. While these are mostly likely to be familiar to readers acquainted with Indian political theory, they are revisited here, in part to offer a ready primer for those less acquainted with these debates, but also to draw attention to their shifting and open-ended definitional status.

Aadhaar

Biometric identity system that involves issuing a twelve-digit unique identification number to Indian residents. Technically voluntary, linking Aadhaar to the delivery of essential services and subsidies makes it effectively mandatory. Its connections to private developers as well as reports of data leaks have raised concerns around privacy, surveillance and sectarian targeting. See Mila Samdub's 'The Archers and Swordsmen of Digital India'.

Aalaap

The opening of a Hindustani classical music rendition, establishing the main melodic patterns of the **raga** and composition. It is not rhythm-bound and serves as free improvisation. A common structuring device is the introduction of a single note at a time. Its pace also makes it a landscape for improvisation in other forms of performance, such as the use of the **dhrupad** *aalaap* in Chandralekha's dance work, *Sharira*.

Akademi/Sangeet Natak Akademi

Akademi, derived from 'academy', used to refer to a society or collective – in this case, in the arts, where state-supported autonomous *akademi*s govern funding

for literature, performance and the visual arts. The Sangeet Natak Akademi is the performing arts arm set up in 1953 with the stated objective of 'preserving and promoting the vast intangible heritage of India's diverse culture expressed in the forms of music, dance and drama'. Its programmes have defined several agendas for performance including how forms are classified, recognized, and thus, funded. See Introduction and 'Not the Keynote Address' by Akshara K.V.

All India Radio/Akashvani, Doordarshan, Prasar Bharati

All India Radio (AIR), now known as Akashvani, India's national public radio broadcaster, and Doordarshan, the television broadcaster, are both part of Prasar Bharati, the national broadcasting agency. Following the dissolution of princely states after Indian Independence, All India Radio became a major employer of musicians. Its often discriminatory rules of employment sometimes made it difficult for musicians from hereditary courtesan communities to enter the system and earn the 'grade' that qualified them to perform on the radio. Though autonomous, AIR and Doordarshan have often been mobilized for state propaganda and have been accused

of censoring content. See the arc of
essays by Sanjay Srivastava, Ashwini
Deshpande and Lakshmi Subramanian
in this volume.

Araimandi

The fundamental posture in
bharatanatyam – symmetric, knees
bent, hip opened out, feet firmly
grounded, spine erect, and the distance
between the head and the navel the
same as that between the navel and
the ground. The position has parallels
in most South Asian dance forms –
such as the *chowka* in Odissi and the
mandiya in Sri Lanka's Kandyan dance.
These square positions ground the
body with their wide stance allowing the
dancing body to find pause and stability.
Also see **bhanga**. See the essays by
Chandralekha and Padmini Chettur in
this volume.

Bani

A stylistic method or school. *Bani*
delineates stylistic lineages in **dhrupad**
and **bharatanatyam**. Similar to *gharana*.
On *bani*, see Leela Samson's essay,
'Classical Dance in Contemporary India'
in this volume.

Bar dancing/bar dancers

Form of performance in low-end bars,
mainly in Mumbai, with women dancing
on a barricaded stage to pre-recorded
songs for a primarily male audience.
Although the dancers are physically
protected (if visually consumed), this
practice was banned in 2005 and again
in 2016 in Maharashtra, which deemed
it a form of sex work, making it a major
cause for feminist groups supporting the
dancers' right to livelihood. This right

was upheld in a major Supreme Court
judgement in 2019. See the essays by
Anna Morcom and Sameena Dalwai in
this volume.

Bhakti, bhakti poetry

Umbrella term for several traditions of
proletarian poetry in Indian languages,
roughly between 600 and 1800 CE,
defining a personal devotion to god, often
manifested as love that is both erotic and
transcendental. In their emphasis on the
marginal, the individual, the domestic
and the trivial, Bhakti saint-poets located
themselves outside, and often at odds
with, institutionalized religion and the
courtly elite. Across the subcontinent,
different traditions of poetry and music
gave birth to regional languages and
popular music, the impact of which
continues into the present. They typically
addressed proletarian gods, and the
songs in their praise often emerged
through the practices of labour, in the
fields and at home. In her essay, dancer
Leela Samson speaks of the influence
of the 'romantic poetry of the southern
region, tenth-century bhakti poetry and
the numerous stories-within-stories of
the great *Purana*s', while Sharmila Rege
speaks of the 'Brahminization of the
Bhakti cults in Maharashtra', referring
thus to the elite appropriation of the
varkari (or travelling mendicant) tradition
that defined itself in praise of the deity
Vitthal (or Vithoba), a local incarnation of
the god Vishnu.

Bhanga/bhangi

A term for a fixed stance or posture, used
in Odissi and allied forms. For instance,
the *samabhanga* is a neutral position
where both sides of the body bear equal

weight. In the *tribhanga*, another popular position, there are three bends in the body – at the knees, the waist and the neck, with the weight skewed to one side, allowing the other foot to move freely. In her essay 'Militant Traditions of Indian Dance' in this volume, Chandralekha contends that both the *tribhanga* and the **araimandi** have links to martial arts exercises that explore the potential of contracting and expanding the body, 'to convert every movement to an energizing exercise'.

Bharatanatyam

One of the dance forms recognized as 'classical' by the **Sangeet Natak Akademi,** often referenced as a prime instance of classical nationalism. It incorporates a range of stylistic influences from across the erstwhile Madras Presidency, which included large parts of southern and south-eastern India. As with many other classical practices, bharatanatyam draws on the work of hereditary courtesan communities across the region who are generally identified as **devadasis.** While some women from these communities across south India did perform in temples, others also performed in royal courts and in private gatherings. The new form sanitized its erotic content with an emphasis on devotion, thus consolidating a classical dance that could be recognized by a newly-formed nation-state with aspirations of modernity and progress. A critique of this tradition defines much of the radicalism of the dancer/choreographer Chandralekha. See especially Padmini Chettur's 'The Body Laboratory' and Leela Samson's 'Classical Dance in Contemporary India'

in this volume. Also see the essays by Navtej Johar, T.M. Krishna, Lakshmi Subramanian and Ranjana Dave.

Brahmin

The caste of priestly elites in the four-part **varna** system or caste hierarchy. Although the history of this particular caste goes back to the Puranic era, its relevance to the present volume is mainly from the early 1920s, when Brahmin modernization and politicization produced a new hierarchy, together with new modes for gatekeeping sacred knowledge. Such gatekeeping was both formal, in the transformation of formerly erotic content into devotional significance, as well as directly political in forbidding, or otherwise preventing, musicians and dancers of certain castes from performing (see, for example, **Carnatic music;** also **All India Radio**). Initially contextualized by the social reform movements under colonialism, and by Brahmin dominance with the colonial bureaucracy after Independence, this domination would continue into the Brahminization of sanctified national cultures (see **bharatanatyam**), extended to forms of national patronage and new elite arts. See T.M. Krishna's 'MS Understood' and Lakshmi Subramanian's 'The Voice in Colonial and Post-Colonial India' in this volume.

Carnatic music: 'Carnatic' (from 'Karnataka'), a prevalent classical music style in south India, in contrast to **Hindustani music** in northern India. Both forms often share similar **ragas** or melodic frameworks, but name and classify these differently. Carnatic music uses the *melakarta* (collection)

classification, identifying 72 parent ragas. Like **bharatanatyam**, Carnatic music was the mainstay of hereditary performance communities often patronized by princely states and the courtly elite. Under colonial rule, it also drew from interactions with the British East India Company and their music, including tunes played by marching bands. The eighteenth-century composer Muthuswami Dikshitar introduced compositions called *nottuswara*s that were based on popular Scottish and Irish melodies, including the song 'Santatam pahimam' (Protect me always), set to the tune of 'God Save the Queen'. Also adopted in this time was the violin, now an essential part of Carnatic performance, played both solo and as an accompaniment. Patronized and performed after Independence largely by **Brahmin** musicians, with some notable exceptions. Musicians from hereditary courtesan communities lost access to performance opportunities and patronage, and the new systems of institutionalized training also made it economically unviable for musicians from these backgrounds to spend time and money on training for a limited and highly competitive set of opportunities. See T.M. Krishna's 'MS Understood' in this volume.

Chhau
Umbrella term for three distinct traditions of martial movement from eastern India: Mayurbhanj chhau from Odisha, Purulia chhau from West Bengal and Seraikella chhau from Jharkhand. Although neatly demarcated across state lines, each with a distinct identity bolstered by the patronage of their home states, they nevertheless draw from common pools of movement vocabularies and narrative traditions. See 'Militant Origins of Indian Dance' by Chandralekha in this volume.

Dalit
Interpreted as 'broken', 'scattered' or 'divided', a translation used for the census classification of the 'Depressed Classes' before 1935. The Dalit Panthers, a radical organization, defined Dalits as 'all those who are exploited politically, economically and in the name of religion'. The term was originally popularized by Dr B.R. Ambedkar as a radical counter to Mahatma Gandhi's preferred use of Harijan (people of god) to refer to India's so-called 'untouchable' castes. The emphasis on majority is typically to oppose Hindu majoritarianism. After the Constitution of India listed, in its First Schedule of the Scheduled Castes and Tribes orders of 1950, an initial total of 1,108 castes and 744 tribes, adding up to approximately 17 per cent and 9 per cent of the population respectively (as of 2011), the official term used in state-supported media and communication has become 'Scheduled Castes'. See the excerpt of Anand Patwardhan's 'Jai Bhim Comrade' in this volume.

Devadasi
Loosely translates to 'female attendants of the deity'. The term pertains to the practice of dedicating young women to temples, effectively 'marrying' them to the deity. Commonly viewed as a form of religiously sanctioned prostitution, the practice was banned in 1947 by the Madras Devadasi Act shortly after Independence, which had several consequences, including making

illegal various traditions of female performance practised by artists from hereditary courtesan communities. Many female artists are referred to as being of 'devadasi' heritage if they belong to such communities, even if they have never had temple dedication ceremonies. These artists were caught in the crossfire of early twentieth-century social reform movements – targeted for their 'immoral influence' on society and framed as victims of trafficking and sexual abuse. The term has also accrued different meanings with changing societal attitudes over time. The dancer Nrithya Pillai makes a useful distinction (Abfact_ anticaste, 'Important Words from Nrithya Pillai of the ISAI Vellalar Hereditary Courtesan Dance Community', Instagram Photo, 5 July 2020) between the hereditary communities that are part of **bharatanatyam**'s history – artists from the Isai Vellalar and Kalavantulu communities in Tamil Nadu and Andhra Pradesh, respectively – and twenty-first-century women from **Dalit** communities who continue to be dedicated to deities to signify their entry into sex work, often forced into these roles over generations through a combination of poverty and systemic oppression. Anna Morcom draws parallels between the public perception of courtesans and the **bar dancers** of Mumbai. The term also centrally features in the texts by T.M. Krishna and Lakshmi Subramanian in this volume. Also see *tawaif*.

Dhrupad
North Indian classical musical form widely considered to draw its grammatical influences from the Puranas and the *Natyashastra*, but which

flourished in the Mughal courts. It is known for its aesthetic minimalism and slow tempo. Compared to **khayal**, which explores a range of themes and musical styles, dhrupad is seen as a slower, less accessible and more concentrated idiom. See Natasha Ginwala's description of the Gundecha brothers in Chandralekha's *Sharira,* in her essay 'Untaming Restraint and the Deferred Apology' in this volume.
.

Gharana
Literally, a 'hereditary school' – widely used to define a small number of such 'schools' with a distinct lineage, an often-coveted repertoire of compositions and stylistic specificities in the north Indian traditions of both **dhrupad** and **khayal** classical music, and also, **kathak**. Among their key significance is the process of sanctifying musical practitioners who belong to some gharanas with the authority of tradition. Prominent gharanas are Gwalior, Jaipur, Kirana and Agra. Also used to define lineage in the **hijra** community. Gharanas originated as clustered lineages of performers, with students and teachers living together in the *guru–shishya parampara* (a focused and hierarchical connection between teacher and student; see **gurukul** for more). See the essays by Sanjay Srivastava and Ashwini Deshpande in this volume for the culturally contentious Muslim influence on different gharanas, especially after Independence.

Ghazal
Extremely popular genre of love poetry in South Asia since the twelfth century. Although it has Arabic origins, its dominant language in South Asia is Urdu. Poets have however

experimented with multiple other languages (including English). In the twentieth century, this tradition was inherited by the cinema, where actress-singer Noor Jehan was considered the most important influence on the form. The ability to correctly recite Urdu lyrics, prominently revealed in the ability to bring to this form the 'pain' often associated with the love, constituted a rite of passage for singers seeking both the authenticity of the tradition and access to its market across north India: especially difficult for singers (such as Lata Mangeshkar and M.S. Subbulakshmi) not native to the language. See Sanjay Srivastava's essay, 'Voice, Gender and Space in the Time of Five Year Plans', for more.

Gurukul/gurukula
A Sanskrit term for a school where the students live in the same space as the teacher, and spend their lives in study and devotion to the teacher. The teacher–student relationship (*guru–shishya parampara)* extends to interactions outside the classroom, defining learning both as technique and skill and a way of life. See Leela Samson's 'Classical Dance in Contemporary India' in this volume.

Hijra
Persian term that refers to a transgender identity in South Asia. A hijra is a member of a community of transgender persons who may or may not be intersex. Traditionally, hijras were organized into **gharanas** (clans/lineages), each one headed by a guru. Hijras are usually transwomen; alongside other transgender people, they are officially recognized as a 'third gender' in India. See the self-description by Kokila, one of Danish Sheikh's protagonists, in his play *Contempt* in this volume.

Hindustani music/Hindustani sangeet
The style of classical music prevalent in the northern part of the subcontinent. Both Hindustani and Carnatic music use the raga system, though they classify and occasionally title ragas differently. Hindustani music organizes ragas into ten *thaat*s or parent scales. Several compositional specialisms exist within Hindustani music, **dhrupad**, **khayal** and **thumri** among them. Like **kathak**, in the medieval period, it benefited significantly from its development in Islamicate courtly cultures starting with the Delhi Sultanate and then the Mughal empire. Structures and techniques from Hindustani music are also in use in the film industry, particularly in north India, where it informs music composition and **playback singing**. Also see **gharana**. See the Lata Mangeshkar debate in this volume – the arc of essays by Sanjay Srivastava, Ashwini Deshpande and Lakshmi Subramanian.

Hindutva
'Hindu-ness', a right-wing ideology of majoritarian nationalism, a culturally hegemonic and militant reading of 'Indian' as 'Hindu'. Since the rise to power of the Bharatiya Janata Party, this has become the primary ideology of the Indian state. This has a major organizational presence online, on social media sites, where media cells plan and manage the dissemination of Hindutva agendas via, among other strategies, managing networks of trolls. See Mila

Samdub's 'The Archers and Swordsmen of Digital India' in this volume.

Indian People's Theatre Association (IPTA)

A theatre initiative formally constituted in 1943 in the context of the great famine that took place in Bengal, advocating for a theatre that reflected the lived realities of the people for whom it was made. IPTA's work both on stage and, after 1946, in film would have a nationwide impact in its characterization of the colonial regime and of class conflicts embedded within Indian society. See, for example, K.A. Abbas's *Dharti ke Lal* (Children of the Earth, 1946) and *Neecha Nagar* (Inferior Town, 1946) by actor–director Chetan Anand. See Gargi Bharadwaj's 'Politics of Location' in this volume.

Item number/Item song

A dance number in a film, often possessing no direct relevance to its narrative. Its lyrics are sexually charged, loaded with double entendres, with performances (usually by women) focusing on the body, documenting male actors' reactions to a series of non-verbal cues in movements and expressions. With its catchy rhythm, the item number is often the biggest selling point of a film, its influence spilling over to advertising and other off-screen forms of circulation. The actors who perform item numbers are often termed 'item girls'. See Introduction.

Jana Natya Manch (Janam)

Influential theatre group founded by Delhi-based amateur performers in 1973 with the intent of taking theatre to the people. It was inspired by, and sought to further, the work done by the **Indian People's Theatre Association (IPTA)**, the cultural wing of the Communist Party of India. Initial productions were made for the proscenium yet performed in different spaces; in 1978, the group moved to street theatre. In 1989, its convenor Safdar Hashmi was killed by goons while performing the play *Halla Bol* (reprinted in this volume). Janam continues to make and perform both street theatre and proscenium plays.

Kabir Kala Manch (KKM)

Group of cultural activists in Pune who came together in the wake of the 2002 Gujarat riots. They have performed at various locations across Maharashtra, addressing sociopolitical issues through their music and poetry. In 2011, KKM members were charged with promoting Naxalite and Maoist thought, and warrants were issued for their arrest. Most of them were imprisoned before being released on bail. The crackdown on KKM raised a huge debate on the erosion of free speech. See the excerpt of Anand Patwardhan's 'Jai Bhim Comrade' in this volume for more.

Kalakshetra

Dance foundation in Chennai set up by the theosophist and dancer Rukmini Devi Arundale (1904–86) in 1936. Best known for its institutionalization of the classical dance style of **bharatanatyam**, adapting the practices of professional performers from hereditary courtesan communities, who were also identified as **devadasis** in some histories of the form. As a performer from the emerging Indian middle class, Rukmini Devi's personal identity as a non-hereditary performer

reinforced its emphasis on the devotional in bharatanatyam's interpretation of episodes from Hindu mythology. Parallelling this shift in content, the modern system of bharatanatyam training also effectively excluded performers from hereditary courtesan communities, socially, economically and culturally. See the essays by Padmini Chettur, Leela Samson and Ranjana Dave in this volume.

Kalakshetra Manipur
Theatre group in Manipur, established in 1969 and run by performers Heisnam Kanhailal (1941–2016) and his wife Heisnam Sabitri. In their work, they turn to Manipuri traditions and performance practices in order to arrive at a 'contemporary cultural expression'. Works like *Pebet* (1975) and *Draupadi* (2000) have offered critiques of state-led oppression and violence, speaking to the sociopolitical situation of Manipur, which has borne the brunt of military excesses. See Trina Nileena Banerjee's 'Contemporary Theatre Practice in Manipur' in this volume.

Kalaripayattu/*kalari*
A martial art practice that originates from Kerala. Earlier used as a mode of training for warriors, with conditioning exercises and lessons in the use of hand-to-hand combat and weapons. Commonly accessed by performing artists for body-conditioning. *Kalari* refers to the space of practice: a sunken rectangular mud pit where kalaripayattu exercises are performed. Sessions usually begin with a salutation addressed to the deities governing the space, and weapons used are both stored

and displayed in the *kalari*. A major influence on both the practice and theory of the dancer Chandralekha, and a key reference to her source of 'militant traditions' of dance practice.

Kathak
North Indian dance form initially linked to itinerant storytelling practices, informed by **Bhakti** and medieval Vaishnavism (devotion to the god Vishnu and his incarnations). The form was effectively defined during the late Mughal era, when it received patronage, and later in nineteenth-century Lucknow, particularly in the court of Wajid Ali Shah. Its proliferation led to the emergence of different **gharanas** across north India. One of the dance forms recognized as 'classical' by state institutions, it has also remained a major popular form associated with the Islamicate genre in cinema.

Kathakali
A form of dramatic performance from Kerala, recognized as a classical dance style by the **Sangeet Natak Akademi**. It has links to dramatic, musical and martial arts practices in the subcontinent. Its initial development largely unfolded in courts and theatres, and its recent history is linked to the founding, in 1930, of the Kerala Kalamandalam by the poet Vallathol Narayana Menon (1878–1958). Kalamandalam's history and significance in terms of nationalist culture parallels that of **Kalakshetra**. While kathakali plays are largely based on episodes from Hindu mythology, artists have also performed adaptations of European classics. See Chandralekha's essay, 'Militant Traditions of Indian Dance', in this volume.

Kotha

'Salon', where courtesans (**tawaifs**) of north India lived and performed. Over the first half of the twentieth century, as public sentiment against female performers rose, courtesans began to be viewed as immoral influences, at odds with patriarchal conceptions of the family unit and with Hindu society, hegemonically understood to stand for Indian society at large. With courtesans being viewed less as artists and more as sex workers, the term, especially when used in popular culture, increasingly references the 'brothel'. See Anna Morcom's essay on the dance bar ban in Maharashtra, 'The Continuation and Repetition of History', in this volume.

Kuchipudi

Form of performance named for its roots in the village Kuchipudi, now part of Andhra Pradesh. Comes from a dance-drama tradition that has links with similar practices in the region, including the *bhagavata mela* and *yakshagana*. While practitioners still perform Kuchipudi *yakshagana* in the dance-drama mode, performing elaborate plays based on mythological narratives, Kuchipudi also comprises a solo dance repertoire, structured like other classical dances of India -- with invocations, pure dance pieces that foreground technique and rhythm, and short narrative episodes. As a form developed by Brahmin artists, until the early twentieth century only men performed on stage, playing both male and female roles, as it was taboo for women from these families to appear on stage. Some dancers continue the practice of female impersonation by performing in *stree vesham* (attired as

women). Post-Independence, it was recognized as a classical dance style. See Chandralekha's essay, 'Militant Traditions of Indian Dance', in this volume

Lavani

Mode of performance (and lyric-writing) that flourished in the late eighteenth century during the **Brahmin** rule in Maharashtra (known as the Peshwai). It is performed in feminine attire by both men and women. While lavani has several genres, the *shringareek* (sensual) lavani is the most prevalent. In the early decades of the twentieth century, this form was repurposed as a key vehicle for popular entertainment, especially catering to Bombay's working classes, from where it was inherited by the cinema. Lavani songs are attuned to current affairs, and mirror social, political and economic realities. See Sharmila Rege's 'Conceptualizing Popular Culture' in this volume.

Madras Music Academy

Key arts institution in Chennai. It started as a music conference in 1927 as part of the All India Congress session, and was inaugurated in 1928. Its annual music conferences gave form to what is now known as the December Music Season, a month-long, high-visibility series of classical music and dance events across various venues in Chennai. Visibility here is an essential prerequisite to artistic renown in classical dance circles, particularly Carnatic music and bharatanatyam. See T.M. Krishna's essay on M.S. Subbulakshmi, 'MS Understood', in this volume.

Manipuri

Dance style from the North Eastern
state of Manipur, originating from the
ritual practices of the majority Meitei
community, now recognized as 'classical'.
In its current iteration, the form draws
extensively from the region's encounter
with Vaishnavism, with many performative
themes emerging from narratives of
Krishna. 'Manipuri' is a blanket term for
several movement idioms within the
tradition – including the feminine *ras-lila*
where Krishna (an incarnation of Vishnu)
dances with his lovers, and forms like
pung cholom where the dancer performs
a series of dynamic movement patterns
while drumming. Also an influence in
the work of **Kalakshetra Manipur.** See
Trina Nileena Banerjee's 'Contemporary
Theatre Practice in Manipur' in this
volume.

Maya

A feminine phenomenon, *maya* can
be said to be the 'faulty reality' that
we may take for real in our minds due
to misperception, illusion, delusion,
denial, projection, etc. Orthodox
religious doctrines such as Vedanta
view it as deceitful, cunning, baffling
and thus spiritually dangerous; in
Tantra, however, the same *maya* is
viewed as 'wishful nature' that can
be made an agent of transformation
through playful engagement, as
opposed to being the beguiling
temptress that needs to be controlled
and subdued. See Navtej Johar's 'True
to the Bone' in this volume.

Mujra

Musical and movement-based form
attributed to female artists who
performed in their salons for private
patrons, traced back to the Mughal era.
See *tawaif*, *kotha*. See Sharmila Rege's
essay, 'Conceptualizing Popular Culture',
in this volume.

Murki

Short and rapid *taan*.

National School of Drama (NSD)

Founded in 1959 as a constituent unit
of the **Sangeet Natak Akademi**, now
a leading theatre training institution
headquartered in New Delhi with several
regional centres across the country.
Primarily associated with the creation
and canonization of a national theatre
in India at different stages. As a national
institution, the foremost of its kind in the
country, the NSD attracts aspiring actors
from all over India. It has, however, also
been critiqued for propagating a Hindi-
centric theatre that does not sufficiently
acknowledge a breadth of language and
practice, effectively pigeonholing actors
into stereotypical and constrained notions
of theatre. An additional purpose has
been the NSD's steady supply of actors
to India's film industries, a role enhanced,
following the controversial closure of the
acting course at the Film and Television
Institute of India, initially in India's New
Cinema movements and more recently in
Bollywood. See Trina Nileena Banerjee's
'Contemporary Theatre Practice in
Manipur' in this volume.

Nautch

The anglicized form of the word *naach*
(dance), which appears in multiple
languages, including Hindi and Urdu.
In colonial times, 'nautch girls' was the
term for dancers or female performers

from hereditary courtesan dance communities. With the rise of the anti-nautch movement in the early twentieth century, the term began to take on derogatory connotations, becoming a reference to women in sex-based occupations. See Anna Morcom's 'The Continuation and Repetition of History' in this volume.

Nayak/Nayika/Sakhi

Sanskrit terms defining the characteristics of the *nayak* (hero), the *nayika* (heroine) and the *sakhi* (heroine's companion) in poetry and performance. Although romantic partners, the duo of hero and heroine also resonate with other dualist constructs such as *prakriti* and *purusha*. The *sakhi*, trusted friend and confidante of the *nayika*, is often tasked with being the messenger between the *nayika* and the *nayak* in their romantic tryst. See Ranjana Dave's 'Friends with Benefis' in this volume.

Odissi

Dance style originating from the state of Odisha in eastern India, largely consolidated into its present form as a recognized 'classical' practice by artists and scholars of the Jayantika movement in 1957. Draws on movement idioms and themes from the dance practised by the *gotipua*s – itinerant troupes of pre-pubescent dancers – and the *mahari*s (temple dancers) at the Jagannath temple in Puri, and from early and mid-twentieth-century Odia theatre. Additionally, during its reconstruction, practitioners actively referenced temple sculpture in Odisha, and dramaturgical texts such as the *Natyashastra* and *Abhinaya Darpana*. The impulses that

informed this reconstruction came from the new agendas being set at the **Sangeet Natak Akademi** and allied fora, and also from similar efforts at restructuring or formulating dance repertoires in forms like bharatanatyam. See Ranjana Dave's 'Friends with Benefits' in this volume.

Parishat theatre

Also known as *Parishatnatakam* (literally, community theatre), first initiated by the Andhra Nataka Kala Parishat (ANKP, Andhra Theatre Assembly) in 1944 to counteract the elitist traditions of *Padyanatakam* (musical theatre) based on historical and mythological stories with little or no attention either to political ideas or to aesthetic finesse. Parishat theatre is historically formated on theatre festivals and annual drama competitions set in realistic environments reflecting contemporary sociopolitical realities of the community. See Gargi Bharadwaj's 'Politics of Location' in this volume.

Parsee/Parsi theatre

Influential proscenium theatre practice launched in the mid-nineteenth century and prevalent until Independence, establishing a modern theatre industry with repertories owned and funded by entrepreneurs, and including full-time employment for writers, actors, musicians, etc. Name derived from the Parsee/Parsi community to which several of its owners and employees belonged. Known for the production of several original plays, usually in Urdu, and adaptations from Shakespeare, Sanskrit classical theatre, and from diverse mythological sources from both Persia and India, presented on stage

with extensive use of spectacular effects.
A major predecessor to the cinema,
with several major companies moving
into film production in both Bombay and
Calcutta. As Gargi Bharadwaj suggests
in her essay, 'Politics of Location', in this
volume, its impact has often been seen
to be the major modern influence on
Indian theatre, often ignored in 'official'
discourses.

Playback singing

A form of performance where a singer
pre-records songs or soundtracks that
are later lip-synced by an actor on
camera. Unlike in several other cinematic
traditions, where actors mouthing songs
rendered by others is usually a secret not
shared with audiences, India's playback
singers are famous, their names hugely
advertised, and no effort is made to
even pretend that it is the actor who has
sung the song. This mode is duplicated,
and perhaps implicitly also satirized, by
the **bar dancers** in Mumbai. Most of
India's famous singers do professional
playback singing for a living, doing live
concerts only occasionally and – as
Sanjay Srivastava points out in the case
of India's best-known playback singer,
Lata Mangeshkar – commonly perform
on stage by standing rigidly, 'head buried
in a notebook'. Although the singer is not
on camera and thus has only an aural
rather than a visual existence, over time,
major playback singers have influenced
on-screen characterization, responding
to broader societal tropes, in the stylistic
and artistic choices they make. See the
Lata Mangeshkar debate reproduced in
this book – the arc of essays by Sanjay
Srivastava, Ashwini Deshpande and
Lakshmi Subramanian.

Powada

A genre of Marathi poetry with ballads
written and performed by *shahirs* (poets);
without exception male performers
eulogize heroic acts, most popularly
narratives about the seventeenth-
century Maratha king Shivaji or his
legendary associates. The form saw a
major renaissance in the 1930s–40s
in Maharashtra when several poet-
singers affiliated with the **Indian
People's Theatre Association** and the
communist working class movements
in Bombay adapted it to sing about the
contemporary (e.g. Shahir Amar Sheikh
and Annabhau Sathe). See Sharmila
Rege's 'Conceptualizing Popular Culture'
in this volume.

Prithvi Theatre

Major independent theatre venue in
Juhu, Mumbai, set up in 1978 with the
intent of promoting professional theatre.
Built as an intimate space, the theatre is
made accessible to groups at subsidized
rates, and also includes rehearsal and
workshop spaces. Until the arrival of
the Prithvi infrastructure, independent
theatre existed mainly in amateur spaces
that required major improvisation. Prithvi
has since housed several independent
theatre initiatives, including the India
Theatre Forum (which hosted the 'Not
the Drama Seminar', see Akshara K.V.'s
essay, 'Not the Keynote Address' in this
volume) and Junoon. It has inspired
other similarly modelled artist-centric
spaces, like the Rangashankara and
Jagriti theatres in Bengaluru.

Raga

A melodic framework in classical music.
The framework offers guidelines for

improvisation, specifying the leading, supporting and excluded notes of the raga, and the construction and cadence of musical phrases. An improvisation within the raga highlights these characteristics.

Rasa/rasika

Rasa: The expressed flavour/quality of an emotion (**bhava**). The nine *rasa*s are *sringara* (love), *hasya* (mirth), *karuna* (compassion), *raudra* (anger), *vira* (valour), *bhayanaka* (fear/terror), *bibhatsa* (disgust), *adbhuta* (wonder) and *shanta* (tranquility). As a term, 'rasa' appears in Vedic literature, while initial forays into **rasa** theory appear in the *Natyashastra* (Sanskrit, 200 BCE to 200 CE) with more detailed studies appearing in Abhinavagupta's commentary on the *Natyashastra*, the *Abhinavabharati* (Sanskrit, 10–11 CE). A connoisseur or aesthete is termed *rasika*, one who harvests and experiences *rasa*. See Navtej Johar's 'True to the Bone' in this volume.

Sanskritic/Sanskritization

Relating to Sanskrit and its definitions of literature and culture, often evinced in post-Independence India in the ways in which practitioners made efforts to establish links between their practice and Sanskrit dramaturgical treatises like the *Natyashastra* and *Abhinaya Darpana*, thus staking claim to a common ancient lineage. In this process of *Sanskritization*, these forms were recognized as 'classical', and their links to ancient literature and culture also reinforced the geopolitical aspirations of the new nation-state. See Sanjay Srivastava's 'Voice, Gender and Space in the Time of

Five Year Plans' and Gargi Bharadwaj's 'Politics of Location' in this volume.

Section 377

The Indian Penal Code was enacted in 1860 by the Imperial Legislative Council of British India. Though it has been revised and amended, many of its sections are still a hangover from colonial times, at odds with contemporary realities. The text of Section 377, an example of this dissonance, is as follows: 'Unnatural Offences – Whoever voluntarily has carnal intercourse against the order of nature with any man, woman or animal, shall be punished with imprisonment for life, or with imprisonment of either description for a term which may extend to ten years, and shall also be liable to fine. Explanation – Penetration is sufficient to constitute the carnal intercourse necessary to the offence described in this section.' Section 377 was often used to wrongfully prosecute and harass members of the LGBTQ (lesbian, gay, bisexual, transgender, queer or questioning) community. A 2018 Supreme Court judgement finally ruled that Section 377 excluded homosexuality from its understanding of intercourse 'against the order of nature'.

Shastriya sangeet

Literally, classical music. Term used, mainly after Independence, to provide India with a classical legacy, by attributing to music a scriptural (or *shastric*) authenticity. Such an authenticity, retrospectively applied through a reappraisal of mainly Sanskrit texts, has been viewed as a key part of the modernist project associated with

nationalism (see **Sanskritization**). With
Brahmins positioned as custodians
of the *shastra*s (scriptures), *shastriya
sangeet* also becomes a reference to an
inherently Brahminical classical music,
devoid of the influence of artists from
the hereditary performance communities
that developed and propagated classical
music for centuries. See Sanjay
Srivastava's 'Voice, Gender and Space
in the Time of Five Year Plans' in this
volume.

Shudra/Ati-Shudra
The Hindu social order (the **varna**
system) is divided into four hierarchical
categories, with the **Shudra** occupying
the lowest rung in the hierarchical
ladder. While definitions of Shudras
appear in various ancient and medieval
texts, these have varied over time. The
oldest definitions framed Shudras as
'givers of grain', the agricultural class.
With the advent of urbanization and
industrialization, the pre-eminence
of agriculture was displaced in this
definition and Shudras were now
understood to be caste groups whose
hereditary occupations involved
performing services for other people.
Even within the Shudra categorization,
there are hierarchical divisions between
Shudras and Ati (or extreme)-Shudras,
who are seen as ranking below their
Shudra counterparts. See Sharmila
Rege's extensive discussion on Shudras
in her essay in this volume.

Silambam/Silamban
Martial arts practice originating from
Tamil Nadu, prevalent amongst Tamil
communities in South and South-East
Asia. Silambam is weapon-based, usually

performed with a long wooden stick,
and was used as a mode of training by
warriors of various Tamil dynasties. Also
see **chhau** and **kalaripayattu**. Referenced
by Chandralekha in her essay, 'Militant
Traditions of Indian Dance', in this volume.

Taan
A melodic passage sung in a short,
rapid burst, usually towards the latter
half of a Hindustani music composition,
enunciated with the aid of a vowel, most
commonly 'a'.

Tamasha
Umbrella term for Marathi theatre
presented by a troupe of performers,
which includes several kinds of music,
dance and drama performances. In the
mid-twentieth century, the tamasha was
the main form of popular entertainment
in several urban centres in western India.
Once a separate strain of theatre with
moral messaging began to evolve for
the middle and upper classes, tamasha
performances began to be stratified
along gender lines, with male performers
making theatre around moral and social
issues, in contrast to forms such as
sangeet baree, performed by women
and foregrounding sensual and erotic
performance, like the *shringareek* lavani.
See Sharmila Rege's 'Conceptualizing
Popular Culture' in this volume.

The Drama Seminar (1956)
In 1956, the **Sangeet Natak Akademi**
organized a major seminar on theatre,
one of a series on different art forms
featuring leading practitioners and
theorists of the arts in India at the
time. The seminars sought to define a
national practice for different art forms,

alongside national policies on funding and institutionalization. The curatorial choices made in putting together that series of seminars continue to inform how we understand the disciplines they addressed. The Drama Seminar of 1956 discussed theatre in India, making recommendations that would filter into state policy on theatre, and the creation of institutional frameworks and support structures. In 2008, the India Theatre Forum planned an event to commemorate, and also interrogate, the Drama Seminar on its fiftieth anniversary. In signalling the impossibility of putting together a 'national' seminar, they instead called their gathering 'Not the Drama Seminar'. See Akshara K.V.'s 'Not the Keynote Address' in this volume.

Tawaif

Female courtesan and entertainer in north India, often hailing from hereditary communities of performers. *Tawaif*s performed in salons or for private gatherings, and took on patrons. Many **bar dancers** were their descendants, and the ban on bar dancing in Maharashtra, a hub for dance bars, mirrored a similar reaction to *tawaif*s and their position as female performers and public figures in the early twentieth century. See the Lata Mangeshkar debate reproduced in this volume – the arc of essays by Sanjay Srivastava, Ashwini Deshpande and Lakshmi Subramanian.

Thumri

A genre of Hindustani music with several gharanas. A thumri is a romantic composition and the male protagonist is usually understood to be Krishna, even though he is rarely identified by that name. This was a staple form in the music of **Parsee Theatre**.

Tribal dance practices

Reference to autochthonous performance practices across the subcontinent. The term tribal, or *adivasi* (original inhabitant), has had a complex career in India. Criminalized during colonialism, for example, under the Criminal Tribes Acts of the 1870s, it has been a significant political presence in several uprisings across the subcontinent in the colonial period as well as after Independence, becoming an enduring and potent signifier for many things over the modern era. However, the concept, in ostensibly referencing practices of tribes or distinct communities, conflates a wide range of performance practices under a single umbrella, where the lack of specific detail renders them indistinguishable from each other. Forms that are individually identified receive more recognition and more institutional support. Alongside 'tribal', 'folk' is another common term used to denote the practices of 'common', often rural, inhabitants. See Chandralekha's essay, 'Militant Traditions of Indian Dance', in this volume.

Varna system

The Hindu class hierarchy which segregated Hindus into caste-based occupational categories — Brahmins, Kshatriyas (the military class), Vaishyas (traders and merchants) and Shudras. Notionally, all Indian citizens have equal access to opportunities for education, employment and advancement; their class position, however, can continue to

define their access to economic, social
and political mobility. Also see **Dalit**.

Yoga
A set of physical and philosophical
frameworks. As a physical practice,
two of eight components of yoga are
foregrounded – *asana* (postures) and
pranayama (breath work). Various schools
of yoga exist, and each specifies a set of
philosophical moorings and sequences
for physical practice. One such school,
mentioned by Padmini Chettur in 'The
Body Laboratory', is Iyengar Yoga, named
after B.K.S. Iyengar. Also see Navtej
Johar's 'True to The Bone' in this volume.

NOTES & REFERENCES

Introduction

1 See Keywords for more on Section 377.

2 See Keywords for more on hijras.

3 Or *parens patriae*. See Ashish Rajadhyaksha, ed., *The Hunger of the Republic: Our Present in Retrospect*, India Since the 90s #1, New Delhi: Tulika Books, 2021, p. vi.

4 A 'throwback to', also 'Throwback Thursday'.

5 Chandralekha, quoted in Ein Lall's *Sharira* (Public Service Broadcasting Trust, 2003).

6 See Akademi in Keywords.

7 *Mile sur mera tumhara* (When our tunes merge) is a prominent example. Promoted by Doordarshan, it was premiered after Prime Minister Rajiv Gandhi's address on 15 August 1988, India's forty-first Independence Day. The video featured several renowned artists, film actors and sportspeople, and was shot at locations across India. It was frequently played on national television in the decade following its release.

8 'Migrant Crisis: Some Workers "Lost Patience" and started walking, claims Amit Shah', *Scroll.in*, 2 June 2020, https://scroll.in/latest/963558/migrant-crisis-some-workers-lost-patience-and-started-walking-claims-amit-shah.

9 Amitav Ghosh, *Gun Island*, London: Hamish Hamilton, Kindle Edition, 2019.

10 Tabassum Fatima Hashmi (b. 1971), known by the mononym 'Tabu'.

11 Andre Lepecki, *Singularities: Dance in the Age of Performance*, London and New York: Routledge, Kindle Edition, 2016.

12 Ibid.

13 R.K. Narayan, *Malgudi Days* (Marathi), Aurangabad: Saket Prakashan, Kindle Edition, 2019; first English edition, Mysuru: Indian Thought Publications, 1943.

14 Sandra Reeve, *Nine Ways of Seeing*, Devon: Triarchy Press, 2011, pp. 47–51.

15 WWF: formerly World Wrestling Federation; since 2002, rebranded as World Wrestling Entertainment.

16 Actor and model Sushmita Sen was the first Indian contestant to win the Miss Universe title.

17 See Keywords for more on Kabir Kala Manch.

18 See Keywords for more on kathak.

19 Cleverbot, www.cleverbot.com, accessed 1 July 2020.
20 See Keywords for more on Aadhaar.

1 | Chandralekha

1 Walter Benjamin, 'The Work of Art in the Age of Mechanical Reproduction', in *Illuminations: Essays and Reflections*, New York: Schocken Books, 1969.

2 **Editor's note:** Semas, Changs, Rengmas, Maos, Aos and Konyaks are Naga tribes based in North East India, primarily Nagaland, and north-western Myanmar. Detailed references to Indian tribal and folk dances are available in Kapila Vatsyayan, *Traditions of Indian Folk Dance*, New Delhi: Indian Book Company, 1976. The term 'Naga' is an exonym from the colonial period, used to refer to a group of isolated tribes, many of whom did not necessarily identify themselves with it. The Indian Constitution accorded Naga tribes the status of 'Scheduled Tribes'. While this status made affirmative action possible, it has also alienated them. In 2019, India's Tribal Affairs Ministry began listing Arunachal Pradesh's Naga tribes by their individual tribe names, making it harder for them to claim a common Naga identity, and thus also harder to claim either greater political representation or separate statehood.

3 **Editor's note:** Raibenshe, dhali, paik (or paika), gotipua, garuda vahanam are forms of martial movement from Bengal and Odisha. Chhau dance: see Keywords. Later in the essay the author points out that the word 'paika' means infantry, adding that '*paika* soldiers were highly trained artistes who were used for facing external aggression. . . . their battle dances are still preserved by their descendants in the Puri district in Orissa'. Martial dance was often used as training exercises for warriors. Most Indian regions have several martial movement practices that share a vocabulary – such as leaps, spins and expansive movements. These inflections often stem from daily life – e.g. in chhau, which incorporates movements drawn from household chores, such as pounding grain and sweeping the floor, or animal-inspired movements, such as *gomutra chanda*, the trailing movement of a urinating cow. *Garuda vahanam* is one such narrative resource drawing from the mythological tale of the eagle, Garuda. Odisha's gotipua dance is a practice involving pre-pubescent and adolescent boys attired as women dancing rhythmic compositions, mythological narratives and acrobatic pieces. Gotipua and Mayurbhanj chhau share with Odissi the use of the *tribhanga* (three-bend) position, where the body is curved at the knees, waist and neck, allowing the dancer to create an asymmetrical curvature by shifting her weight to one side of the body.

4 **Editor's note:** Kolattam, daand, pulavarkali, velakali – dances that use props such as sticks or swords – often emerge from practices that prepare the body for armed combat, but these may also be social dances. Kerala's velakali is a martial dance performed with swords and shields. Kolattam and dances like Gujarat's dandiya are social dances where dancers use sticks to maintain a rhythm and create complex patterns of movement.

5 **Editor's note:** Gonds and Bhils are tribes who live across central India. The Maria Gonds (referred to as Bastar Maria here) live in Chhattisgarh's Bastar region and the districts of Chandrapur and Gadchiroli in Maharashtra. Irulas are a tribe in the southern state of Tamil Nadu. All of these hold the Indian Constitution's Scheduled Tribe status. The Gonds and Bhils have been marginalized by the loss of land, forests and livelihoods to mining and other industrial activities that have made no space for them while depriving them of traditional economic and social moorings. Their understanding of land and natural resources as community-owned is illegible to the capitalist enterprises that gain access to these resources. Marginalized communities are also particularly hit by natural disasters and don't receive adequate access to welfare. The Irulas bore the brunt of the 2004 Indian Ocean tsunami. Often, since they do not have ration cards or identity documents, or the stability to apply for these documents, they are unable to apply for and benefit from welfare schemes. The dances of these tribes remain in circulation on an eclectic menu of 'folk culture', but these do not translate into proportional levels of representation for members of the tribes as citizens of a welfare state.

6 **Editor's note:** Akhada, kalari are spaces for practising martial arts, precursors of the modern gymnasium. In some traditional physical practices, the *akhada* serves as a conduit to modern forms of sport. The *kusti* (wrestling) *akhada*s produce body-builders and wrestlers trained in competitive forms of the sport practised internationally. Malkhamb gymnasts, who practise using a pole and a rope, make easy transitions

to the Olympic discipline of artistic gymnastics and to performing on aerial silks – long swathes of silken cloth suspended from a height. These spaces often combine sport and medicine. The *kalari*, for instance, is also a medical facility, with people visiting to find treatments and remedies for illnesses, medical conditions and mobility issues. For more on kalaripayattu, see Keywords.

7 **Editor's note:** *Lasya*, *tandava* are concepts of feminine and masculine energy in dance, associated with the mythological figures of Parvati and Siva. In dance performance, *lasya* is often associated with grace, fluidity and softness, while *tandava* is viewed as vigorous and bursting with destructive or explosive potential.

8 **Editor's note:** Pandya dynasties ruled what is now modern-day Tamil Nadu at several points in time, with the earliest records of their reign dating back to 4 CE. The silamban warriors correspond to the medieval Pandya dynasties, who ruled different parts of south India from 10–14 CE.

9 **Editor's note on chhau, paika, kathakali, *kalari*:** See endnote 3 and Keywords.

2 I Navtej Johar

1 **Editor's note:** Vedic chanting: an oral tradition involving the recitation of verses from the Vedas, a series of texts ascribed to 1500–2000 BCE, with a focus on production of a sonic landscape. In Johar's practice, while movement and breath are ways of mapping points in the body, chanting emphasizes ways in which the body can orchestrate states of being to arrive at particular manifestations in sound.

2 **Editor's note:** An enduring ideal in dance is to make and experience movement as 'sapful'. It encourages the practitioner to think of the body as an active mass of experience, vesting all movements with experience.

3 **Editor's note:** When a performance formally presented on a proscenium stage, the audience is seen as receiving and reaping the after-effects of performance. The performer produces and gives, while the viewer receives and responds. In speaking of the performer as a 'farmer of after-effects', Johar's Somatics practice draws attention to what it means to acknowledge and allow the body to respond to the effects of its 'doing'.

3 I Padmini Chettur

1 **Editor's note:** Pandanallur Subbaraya Pillai was a teacher and exponent of the Pandanallur style of bharatanatyam, practised and shaped by his family in a village in Tamil Nadu's Thanjavur district. Pillai's ancestors were members of the Thanjavur Quartet, the mid-nineteenth-century group of bharatanatyam artists who defined the current structure of the bharatanatyam repertoire or *margam*.

2 **Editor's note:** BITS Pilani, or the Birla Institute of Technology and Science in Pilani, Rajasthan, is a technological university in India, renowned for its engineering programmes.

3 *Angika* (1985), choreographed by Chandralekha in an attempt to decipher and recreate the mythical *angika-lipi* – a dance, or rather a collective physical tradition, depicting the everyday life of prehistoric women and men of India.

4 *Lilavati* (1989), choreographed by Chandralekha, based on the playful riddles in Bhaskaracharya's tenth-century mathematics text of the same name.

5 **Editor's note:** E.P. Vasu Gurukkal was a renowned practitioner of the northern kalaripayattu style.

6 *Praana* (1990), choreographed by Chandralekha, exploring the interrelation of body, breath and planetary movements.

7 *Sri* (1991), choreographed by Chandralekha, a chronology of the women's movement depicting enslavement and empowerment.

8 *Sharira* (2003), choreographed by Chandralekha, celebrating the freedom of the body. This was her last choreography.

9 With light designed by Jan Maertens, collaboration on text with Vivek Narayanan that required all the dancers to be close-miked, and sound score by Maarten Visser that was an integral part of the premise of

the work, exploring how the acceleration or deceleration of time could be felt in the body and how it could visibly create a sense of changing movement qualities.

10 *Der Standard*, 2009.

4 | Natasha Ginwala

1 Nikki Giovanni, 'Ego-tripping (There May Be A Reason Why)', in *The Women and the Men*, New York: Harper Perennial, 1979.

2 'Mass protests in Poland Against Tightening of Abortion Law', *The Guardian*, 23 March 2018, available at https://www.theguardian.com/world/2018/mar/23/abortion-poland-mass-protests-against-tightening-of-law, accessed 10 September 2018.

3 Frantz Fanon, *Black Skin, White Masks*, London: Pluto Press, reprint, 1967, p. 229.

4 Stefano Harney and Fred Moten, 'Policy and Planning', *Social Text*, Fall 2009, p. 185.

5 See Michel Foucault, *Discipline and Punish: The Birth of the Prison*, Ringwood, Victoria: Penguin Books, reprint, 1977.

6 Verónica Gago, 'Witchtales: An Interview with Silvia Federici', *Viewpoint Magazine*, 15 April 2015, available at https://www.viewpointmag.com/2015/04/15/witchtales-an-in terview-with-silvia-federici/, accessed 10 September 2018.

7 See https://de.labournet.tv/caliban-und-die-hexe, accessed 10 September 2018.

8 Sutapa Chattopadhyay, 'Caliban and the Witch and Wider Bodily Geographies', *Gender, Place & Culture: A Journal of Feminist Geography*, 24, 2017, pp. 160–73.

9 Foucault, *Discipline and Punish*, p. 137.

10 Angela King, 'The Prisoner of Gender: Foucault and the Disciplining of the Female Body', *Journal of International Women's Studies*, vol. 5, no. 2, March 2004, p. 30.

11 Ethan H. Shagan, *The Rule of Moderation: Violence, Religion and the Politics of Restraint in Early Modern England*, Cambridge: Cambridge University Press, 2011, p. 65.

12 Shagan, *The Rule of Moderation*, p. 65.

13 Emily Dickinson, *The Complete Poems of Emily Dickinson*, Boston: Little, Brown and Company, 1924.

14 See https://www.youtube.com/watch?v=iUcApaxrSqs&index=19&list=PLQAzCmbFRB02DZ1UcJIA DjNWQGWObplu, accessed 10 September 2018.

15 Helene Cixous, 'The Laugh of the Medusa', in Elaine Marks and Isabella de Courtivroin, eds, *New French Feminisms*, Amherst, Massachusetts: University of Massachusetts Press, 1980, p. 252.

16 Ibid.

17 Luce Irigaray, *This Sex Which Is Not One*, Ithaca, NY: Cornell University Press, 1985, p. 163.

18 Jacqueline A. Bussie, *The Laughter of the Oppressed: Ethical and Theological Resistance in Wiesel, Morrison, and Endo*, London: T & T Clark, 2007, p. 167.

19 Ibid., p. 169.

20 'Revolutionary Hope: A Conversation between James Baldwin and Audre Lorde', originally published in *Essence Magazine*, 1984, available at http://mocada-museum.tumblr.com/post/73421979421/revolutionary-hope-a-conversation-between-james, accessed 10 September 2018.

21 'Sri Lanka Reimposes Ban on Women Buying Alcohol Days After It Was Lifted', *The Guardian*, 14 January 2018, available at https://www.theguardian.com/ world/2018/jan/15/sri-lanka- reimposes-ban-on-women-buying-alcohol-days-after-it- was- lifted, accessed 10 September 2018.

22 See https://www.facebook.com/groups/lkafeministconversations/, accessed 10 September 2018.

23 I'm also referring here to Ovul Durmusoglu's presentation, 'Who Will Love Us to The End of Time?', as part of the *Speaking Feminisms* series curated by Elena Agudio, Federica Bueti and Nathalie Anguezomo Mba Bikoro at SAVVY Contemporary, 15 November 2016; https://savvy-contemporary.com/en/events/2016/who-will-love-us-to-the-end-of-time/, accessed 10 September 2018.

24 Safiya Sinclair, 'How to be a More Interesting Woman: A Political Guide for the Poetess', in *Cannibal*, University of Nebraska Press, 2016.

25 Audre Lorde, 'Uses of the Erotic as Power' in *Sister Outsider*, Berkeley: The Crossing Press, 1984.

26 Ibid., p. 341.

27 **Editor's note:** See Chandralekha's 'Militant Origins of Indian Dance' in this volume.

28 Rustom Bharucha, *Chandralekha: Woman, Dance, Resistance*, New Delhi: Indus, 1995.

29 **Editor's note:** *Sharira* was Chandralekha's last work, made in 2000 and subsequently revised until 2003. In Ein Lall's eponymous documentary, Chandralekha asks, 'Where does the body begin? And where does it end?' *Sharira*, in its exploration of feminine energy, one that offers space for sexuality, sensuality and spirituality, takes these questions by the horns. The two performers create and sustain a field of energy using a delicately orchestrated web of movement and gaze to hold together and amplify this force field. See https://www.youtube.com/watch?v=OXCc10lBklw.

30 Ananya Chatterjea, *Butting Out: Reading Resistive Choreographies through Works by Jawole Willa Jo Zollar and Chandralekha*, Middletown: Wesleyan University Press, 2004.

31 **Editor's note:** See Padmini Chettur's 'The Body Laboratory' in this volume. Kalaripayattu: see Keywords.

32 **Editor's note:** *Dhrupad:* north Indian classical music form known for its aesthetic minimalism and slow tempo. See Keywords for more. *Aalaap:* In Dhrupad, the *aalaap* is a measured and elaborate section of the composition. The Gundecha Brothers, prominent exponents of the form, sing an *aalaap* through the duration of *Sharira*, staying in the slow *vilambit* tempo for a long time, making the musical landscape a stable foundation for the performers to use as a basis for their work.

33 Malini Nair, 'The Rediscovery of Chandralekha, the Dancer Who Didn't Want a Legacy,' *Scroll.in*, 30 December 2016, https://scroll.in/magazine/825457/the-rediscovery-of-chandralekha-the-dancer-who-didnt-want-a-legacy, accessed 10 September 2018.

34 Tishani Doshi, 'Remembering Chandralekha on Her 11th Death Anniversary,' *The Hindu*, 30 December 2017, available at http://www.thehindu.com/entertainment/art/remembering-chandralekha-being-a-dancer-on-loneliness-and-a-cockroach-wing/article22326530.ece, accessed 10 September 2018.

35 Tishani Doshi, email conversation with the author, 17 May 2018. **Editor's note:** The dualist, independent and oppositional principles of masculine/feminine energy, *purusha/prakriti, Shiva/Shakti* or *lingam/yoni*, constitute the philosophical moorings of many spiritual and movement practices, where interdependent realities intersect yet remain at odds with each other. In conventional understandings, the *purusha, Shiva* or *lingam* might be viewed as the masculine principle, spirit, the universal consciousness, while *prakriti, Shakti* and *yoni* constitute the feminine principle, representing matter and *doing*.

36 Hélène Cixous, 'The Laugh of the Medusa', *Signs*, vol. 1, no. 4, Summer 1976, pp. 875–93.

37 Stefano Harney and Fred Moten, *The Undercommons: Fugitive Planning and Black Study*, Wivenhoe, New York, Port Watson: Minor Compositions, 2003.

38 Paula Erizanu and Lewis Gordon, 'A Black Existentialist Response to Kanye West,' *IAI News*, 8 May 2018, available at https://iainews.iai.tv/artic les/kanye-west-from-freedom-to-license-auid-1083, accessed 10 September 2018.

39 Haroon Moghul, 'It's Ludicrous that Tony Blair and the West Still Refuse to Apologize for the Iraq Debacle', *Quartz*, 8 July 2016, available at https://qz.com/726104/its-ludicrous-that-tony-blair-and- the-west-still-refuse-to-apologize-for-their-iraq-debacle/

40 Alex Ward, 'Chelsea Manning on Why She Leaked Classified Intel: "I have a responsibility to the public"', *Vox*, 9 June 2017, available at https://www.vox.com/2017/6/9/15768216/chelsea-manning-interview-abc-news, accessed 10 September 2018.

41 bell hooks, 'Choosing the Margin as a Space of Radical Openness,' *Framework: The Journal of Cinema and Media*, 36, 1989, pp. 15–23.

42 Denise Ferreira da Silva, 'Hacking the Subject: Black Feminism and Refusal Beyond the Limits of Critique', *philoSOPHIA*, vol. 8, no. 1, Winter 2018, pp. 19–41.

43 Pierre Chaillan, 'Thinking in Alliance: An Interview with Judith Butler', Verso Blog, 2 April 2018, https://www.versobooks.com/blogs/3718-thinking-in-alliance-an-interview-with-judith-butler, accessed 10 September 2018.

44 Lorde, *Sister Outsider*.

5 | Danish Sheikh

1 **Editor's note:** Non-governmental organizations (NGOs) are often registered as charitable trusts or societies under Indian law and receive tax benefits. They can apply for FCRA (Foreign Contribution Regulation Act) clearance to receive funding from international donors. While NGOs sometimes complement services or schemes set up by the government, they often create support structures from scratch in areas previously left unaddressed by the government, and, as in the case of Section 377, work towards securing the fundamental rights of the people they advocate for by seeking legal or constitutional reforms. For work of this nature, many NGOs rely on international funding. However, clearance to receive such funding is hard-won, and requires frequent renewals, subjecting NGOs to the unrelenting moral gaze of the state.

6 | Jana Natya Manch

1 **Editor's note:** Jana Natya Manch continues to maintain and reinforce a relationship with Jhandapur. Each year on 1 January it collaborates with CITU to mark Safdar Shahadat Diwas (Safdar's Day of Martyrdom) at a local park in Jhandapur, celebrating the relationship between workers and cultural activists through a programme of performances. Initially starting with plays set in the proscenium but performed in varying locations, Janam became known for its street theatre, which it made starting 1978, addressing burning social, cultural and political issues in performance, and taking this to large numbers of people.

2 **Editor's note:** Rama, Janaka are characters in the epic Ramayana where Rama marries Janaka's daughter Sita.

3 **Editor's note:** *Wala* is a possessive term used to denote belonging or affiliation in Hindi and Hindustani. For instance, CITU-*walas* (CITU folk/members).

4 **Editor's note:** Both ESMA and NSA are Acts that have been used to target striking workers, quashing resistance and dissent on the pretext that it is illegal for workers providing 'essential services' to stop work. This strips them of the right to stage sustained resistance in order to advocate better working conditions and fairer wages, among other demands.

7 | Orijit Sen

1 **Editor's note:** Rohith Vemula was a PhD scholar at the University of Hyderabad. Six months prior to his death, the university unfairly started withholding his stipend, eventually taking a decision to suspend him. Vemula was a member of a student group, the Ambedkar Students' Association (ASA). Despite no evidence to that end, he was accused of having attacked a member of the Akhil Bharatiya Vidyarthi Parishad (ABVP), the student wing of India's ruling Bharatiya Janata Party (BJP). On 17 January 2016, having had his academic career systematically extinguished by the university administration, he died by suicide, using an ASA banner to hang himself.

8 | Sharmila Rege

1 Bharat Itihas Sanshodhak Mandal Pune collections, nos. 311 (5) and 286.

2 G. Morje, *Marathi Lavani Vangmay* (Marathi), Pune: Moghe Prakashan, 1974. Some scholars have traced it to the Domb and Matangi songs performed by the women of these castes. See M. Dhond, *Marathi Lavani* (Marathi), Mumbai: Mauj Prakashan, 1988. **Editor's note:** The Dombs (also known as Doms) are a nomadic community with a presence across several regions in India. The Matangs or Mangs mainly live in Maharashtra. Members of both groups identify as Dalit.

3 **Editor's note:** The Marathi poet and religious figure Dnyaneshwar authored *Dnyaneshwari* (also known as *Jnaneshwari*), a commentary on the Sanskrit text *Bhagavad Gita*, dated to 1290 CE.

4 Journals such as the *Vividhyanvistar, Nibhandhamala* and *Kavyaitihas Sangraha*. **Editor's note:** These mid-nineteenth-century journals often published collections of powadas. *Nibandhamala* and *Kavyaitihas Sangraha* were published by Vishnushastri Chiplunkar (see endnote 7 below), who also set up several journals and newspapers independently and with other collaborators. These include the Marathi newspaper *Kesari* and the English newspaper *Mahratta* (an anglicization of Maratha), set up by Indian nationalist Bal Gangadhar Tilak (1856–1920) and educationist and reformer Gopal Ganesh Agarkar (1856–1885).

5 Anonymous, *Ballads of the Marathas*, Bombay: Shaligram and Acworth, 1890.

6 R. O'Hanlon, *Caste, Conflict and Ideology: Mahatma Jotirao Phule and Low Caste Protest in Nineteenth-Century Western India*, London: Cambridge University Press, 1985.

7 **Editor's note:** Vishnushastri Chiplunkar (1850–82), major Marathi essayist and author, a commentator on the Marathi language, and key figure in defining literary modernism in Marathi.

8 Y. Kelkar, *Marathi Shahir ani Vangmay* (Marathi), Pune: University of Pune, 1974.

9 P. Gavali, *Peshwekaleen Gulamgiri va Asprushta* (Marathi), Kolhapur: Prachar Prakashan, 1981.

10 R. Oturkar, *Peshwekaleen Samajeek va Aarthik Patrvyavhar* (Marathi), Mumbai: Mumbai Vidyapeeth, 1950.

11 Gavali, *Peshwekaleen Gulamgiri va Asprushta*.

12 H. Fukazawa, *Medieval Deccan: Peasants, Social Systems and Status, 1600–1900*, Delhi: Oxford University Press, 1991.

13 U. Chakravarti, *Rewriting History: The Life and Times of Pandita Ramabai*, New Delhi: Kali for Women, 1998.

14 Y. Kelkar, ed., *Andharatil Lavanya* (Marathi), Pune: Thokar Prakashan,1956, pp. 18, 41, 141, 155, 165, 177–78, 189, 249. **Editor's note:** Literally, 'Lavanis of the Dark'.

15 Kelkar, *Marathi Shahir ani Vangmay*, p. 23.

16 S. Varde, *Marathi Kavitecha Ushak Kal* (Marathi), Mumbai: Mumbai Marathi Sahitya Sangh, 1930.

17 **Editor's note:** Shahir Anantaphandi: major eighteenth-century poet-performer, one of the most popular literary figures of his time, and confidante of Bajirao II, the last Peshwa (1795–1818) of the Maratha empire.

18 O'Hanlon, *Caste, Conflict and Ideology*, pp. 164–86. **Editor's note:** The first account, by Jyotirao Phule, presented Shivaji as the leader of Maharashtra's lower castes, with the Shudra and ati-Shudra armies ensuring the creation of the Maratha state as opposed to Shivaji's Brahmin ministers, thus, as O'Hanlon points out, framing the lower castes as the 'rightful leaders of Maharashtrian society and the representatives of its traditions'. The second account, by the reformer Rajaramshastri Bhagwat, saw Shivaji's Maharashtra as a cohesive community with all citizens working towards the betterment of the state, untroubled by social or religious conflict. Hinduism may have been the basis of this identity, but it was the idea of the Marathas – those who were 'brothers in language, country, and religion', in Bhagwat's words – that this account foregrounded. The third account, Eknath Annaji Joshi's powada, O'Hanlon notes, 'presented Shivaji as the saviour of orthodox Hinduism from the threat of Islam', also speaking of the threat that western influences posed to Hinduism.

19 G. Omvedt, *Cultural Revolt in a Colonial Society*, Mumbai: Scientific Socialist Education Trust, 1976.

20 **Editor's note:** Jyotirao Phule (1827–1890): greatly influential and pioneering anti-caste social activist and reformer in Maharashtra, defining most of the terms of caste in the region and across India. Major influence on political history since (e.g. on B.R. Ambedkar), and on the cultural history of the region. Founder of the social organization Satyashodhak Samaj (started in 1873), which advocated for greater educational, social and political freedoms for women and Dalits. Married to author, social reformer and educationist Savitribai Phule, with whom he started a girls' school in Pune in 1848.

21 Y.D. Phadke, ed., *Mahatma Phule Samagrya Vangmay* (Marathi), Mumbai: Maharashtra Rajya Sahitya aani Sanskriti Mandal, 1991. **Editor's note:** *Mang, Mahar, Mali, Kunbi*: The Mangs or Matangs are a caste group in Maharashtra traditionally associated with village security and craft-based practices such as rope- and broom-making. Mahars were associated with village security (and thus later with the military), also as sweepers or messengers. Several major literary and political figures in modern Maharashtra are from this community, most famously B.R. Ambedkar. Kunbi is an umbrella term for a range of caste groups working in

agriculture. Kunbi are mostly coastal, and sometimes conflated with Maratha on economic status. Malis were traditionally gardeners, florists and cultivators. Mangs and Mahars are recognized as Scheduled Castes, while Kunbis and Malis are part of the OBC (Other Backward Classes) list in the Constitution of India.

22 G. A. Duff, *History of the Marathas*, London: Oxford University Press, 1921.

23 **Editor's note:** Dadaji Kondadev: credited as the Maratha king Shivaji's tutor in many historical accounts. The caste politics of this relationship continues to play out in the twenty-first century, with Kondadev, a Brahmin, having been seen as guiding a Maratha king. In 2008, following protests by Maratha groups, the Maharashtra government renamed the Dadaji Kondadev Award, given to coaches of successful sportspeople. Ramdas: poet and philosopher, also viewed as Shivaji's spiritual adviser and guiding figure in Shivaji's legacy after his death.

24 O'Hanlon, *Caste, Conflict and Ideology*, pp. 164–86.

25 Eknath Annaji Joshi, *The Advice Given to Maharaja Shivaji by Dadaji Kondadev* (Marathi), Bombay, 1877.

26 **Editor's note:** Narasimha: mythological character, half-man and half-lion, one of the incarnations of the god Vishnu.

27 **Editor's note:** The 1802 Treaty of Bassein (Vasai) was a pact signed between the British East India Company and Bajirao II, the Maratha Peshwa of Pune, finally bringing the Maratha empire under colonial control. The treaty officially made the Marathas 'clients' of the British, and while Bajirao II was reinstated as Peshwa by the East India Company in 1803, he was essentially a puppet monarch.

28 **Editor's note:** Vishnudas Bhave (1819–1901), considered the founder of the modern Marathi theatre when he staged the play *Sita Swayamvar*, depicting the marriage ceremony of Sita, in 1853, in the court of Sangli.

29 *Bombay Times*, 8 March 1853.

30 **Editor's note:** The *stree* (woman) party was a group of male actors who performed female roles on stage. Marking a distinct shift from the public presence of women performers from hereditary performance communities, the new and sanitized Marathi theatre, aimed at the middle class, did not employ women as performers, choosing to have men play female roles. Over time, several male actors would become immensely popular for their female characterizations on stage, such as Narayan Shripad Rajhans, better known as Bal Gandharva (1888–1967), a Marathi actor who shaped and modelled an ideal femininity for the early twentieth-century upper-caste Hindu women in Maharashtra.

31 N. Adharkar, 'In Search of Women in the History of Marathi Theatre, 1843–1933', *Economic and Political Weekly*, vol. 43, no. 26, 1991, pp. 87–90.

32 **Editor's note:** A caste panchayat is a caste-specific body of village elders, an informal body (as opposed to the gram panchayat which is an official body allowing for local governance), often led by men, who adjudicate issues that involve members of their caste.

33 S. Hall, 'Notes on Deconstructing the Popular', in R. Samuel, ed., *People's History and Socialist Theory*, London: Routledge and Kegan Paul, 1981, pp. 22–40.

34 R. Chandavarkar, *Imperial Power and Popular Politics*, London: Cambridge University Press, 1998.

35 **Editor's note:** Raw film stock was imported into India. In 1943, the British government began rationing raw stock. Access to stock was competitive and producers could only make a limited number of films per year. These restrictions continued to apply to early cinema in independent India, with the government buying film stock against foreign exchange and rationing this out very cautiously. Filmmakers were required to certify an efficient usage ratio for each film in order to petition for stock for their next film.

36 **Editor's note:** *Jai Malhar* (dir. D.S. Ambapkar, Marathi, 1947) and *Lokshahir Ram Joshi* (dir. Baburao Painter and V. Shantaram, Marathi, 1947) were major commercial hits, giving new visibility to the lavani form. *Lokshakir Ram Joshi*, a biographical on an eighteenth-century poet, also starred the major actress and dancer Hansa Wadkar.

37 B. Jintikar (1948), *Shaiv Samachar Tamasha Visheshank* (Marathi), Pune: Ghorpadkar. **Editor's note:** Tamasha performances were banned for a period in the 1940s, even as tamasha-style films became increasingly popular. The ban coincided with a wave of similar prohibitions across the country, including the Madras Devadasis (Prevention of Dedication) Act of 1947, which gave women from hereditary courtesan

dance communities (generally termed devadasis) the legal right to marry, and prohibited attempts to dedicate these women to specific temples or deities. Framed as well-intentioned measures, such legal diktats served to stigmatize the performance practices of the hereditary communities they targeted. As in the case of tamasha, these dancers lost their usual avenues of patronage even as a new generation of middle-class women replaced them. In the case of Madras Presidency, women from high-caste backgrounds now performed bharatanatyam, the classical dance that emerged from sadir, the dance practised by women from hereditary communities. While a few dancers from these communities – Balasaraswati, for instance – continued to have flourishing dance careers, most were relegated to the margins of the dance landscape. As in Maharashtra, some of them chose to move into Tamil and Telugu cinema, but the majority of them lost their livelihoods as a result of the Act. For devadasi and bharatanatyam, see Keywords.

38 J. Khebudkar, *Lavanya Geete* (Songs of Beauty), Pune: Asmita Prakashan, 1980.

39 D. Attwood, *Raising Cane: The Political Economy of Sugar in Western India*, New Delhi: Oxford University Press, 1993; J. Lele, 'Caste, Class and Dominance: Political Mobilization in Maharashtra', in Francine R. Frankel and M.S.A. Rao, eds, *Dominance and State Power in Modern India: Decline of a Social Order*, New Delhi: Oxford University Press, 1990. **Editor's note:** Sugar lobby: Class of political elites in Maharashtra who rose to both regional and national prominence following the founding of sugar cooperatives across the state. Members and leaders of these cooperatives, often the new rich, were often involved in local politics, and with time, they garnered significant political clout in Maharashtra, leveraging this to seek special concessions and more political access.

40 **Editor's note:** The use of metaphors to describe the woman as sexual being often translated to the use of metaphors that drew on common local references. For instance, in the song 'Amba Totapuri' (totapuri, or parrot-faced, is a widely grown mango variety), written by major Marathi film lyricist Jagdish Khebudkar and used in the film *Maayechi Sawali* (Mother's Shade, dir: Prakash Devle, Marathi, 1994), the dancer exhorts her audience to come get their totapuri mango, a metaphor for her sexual availability. In another song, 'Tujhya Usala Lagal Kolha', sung by Sulochana Chavan for a 1965 album, the sugarcane field with its ripe cane serves as a reference to puberty. The field is ripe and ready for theft, the singer warns. It already bears the marks left by a previous thief and now a wolf prowls, waiting for its chance to attack.

41 L. Joshi, *Marathi Vishvakosh*, vol. 7 (Marathi), Mumbai: Maharashtra Rajya Sahitya Sanskriti Mandal, 1977, p. 164.

42 **Editor's note:** Satyashodhak Samaj: literally, truth-seekers' society.

43 These issues came to be debated in newspapers like *Dinbandhu, Vijayi Maratha, Kaivari* and *Deccan Rayat.*

44 V. Shinde, *Shahiri Vangmayachya Dhara* (Marathi), Kolhapur: Pratima Prakashan, 1996.

45 **Editor's note:** Gavlan, a performative idiom described in the essay. The *gavlan* usually focuses on Krishna, another incarnation of Vishnu, who is at the centre of several amorous narratives in mythology and literature across several Indian languages. Growing up in a pastoral setting, most of Krishna's encounters with milkmaids are of a mischievous nature. He steals butter from them, breaks their pots and hides their clothes while they are bathing, harassing them as a means of demonstrating desire. The milkmaids or *gopis*, as they are known, treat Krishna's overtures with exasperation and anger, but also reciprocate his desire on certain occasions, often doing so outside of their own marriages to other men.

46 Omvedt, *Cultural Revolt in a Colonial Society.*

47 The organizers of the jalsa, Vichari and Anandswami, were also the major organizers of the tenant rebellion. **Editor's note:** In the 1920s, tenant farmers who farmed land owned by Brahmins, paying the owners a share of the crop, began to protest the large shares demanded by the landowners. Often, the landowners would take two-thirds to three-fourths of the crop, with the remaining crop sold to cover debts incurred for agricultural supplies. The moneylenders to whom these debts were owed were mostly landowners themselves. After conferences by the Satyashodhak Samaj, large numbers of sharecroppers began to resist these mechanisms over a period of several years. As Gail Omvedt notes in 'The Satyashodhak Samaj and Peasant Agitation' (*Economic and Political Weekly*, vol. 8, no. 44, 3 November 1973, pp. 1971–82), while the rebellion spurred by the Satyashodhak Samaj in Satara did succeed in improving conditions for tenants and enabling non-Brahmin unity, it stopped short of overhauling the rural class structure.

48 **Editor's note:** When their husbands died, women, especially those from higher castes, were expected to relinquish all trappings of luxury and vanity, and often, a series of basic freedoms. Having their heads tonsured marked them as widows. While Hindu men might also tonsure their heads after a death in the family, this is usually a temporary sign of bereavement. For the woman, the tonsured head was a more permanent fixture.

49 Chakravarti, *Rewriting History.*

50 **Editor's note:** Rajarshi Shahu Chhatrapati (1874–1922), hereditary prince of the Maratha empire in Kolhapur. Although the throne had become largely ceremonial by the early twentieth century, he was a major social reformer with often radical views on democracy, and a patron of several art forms, including theatre, music and the cinema, making the city of Kolhapur a major centre for art under his reign.

51 A detailed analysis of the same has been done in 'Contesting Claims to the Public: The Ganesha Festival and Chatrapati Melas', a paper read at a workshop on 'Popular Culture' organized by the Vikas Adhyayan Kendra, Pune, March 1999. This was published in *Sociological Bulletin*, vol. 49, no. 2, September 2000.

52 K. Kirwale, *Ambedkari Shahiri: Ek Shodh* (Marathi), Pune: Nalanda Prakashan, 1992.

53 **Editor's note:** Patthe Bapurao was a tamasha singer and poet who worked with performers (including women) from hereditary communities. In framing these women as victims without accounting for their agency, the modern Indian state took a moral position that deprived them of their livelihoods without accounting for the systems and networks within which they functioned, where performative and sexual labour were viewed and negotiated differently.

54 **Editor's note:** Samyukta Maharashtra movement (movement for a United Maharashtra) – a political movement for Marathi nationalism that culminated in the formation of the state of Maharashtra in 1961; also a leading force in making the city of Bombay its capital.

55 Shahir Amar Shaikh, Shahir Annabhau Sathe and Shahir Gavankar represent the trends in the Communist tradition, Lokshahir Vaman Kardak represents the Ambedkari Dalit trend, while Shahir Vasant Bapat represents the socialist trend. **Editor's note:** Amar Shaikh, Annabhau Sathe (1920–1969) and D.N. Gavankar were literary figures and members of the Lal Bawta Kalapathak (Red Flag Cultural Squad), the cultural wing of the Communist Party of India. Vaman Kardak (1922–2004): Marathi poet and playwright. Vasant Bapat (1922–2002): Mumbai-based poet and academic.

56 D. Salve, *Teen Shahir: Ek Tulana* (Marathi), Pune: Krantisinh Nana Patil Academy, 1997.

57 B. Jadhav, *He Geet Vamaanache* (Marathi), Ahmednagar: Shramik Prakashan, 1997. **Editor's note:** References the industrial houses of Tata and Birla, prominent Indian business families since the late nineteenth century. 'Tata–Birla' is often used as a colloquial term to signify prodigious wealth.

58 *Annabhau Sathe Samagra Vangmay*, Pune: Pratima Publications, 1999.

59 Salve, *Teen Shahir: Ek Tulana.*

60 **Editor's note:** Samyukta Maharashtra movement versus the working class. Bombay historically has had one of the most important Communist-led working class movements, led by workers of its textile industries. These movements were also the context for the linking of popular culture to radical politics by, for example, Annabhau Sathe and other poet-activists. When the regional campaigns for statehood on the basis of linguistic identity emerged, they were very often ethnicized and targeted against outsiders, e.g. by the anti-Communist Shiv Sena, founded by Bal Thackeray, son of Prabodhankar Thackeray, a major leader of the Samyukta Maharashtra agitations.

61 *Annabhau Sathe Samagra Vangmay.*

62 B. Korde, *Anna Bhau Sathe*, New Delhi: Sahitya Akademi, 1999.

63 V. Bapat, *Shur Mardacha Powada* (Marathi), Pune: Sadhana Prakashan, 1988.

64 Salve, *Teen Shahir: Ek Tulana.*

65 B. Thackeray, *Hindutva: Saar Aani Dhar*, (Collection of speeches in Marathi), Thane: Dimple Prakashan, 1990.

66 J. Wallerstein, 'The National and Universal: Can There Be Such a Thing as World Culture', in A.D. King, ed., *Culture, Globalization and the World-System*, London: Macmillan, 1991.

67 Sharmila Rege, 'The Hegemonic Appropriation of Sexuality: The Case of the Lavani Performers of Maharashtra', *Contributions to Indian Sociology*, vol. 29, no. 1–2, January 1995, pp. 23–38.

68 Sharmila Rege, 'Understanding Popular Culture: The Satyashodhak and Ganesh Mela in Maharashtra', *Sociological Bulletin*, vol. 49, no. 2, 2000, pp. 193–210.

9 | Anna Morcom

1 **Editor's note:** A British-era term for 'dance', from the Hindi *naach*. See Keywords for more.

2 These attitudes are in many ways contradictory, as Flavia Agnes points out ('Hypocritical Morality', *Manushi*, October 2005, available at http://www.indiatogether.org/manushi/issue149/index.htm, last accessed 5 May 2008, and 'The Right to Dance', *Manushi*, July 2006, available at http://indiatogether.org/2006/jul/soc-dancebar.htm, last accessed 5 May 2008). However, with a conflation of women, honour and culture, the violation of women and the violation of culture are one. On the grounds of rights too, as I discuss in the next section, these two arguments serve the same purpose, acting as 'good' and 'bad' cop.

3 Published in *Mid Day* on 13 May 2005.

4 **Editor's note:** R.R. Patil was a politician and key architect of the dance bar ban in 2005 when he was Deputy Chief Minister and Home Minister of Maharashtra (2004–08). In an address to the State Legislative Assembly, his rationale was that 'such performances or dances are giving rise to the exploitation of women', that the government considers them 'derogatory to the dignity of women and is likely to deprave, corrupt or injure the public morality or morals'.

5 In Hindu mythology, Savitri is the wife of Satyavan. Satyavan dies soon after their marriage, but Savitri is so loyal to her husband that she visits the lord of death, Yama, and demands that Satyavan be returned to life. She ultimately manages to persuade Yama.

6 Published in the *Indian Express* on 22 August 2005. **Editor's note:** The Maharashtra State Commission for Women (MSCW) is a statutory body with powers equal to a civil court, whose main focus is the eradication of violence against women. It receives grievances and can requisition public records and invite respondents to provide answers. It also takes public positions on issues, and took a pro-ban position in 2005.

7 The survey report, 'Working Women in Mumbai Bars: Truths Behind the Controversy. Results from Survey among 500 Women Dancers across 50 Bars' (Research Centre for Women's Studies, SNDT Women's University, Mumbai, 2005, p. 9), states that only 25.8 per cent of bar girls were earning between Rs 15,000 and Rs 30,000 per month.

8 **Editor's note:** In linking the social and economic dimensions of women's work, Marxist feminism also calls attention to the sexual division of labour and the place of women's work within the capitalist system, which is what Morcom refers to here. But as the MSCW argued against the commodification of women's bodies, they subscribed to a carceral feminism in refusing to acknowledge women's agency within bar dance, and in their reductive definition of *dignified work* (emphasis added). After the ban, many bar dancers transitioned to sex work. Although prostitution is legal in India, allied activities like soliciting, running a brothel and pimping are not, putting sex workers at greater risk of being harassed or prosecuted in the course of their work.

9 Babu Keshub Chunder Sen, *Opinions on the Nautch Question: Collected and Published by the Punjab Purity Association*, Lahore: New Lyall Press, 1894, pp. 3–5, quoted in Shweta Sachdeva, 'In Search of the Tawa'if in History: Courtesans, Nautch Girls and Celebrity Entertainers in India (1720s–1920s)', PhD dissertation, School of Oriental and African Studies, London, 2008, p. 327.

10 **Editor's note:** Muthulakshmi Reddy (1886–1968) was a medical practitioner and social reformer born into a hereditary courtesan dance community. In 1927, as a member of the Madras Legislative Council, she recommended that the government undertake legislation to end the dedication of young girls to Hindu temples. She argued that the girls being dedicated were not of an age where they could give consent, and that they were then vulnerable to sexual and mental exploitation. She cast the courtesans as victims, pointing out that they were exploited under the guise of tradition and religious belief. They did not have access to health care, and this put them at high risk of sexually transmitted diseases and a range of gynaecological issues. Her recommendation had little to do with their roles as performers; it targeted the systems that profited from their sexual labour. The resolution was passed unanimously by the Legislative Council.

11 Muthulakshmi Reddy, *My Experience as a Legislator*, Madras: Current Thought Press, 1930, p. 56.

12 Ibid., p. 117.

13 *Free Press*, 3 September 2005.

14 Prerana, the most important NGO in the pro-ban lobby which deals with trafficking and prostitution, claimed that they had no moral stance at all (interview, Praveen Patkar, 6 March 2007). Other tropes existed around the harm that bars were deemed to cause: for example, that they were a nexus of criminality, or that since most bar girls came from Bangladesh, bars represented a security threat.

15 In particular, the government itself had issued the liquor and performing licenses and made considerable money from the dance bars. See Agnes, 'Hypocritical Morality', and statements by the Bharatiya Bargirls' Union (BBU) (V. Kale, Bharatiya Bargirls' Union, 'Struggle for the Complete Rehabilitation of Bargirls and Other Hotel Employees', 9 April 2005; and V. Kale, Bharatiya Bargirls' Union, letter to Girija Vyass, Chairperson, National Commission for Women, 16 May 2005).

16 **Editor's note:** The Bharatiya Bargirls' Union (Indian Bargirls' Union) or BBU is an association of women dancers, waitresses and other performers who work in bars and hotels set up by Varsha Kale, one of the key voices advocating the fundamental rights of bar dancers in the wake of the 2005 ban.

17 The letter from the BBU to the National Commission for Women, New Delhi, for example, includes a section on 'caste-class composition of the performers' (V. Kale, Bharatiya Bargirls' Union, letter to Girija Vyass, Chairperson, National Commission for Women, 16 May 2005). Two articles on the ban and a third in an academic publication by Flavia Agnes, the lawyer representing BBU, are almost unique in their clear historicizing of the bar girls. See Flavia Agnes, 'Hypocritical Morality'; 'The Right to Dance' and 'State Control and Sexual Morality: The case of the bar dancers of Mumbai', in Mathew John and Kakarala Sitharamam, eds, *Enculturing Law: New Agendas for Legal Pedagogy*, New Delhi: Tulika Books, 2007. However, the mention is relatively brief since the focus of the articles is legal arguments, and the similarities with anti-nautch are not mentioned.

18 I saw it mentioned in only three out of hundreds of press cuttings, two of those relating to Mahasweta Devi, who supported the bar girls specifically due to their background in performing communities (see, for example, *Asian Age*, 9 September 2009), and one for which I do not have a date or the name of the newspaper. Chaukar mentions performing communities in her paper on bar girls (S. Chaukar, *Problems of Mumbai's Bargirls*, Wadala, Mumbai: Vinay Sahasrabuddhe, 1997, p. 7) . Faleiro also mentions them in her book on bar girls (S. Faleiro, *Beautiful Thing: Inside the Secret World of Bombay's Dance Bars*, New Delhi: Penguin, 2010, pp. 21–22), but does not make the link between the stigmatizing of these communities and curtailing their livelihood from the late nineteenth century and the current stigma and restrictions on their livelihood. An article on a *tawaif* in *Tehelka* (T. Gupta, 'Bring on the dancing girls', *Tehelka*, vol. 6, no. 44, 7 November 2009) mentions the bar girls, citing a short chapter written by myself on the topic (A. Morcom, 'Indian Popular Culture and its "others": Bollywood dance and the anti-*nautch* in twenty-first century global India', in M. Gokulsing and W. Dissanayake, eds, *Popular Culture in a Globalized India*, Oxford and New York: Routledge, 2009, pp. 125–38), the author having contacted (music historian) Katherine Schofield who advised on the entire article and passed on details of my work. *Tehelka* is a distinctly intellectual, leftist news magazine, and this article was exceptional within Indian journalism concerning the bar girls.

19 Anil Thakraney, 'They did not sleep with me, Mr Patil. Four bargirls turn down correspondent Anil Thakraney. Still think dance bars are a front for prostitution, Mr Home Minister?', *Mid Day*, 15 April 2005, pp. 1, 6.

20 Santosh Harhari, 'Our secret probe into dance bars. Mid Day reporter becomes a dancer to find the truth. Mr Home Minister, read this before you change the law', *Mid Day*, 11 April 2005.

21 Ibid.

22 (Prabha) Kotiswaran similarly criticizes the debate on the bar girls for its fixation on the question of whether or not the girls were 'prostitutes'. She argues that the argument carries with it a judgment of 'morally "good" and "bad" female labour, namely, bar dancing and sex work'. She continues: 'This is ironic given their striking sociological similarities and the stigmatization and levels of state abuse inflicted against both' (P. Kotiswaran, 'Labours in vice or virtue? Neo-liberalism, sexual commerce and the case of Indian bar dancing', *Journal of Law and Society*, vol. 37, no. 1, 2010, p. 105). The attempts to prove or disprove the 'prostitution' of bar girls does tend to carry an implicit disapproval of prostitution. Kotiswaran is also correct in pointing out the similarity of bar girls and sex workers. However, this argument fails to take into account history and causality, or the significance of skilled, artistic labour in terms of earning capacity and also sociocultural place.

23 'A radical history of development studies: Individuals, institutions and ideologies' (pp. 1–13), and 'From colonial administration to development studies: A postcolonial critique of the history of development studies' (pp. 47–66), in Uma Kothari, ed., *A Radical History of Development Studies: Individuals, Institutions and Ideologies*, London: Zed Books, 2005.

10 | Sameena Dalwai

1 Maya Pandit, 'Gendered Subalternity and the State', *Economic and Political Weekly*, vol. 48, no. 32, 10 August 2013, pp. 33–38.

2 **Editor's note:** Also see Anna Morcom's 'The Continuation and Repetition of History: The Dance Bar Ban as Anti-Nautch II' in this volume.

3 Flavia Agnes, 'Hypocritical Morality', *Manushi*, no. 149, 20 October 2005, p. 12, available at http://www.indiatogether.manushi/issue149/bardance.htm, accessed on July 2012.

4 Ibid.

5 I conducted my field research in 2009 and interviewed customers, bar owners, bar girls apart from political personalities and action groups that participated in the dance bar debate.

6 **Editor's note:** Bhatu, Bedia, Nat, Deredar: Bhatu is not a formal caste or community name, Anna Morcom writes; it is an umbrella term used to refer to women from hereditary performing and sex work communities, and encompasses women of the Nat, Deredar and Bedia communities. See Anna Morcom, *Courtesans, Bar Girls and Dancing Boys: The Illicit Worlds of Indian Dance*, Gurgaon: Hachette India, 2014, p. 62.

7 Pramila Neelkanth Kunda, 'Bargirls Come, Join the Struggle for Self-respect', *Loksatta*, 17 May 2005.

8 Anupama Rao, *The Caste Question: Dalits and the Politics of Modern India*, London: University of California Press, 2009, p. 235. Rao asserts that caste hegemony is secured in two ways: by regulating caste respectability and by justifying flagrant transgression as a form of upper-caste privilege. So, the sexual economy of caste is doubled – the exchange of women within the caste through the formal closed circuit of respectability and marriage, and the informal circuit of sexual liaisons with women seen as amenable to sexual violation. This 'other' economy of sexual violation/ pleasure equates caste privilege with the availability of lower-caste women as upper-caste property.

9 **Editor's note:** The dance bar ban was positioned as a ruling that would prevent the exploitation of women who worked in bars while saving customers from moral corruption. In the media coverage around the ban, stories of men who spent their money on dancers, while failing to look out for the needs of their families, circulated easily, without particular basis in fact. Introducing the bill in the Maharashtra legislature, the Deputy chief minister and home minister at that time, R.R. Patil, argued that performances in bars had the potential to 'deprave, corrupt or injure the public morality or morals'. See Anna Morcom, in this volume.

10 As per Katherine Butler-Brown, the musician becomes the embodiment of the erotic; music empowered the performer not only to arouse general feelings of love in the listener, but also to make him attach them specifically to the performer. (See Katherine Butler-Brown, 'If Music be the Food of Love: Masculinity and Eroticism in Mughal Mehfil', in Francesca Orsini, ed., *South Asia: A Cultural History*, UK: Cambridge University Press, 2006, pp. 61–86.) The ban on dancing breaks this connection between the bar girls and their customers.

11 Ibid., p. 62.

12 Rajendra Vora uses the term Maratha Rashtra for Maharashtra as the Maratha caste cluster has managed to keep a majority hold on the legislative assembly as well as the Cabinet of the state. From 1967, the Maratha strength in Vidhan Sabha has been in the range of 125 to 140. While they account for 31 per cent of the population, they claim around 45 per cent seats. See Rajendra Vora, 'Maharashtra or Maratha Rashtra?', in Christophe Jaffrelot and Sanjay Kumar, eds, *Rise of Plebeians: The Changing Face of Indian Legislative Assemblies*, New Delhi: Routledge, 2009. **Editor's note:** The Vidhan Sabha is the State Legislative Assembly, the lower house of the bicameral state legislature. In 2018, despite reports that the Maratha community constituted nearly 30 per cent of Maharashtra's total population, the Maharashtra Assembly passed legislation granting reservations to Marathas in educational institutions and for job appointments.

11 I T.M. Krishna

1 **Editor's note:** Refers to her two most prominent film roles, in *Sakuntalai* (dir: Ellis R. Duncan, Tamil, 1940) and *Meera* (dir: Ellis R. Duncan, Tamil, 1945). See endnote 2 below.

2 **Editor's note on Shakuntala, Meera, Tyagaraja, Kabir, Surdas:** The mythological figure Shakuntala lived in a forest, where she encountered and eventually married King Dushyanta. She is the heroine of *Abhijnanasakuntalam* (The Recognition of Shakuntala), ascribed to Kalidasa, a poet who lived around 5 CE. MS played Shakuntala in the 1940 Tamil film, *Sakuntalai*. Tyagaraja was a late eighteenth-/early nineteenth-century Carnatic composer, most popularly remembered for his Telugu *kriti*s (devotional compositions), which featured in many of MS's music albums. MS, like other singers of her generation, sang across several languages. Accordingly, she also sang extensively in northern Indian languages and dialects, singing the poetry of the saint-poets Meera, Surdas and Kabir. Meera and Surdas are both understood to be sixteenth-century Bhakti poets who were devotees of Krishna, another incarnation of Vishnu. In the poetry attributed to her, Meera referred to herself as a *dasi* (servant/devotee) of Krishna. MS's last and most remembered movie role saw her playing Meera in an eponymous film. Kabir was a fifteenth-century Bhakti poet whose mixed Hindu and Muslim upbringing fed into his work as a critique of organized religion.

3 **Editor's note:** Tanjore Balasaraswati (1918–1984) was a renowned artist from a family of hereditary courtesan performers (often identified as devadasis), primarily known for her work in bharatanatyam. A contemporary of Rukmini Devi Arundale, her style of bharatanatyam countered Kalakshetra's stark and sanitized style. See Keywords for more on devadasi and bharatanatyam.

4 **Editor's note:** Jenjooti or Senjurutti, Harikamboji, Shankarabharanam, Bhairavi, Saveri, Begada, Todi, Anandabhairavi and Kharaharapriya are all ragas in the Carnatic system.

5 **Editor's note:** Kalki Krishnamurthy (1899–1954) was an editor of the famous magazine *Ananda Vikatan*, a Tamil weekly founded in Chennai in 1926. His actual name was Ramaswamy Aiyer Krishnamurthy, but he was popularly identified by his pen name, Kalki.

6 **Editor's note:** Chakravarti Rajagopalachari (1878–1982) was a politician, lawyer and historian, member of the Indian National Congress, chief minister of British India's Madras Presidency (a province that included present-day Tamil Nadu, Andhra Pradesh, Telangana, and parts of Odisha, Kerala, Karnataka and the Lakshadweep Islands) between 1937 and 1939. He founded the right-wing Swatantra Party (1959) as a counter to the Nehru-led Congress's socialist ideology, advocating a market-based economy and opposing the Indian government's stance of non-alignment vis-à-vis the major power blocs of the Soviet Union and the United States of America. He also briefly formed the Indian Parliament's largest opposition group in 1967 after the general elections. The Swatantra Party was dissolved in 1974.

7 **Editor's note:** 'Veena' Dhanammal (1867–1938) was an influential Carnatic musician who both sang and played the Saraswati veena. She was also Balasaraswati's grandmother. See endnote 3.

8 T.J.S. George, *M.S. Subbulakshmi: The Definitive Biography*, New Delhi: Aleph, 2016.

9 **Editor's note:** Madurai Pushpavanam was a Carnatic musician who lived and worked in the late nineteenth/early twentieth century, at the same time as MS's mother, Shanmukhavadivu.

10 **Editor's note:** G.N. Balasubramaniam aka GNB (1910–1965) was a Carnatic singer and a major influence on many of his contemporaries, MS included.

11 **Editor's note on Mylapore, Kanjeevaram silk:** Mylapore, an upmarket locality in Chennai, understood to be dominated by a Brahmin, upper-class demographic, is a hub of religious and cultural activity for Brahmin communities. Kanjeevaram silk originates from the neighbouring district and town of Kanchipuram and is one of the most popular, ornate and expensive handloom textiles. It is prominently advertised and sold in Chennai markets.

12 **Editor's note:** *Sakuntalai* (dir. Ellis Duncan, Tamil, 1940). Also see endnote 2.

13 **Editor's note:** *Sevasadanam* (House of Service, dir: K. Subrahmanyam, Tamil, 1938) was MS's debut on the big screen. She played an abused wife who turns to sex work, later shifting gears to run an institution for the children of sex workers. *Sakuntalai* (dir: Ellis R. Duncan, Tamil, 1940) and *Savitri* (dir: Y.V. Rao, Tamil, 1941), both featured MS playing mythological roles, while *Meera* (dir: Ellis R. Duncan, Tamil, 1945), her last and best known film, saw her playing the sixteenth-century poet of the same name.

14 **Editor's note:** Dasara is a ten-day festival during which the goddess is worshipped in different incarnations. In Mysore, the festival ends with the deity of Chamundeshwari being taken in a procession. Musical concerts are organized through the festival, inviting major performers across the country.

15 **Editor's note:** Tulsidas, Nanak and Tukaram were major medieval-era saint-poets from Banaras, Punjab and Maharashtra, respectively.

16 **Editor's note:** Music composed by Rabindranath Tagore and identified as a distinct musical genre.

17 **Editor's note on K.S. Narayanaswamy, Musiri, Semmangudi:** These are all major figures in twentieth-century Carnatic music. K.S. Narayanaswamy (1914–1999) was a veena performer, Musiri Subramania Iyer (1899–1975) and Semmangudi Radhakrishna Srinivasa Iyer (1908–2003) were Carnatic vocalists.

18 **Editor's note:** English lyrics and classical music traditions in India have always had uneasy encounters with each other, coloured by a history of colonial influences on Carnatic and Hindustani music, and the positioning of English as a language crucial to Indian public life and to democracy but one that is firmly outside the sphere of 'traditional' or 'cultural' knowledge.

19 **Editor's note:** Muthuswami Dikshitar (1775–1835) was a composer and musician, one of the three late eighteenth-/early nineteenth-century figures alongside Tyagaraja and Syama Sastri who are considered to have formed Carnatic music.

20 **Editor's note:** *Sangita kalanidhi* (roughly translates as 'musical treasure') is the highest honour bestowed by the Music Academy, and is highly coveted as a kind of entry into the hegemonic hall of fame for Carnatic musicians.

21 **Editor's note:** *Melaragamalika* is a composition by Maha Vaidyanatha Iyer (1844–1893) using all the ragas in the Carnatic *melakarta* system. Carnatic music identifies 72 parent ragas that use all seven notes of the octave in both the ascending and descending scales. Multiple ragas may be grouped under a parent raga. Any artist who could sing this composition would demonstrate his/her grasp of the entire Carnatic system.

22 **Editor's note:** A devotional composition by the saint-poet Meera with which MS was most closely associated, 'Morey to giridhar gopal, doosro na koi' (There is none other than Giridhar Gopal for me), refers to Krishna as *giridhar gopal*, the cowherd *(gopal)* who held the mountain aloft *(giri-dhar)*, after the tale in which Krishna holds the Govardhana mountain aloft on his little finger in order to shelter his village from torrential rains.

23 **Editor's note:** Damal Krishnaswamy (DK) Pattammal (1919–2009) was a renowned vocalist and a contemporary of MS.

24 **Editor's note:** Shankarabharanam is a Carnatic raga that uses all seven notes on the major scale in western music, equivalent to Bilawal *thaat* in the Hindustani raga system. Since it is one of the commonest scales with parallels across musical styles, it is the base for a wide range of work, including music in popular culture. In the classical music world, its ubiquity taints it as being far too common to be performed frequently by renowned artists.

25 **Editor's note:** The third key note of the *swara* scale followed across Carnatic and Hindustani music, which is the equivalent of the note 'mi' in the western solfege system.

26 **Editor's note on T.N. Rajaratnam Pillai, Nagaswaram:** Rajaratnam Pillai (1898–1956) played the *nagaswara*, a double reed wind instrument, and was known for his influential ability for extended improvisation.

27 **Editor's note:** Ariyakudi Ramanuja Iyengar (1890–1967) was a Carnatic vocalist credited with structuring the *katcheri* (concert) format. Discussing the impulses that triggered Ariyakudi's work (in *New Mansions for Music: Performance, Pedagogy and Criticism*, New Delhi: Social Science Press, 2008, p. 48), Lakshmi Subramanian writes: 'Ariyakudi's experiments were, at one level, a creative response to the growing need for a compact concert repertoire that suited the logistic requirements of commercial entertainment as well as the aesthetic parameters being put forward by self-appointed custodians and connoisseurs of music. For Iyengar . . . the selection of the repertoire was indispensable in endorsing the classical potential of the music being performed.'

28 **Editor's note:** K.V. Narayanaswamy (1923–2002) was a Carnatic vocalist and key disciple of Ariyakudi Ramanuja Iyengar.

29 **Editor's note on *mridangam, kanjira, ghatam:*** The *mridangam*, a two-headed drum, the *ghatam*, a ridged clay pot, and the *kanjira*, a flat frame drum from the tambourine family, are all percussion instruments.

30 **Editor's note:** The *kirtana/keerthanam/kriti* is often the central component of a Carnatic music concert, divided into a three-part structure that allows the artist to establish and explore a raga. A *padam* is a devotional composition that may sometimes have erotic overtones. The *javali*, an erotic composition, allows a similar emotional landscape. Both *padams* and *javalis* are used in classical dance performance. A *thillana* is a composition that uses rhythmic syllables instead of words to populate a melodic framework. It is sung and is also used in bharatanatyam performances. A *virutham* is a devotional verse that offers space for melodic improvisation in the absence of a set rhythmic structure. A *varnam* is a compositional form that is often used to open a Carnatic music performance because its structure serves to warm up the singer's voice.

12 I Sanjay Srivastava

1 Another context – Lata's popularity among the recent Indian diaspora – is a project in itself, and might be explored in the context of contemporary imaginings of 'home' and 'tradition'.

2 Rahul Sankrityayan's *ghummakkad* (itinerant) methodology and Michel Foucault's 'genealogical' analyses have, in their different ways, helped me to think about the relationship between discursive and non-discursive realms in a non-teleological manner. See Rahul Sankrityayan, *Ghummakkad Shashtra* (Hindi), Delhi: Kitab Mahal, 1994, first published 1948; Michel Foucault, *Discipline and Punish: The Birth of the Prison*, New York: Vintage Books, 1979; and Michel Foucault, *The History of Sexuality, Volume 1: An Introduction*, London: Penguin, 1990.

3 I am grateful to Moinak Biswas for raising this issue.

4 **Editor's note:** Asha Bhosle (b. 1933), Lata Mangeshkar's sister and equally famous singer, with a similar width of range. Sometimes considered to be a more contemporary, perhaps more 'hip' singer, known for doing playback for sultry cabaret numbers, in collaboration with her husband, the film composer Rahul Dev Burman, known in the 1980s for having transformed Hindi film music with disco, rock and hip-hop influences.

5 Peter Manuel, *Cassette Culture: Popular Music and Technology in Northern India*, Chicago: University of Chicago Press, 1993, p. 267, n10.

6 Ibid., p. 52.

7 Raghava Menon, quoted in Manuel, *Cassette Culture*, p. 53.

8 Chandavarkar, quoted in Manuel, *Cassette Culture*, p. 53.

9 Manuel, *Cassette Culture*, p. 53.

10 The main singers of the *dholi gayikayen* (female singers with drum accompaniment) group whose recording I possess are Jamila Kulsum and Natha Bai. The Dholis are a caste of professional musicians from Rajasthan and commonly perform at Hindu ritual occasions. The singing is accompanied by large drums known as the *dhol* (Varsha Joshi, 'Drum and Drummer in the Peasant Society', in R. Joshi and N.K. Singh, eds, *Folk, Faith and Feudalism*, Jaipur: Rawat Publications, 1994). I am grateful to Ann Grodzins Gold, Varsha Joshi, Manohar Lalals, Nancy Martin and Shirley Trembath for responding to my request for information. The recording I have access to was made by the Social Work and Research Centre at Tilonia in Rajasthan, and is part of its archive on folk music.

11 **Editor's note:** Gangubai Hangal (1913–2009), major Hindustani vocalist from Dharwad, Karnataka, and pioneering female musician from the Kirana Gharana (see Keywords for 'gharana'). Known later for a change in the timbre of her voice, after she had to have a throat surgery, leaving her with the voice Srivastava describes as 'masculine'.

12 A series of five cassette recordings: The Festival of India, Volume 1, The Gramophone Company of India. Here, Zohra Bai sings in raag Bhoopali. **Editor's note:** Zohra Bai Agrewali was a late nineteenth-/early twentieth-century Hindustani vocalist of the Agra Gharana.

13 As stated earlier, I am aware of the limitations of such a *description* of voice qualities, and invite the reader acquainted with Indian music to evaluate my statements in light of personal experience. Of course, many will already be familiar with the performers and performance styles I refer to, as also with the ritual singing mentioned. From my own experience, the chief criterion for inclusion in the latter is usually perceived kin responsibility, rather than a predefined voice quality; in his autobiography, Mahatma Gandhi was to note that

during Hindu marriage ceremonies 'women, whether they have a voice or no (sic), sing themselves hoarse'. M.K. Gandhi, *An Autobiography: Or the Story of My Experiments with Truth*, Ahmedabad: The Navjivan Trust, 1990, p. 7.

14 Cassette recording: *The Best of Farida Khanum: Urdu Modern Songs*, Volumes 1 and 2, The Gramophone Company of India, 1992. **Editor's note:** Farida Khanum: Pakistan-based classical singer and performer of the ghazal (a form of musical poetry of Arabic origins, often singing of love, loss and yearning).

15 Shamshul Rahman Faruqi and F.W. Pritchett, 'Lyric Poetry in Urdu: The Ghazal', in Barbara Stoler Miller, ed., *Masterworks of Asian Literature in Contemporary Perspective: A Guide for Teaching*, New York: M.E. Sharpe, 1994, p. 94.

16 Manuel, *Cassette Culture*, p. 53. The issue of a fortuitous fit between Lata's voice and the technology for public recordings is also sometimes offered as an explanation for its popularity; there is always some merit in arguments that tell us something about the intersection between technology and culture, but to leave matters at this is merely to defer to technological determinism.

17 S. Zutshi, 'Women, Nation and the Outsider in Contemporary Hindi Cinema', in T. Niranjana, P. Sudhir and V. Dhareshwar, eds, *Interrogating Modernity: Culture and Colonialism in India*, Calcutta: Seagull, 1993, p. 94.

18 **Editor's note:** The iconography of 'Mother India' or *Bharat Mata* coincides with the history of popular Indian nationalism, with numerous depictions in popular painting, literature and theatre. Among its best-known visual representations is a 1905 painting by Abanindranath Tagore. The further links with a militant Hindu nationalism, involving the Mother as the embodiment of aggressive nationalist patriarchy and as the provider of male virility, has been extended into the Hindutva agitations of the 1990s, for example, in aggressive female *sadhvi*s (female mendicants) arousing men to violent acts.

19 S. Zutshi, 'Women, Nation and the Outsider in Contemporary Hindi Cinema', p. 102.

20 Partha Chatterjee, 'The Nationalist Resolution of the Women's Question', and Lata Mani, 'Contentious Traditions: The Debate over *Sati* in Colonial India', in K. Sangari and S. Vaid, eds, *Recasting Women: Essays in Colonial History*, New Delhi: Kali for Women, 1993; emphasis added.

21 S. Srivastava, *Constructing Post-Colonial India: National Character and the Doon School*, London: Routledge, 1998, chapter 4.

22 James Clifford, *The Predicament of Culture: Twentieth-Century Ethnography, Literature and Art*, Cambridge, Mass.: Harvard University Press, 1988; A. Gupta and J. Ferguson, 'Beyond "Culture": Space, Identity and the Politics of Difference', *Cultural Anthropology*, vol. 7, no. 1, 1992, pp. 6–23.

23 R. Gibson, 'Camera Natura: Landscape in Australian Feature Films', in J. Frow and M. Morris, eds, *Australian Cultural Studies: A Reader*, Sydney: Allen and Unwin, 1993.

24 Sister Nivedita, *Hints on National Education in India*, Calcutta: Ubodhan, 1923. All references in this paragraph from pages 57, 59 and 61. **Editor's note:** Sister Nivedita (1867–1911, b. Margaret Noble) was an Irish educator and activist, a follower of late nineteenth-century Hindu reformer Swami Vivekananda, whom she met in London. Eventually, she followed him back to Kolkata, establishing a girls' school in the city.

25 **Editor's note:** *Bhagabata* (or *bhagwat*) narrators of devotional stories, usually from the Puranas, and *kathaka*s (storytellers).

26 My most immediate gesture is to recent work in anthropology that has sought to problematize this spatial consciousness within anthropological theory. A representative sample of discussions can be found in A. Gupta and J. Ferguson, 'Beyond "Culture"'.

27 V. Godse, *Ankhon Dekha Gadar (A Mutiny Witnessed)*, translated into Hindi with an introduction by Amritlal Nagar, New Delhi: Rajpal and Sons, 1986.

28 C. Pateman, *The Disorder of Women: Democracy, Feminism and Political Discourse*, Cambridge: Polity Press, 1989.

29 A.K. Coomaraswamy, *The Dance of Shiva: Fourteen Indian Essays*, New Delhi: Munshiram Manoharlal, 1974. All quotations from Coomaraswamy, pp. 103–04.

30 The milieu I am gesturing at could be better described as constituted through the 'patron–performer–audience nexus'. K. Hansen, *Grounds for Play: The Nautanki Theatre of North India*, Berkeley: University of California Press, 1992, p. 251.

31 Coomaraswamy, *The Dance of Shiva*, p. 103.

32 I could be accused here of falling into the kind of romanticism – based on the speech–writing binary – that Derrida critiques in Levi-Strauss's work. However, one can argue that cultural contexts where orality continues to be a major aspect of social interaction, whilst not intrinsically 'superior' to 'writing' contexts (indeed, this would be a banal point), may have different modes of sociality. This may or may not have any implications for the presence or lack of hierarchies; the question is one of investigating the variations of sociality, rather than asking: 'Do we really know what writing is?' (Jacques Derrida, *Of Grammatology*, Baltimore: Johns Hopkins Press, 1976; Christopher Johnson, *Derrida: The Scene of Writing*, London: Phoenix, 1997.) The issue, specifically, is about the different forms of power (not their lack!) that characterize different interactional contexts. Oral contexts, no matter how contingent, can have their own social and cultural dynamic and this does not, in itself, suggests the reduction of 'textuality' to a 'second order ideological expression' (H.K. Bhabha, *The Location of Culture*, London: Routledge, 1994, p. 23).

33 S.S. Wadley, 'Choosing a Path: Performance Strategies in a North Indian Epic', in S.H. Blackburn, P.J. Claus, J.B. Flueckiger and S.W. Wadley, eds, *Oral Epics in India*, Berkeley: University of California Press, 1989, p. 81; emphasis added. **Editor's note:** Ram Swarup Dhimar is a well-known dhola performer based in Uttar Pradesh, where he runs his own troupe.

34 Ibid., p. 97; see also Hansen, *Grounds for Play*, on north Indian nautanki theatre. **Editor's note:** Nautanki is a popular form of theatre prevalent in north India and usually performed by troupes of itinerant actors. Before Bollywood and television became easily accessible, nautanki served as a primary form of entertainment, particularly in non-urban areas. Across India, itinerant theatre practices continue to exist, though they must now compete with film and television for their audience's attention.

35 Lest this be regarded as a variety of romanticism on behalf of 'tradition', we should remember that even in the relatively structured milieu of an Indian classical music concert in urban India, the audience has considerable scope for (vocal) interaction with the performer (see ibid.: pp. 243–51); and this in a post-colonial context with a long history of instruction on the 'proper' relationship between audiences and performers. However, I am also mindful of Kathryn Hansen's comment (personal communication) that not all 'traditional' performance genres were necessarily strictly oral, and hence my take on orality may be open to dispute.

36 Manuel, *Cassette Culture*, p. 50.

37 Hansen, *Grounds for Play*, p. 243.

38 Quoted in H. Bhimani, *In Search of Lata Mangeshkar*, New Delhi: Indus, 1995, p. 16.

39 David Lelyveld, 'Upon the Subdominant: Administering Music on All India Radio', in Carol A. Breckenridge, ed., *Consuming Modernity: Public Culture in a South Asian World*, Minneapolis: University of Minnesota Press, 1995, p. 55.

40 P. Bourdieu, 'The Forms of Capital', in J.G. Richardson, ed., *Handbook of Theory and Research in the Sociology of Education*, New York: Greenwood Press, 1986.

41 Lelyveld, 'Upon the Subdominant', p. 55. **Editor's note:** B.V. Keskar was the Union Minister for Information and Broadcasting starting 1952. See Keywords for more on All India Radio.

42 Ibid.

43 Srivastava, *Constructing Post-Colonial India*.

44 Vishnu Narayan Bhatkhande (1860–1936) was another extremely influential figure in the movement that sought to construct a 'national' music culture through returning Indian music to its putative ancient Hindu roots (Lelyveld, 'Upon the Subdominant'). **Editor's note:** Bhatkhande was a musicologist known for reworking Hindustani music into the structure it currently uses, with ragas grouped into ten *thaats* or parent scales. His work, such as his four-volume text *Hindustani Sangeet Paddhati* (Hindustani music method/ technique), consolidated and made the grammar of Hindustani music accessible. See Keywords for more.

45 **Editor's note:** In *Tawaifnama* (Chennai: Westland Books, 2019), Saba Dewan notes that leading Congress leader Vallabhbhai Patel, in his time as Minister of Information and Broadcasting, moved to ban those 'whose private life was a public scandal' from performing on the radio, effectively making it impossible for courtesans to access opportunities at state institutions. Moving away from Hindustani, which was a mix of Hindi and Urdu, Hindi was proposed as the official language to be used on radio during his tenure (ibid., p. 454).

46 Lelyveld, 'Upon the Subdominant', p. 57.

47 Ibid., p. 58.

48 I am aware that at this time AIR had several Muslim musicians on its staff and recognize that everyday relationships between Hindu and Muslim musicians may, in fact, have been quite cordial. However, metadiscourses – such as those of Hindu nationalism – are not, usually, about complexities of practices.

49 R. Sunder Rajan, *Real and Imagined Women*, London: Routledge, 1993; Partha Chatterjee, *The Nation and its Fragments: Colonial and Postcolonial Histories*, Princeton: Princeton University Press, 1993.

50 Lelyveld, 'Upon the Subdominant', p. 59; see also S. Chakravarty, *National Identity in Indian Popular Cinema, 1947–1987*, Austin: University of Texas Press, 1993; E. Barnouw and S. Krishnaswany, *Indian Film*, New York: Columbia University Press, 1963, pp. 200–05.

51 **Editor's note:** Noor Jehan (1926–2000), legendary actress and singer, and major movie star in pre-Partition India. She moved to Pakistan following Partition, where she had a further career in film and music, leaving (it is often said) the field free in Bombay-based cinema for Lata Mangeshkar. Noor Jehan's style of performance and singing had distinct Islamicate influences, including possible associations with the *kotha* (or salon), defining Mangeshkar's transition into the purer or more 'Hindu' popular arena.

52 Bharatendu Harishchandra, *Pratinidhi Sankalan* (essays in Hindi, edited by Kamala Prasad), New Delhi: National Book Trust, 1995, p. 117. **Editor's note:** Bharatendu Harishchandra (1850–85), widely considered the father of modern Hindi literature and theatre, was also known for propagating a Hindu traditionalism in his writing.

53 **Editor's note:** Gandharva Mahavidyalaya, influential series of musical schools, the first of which was set up by the musician Vishnu Digambar Paluskar in Lahore in 1901. See Keywords for more.

54 B. Chaitanya Deva, *An Introduction to Indian Music*, New Delhi: Publications Division, Government of India, 1992, p. 106.

55 Mukul Kesavan, 'Urdu, Awadh and the Tawaif: The Islamicate Roots of Indian Cinema', in Zoya Hasan, ed., *Forging Identities: Gender, Communities and the State in India*, Boulder: Westview Press, 1994, p. 245.

56 And, although, as Kesavan points out, 'Muslim influence' may not itself be a simple term to define, it is nevertheless one we can meaningfully employ. Further, this is not to suggest that other non-Hindu groups such as Parsis and Christian did not have a presence in the film industry; rather, that at the time Muslims formed a considerable population of film-industry workers, and that the idea of 'Muslim influence' had considerable public currency. I owe this point to a discussion with Kathryn Hansen.

57 Chakravarty, *National Identity in Indian Popular Cinema*, p. 39.

58 See also, for example, Saadat Hasan Manto's description of the friendship between his wife and the actress Nargis (1929–1981) and the former's insistence that the relationship be kept a secret. S.H. Manto, *Meenabazar* (memoir, in Hindi), Delhi: Rajkamal Paperbacks, 1984; first published 1962.

59 Krishna Sobti, *Mitro Marjani* (novel, in Hindi), New Delhi: Rajkamal Paperbacks, 1991; first published 1967. **Editor's note:** Krishna Sobti (1925–2019), noted Hindi novelist. *Mitro Marjani Mitro Marjani* (translated into English as 'To Hell with You, Mitro'), published in 1967, was a frank portrait of female sexuality set in a deeply conservative Indian household.

60 **Editor's note:** Shamshad Begum (1919–2013) was a playback singer. Born in Lahore, she battled family opposition to begin singing professionally from a young age. By the age of eighteen she was singing on All India Radio, and a few years after that, she moved to Bombay to sing in the Hindi film industry.

61 Hence, the 'professional' singer of Hindi films – as opposed to the 'spontaneously' melodic heroine who was liable to break out into a song at any time in order to express her 'inner' self – was usually the *tawaif* figure; the (Hindu) heroine who aspired to be a professional singer was usually a representative of the 'modern' woman, and carried within her an unsettling aspect. Illustrative examples of this may be found in films such as *Anuradha* (1960) and *Abhimaan* (1973), both directed by Hrishikesh Mukherjee.

62 See, for example, Munshi Premchand, *Sewa Sadan*, New Delhi: Rajkamal Paperbacks, 1994; first published 1921. This aspect of courtesan characterization was perhaps most successfully propagated through the medium of Hindi films. So, in films such as *Kalapani* (dir. Raj Khosla, Hindi, 1958), *Sahib Bibi aur Ghulam* (dir. Abrar Alvi, Hindi, 1962) and *Chitralekha* (dir. Kidar Sharma, Hindi, 1964), the courtesan is a figure of mysterious sophistication.

63 There is another interesting aspect to the aura of middle-class respectability that subsequently gathered around Lata. Her own family background was, in the context of early twentieth-century culture, an ambiguous one. For, her father – Master Dinanath – had been a very well-known singer and actor on the Marathi stage and, hence, may have been somewhat at the margins of 'respectable' Maharashtrian society; to reiterate his strong opposition to a life on the stage for his daughter, Dinanath is reported to have said that 'this work might offer money and fame, but not social standing' (Bhimani, *In Search of Lata Mangeshkar*, p. 83). The extent to which Lata's own career also constitutes a drive towards attaining 'respectability' must remain a point of conjecture. I am grateful to Kathryn Hansen for raising this issue.

64 This point is nicely encapsulated in some stray comments in Harish Bhimani's hagiographic *In Search of Lata Mangeshkar*.

65 Ibid., p. 21.

66 Ibid. **Editor's note:** 'Paaon chhoo lene do . . .' ('Let me touch your feet', a duet from the film T*aj Mahal*, dir. M. Sadiq, 1963). The song is picturized on actors Pradeep Kumar and Bina Rai, who play the Mughal couple Shah Jahan and Mumtaz Mahal respectively.

67 Ibid., p.34.

68 This of course begs the question of the grounds of women's attraction to Lata's voice, a research project in itself. However, given what G.G. Raheja and A.G. Gold have to say about the abundant 'sexual play' in the songs of rural women in Uttar Pradesh and Rajasthan, the admiration for Lata's 'pre-sexual' style merits careful scrutiny. See G.G. Raheja and A.G. Gold, *Listen to the Heron's Words: Reimagining Gender and Kinship in North India*, Berkeley: University of California Press, 1994.

69 From the 1990s, Hindi films have witnessed the incursion of other kinds of female voices, such as those of Ila Arun's in Subhash Ghai's 1993 film *Khalnayak*, and Sapna Awasthi's in the 1998 film *Dil Se*, directed by Mani Ratnam. These 'other' tonalities provide Indian public culture with a resonance that is markedly different from that of Lata's style, as well as pointing to a ferment over the meaning of desirable femininity, or at least to an opening up of the question of feminine identity. **Editor's note:** Ila Arun is a playback singer and actor best known for introducing a raunchy style of music borrowing from Rajasthani folk traditions. 'Choli ke peeche kya hain' (What are you hiding behind the blouse?) from the Hindi film *Khalnayak* (The Villain, dir. Subhash Ghai, Hindi, 1993), one of her biggest hits, was picturized on two female actors and also sparked a huge debate about the articulation of female desire, drawing the ire of right-wing organizations who thought the song was vulgar and obscene (Shohini Ghosh, 'Sex and Television: Feminists Engage with Censorship', *Screen*, Mumbai, 13 July 2007). Sapna Awasthi, another Bollywood playback singer, sang two equally contentious songs, 'Chaiyya chaiyya' for *Dil Se* (dir. Mani Rathnam, Hindi [dubbed], 1998) and 'Main aayi hoon UP Bihar lootne' (I am here to rob UP and Bihar) in *Shool* (The Trident, dir. Eeshwar Nivas, Hindi, 1999).

70 Interestingly, Lata's sister Asha Bhosle, who specialized in providing playback voices for 'non-domesticated' female characters, also occasionally sang in an adolescent-girl voice: for example, in *Sahib Bibi aur Ghulam*, the 'Bhanwara bara nadan hai' (The bumblebee is rather silly) number picturized on Waheeda Rehman. However, these songs were regarded as oddities in Asha's repertoire. **Editor's note:** *Sahib Bibi aur Ghulam* (The Master, the Wife and the Servant, dir. Abrar Alvi, Hindi, 1962), famous Hindi film melodrama about a decaying feudal era, of pleasure-loving zamindars and their pining wives (incarnated by the star Meena Kumari). The Asha Bhosle song in the film is picturized to contrast with the feudal weight of much of the rest of it.

71 Of particular interest is Lata's playback role in films which were predominantly about Muslim contexts, such as *Mere Mehboob* (dir. H.S. Rawail, Hindi, 1963).

72 Masculinity has had a varied career in Hindi films; for some other examples, see Chakravarty, *National Identity in Indian Popular Cinema*, especially chapter 6; Sudhir Kakar, *Intimate Relations: Exploring Indian Sexuality*, Chicago: University of Chicago Press, 1990; Madhava Prasad, *Ideology of the Hindi Film: An Historical Construction*, Delhi: Oxford University Press, 1998. It should also be added that the singing voices that most typified the FYP hero were those provided by Mohammed Rafi and the 'earlier' Kishore Kumar. And, that the dominance of Lata's voice was part of the same process that established the styles popularized by Rafi and Kishore Kumar as the norms for male singers. I have been led to make this point explicit through a suggestion by Madhava Prasad (personal communication). **Editor's note:** Mohammed Rafi (1924–1980), Mukesh (1923–1976) and Kishore Kumar (1929–1987) were the ruling troika of male playback singers for over

thirty years, often considered the golden era of the Hindi film song. Each was associated with specific styles, and in turn with specific movie stars.

73 S. Srivastava, 'The Garden of Rational Delights: The Nation as Experiment, Science, as Masculinity', *Social Analysis*, no. 39, 1996, pp. 119–48.

74 Bourdieu, 'The Forms of Capital'.

75 **Editor's note:** The 1950s, often considered the 'golden age' of the cinema in India, was also one when several film industries were set up, fuelled by the staple genre of romances set within the era of Nehruvian high-nationalism, definitive to the careers of several of India's best-known movie stars, directors, composers, lyricists and singers.

76 Film songs play a considerable role in the promotional activities of 'sex-clinic' operators in Delhi and Mumbai. Inasmuch as sexuality has become an important site for expressing contemporary individuality and autonomy, it further highlights the popular association between filmic romance and the possibilities of achieving one's 'full' potential. S. Srivastava, 'Non-Gandhian Sexuality, Commodity Cultures and a "Happy Married Life": Masculine and Sexual Cultures in the Metropolis', in S. Srivastava, ed., *Sexual Sites, Seminal Attitudes*, New Delhi: Sage, 2004.

77 I do not, of course, wish to suggest that Indian metropolitan culture of the period was a feminist utopia. Rather that, in this particular instance, there was a specific relation between the 'province' and the 'metropolis', particularly in the context of the politics of gender.

78 **Editor's note:** Phanishwarnath 'Renu' (1921–1977), Rajendra Yadav (1929–2013) and Sobti were all major writers whose works significantly defined stylistic shifts in twentieth-century Hindi literature, defining several significant sites for the playing out of the dilemmas of modernity, both in style and thematic concerns. All three produced works that, as it happens, were made into well-known films.

79 For example, *Anuradha*, 1960. **Editor's note:** *Anuradha* was a famous film made by Hrishikesh Mukherjee in 1960, apparently influenced in its plot by Madame Bovary, in telling the story of an upper-class woman and her traumatic encounter with the Indian village.

80 Srivastava, *Constructing Post-Colonial India.*

81 C.A. Holmlund, 'Visible Difference and Flex Appeal: The Body, Sex, Sexuality, and Race in the *Pumping Iron* Films', in S. Birrell and C. Cole, eds, *Women, Sport and Culture*, Champaign, IL: Human Kinetics, 1994, p. 305.

13 I Ashwini Deshpande

1 The only citations in Srivastava's piece are other articles, again quoted without any reference to actual recordings.

2 **Editor's note:** In the 1970s, the Guinness Book of Records listed Lata Mangeshkar as the most-recorded artist in history, noting that she had sung over 25,000 songs. However, the playback singer Mohammed Rafi disputed this entry and was also listed in Guinness for a few years. This category disappeared from Guinness entries by the early 1990s. In 2011, it reappeared with Mangeshkar's sibling Asha Bhosle now being given credit for having the most recordings. See Neepa Majumdar's *Wanted Cultured Ladies Only!: Female Stardom and Cinema in India, 1930s–1950s*, Champaign, Illinois: University of Illinois Press, 2010, p. 232.

3 Incidentally, SS uses 'Indian cinema' when he is actually referring to commercial Hindi cinema, and 'Indian popular music' to refer to Hindi film music. What is this – carelessness, insensitivity, a faux pas?

4 **Editor's note:** Actor and singer Kishore Kumar was known for extreme comedies. In *Half Ticket* (dir: Kalidas, Hindi, 1962) he cross-dresses, impersonates a girl and sings in two voices.

5 **Editor's note:** Narendra Chanchal, a devotional singer in the Punjabi Sufi style, did occasional film songs after singing a major hit in Raj Kapoor's film *Bobby* (1971), 'Beshaq mandir masjid todo . . . par pyar bhara dil kabhi na todo' (Feel free to break down temples and mosques . . . but never break a heart full of love), which he sang in A-sharp (*kali* 5).

6 **Editor's note:** On the scale followed in Indian music, particularly Hindustani music, *kali* 1 or 2 are equivalent to the musical notes C-sharp and D-sharp.

7 Though in some songs, the effect at the high end is not always pleasing, particularly in-tandem songs with Mohammed Rafi, where the latter sounds more relaxed (than Mangeshkar does).

8 Ustad Bade Ghulam Ali Khan is reported to have said about Lata, *'Kambakht, kabhi besuri nahi hoti'* (The wretched woman is never out of tune!).

9 **Editor's note:** The beginning of the octave, equivalent to the 'do' of 'do re mi'.

10 Interview with Lata Mangeshkar, on the occasion of her completing twenty-five years in film music, published in the *Illustrated Weekly of India*, April 1967. **Editor's note:** Gangadhar Gadgil (1923–2008), major Marathi short-story writer and author.

11 **Editor's note:** This paragraph refers to several of the leading female voices in Hindustani classical music in the second half of the twentieth century. The more contemporary singers are Parveen Sultana (b. 1950, from the Patiala Gharana, known especially for her ability to hit very high scales), Kishori Amonkar (1932–2017) and Ashwini Bhide Deshpande (b. 1960) – both leading figures from the Jaipur Gharana and both of whose mothers were themselves well-known singers – Shruti Sadolikar (b. 1951), also from Jaipur, and Veena Sahasrabuddhe (1948–2016) from the Gwalior school. Kesarbai Kerkar (1892–1977) from Jaipur and Malini Rajurkar (b. 1941) from the Gwalior Gharana, and Shobha Gurtu (1925–2004), who mainly sang thumri, belong to a slightly older generation and have heavier voices.

12 **Editor's note:** Sultana is known, among other things, for the range of notes her voice can span, covering more than three octaves, nearly half the span of a grand piano.

13 **Editor's note:** For Gangubai Hangal, see endnote 11 in Srivastava's essay. Hangal's name at birth was Gandhari, but the recording company she worked with had her change it to Gangubai, by which she is better known. Early recordings appear in the name 'Gandhari'.

14 **Editor's note:** Farida Khanum, see endnote 14 of Srivastava's essay.

15 **Editor's note:** Runa Laila (b. 1952), noted popular Bangladeshi singer who began her career in Pakistani films before the 1971 liberation, had a major following in India in the 1970s.

16 **Editor's note:** Chitra Singh, ghazal singer usually performing alongside Jagjit Singh, was one of the most popular ghazal performers in the 1980s.

17 **Editor's note:** *Bai*, a term of address for a woman, was often used as a suffix to the names of Hindustani musicians, particularly those from hereditary performing communities. For instance, it was attached to Hangal's name – Gangubai, and was also in the names of other key Hindustani vocalists – Kesarbai Kerkar, Hirabai Barodekar and Rasoolan Bai. When the anti-nautch movement spread to Varanasi and other areas in Uttar Pradesh and Bihar, which held big communities of *tawaif*s (courtesans), curbing the freedoms and livelihoods of women who did not integrate into the new narrative of a 'national culture', many female musicians of courtesan origin dropped the *bai* from their names, replacing it with devi (goddess). In Saba Dewan's 2009 documentary, *The Other Song*, art historian Rai Anand Krishna recalls Rasoolan Bai in her final years in Allahabad, wandering the hallways of the radio station and looking at a long row of portraits of musicians with the suffix 'devi' attached to their names. Her portrait was also up on the wall, but labelled 'Rasoolan Bai'. Seeing this, she remarked, 'They have all become devis; I am the only *bai* left!'

18 **Editor's note:** A chorus for the film *Badi Maa* (Supreme Mother, 1945). The text translates to: Mother, may our lives pass at your feet.

19 **Editor's note:** 'Chidiya bole ku ku ku' (The birds sing, *ku ku ku*).

20 **Editor's note:** Here, Mangeshkar sings 'Shyam mose na khelo Hori' (Shyam, do not play Holi with me). The angry female protagonist of the song is tired of being the victim of Krishna's pranks, and she begs to be left alone. Sung in Raga Pilu of the Kafi *thaat*, a raga often used for thumris.

21 **Editor's note:** *Sringara* is one of the nine *rasa*s in the *navarasa* system and pertains to love, often of an erotic or romantic nature.

22 **Editor's note:** Veena, a string instrument.

23 **Editor's note:** Crowd-sourced filmographies put the number of Lata songs at twelve until 1947. But in 1948 and 1949 that number grew exponentially, with Lata singing over 200 songs as solos or duets with the occasional trio or chorus appearance.

24 **Editor's note:** Why have you married me into a foreign land, O my father?

25 **Editor's note:** A popular tragic romance from Punjab. The lovers Heer and Ranjha battle family

opposition to sustain their romance, but when Heer dies after being poisoned by a relative, the heartbroken Ranjha kills himself, following her to death.

26 **Editor's note:** Noor Jehan, see endnote 51 in Srivastava's essay.

27 **Editor's note:** 'Ask not for my love as it used to be' or, 'Do not ask me to love you like I used to'. A *nazm* (poem) by celebrated Urdu poet Faiz Ahmad Faiz. Noor Jehan's rendition of it was iconic. Later, in Pakistan, she sang it for the film *Qaidi* (The Prisoner, dir: Najam Naqvi, Urdu, 1962).

28 **Editor's note:** Asha Bhosle, see endnote 4 in Srivastava.

29 Yet, Lata's is seen as the more prevalent voice. Why this happens is an interesting question, but we can't address this without adding substantially to the length of this piece.

30 **Editor's note:** Suraiyya (1929–2004), singer and Hindi movie star, defining with Noor Jehan a dominant style preceding Mangeshkar's arrival. Interestingly, Mangeshkar occasionally sang songs picturized on Suraiya, like in *Jeet* (Victory, dir. Mohan Sinha, Hindi, 1949). Geeta Dutt (1930–1972), major playback singer with a career in Hindi and Bengali, most notably in films in the 1950s–60s, considered the stylistic predecessor to Asha Bhosle.

31 **Editor's note:** In numerous songs, e.g. iconic rendition picturized on cabaret dancer Helen, 'Piya tu ab toh aaja' (My beloved, now come to me) from the film *Caravan* (dir. Nasir Hussein, Hindi, 1971). Helen plays the lover of the villain.

32 Peter Manuel, *Cassette Culture: Popular Music and Technology in Northern India*, Chicago: University of Chicago Press, 1993, p. 53

33 **Editor's note:** Alka Yagnik (b. 1966), Richa Sharma (b. 1974) and Sunidhi Chauhan (b. 1983), major 1990s playback singers in Hindi. Yagnik sang the raunchy 'Choli ke peeche kya hain' with Ila Arun (whom Srivastava mentions as having a distinctly different kind of voice) in the film *Khalnayak* (The Villain, dir. Subhash Ghai, Hindi, 1993). See endnote 69 in Srivastava.

34 **Editor's note:** For instance, 'Kaanta laga' (Pricked by a thorn), originally sung for *Samadhi* (1972), was remixed by DJ Doll (Shefali Jariwala) in 2002. The 1972 version shows the female protagonist dancing in a community gathering while the 2002 version is filmed in the environs of a club. 'Pardesiya yeh sach hain piya' (Stranger, my lover, this is true) from *Mr Natwarlal* (1979) was remixed by DJ Aqeel in a song featuring the actor Rakhi Sawant in 2005. The *Mr Natwarlal* song is a romantic duet featuring the actors Amitabh Bachchan and Rekha, while the 2005 version features Rakhi Sawant as an office assistant who is secretly in love with her boss, imagining sexual encounters with him in the workplace.

35 **Editor's note:** Mohammed Rafi, see endnote 71 in Srivastava.

36 **Editor's note:** *Awara* (The Vagabond, dir. Raj Kapoor, Hindi) and *Tezaab* (Acid, dir. N. Chandra, Hindi, 1988), both landmark films with two different categories of modern women, the first a lawyer and the second a dancer, played by Nargis and Madhuri Dixit respectively.

37 **Editor's note:** Sample list of leading female movie stars in India since Independence into the 1970s.

38 **Editor's note:** Two very famous songs, both indicating some kind of freedom from bondage. 'Pyar kiya toh darna kya' (Why have fear if one has loved?) is picturized on a courtesan in the Mughal court, in the film *Mughal-e-Azam* (King of Kings, dir. K. Asif, Urdu, 1960), and the second, 'Kaanton se kheench ke ye aanchal' (Freeing my scarf from the thorns) in the film *Guide* (dir. Vijay Anand, Hindi, 1965) when Rosie (played by Waheeda Rahman), the daughter of a courtesan, who has had to give up dancing in order to marry, finds fresh motivation to live in symbols from her past, like the ankle-bells she used as a dancer.

39 Students of classical music are trained in being able to sing without swaying their bodies.

40 **Editor's note:** Well-known male playback singers between the 1950s and 1980s. Mohammed Rafi, Kishore Kumar, see endnote 72 in Srivastava. Manna Dey (1919–2013) and Hemant Kumar, aka Hemant Mukhopadhyay (1920–1989), were both Bengali singers. Dey was the nephew of the major Bengali actor–singer K.C. Dey, Hemant, one of the leading singers of Rabindrasangeet (Tagore's songs). Both, however, made major careers in Hindi cinema as well.

41 **Editor's note:** While Mangeshkar never married, she is reputed to have had several relationships including with the actor–filmmaker Raj Kapoor and a more sustained one with Raj Singh Dungarpur, a cricketer, sports administrator and member of a Rajasthan royal family.

42 **Editor's note:** C. Ramchandra (1918–82), major Hindi film composer best known for bringing jazz

into Hindi film, with a long collaboration with Mangeshkar, most notably the song 'Ai mere watan le logon' (O the people of my country) mourning dead soldiers during the military conflict with China in 1962. O.P. Nayyar (1926–2007), also a major film composer with numerous hits, had a history of working with Asha Bhosle, but interestingly, never recorded a song with Mangeshkar.

43 In fact, the presence of a 'Khan Saheb' often imparts an aura of solidity and seriousness to the learning of music.

44 **Editor's note:** The author names Hindustani classical musicians across gharanas, variants of the same musical tradition.

45 **Editor's note:** Omkarnath Thakur was a singer and musicologist who led the Gandharva Mahavidyalaya in Lahore and the music faculty at Banaras Hindu University when it was established. Bismillah Khan played the shehnai, a wind instrument. His uncle and teacher, Ali Buksh Khan, also a *shehnai* player, was attached to the Kashi Vishwanath temple in Varanasi (Banaras) when the younger Khan moved there from Bihar to study with him.

46 **Editor's note:** Hangal, endnote 13 above and endnote 11 in Srivastava's essay. Gurtu, see endnote 11 above. Girija Devi (1929–2016), known mainly as a thumri singer.

47 One would have expected SS to bring up Lata's intimacy with the Hindu right, Shiv Sena in particular, but he doesn't.

48 **Editor's note:** See endnote 60 in Srivastava's essay.

14 I Lakshmi Subramanian

1 Amanda Weidman, 'Gender and the Politics of Voice: Colonial Modernity and Classical Music in South India', *Cultural Anthropology*, vol. 18, no. 2, May 2003, pp. 194–232. **Editor's note:** See T.M. Krishna's *MS Understood* in this volume. Saraswati Bai was a popular twentieth-century harikatha exponent. In harikatha, the musician sings and recites a story that is religious or devotional, usually from an epic, where it might be part of a longer narrative.

2 **Editor's note:** E. Krishna Iyer was a lawyer, activist and dancer, and the founder–secretary of the Madras Music Academy. In this position, he became a vocal critic of Muthulakshmi Reddy's views on devadasis (used here as a term of reference for women of hereditary courtesan dance communities), bringing dancers from those communities, and later from Brahmin families, to the Music Academy stage. He was also behind the 1932 Music Academy resolution to rename sadir, terming it bharatanatyam. See Amanda J. Weidman, *Singing the Classical, Voicing the Modern: The Postcolonial Politics of Music in South India*, Durham: Duke University Press, 2006, pp. 119–20.

3 Quoted in Amanda J. Weidman, 'Gender and the Politics of Voice: Colonial Modernity and Classical Music in South India', in *Singing the Classical, Voicing the Modern: The Postcolonial Politics of Music in South India*, Durham: Duke University Press, 2006, p. 121.

4 Lalita du Perron, 'Thumri: A Discussion of the Female Voice of Hindustani Music', *Modern Asian Studies*, vol. 36 (I), February 2002, pp. 173–93.

5 T.J.S. George, *MS: A Life in Music*, New Delhi: HarperCollins, 2004.

6 Lakshmi Subramanian, 'Gender and the Performing Arts in Nationalist Discourse: An Agenda for the Madras Music Academy, 1930–1947', *The Book Review*, vol. 23, no. 1 –2, 1999, pp. 81–84.

7 **Editor's note:** *Tawaif*s or courtesans were also known as *baiji*s for the suffix of *bai* attached to their names. *Ji* is an honorific. Ustad is a respectful term of address for a male teacher, usually one of Muslim heritage. See Keywords.

8 **Editor's note:** An event that brought together a prodigious number of Indian musicians, both of the Hindustani and Carnatic traditions, the All India Music Conference initiated by V.N. Bhatkhande was envisioned as a platform that would allow discussions about a codified and systematized vocabulary for classical music.

15 | Rahul Bhatia

1	**Editor's note:** 'Rakeshji, king and queen *aa gaye hain*?' (Rakeshji, have the king and queen arrived?), where *ji* is a suffix denoting respect, that is added to the name Rakesh.

2	**Editor's note:** 'Rishi, Sherlyn *ka* exposure *thoda kam kar*.' (Rishi, reduce the amount of exposed skin [Sherlyn's] [seen on camera].)

3	**Editor's note:** 'Welcome to *Splitsvilla, aaj main uski pant utaarne waali hoon*.' (Welcome to *Splitsvilla*, today I'm going to take its pants off.)

4	**Editor's note:** '*Pant utaarna waali hoon*?' (Take its pants off?)

5	**Editor's note:** 'Fluffy, *behenchod peeche se gaadi-waadi jaa rahi hai, aunty-wanty jaa rahi hai*!' (Fluffy, sister-fucking cars are passing by, middle-aged women are passing by.)

6	**Editor's note:** '*Bas behenchod* airplane *jaana baaki hain.*' (Only sister-fucking airplanes are yet to pass by.)

7	**Editor's note:** A cuss word derived from the Hindi '*choot*', or vagina.

8	**Editor's note:** *Khana*: food/ meal

9	**Editor's note:** '*Chee, be-izzati kar di.*' (Damn, it's insulting. [said lightly])

10	**Editor's note:** The Barry John Acting Studio offers acting and filmmaking courses that are particularly popular among Bollywood aspirants.

16 | Leela Samson

1	**Editor's note:** At the time of delivering this lecture, Leela Samson was chairperson of the Sangeet Natak Akademi (SNA) and chief of the Censor Board. Shortly after the 2014 general elections when the BJP formed the central government, she resigned from both posts – the SNA in September 2014, and the Censor Board in January 2015. Also see endnote 20.

2	**Editor's note:** In 2012, dancer and choreographer Aditi Mangaldas turned down the Sangeet Natak Akademi award in the category of 'creative and experimental dance', saying that she saw her work as being in the field of kathak. In a series of letters published on the dance website *Narthaki*, she wrote, 'This is perhaps the right moment to introspect about what exactly is meant by 'kathak'. . . . Kathak today is an amalgamation of multitude of tributaries that has fed it over the centuries. To reinforce it, maybe we need to make sure that this gushing water is always rejuvenated by fresh input from today's performers. Only the substantial will remain, all else will fall away like dead skin.' *Narthaki*, January 2013, https://narthaki.com/info/rt/rt53.html, accessed 30 March 2020.

3	**Editor's note:** Mrinalini Sarabhai, who worked primarily in the bharatanatyam idiom, was given the SNA award for 'creative and experimental dance' in 1970. Sarabhai trained in a range of classical dance forms, and also spent time studying movement in Europe and the USA. She set up the performing arts institution Darpana in Ahmedabad. Social and political issues were central to her choreographic practice, as evinced in works like *Memory Is a Ragged Fragment of Eternity* (1969), made in response to the high suicide rate of women who were victims of domestic abuse in India.

4	**Editor's note:** Sadanand Menon is an arts editor, teacher of cultural journalism, photographer, stage lights designer and speaker at seminars on politics, ecology and the arts. A close associate of legendary choreographer Chandralekha, he is deeply involved with issues concerning contemporary Indian dance.

5	Sadanand Menon (2013), 'Cultural Policy and its Challenges', *Business Standard*, 14 June 2013, https://www.business-standard.com/article/opinion/sadanand-menon-cultural-policy-and-its-challenges-108012501015_1.html, accessed 10 March 2014.

6	**Editor's note:** Maria Montessori (also known as Madame Montessori, 1870–1952) was an Italian physician and educator who developed the Montessori method of early childhood education that allowed children to learn and grow at their own pace, taking the initiative to discover their own intellectual and creative abilities in the process.

7	**Editor's note:** The Puranas are a series of narrative texts that are part of the Vedas, ascribed to

1500–2000 BCE. It is possible that the stories they feature were part of oral historical narratives prior to being included in the Puranas.

17 | Amitesh Grover

1 How is productivity, idleness, and attention measured and quantified across the dispensable resource of contemporary digital capital? I inserted myself as a waged worker in one of India's biggest technology companies. I 'went to work' every day for six months, and performed disruptions within the workplace – exercises in abstraction, uselessness and work-lessness. I was an artist-as-employee, and an employee-as-artist. My performances resulted in a choreography of quiet thoughts exteriorized and staged for the surveillance archive, for colleagues, and left for the system to decode and reassemble. Can the world of digital capital, and its obsession with logistics and automation, be messed up, be pointed towards what is unmeasurable?

18 | Akshara K.V.

1 **Editor's note:** 'Apoha' translates to 'exclusion', defining things in relation to what they are not. Many of the presentations at the 2008 Not the Drama Seminar furthered the tone of the keynote address in engaging with the dialectic of drama/not drama.

2 **Editor's note:** India Theatre Forum is a forum of theatre practitioners across India, headquartered in Mumbai at the Prithvi Theatre (see Keywords). It works towards creating a national resource for theatre through seminars, a website with information on best practices and, most recently, a leadership programme for theatre practitioners.

3 **Editor's note:** Sudhanva Deshpande is an actor and director with the Jana Natya Manch (see Keywords, and 'Halla Bol' in this volume).

4 **Editor's note:** The Drama Seminar was organized by the Sangeet Natak Akademi (SNA) in April 1956. Writing about it, Anita Cherian notes that participation in the seminar was a great honour for invited artists because it signified the Akademi's recognition of their work and gave them the responsibility of shaping what Indian theatre could be in the years to come. In doing so, the Akademi also constructed a vision of what 'Indian theatre' could mean, curating the seminar in line with the ways in which the nation-state was being linguistically restructured. The SNA seminars made the performing arts a site of aesthetic and moral reform, moving them away from their role as sources of livelihood and pleasure. Now institutionalized and supported by the state, 'they (the arts) were moved into the sanctified spaces of high art, seemingly isolating them from popular consumption and from systems of valuation' (Anita Cherian, 'Imagining a National Theatre: The First Drama Seminar Report', *Sangeet Natak*, vol. XLI, no. 2, New Delhi, 2007, pp. 15–39).

5 **Editor's note:** Sombhu Mitra (1915–1997) was an iconic theatre director and actor, and occasional filmmaker, associated in early years with the Indian People's Theatre Association (see Keywords). He is known for numerous famous plays, most notably those of Tagore, e.g. *Raktakarabi* (Red Oleanders, 1954).

6 Attributed to Sombhu Mitra at the Drama Seminar.

7 **Editor's note:** Kamaladevi Chattopadhyay (1903–1988) was a social activist and freedom fighter, who is credited with formulating key central institutions in the arts and crafts, including the Central Cottage Industries Emporium and the Sangeet Natak Akademi. See endnote 8 of Leela Samson's essay.

8 Attributed to Kamaladevi Chattopadhyay at the Drama Seminar.

9 **Editor's note:** The Ministry of Culture in its present form has existed only since 2006. First created in 1961 in the Ministry of Scientific Research and Culture Affairs, becoming in 1971 the Sanskriti Vibhag (Department of Culture), it passed around from the Human Resources Ministry to the Ministry of Youth Affairs and Sports, Education, and finally in 2000, to the newly formed Ministry of Tourism and Culture. Between 2000 and 2006 it remained of uncertain status, until it became the Ministry of Culture in 2006. However, the Ministry of Culture is responsible for a very small part of the work that is identified under the broad rubric of culture. For instance, cultural institutions such as museums and archaeological sites fall under the Ministry of Culture, while

sectors such as textiles and handicrafts are housed under other ministries such as the Ministry of Commerce, the Ministry of Small-Scale Industries, etc.

10 **Editor's note:** Mulk Raj Anand (1905–2004) is known primarily as an English novelist, an editor (founder of the arts journal *Marg*) and an activist.

11 **Editor's note:** Ebrahim Alkazi (1925–2020) was a theatre director, drama teacher and director of the National School of Drama (1962–77) at a crucial juncture in its history. He played a big role in constructing its curriculum and defining the kind of theatre it would make. The NSD Repertory, the wing of the school that promotes professional theatre practice, was set up during his tenure. For more on National School of Drama, see Keywords.

12 **Editor's note:** The FICCI–PriceWaterhouseCooper's 'Indian Entertainment and Media Industry: Sustaining Growth' (2008) comprised an analysis of various media segments and forecasts for their growth. It projected an 18 per cent growth for the sector over the next five years, also noting that digital media would have an important role to play in the near future.

19 | Gargi Bharadwaj

1 **Editor's note:** The question of whether India can at all have a national policy on culture, and if so, what it might look like, has been a vexing question since Independence. For some years after Independence, the assumption was that the national Five Year Plans would include (as they did) a broad rubric of cultural policy, on, for example, small-scale industry, handicrafts, etc. The two key principles of any policy, namely autonomy and 'arm's length', have been hard to realize, especially with the central and state *akademi*s (see Keywords). The role of the Department/Ministry of Culture has been confusing, in part administratively – as evidenced by its very placement (at different junctures with the ministries for human resources, sport, education, youth affairs and tourism) – and substantively, as questions on 'what is culture' get further vexed by its weaponization into ideological constructs. Yet, more complex is the question of 'contemporary' culture, and, for example, the Sangeet Natak Akademi's (SNA) longstanding reluctance to recognize the 'contemporary' as a category of practice. The closest India got to a policy was the Government of India's 'Approach Paper on the National Policy on Culture' (1992). Since then, despite pressure from UNESCO, the very possibility of a single cultural policy has been effectively abandoned.

2 Geeta Kapur, *When was Modernism: Essays on Contemporary Cultural Practice in India*, New Delhi: Tulika Books, 2000, p. 202. **Editor's note:** Writing about filmmaker Satyajit Ray's *Pather Panchali* (1955) – part of his Apu trilogy – Kapur examines the success of his work as evidence of an Indian cultural creativity that linked 'civilizational memory with a sense of sovereignty that independence brings'. In doing so, it glosses over the implications of the colonial experience, she argues, sublimating and displacing 'the threat of modernization into a dream of autonomy'. Discussing Ray's work in the context of the first decade of Indian independence (1947–57), she considers the ways in which artists perpetrate a series of self-deceptions effected through an 'overlapping projection of (past) authenticity and (future) progress . . . at the cost of the very people on whose behalf freedom was won'. Ibid., pp. 201–05.

3 Partha Chatterjee, *Empire and Nation: Selected Essays*, New York: Columbia University Press, 2010, p. 53.

4 Anita Cherian, 'Institutional Maneuvers, Nationalizing Performance, Delineating Genre: Reading the Sangeet Natak Akademi Reports 1953–1959', *Third Frame: Literature, Culture, and Society*, vol. 2, no. 3, 2009, pp. 32–60.

5 The recommendations included repealing the Dramatic Performances Act, 1876 and exemption of all theatre from entertainment tax; construction of theatres, financial support to commercial theatre companies and amateur groups; creation of NSD as a publicly subsidized theatre-training institution; establishing a system of awards and recognition for existing institutions; publication, preservation and documentation of folk and traditional theatre; and funding theatre festivals to showcase regional theatre. (Sangeet Natak Akademi's published proceedings of the 1956 Drama Seminar). **Editor's note:** For more on the Drama Seminar, see Akshara K.V.'s 'Not the Keynote Address' in this volume; also see Keywords.

6 Unpublished report of the Homi Bhabha Committee (1964) on improving the functioning of the *akademis* and ICCR, focusing particularly on ways to preserve the autonomy of the Akademi. **Editor's note:** Published by the Ministry of Education, the committee chaired by Bhabha (then chairman of the Atomic Energy Commission) authored the *Report of the Reviewing Committee for the Three Akademis (Sahitya, Lalit Kala and Sangeet Natak) & The Indian Council for Cultural Relations.* The committee was expected to review their functioning and suggest schemes for inclusion in the Fourth Five Year Plan.

7 **Editor's note:** In August 2013, a photojournalist who was visiting the abandoned Shakti Mills complex near the locality of Mahalaxmi in Mumbai was raped by five men. The rapists restrained her colleague in another section of the mill complex and held a beer bottle to her neck to prevent her from screaming for help. A few weeks later, it transpired that they had previously raped a telephone operator in July 2013. Following the 2012 Delhi gang rape, where a woman was brutally raped and tortured in a private bus, widespread protests demanded safer public spaces and stricter laws against sexual harassment and violence. The Shakti Mills rapists were tried after the Criminal Law (Amendment) Act, 2013 came into force. Under the stricter terms of this amendment, three of the seven accused were sentenced to death for multiple offences. They are in the process of appealing the sentence. While four of the Delhi gangrape convicts were hanged to death in March 2020, the use of the death penalty as a punitive mechanism for gender violence has been critiqued extensively for being an empty gesture.

8 Zurich Theatre Spektakel, Switzerland (2015), ITFOK (2016), Alchemy Festival, UK (2016), La Villette, France (2016), Colombo Dance Festival (2016), TPAM-Yokohama, Tokyo (2017), Women of the World Festival, Melbourne (2017) and Recontres Choreographique, Paris (2017). In 2015, she was awarded the ZKB Acknowledgement Prize at the Zurich Theatre Spektakel.

9 **Editor's note:** *Talatum* is an Urdu word that refers to the topsy-turvy movement of waves in the sea during a storm.

10 The emergence of circus as commercialized entertainment and leisure since the early twentieth century owes in large part to the Malabar region in Kerala, particularly the city of Thalassery that has been the cradle of Indian circus since the 1950s.

11 **Editor's note:** 'Strike' is a technical term for the dismantling of a performance set-up.

12 **Editor's note:** Also see Ari Sitas, with Kristy Stone, Greg Dor and Reza Khota, *Notes for an Oratorio: on small things that fall (like a screw in the night)*, New Delhi: Tulika Books, 2020.

20 | Trina Nileena Banerjee

1 **Editor's note:** Heisnam Kanhailal, see Keywords. Ratan Thiyam (b. 1948) is one of Manipur's (and India's) best known theatre directors. Known mainly for spectacular productions using traditional forms from the region, with both original plays and translations.

2 Yumnam Nirmala Devi and Ramthai, 'Growth of Modern Manipuri Theatre and its Importance in Manipuri Society', *Asian Journal of Multidisciplinary Studies*, vol. 4, no. 6, May 2016.

3 The Manipuri scholar, revolutionary and playwright Arambam Somorendra has written of 'the case of drama which has been found embedded alive in the age-old religious performance of the *Lai Haraoba.* The *Tangkhul Saram Pakhang* (the Youth Tangkhul Saram) and *Nurabi* (Maiden) episode with exchange of dialogue, songs and its conflict of claiming the ownership of the land is really a drama in action'. See Arambam Somorendra, 'Manipuri Drama', *Indian Literature*, vol. 44 (2 [196]), March–April 2000, p. 32.

4 **Editor's note:** Ras leela is a theatrical tradition which sources its narrative from the lives of Radha and Krishna. It emerges from Manipuri Vaishnavism, whose followers worship Vishnu, particularly through the figure of Krishna,and his lover Radha. Nata-sankirtana is a component of the ras leela, usually performed as a prelude to the *ras* episode. It draws from ritual-based modes of drumming, singing and dancing. Goura leela, gostha leela and udukhan leela are also modes of performance that draw on episodes from the life of Krishna. For example, udukhan leela works with the stories of Krishna's childhood pranks. L. Joychandra, 'Review of Rituals and Performances: Studies in Traditional Theatres of Manipur, by Nongthombam Premchand', *Indian Literature*, vol. 49 (6 [230]), 2005, pp. 195–99.

5 The phagee leela or farce preceded the contemporary form of the shumang leela or courtyard theatre, which remains extant and incredibly popular in Manipur to this day. The primary intent of phagee leela was satirical. These short comical plays were performed in order to entertain royalty in the palace courts from pre-Hindu times and they aimed at generating laughter through the criticism of social ills, often mimicking those who were in positions of political authority.

7 L. Somi Roy, 'Window on the World: A Remote Corner of Asia Puts on a Play about 9/11', *The Drama Review*, vol. 48, no. 2, Summer 2004, pp. 68–75.

8 There was one notable exception to this rule in this period. Elangbam Joychandra was a dramatist, lyricist and director who started in 1949 the National Training Drama Party, the name of which was changed later to Manipur Artist Touring Drama Party. It was also popularly known as 'Joy Drama'. Elangbam Joychandra is remembered especially for his contribution in taking these modern plays to the remotest corners of the state along with his team of touring professional actors. Unlike the other companies of his time, Elangbam did not have access to a permanent auditorium but performed his plays on makeshift stages and open spaces across the region. Consequently, his plays reached a much wider cross section of audiences than that of some of his contemporaries.

9 Somorendra writes: 'This period showed the maturity of Manipuri drama with complete Manipuriness in style and form. Many other theatre organizations such as Imphal Theatre, Prabhat, Rangashree, Metropolitan, Raja Dumbra Memorial Theatre, Roxy, etc. put up their shows, though sporadically, in Imphal and its suburbs. Out of these theatre houses, the Manipur Dramatic Union, the Aryan Theatre and the Rupmahal Theatre stood apart as major standing theatres with their permanent halls. Plays on historical, mythological, folk and social themes were produced and with mutual competition, the momentum was gained gradually. The people who were gripped by the tensions of the war got an environment where they could release their pent-up fear and lighten themselves with the fresh air of drama.' Arambam Somorendra, 'Manipuri Drama', *Indian Literature*, vol. 44 (2 [196]), March–April 2000, p. 35.

10 **Editor's note:** Arambam Somorendra (1935–2000), eminent playwright and author, and iconic figure in Manipur's radical cultural history, was shot dead in 2000 when taking part in a seminar. G.C. (or Gitchandra) Tongbra (b. 1913), known satirist, poet and playwright.

11 Lokendra Arambam writes of Arambam Somorendra that, 'In 1955–56, he along with some close colleagues formed the Amateur Artists' Association in 1956, and merged with the Aryan Theatre to become a vanguard for change and modernization in theatre. He was also associated with the founding of Pan-Manipuri Youth League in 1968, an active youth organization for the unity of Manipuris in Manipur, Cachar, Myanmar and Bangladesh (former East Pakistan).' Lokendra Arambam, 'Arambam Somorendra (12 July 1935–10 June 2000)', *Indian Literature*, vol. 44 (4 [198]), July–August 2000, p. 104.

12 See Anjum Katyal, ed., *Seagull Theatre Quarterly*, Issue 14–15, June–September 1997.

13 **Editor's note:** Badal Sircar was a theatre director who was known for his efforts to take theatre to new audiences by dismantling the formal settings that surrounded it. His practice came to be understood as 'third theatre', after a term coined by the European theatre director Eugenio Barba, rejecting the conditions of the proscenium stage in favour of a theatre that would be closer to the people it sought to reach out to.

14 **Editor's note:** For twenty-one months between 1975 and 1977, India was in an official state of Emergency, proposed by the ruling prime minister Indira Gandhi, citing internal threats to the security of India. Thousands of protestors and political opponents were heedlessly placed in preventive detention, and many political prisoners were abused and tortured. Elections were postponed, and the prime minister had unprecedented power, rewriting laws and amending the Constitution to her advantage. Press coverage was censored, and state broadcasters such as Doordarshan (see Keywords) were used for government propaganda. In the 1977 general elections, held at the end of the Emergency, Gandhi's party, the Indian National Congress, suffered its first defeat since 1947, with Gandhi losing her own seat and failing to be elected to the Lok Sabha. The Emergency remains a glaring instance of authoritarian excess, often invoked in the context of, and compared to, repressive governmental mechanisms that have been proposed or implemented by successive governments.

15 Rustom Bharucha, 'Politics of Indigenous Theatre: Kanhailal in Manipur', *Economic and Political Weekly*, vol. 26, no. 11–12, Annual Number, 1991, p. 747.

16 **Editor's note:** The Armed Forces Special Powers Act (AFSPA) gives the Indian armed forces the power to do a wide range of things in the name of maintaining 'public order' in areas classified as 'disturbed areas' by a provision in the Act. This includes the right to occupy property, prohibit large gatherings, arrest citizens without a warrant, and the right to use force and open fire. In Manipur, AFSPA is in force in all areas excluding the state's capital, the Imphal municipal council area. Several acts of resistance have sought to draw attention to the untrammelled power the AFSPA bestows on the armed forces in Manipur. The activist Irom Chanu Sharmila began a sixteen-year hunger strike to demand the repeal of AFSPA in Manipur in 2000, after ten civilians were shot and killed by security forces as they waited at a bus stop in the town of Malom. Sharmila was arrested on charges of 'attempting suicide', a criminal offence in Indian law and force-fed via nasal tubes for the better part of the sixteen years. Another instance involved the rape and murder of Thangjam Manorama by the 17th Assam Rifles in 2004. No arrests were ever made. To protest her murder and the state apathy that followed, a few days after her death, a group of women protested outside Imphal's Kangla Fort, the office of the commandant of the 17th Assam Rifles. Stripping publicly as an act of protest, they shouted and held up a banner with the words – 'Indian Army Rape Us'.

17 **Editor's note:** Kanhailal's *Draupadi* was based on a Bengali short story of the same name by writer Mahasweta Devi, its protagonist, Dopdi Mejhen, a Santhal woman. The historically marginalized Santhal community is dispersed across east India, with a presence in Jharkhand, Assam, Bihar, Odisha and West Bengal. The story is set against the backdrop of the 1960s peasant uprising that began in Naxalbari in North Bengal. The peasants, mostly sharecroppers, are revolting against the usurious practices of wealthy landowners. Some, including Dopdi, join an armed resistance. Death and torture are a frequent occurrence for Dopdi and her comrades, and the English term *encounter*, often morphed to *counter*, suggesting an ambush and death at the hands of the authorities, is part of the local vocabulary. Hotly pursued by the police, she is on her way into the forest, a safe haven, when she is captured. Dopdi is raped and tortured as the police attempt to get information about the resistance movement. This doesn't break Dopdi, and at the end of the story, naked and injured after a night of violence, she confronts the leader of the police camp, shoving him with her breasts, challenging him to *'counter'* her – reversing the power dynamic in the process. In Kanhailal's work, Heisnam Sabitri, playing Draupadi, appears naked for a few seconds in a now-iconic scene at the end of the play. Four years later, the women at the Kangla Fort protest would adopt a similar tactic, deploying their naked bodies to question the morality of the Indian army's actions in Manipur.

18 Lokendra Arambam, 'Experimental Theatre in Manipur: At a Critical Juncture', *Seagull Theatre Quarterly*, issue 14/15, June–September 1997, p. 18.

19 **Editor's note:** The central government's Look East policy, formulated in the 1990s, was an economic initiative meant to strengthen ties with countries in Southeast Asia and East Asia. In 2014, it was replaced by the Act East policy, with North East India becoming a high-priority zone for Act East endeavours, which promised measures to improve the region's connection to ASEAN (Association of Southeast Asian Nations).

20 James Khagembam, 'Surjit Nongmeikapam – An Emerging International Performer in Contemporary Dance', *Manipur Times*, 7 August 2013, available at https://manipurtimes.com/surjit-nongmeikapam-an-emerging-international%20performer-in-contemporary-dance, accessed 5 December 2018.

21 Sanjoy Roy, 'Fears and Frustrations of Modern India Told through Dance', *The Guardian*, 19 October 2015, available at https://www.theguardian.com/stage/2015/oct/19/dance-umbrella-out-of-india-surjit-nongmeikapam-hemabharathypalani-deepak-kurki-shivaswamy, accessed 5 December 2018.

22 Suhani Singh, 'How Nerves Helps Raise a Voice for Gagged, Traumatized Manipur', *Daily O*, 19 September 2016, available at https://www.dailyo.in/arts/dance-nerves-surjit-nongmeikapam-manipur-afspa-kashmir-indianarmy/story/1/12981.html, accessed 5 December 2018.

23 **Editor's note:** Sanabam Thaninleima Chanu and Toijam Shila Devi: graduates of the National School of Drama, now running their own theatre groups and staging plays. Thaminleima is associated with the theatre group Khenjonglang. Shila Devi runs the Prospective Repertory Theatre, Manipur (PRTM) where she staged the play *Amamba Yug* (*Andha Yug*, Era of Blindness).

24 **Editor's note:** L. Dorendra Singh: eminent actor and director in Manipur; played major roles in several productions by Ratan Thiyam's Chorus Repertory Theatre; later co-founded the Cosmopolitan Dramatic Union, directing several plays.

25 **Editor's note:** *Andha Yug* (Era of Blindness): one of the most famous plays in modern Indian history, written by Dharamvir Bharati, telling the story of the Mahabharata as an allegory for Indian independence.

21 I Anand Patwardhan

1 **Editor's note:** Followers of the philosophy and ideological frameworks proposed by jurist, politician and social reformer B.R. Ambedkar.

2 **Editor's note:** As depicted in the following scene, their performances touched on social, political and economic issues through poetry and music. In 2011, they were booked under the Unlawful Activities (Prevention) Act, which offers ways for the state to 'deal' with activities that are perceived to harm the sovereignty and integrity of India. Initially going into hiding, some members of the KKM appeared at Mantralaya (the state government's administrative headquarters in Mumbai) in 2013 and were arrested. While Sheetal Sathe was granted bail on humanitarian grounds, three male members of the troupe, Sagar Gorkhe, Sachin Mali and Ramesh Ghaichor, were in jail for over three years. In 2017, they were granted bail by India's Supreme Court. Since then, Sathe and Mali have split from the Kabir Kala Manch, forming their own cultural group, Navayana Mahajalsa.

3 **Editor's note:** Lavasa City is a privately planned 'gated' city marketing various ultra-luxury services, near the city of Pune in western India. The project had problems clearing environment laws, faced questions about land acquisition processes, and as of 2020, the promoters have been declared bankrupt.

4 **Editor's note:** Refers to the famous temple of Amba in Kolhapur, which has a history going back to the seventh century. Several kings from the Kolhapur dynasty prayed here.

5 **Editor's note:** In 2006, Surekha Bhotmange, her sons Sudhir and Roshan, and her daughter Priyanka, residents of Khairlanji village in Maharashtra's Bhandara district, were murdered by fellow villagers over a land dispute. The Bhotmanges were a Dalit family, classified as belonging to a Scheduled Caste (a term recognized in the Constitution, signifying an officially designated group of people), while the murderers belonged to the Kunbi caste. The women in the family, Surekha and Priyanka Bhotmange, were paraded naked, abused and then hacked to death.

6 **Editor's note:** Annabhau Sathe (1920–1969), legendary Marathi poet, singer and actor associated with the Communist Party, often using the traditional form of powada (see Keywords). Also see endnote 56 in Sharmila Rege's essay. Savitribai Phule (1835–1897), major social reformer and educationist, wife of Jyotirao Phule, and herself now a feminist icon. See endnote 20 in Sharmila Rege's essay.

22 I Maya Indira Ganesh

1 **Editor's note:** Aadhaar: The Government of India's biometric programme for giving 'unique identities' to all Indian residents; also the face of state digitization. See Keywords for more.

2 Katherine Hayles, 'Computing the Human', in Mariam Fraser, Sarah Kember and Celia Lury, eds, *Inventive Life: Approaches to the New Vitalism, Theory, Culture and Society*, vol. 22 (1), London, Thousand Oaks and New Delhi: Sage, 2005, p. 136.

3 **Editor's note:** Cynthia Breazeal: scientist at the MIT Media Lab, where her work with robots in the areas of social robotics and human robot interaction considers how robots can be socially intelligent, learning from humans and interacting with them as peers. Her Kismet robot sought to build the simplest iteration of the ability to engage in 'intimate, human-style interactions'.

4 See *Kismet*, an interview with Breazeal, at https://www.youtube.com/watch?v=P7AWBB1XhqU&feature=youtu.be, accessed 28 April 2019.

5 See *Sex Robots* by Kate Devlin at TEDx Warwick, https://www.youtube.com/watch?v=qlNV2fx7iS0, accessed 15 April 2019.

6 See Lauren Walker, 'Japan's Robot Dogs Get Funerals as Sony Looks Away', *Newsweek*, 8 March 2015.

7 See Emily Selleck, 'This Cute Robot is Programmed to Make Humans Feel Loved', *New York Post*, 18 December 2018.

8 Jeffrey Van Camp, 'My Jibo is Dying and It's Breaking My Heart', *Wired*, March 2019.

9 See C.B. Jensen and A. Blok, 'Techno-animism in Japan: Shinto Cosmograms, Actor-network Theory, and the Enabling Powers of Non-human Agencies', *Theory, Culture and Society*, vol. 30, no. 2, 2013, pp. 84–115, https://doi.org/10.1177/0263276412456564.

10 Donna Haraway, *Primate Visions: Gender, Race and Nature in the World of Modern Science*, London and New York: Routledge, 1990.

11 See Kate Darling, '"Who's Johnny?" Anthropomorphic Framing in Human-Robot Interaction, Integration, and Policy', in P. Lin, K. Abney and R. Jenkins, eds, *Robot Ethics 2.0: From Autonomous Cars to Artificial Intelligence*, New York: Oxford University Press, 2015, pp. 173–88.

12 See Nathan McAlone, 'Japanese Researchers Watch a Gang of Children Beat Up Their Robot in a Shopping Mall', *Business Insider*, 7 August 2015.

13 See Todd Leopold, 'HitchBOT, the hitchhiking robot, gets beheaded in Philadelphia', *CNN*, 4 August 2015.

14 Haraway, *Primate Visions*.

15 See Donna Haraway, 'A Cyborg Manifesto: Science, Technology, and Socialist-Feminism in the Late Twentieth Century', in *Simians, Cyborgs and Women: The Reinvention of Nature*, New York: Routledge, 1991, pp. 149–81.

16 See https://twitter.com/tinycarebot, accessed 15 April 2019.

17 See https://twitter.com/virtuosobot, accessed 20 April 2019.

18 See www.invisiblegirlfriend.com and www.invisibleboyfriend.com, accessed 3 May 2019.

19 See 'Emotion AI Overview', https://www.affectiva.com/emotion-ai-overview/, accessed 4 May 2019.

20 See 'Affectiva Automotive AI', http://go.affectiva.com/auto, accessed 3 May 2019.

21 See Hiawatha Bray, 'Back Seat Driver? New Car Cams May Soon Sense Driver Fatigue, Texting, Other Distractions', *Boston Globe*, 27 September 2018.

22 See '20% of UK adults admit to lying to their insurance company', https://bobatoo.co.uk/blog/20-uk-adults-admit-lying-insurance-company/, accessed 4 May 2019.

23 | Ranjana Dave

1 **Editor's note:** 'Kuru yadunandana' (O, yadunandana): the final song of the *Gita Govinda*, where Radha and Krishna engage in playful and intimate conversation after a night of lovemaking.

2 **Editor's note:** Rukmini Devi (Arundale) (1904–1986): theosophist and dancer who founded Kalakshetra (see Keywords; also see endnote 9 in Leela Samson's essay in this volume). Kelucharan Mohapatra (1926–2004), one of the founding figures of the Odissi dance in its post-Independence consolidation (see Keywords).

3 Anne Carson, *Eros the Bittersweet: An Essay*, Princeton: Princeton University Press, 2014, pp. 36–38.

4 **Editor's note:** 'Lalita lavanga lata parisheelana komala malaya samire' (Delicate clove creepers quiver in the soft mountain breeze): the third song in the *Gita Govinda* sees an exuberant Radha and her *sakhi* marvelling at the signs of love and union that springtime brings with it.

24 | Skye Arundhati Thomas

1 Amitav Ghosh, *The Great Derangement: Climate Change and the Unthinkable*, Chicago: University of Chicago Press, 2016.

2 **Editor's note:** The Royal Bengal tiger is an endangered species of tiger indigenous to the subcontinent. The Panna National park (est. 1981) is India's leading tiger reserve. In 2016, the National Board

for Wildlife granted clearance to the Ken–Betwa River Linking Project despite objections from the forest official and field director of this park. Following a petition filed by environmentalists, a Supreme Court-appointed committee in 2019 filed a report lauded by environmentalists, noting that the government had understated the ecological damage, had not explored viable and cost-effective options, and that compensatory measures could never replace the lost ecosystem.

3 **Editor's note:** The Ken–Betwa River Linking Project proposes a dam to transfer surplus water across state boundaries from the river Ken in Madhya Pradesh to the basin of the river Betwa in Uttar Pradesh, to irrigate the drought-prone region of Bundelkhand. The project has complex environmental concerns around actual availability of water and methods of farming. Farmers in Bundelkhand irrigate their crops by harvesting rainwater using ponds, a method that also replenishes groundwater supply. The canals that will channelize water from the Ken into Bundelkhandi farms will be seasonal at best, and will not be useful to farmers who don't live right by the canals. Meanwhile, in the area around Panna National Park, citizens and politicians have come together across party lines to oppose the project, since it would submerge several villages.

4 **Editor's note:** Sir Arthur Thomas Cotton was an irrigation engineer who worked on the rivers Godavari, Krishna and Cauvery, in present-day Telangana, Andhra Pradesh and Tamil Nadu. He built barrages on the Godavari, thus allowing its water to be utilized for agriculture before the river merged with the Bay of Bengal. In the ways in which the narrative of 'development' has played out in twentieth- and twenty-first-century India, infrastructural projects that gesture towards urban and industrial futures have always been privileged – dams, hydroelectric projects, mines – often at the cost of rural and forest livelihoods. Cotton battled similar biases, trying to advocate his work in an era of grand projects, such as the railway network the British were building across India. Though he proposed river-linking as a solution to end famines and droughts by allowing water to be harnessed for agricultural purposes, colonial authorities did not express interest in the project.

5 Judith Butler, *Frames of War: When is Life Grievable?* London: Verso, 2009, p. 14.

6 Nancy Tuana, 'Viscous Porosity: Witnessing Katrina', in Stacy Alaimo and Susan Hekman, eds, *Material Feminisms*, Bloomington: Indiana University Press, 2008, pp. 188–213.

7 T.J. Demos, 'Creative Ecologies,' *Take on India*, January–June 2017, pp. 18–21.

8 **Editor's note:** Khoj International Artists' Association is a contemporary arts organization based in Delhi. It supports the development of experimental, interdisciplinary and critical contemporary art practice in India.

9 **Editor's note:** Ravi Agarwal, Navjot Altaf and Sheba Chhachhi are artist-activists whose work display a sensitivity to social injustice and the implications of urban transformation. Agarwal, through his work and interactions with at-risk communities, questions the expansionist impulse that the human–nature binary fuels. Altaf's practice has extended to long-term collaborations with artists and communities in Chhattisgarh's Bastar region in central India. Though mining companies and other private interests have unprecedented access to forest resources in mineral-rich Bastar for resident communities, industrial activity has displaced them and deprived them of their livelihoods. Sheba Chhachhi, who was part of the women's movement, has, in her own words, concerned herself with 'women on the edge', making work that emerges from questions around gender and ecology.

10 **Editor's note:** Zuleikha Chaudhari is a theatre director and lighting designer. Her 2016 work reprised a famous legal case in colonial India when a person claiming to be a prince of the Bhawal estate, now in Bangladesh, resurfaced a decade after he had supposedly died of syphilis. The estate had long passed to British rule, with the Court of Wards, a legal body, taking over its management in the absence of a male heir. Parts of the *kumar*'s (prince's) family and some tenants of the estate accepted that the newcomer was who he claimed to be. His battle to get the colonial government to recognize his rights over the estate took twenty years, but he ultimately won the case. Unravelling questions of identity and feudal authority in the twentieth-century courtroom, the case also became illustrative of social and religious faultlines in colonial Bengal. Also see Partha Chatterjee, *A Princely Impostor?: The Kumar of Bhawal and the Secret History of Indian Nationalism*, New Jersey: Princeton University Press, 2002.

11 Donna Haraway, 'Anthropocene, Capitalocene, Chthulucene: Staying with the Trouble', presented at the conference 'Anthropocene: Arts of Living on a Damaged Planet', Santa Cruz, California, 9 May 2014.

25 I Mila Samdub

1 These epithets are phrases that originated in online trolling that have now become a part of mainstream political discourse, used on television channels and by politicians. **Editor's note:** #JNUType[s]: refers to the faculty and students of the Jawaharlal Nehru University (JNU), New Delhi, accused of being 'anti-national' for speaking up against authoritarian actions and regimes within and beyond the university space. Expressions of dissent against repressive state mechanisms or critiques of the lack of free speech are a magnet for the epithet. 'Lutyens armchair folks': refers to the elite central section of New Delhi designed by British architect Edwin Lutyens in late colonialism, now prime real estate. It is also a broader term for anyone with cultural capital critiquing state policies: e.g. @Confident_India, which Samdub references, posted in response to anti-Aadhaar lawyer-activist Usha Ramanathan's critique of the project, remarks, 'These Lutyens armchair folks never built anything in their life. They just sip coffee and critique the world.'

2 **Editor's note:** Kiran Jonnalagadda: technology practitioner and anti-Aadhaar activist, who has constantly called out the Aadhaar project for its opacity and the chilling ease with which it might be used to make India a surveillance state. In recent years, activists such as Jonnalagada have highlighted, with increasing alarm, the rapid expansion of state surveillance mechanisms. As of 2020, the Aarogya Setu app, released by the government to enable Covid-19 tracking, raised concerns for its lack of clarity on what personal data the app would mine and who would have access to these data, and also whether it is voluntary or not (both government and private employers are making its use compulsory, as are modes of travel).

3 The entire incident is covered in three blog posts: Kiran Jonnalagadda, 'Inside the Mind of India's Chief Tech Stack Evangelist', *Medium*, 17 May 2017, https://medium.com/karana/inside-the-mind-of-indias-chief-tech-stack-evangelist-ca01e7a507a9, accessed 15 February 2020; Kiran Jonnalagadda, 'Sharad Sharma's Dubious Denial', *Medium*, 18 May 2017, https://medium.com/@jackerhack/sharad-sharmas-dubious-denial-b0b9aa6c6b8f, accessed 15 February 2020; Kiran Jonnalagadda, 'Vigilante Justice Is Never a Good Idea', *Medium*, 29 May 2017, https://medium.com/@jackerhack/vigilante-justice-is-never-a-good-idea-4e377a157c6a, accessed 15 February 2020. Its aftermath and the process of Sharma's denial are well covered in *The Ken*. See Rohin Dharmakumar, 'Platform Ambitions: The Story of How iSpirt Lost Its True North', *The Ken*, 21 September 2017, https://the-ken.com/story/platform-ambitions-story-ispirt-lost-true-north/, accessed 15 February 2020.

4 Comprising Aadhaar, eKYC, Unified Payments Interface and Digilocker, India Stack is a group of Application Programming Interfaces, protocols and databases that operationalizes Aadhaar in order to make its data more available to various state and corporate bodies. If Aadhaar had been started with the goal of smoothing out the process of delivering welfare, India Stack turned it into the all-pervasive surveillance tool and the cornerstone of Digital India that it has now become.

5 Wendy Hui Kyong Chun, 'Big Data as Drama', *ELH*, vol. 83, no. 2 (Baltimore: Johns Hopkins University Press), Summer 2016, p. 363.

6 Wendy Hui Kyong Chun, *Updating to Remain the Same: Habitual New Media*, Cambridge, Mass. and London: MIT Press, 2016, p. 3.

7 It's no accident that some of the biggest beneficiaries of Digital India are insurance companies.

8 Sahana Udupa, 'The Wannabe Victims: India's Online Right', *Livemint*, 14 February 2019, https://www.livemint.com/politics/news/the-wannabe-victims-india-s-online-right-1550165952378.html, accessed 15 February 2020.

9 UrbanNazi.com, 'A Social Media Report for Bot Detection', https://www.notion.so/UrbanNazi-com-A-Social-Media-Report-for-Bot-Detection-9aab55d505dd43a7b74c96586d071432, accessed 15 February 2020.

10 On a critique of digital dualism which sees the online and offline as separate spheres, see Nathan Jurgenson, 'Digital Dualism versus Augmented Reality', *Cyborgology*, 24 February 2011, https://thesocietypages.org/cyborgology/2011/02/24/digital-dualism-versus-augmented-reality/, accessed 19 February 2020.

11 Geert Lovink, *Sad By Design*, London: Pluto Press, 2019, p. 137.

12 See Rob Horning, 'Mass Authentic', *The New Inquiry*, 20 December 2016, available at https://thenewinquiry.com/blog/mass-authentic/, accessed 15 February 2020; and Rob Horning, 'Authenticity as

a Service: Networked Society and the Disavowal of Self-Representation', (n.d.), http://dismagazine.com/dystopia/73316/rob-horning-authenticity-as-a-service/, accessed 15 February 2020.

13 Sarah Thornton as quoted in Rob Horning, 'Authenticity as a Service'.

14 Trolls share platform cynicism with social media influencers. Like social media influencers, trolls use the platforms that most of us use as the background of our social lives in intentional, goal-oriented ways. And like social media influencers, trolls are not simply a side-effect of platforms but are central to their functioning. This is a thread that may be worth investigating further.

15 In fact, Anja Kovacs observes that trolling is itself often a form of social surveillance, policing behaviours that are 'unacceptable' in women. See interview with Anja Kovacs by Poorvi Gupta in *SheThePeople*, 4 July 2017, https://www.shethepeople.tv/news/anja-kovacs-shares-why-we-need-to-be-careful-of-surveillance-on-the-internet, accessed 19 February 2020.

16 It is worth noting that anonymity is only useful for trolls when it functions as a safeguard against social judgement. As long as the actions of trolls are still beyond the pale of mainstream society, anonymity is a useful veil. With the normalization of hate speech under Hindutva, anonymity is increasingly becoming unnecessary.

17 Robin Celikates and Daniel de Zeeuw, 'Botnet Politics, Algorithmic Resistance and Hacking Society: New Forms of Disobedience in the Age of Planetary Computerization', in *Hacking Habitat* (exhibition catalogue), Amsterdam: University of Amsterdam, 2016.

18 Geert Lovink, *Sad By Design*.

19 Itty Abraham and Ashish Rajadhyaksha, 'State Power and Technological Citizenship in India: From the Postcolonial to the Digital Age', *East Asian Science, Technology and Society*, vol. 9, no. 1, March 2015, pp. 65–85, https://doi.org/10.1215/18752160-2863200.

20 Nick Monaco and Carly Nyst, 'State-Sponsored Trolling: How Governments Are Deploying Disinformation as Part of Broader Digital Harassment Campaigns', Palo Alto: Institute for the Future, 2018. It's worth noting that the rise of information abundance has by no means displaced strategies of scarcity. In India, for example, the state uses both side by side, promoting the production and dissemination of information through various digital governance projects whilst instituting more internet shutdowns than ever before. On the latter, see 'Internet Shutdown Stories', Bengaluru: Centre for Internet and Society.

21 In-depth investigations into Reliance Jio, state connections and the boom of cheap internet can be found in Daniel Block, 'Data Plans', *Caravan*, February 2019; and Tushar Dhara, 'Is Rajasthan Government's Free-Phone Scheme Directly Benefiting Reliance Jio?', *Caravan*, September 2018.

ACKNOWLEDGEMENTS

This book owes everything to all the makers who have generously allowed us to reprint their texts and artworks, trusting how we have chosen to reconfigure and reinterpret their work in the process. Thank you for making this assemblage possible.

Grateful acknowledgements to everyone at Tulika Books. To Puja Chakraborty for her work on permissions. To Nilanjana Dey and Haobam Basantarani for the care and complexity that they brought to their editorial work.

To Huang Chenyun, Iris Huang and Liu Yan for their work on translating the book in deeply contextual ways.

I am very grateful to Indira Chandrasekhar and Chen Yun for making this series happen, and for steering me through the process of planning the volume.

I started working on the book at Adishakti in Puducherry. Thanks to Nimmy Raphel, Vinay Kumar, Arvind Rane, Dhavamani and all the actors, staff and dogs at Adishakti for welcoming me into their lives for a month.

A big thank you to Ashish Rajadhyaksha for holding this six-volume series together, for his unwavering support and faith in the project, and for the incredible detail he has brought to this assemblage.

Also, to Gauri Nagpal for her deeply invested design process, fuelled by unlimited reserves of curiosity and imagination, and for saying 'mirror' with such ubiquity.

Thanks are always due to chocolate, which fuels all writing. To Srinivas Aditya Mopidevi, Noor Enayat and Deepak Kurki Shivaswamy, and my mother, Vasantha Rao, for being willing (or unwilling yet indulgent) listeners. And to Mandeep Raikhy, for always being there, for years of thinking through these ideas together, and for making it possible for me to have the time I needed to work on this.

Ranjana Dave
New Delhi, 13 July 2020

Ranjana Dave is an artist and writer. Her practice, emerging from her movement training in Odissi and her writing, unfolds at the intersection of text and movement. Recent performance work includes *Age Sex Location (asl)*, 2020. Ranjana is programmes director at Gati Dance Forum, where she edits the annual performance journal *Indent*. She worked on developing a curriculum for a master's programme in dance practice with colleagues at Gati, teaching on the MA Performance Practice (Dance) programme at Ambedkar University Delhi. Her work has appeared in Firstpost, The Hindu, Scroll, Time Out, Asian Age, Indian Express, and Marg Magazine, among other publications. She curated and annotated an online archive of dance video at Pad.ma (Public Access Digital Media Archive). She is the co-founder of Dance Dialogues, a Mumbai-based initiative that connected the local dance community to provocative and diverse ideas, individuals and institutions. Ranjana has curated conferences for the IGNITE! Dance Festival and Indent. She co-curated the performing arts track at The Goa Project (2015), and was the dance curator for Serendipity Arts Festival (2018).

Front cover

Chandralekha performing the Sakambhari sequence in her work *Sri* (1991); photo by Bernd Merzenich. The montage uses a 2020 government-issued quarantine rubber stamp marked on the skin of incoming passengers during the early days of the Covid pandemic.

Back cover

'Ya toh duniya sabki hain ya nahi kisi ki bhai' (This world, it either belongs to all or to none at all) – from the children's poem 'Duniya Sabki' (The World Is for All) by Safdar Hashmi.